ARR CARLA GAY *RENITA VAL*
IVIA HART GLAMAMORE *JUA*
ITA AIDA BEBE SWEETBRIAI
MAN *DONNA PERSONNA* RUM
ON WATERS *LADY RED COU*
IANA KRYSTAL DELITE *THE*
IOMMA THE FABULOUS WON
NTASIA L'AMOUR *GYPSY* LOVE
E SIR LADY JAVA *HOT CHOCO*
NA MOORE LAWANDA JACK
*IELSS*HANNONDUPREE*THE*
KEESTER CHRISTINA CHASE
S JOJO BABY CAPUCINE DEVE
DAMS DANA ST. JAMES KEL
A BROOKS *TASHA KOHL* DIN
A ADAMS *TERYL LYNN FOXX*
NALOT FONTAINE AGNES D
CHARITY CHARLES CHIN
ECTRA EGYPTT L
NBEAM PRINCESS *DIANDRA*
COCO LACHINE *PANZI* BAR
WITTI REPARTEE SIMON

D1272543

LEGENDS of DRAG

Queens of a Certain Age

HARRY JAMES HANSON & DEVIN ANTHEUS

LEGENDS
of DRAG
Queens of a Certain Age

HARRY JAMES HANSON & DEVIN ANTHEUS

CERNUNNOS

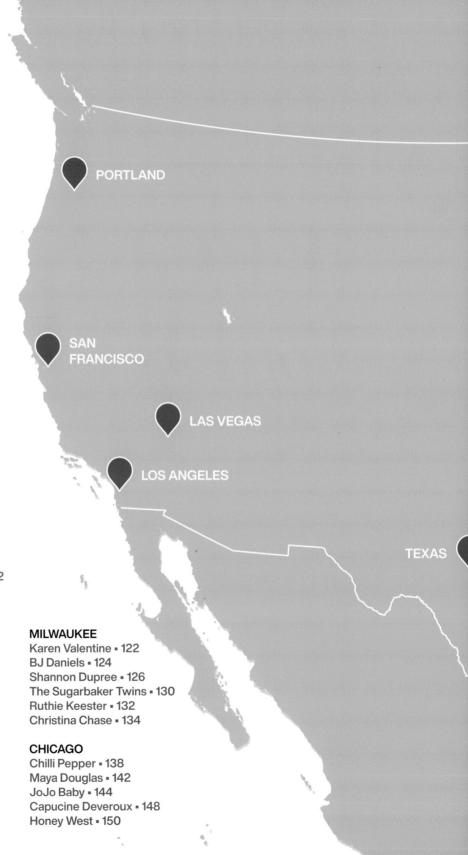

Prelude by Miss J Alexander ▪ 6
Foreword by Sasha Velour ▪ 7
Introduction ▪ 8

SAN FRANCISCO
Phatima Rude ▪ 18
Joan Jett Blakk ▪ 22
Carla Gay ▪ 24
Renita Valdez ▪ 26
Collette LeGrande ▪ 28
Olivia Hart ▪ 30
Glamamore ▪ 32
Juanita More ▪ 34
Mutha Chucka ▪ 38
Tita Aida ▪ 40
BeBe Sweetbriar ▪ 42
Sister Roma ▪ 44
Mrs. Vera Newman ▪ 48
Donna Personna ▪ 50
Rumi Missabu ▪ 52

PORTLAND, OR
Darcelle XV ▪ 58
Poison Waters ▪ 60

LOS ANGELES
Lady Red Couture ▪ 64
Dolly Levi ▪ 68
Maximilliana ▪ 70
Krystal Delite ▪ 72
The Goddess Bunny ▪ 74
Glen Alen ▪ 78
Momma ▪ 80
The Fabulous Wonder Twins ▪ 82
Vancie Vega ▪ 84
Fontasia L'Amour ▪ 86
Gypsy ▪ 88
Love Connie ▪ 90
Psycadella Facade ▪ 92
Sir Lady Java ▪ 94

LAS VEGAS
Hot Chocolate ▪ 100
Crystal Woods ▪ 104
DuWanna Moore ▪ 106
Lawanda Jackson ▪ 108

TEXAS
Tasha Kohl ▪ 112
Dina Jacobs ▪ 114
Kitty Litter ▪ 118

MILWAUKEE
Karen Valentine ▪ 122
BJ Daniels ▪ 124
Shannon Dupree ▪ 126
The Sugarbaker Twins ▪ 130
Ruthie Keester ▪ 132
Christina Chase ▪ 134

CHICAGO
Chilli Pepper ▪ 138
Maya Douglas ▪ 142
JoJo Baby ▪ 144
Capucine Deveroux ▪ 148
Honey West ▪ 150

PORTLAND

SAN
FRANCISCO

LAS VEGAS

LOS ANGELES

TEXAS

Map of Contents

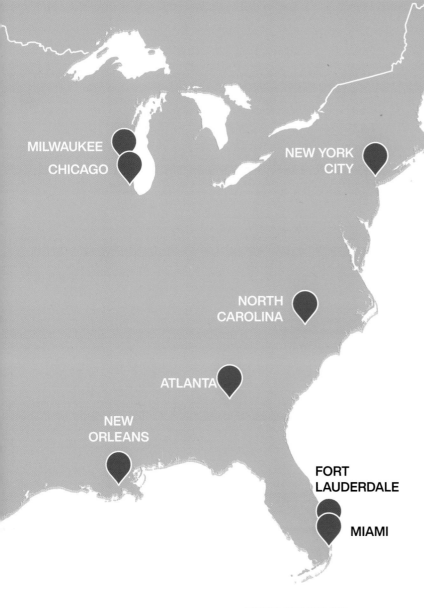

MILWAUKEE

CHICAGO

NEW YORK CITY

NORTH CAROLINA

ATLANTA

NEW ORLEANS

FORT LAUDERDALE

MIAMI

NEW ORLEANS
Regina Adams • 172
Teryl Lynn Foxx • 174
Vanessa Carr Kennedy • 176
Moanalot Fontaine • 178
Agnes de Garron • 180

MIAMI
Adora • 186
Kitty Meow • 188

FORT LAUDERDALE
Charity Charles • 192
China • 194
Sharde Ross • 196
Nikki Adams • 198
Electra • 200

NEW YORK CITY
Egyptt LaBeija • 206
Linda Simpson • 208
Harmonica Sunbeam • 210
Princess Diandra • 212
Perfidia • 214
Flotilla DeBarge • 216
Coco LaChine • 218
Panzi • 222
Barbra Herr • 224
Pickles • 226
Ruby Rims • 228
Witti Repartee • 230
Simone • 232

Chronology • 234
Special Thanks • 239

NORTH CAROLINA
Ebony Addams • 154
Dana St. James • 156
Kelly Ray • 158

ATLANTA
Tina Devore • 164
Shawnna Brooks • 168

Prelude
Miss J Alexander

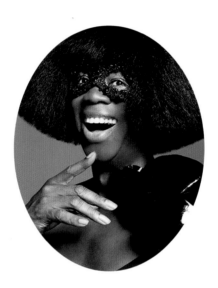

While simple enough to define—a form of entertainment in which performers wear elaborate costumes and transgress gender expectations—drag poses a much more slippery question: *Why?* What purpose does the act of transformation serve?

A singular answer eludes us: some get in drag for fun and fantasy, while others reveal their authentic selves. Drag can be performed privately, or in outrageous public displays. Drag serves delicacy and severity, glamour and horror, butch and femme—sometimes all these at once, other times somewhere in between.

My drag has always been rooted in fashion. Growing up in the Bronx in the 1960s, I taught myself to sew at a young age. Being the naturally creative and gifted Black boss that I am, I was sewing my first looks by the age of twelve. It's an intuitive process; I

don't overthink it. Some of us are gay, and some of us are gayer than gay. I never had time to think about the implications, I just did the damn thing. If this life chooses you, baby don't hold back.

When I look through these bold and beautiful portraits of our community's drag elders, I am in awe at the lives these souls have lived and touched. To not just survive but thrive in a world that wasn't built for us requires a truly unfathomable degree of strength and wisdom. Which is to say nothing of the enormous amount of fun they must have had throughout it all, breaking boundaries while claiming their individuality and identity.

The children need to hear these stories; the power is theirs to inherit. From William Dorsey Swann to the Lady Chablis, and the millions of drag queens, kings, and gender nonbinary royalty who have performed, rebelled, and created—we are beautiful and infinite.

Foreword
Sasha Velour

We should call ourselves drag queens with pride. It's a name that connects us to a glorious legacy of gender transgression that spans hundreds of years! Even before I learned how to paint a cat-eye, I aspired to be a "researcher" of the long queer history of drag. It is a history that is largely unknown and misunderstood—but it attests to the undeniable existence of queer people throughout time and our enduring belief that we deserve to live authentic lives that are full of joy, even in the face of direct oppression.

It was this radical history that inspired me to become a drag queen myself. I honestly liked the feeling that there was nothing I could do in drag that hadn't already been done. We don't need to worry about being innovators in drag, instead we can stay true to the enduring spirit that's already there and channel the power of this legacy for the present and future.

Connecting with history is priceless, and the best way to do so is by hearing stories from people who've lived it. This is especially true for drag, where traditional archives and histories left us out. Perhaps we have no choice but to learn our legends through storytelling. Folk traditions appeal to us because they remind us that queer people function like a large family, bonded not by blood, but by shared sensibility and the choice for liberation. Like in any family, we may not agree on everything, but we still need our elders to help us understand where we came from.

When I first came to Brooklyn in 2015, I was surprised to see such a young drag scene. Growing up in small towns, I was used to seeing older people living big queer lives and presiding over drag at local bars. In bigger cities, I learned, nightlife culture is often more disconnected from previous generations. The legends are still around—but sometimes you must seek them out yourself and pay them their dues!

In early 2018, my young career bolstered by a surreal *Drag Race* win, I was back at work in Brooklyn putting on shows and brainstorming articles for the fourth issue of *Velour: The Drag Magazine*. It was then that I received, quite simply, a perfect pitch from Harry James Hanson (a fellow queen from the Brooklyn scene). Harry wrote, "I'm particularly interested in pursuing a photo essay/interview(s) that address the [lack of] intergenerational exchange within the drag community." YES! With a small budget, mostly for flowers, I happily gave them the OK. Three months later, Harry flew to California to create the first images for "The Legends of San Francisco" with Devin Antheus.

Phatima Rude, Renita Valdez, Carla Gay, and Mutha Chucka all agreed to be subjects and posed for the first four portraits and interviews. When I first read the accompanying text, it sent a shiver of recognition down my spine. "Each [photo] offered another lens into a lifestyle, a scene, a neighborhood, and a city thoroughly enchanted by spirits of place," Harry and Devin wrote. "Phatima described recognizing the spirits of long-dead queens in the very specific affects and aesthetic choices of kids who'd moved to the city a decade after their ancestors of style had passed." Generation after generation, we are connected to each other, even if we don't realize or acknowledge it. Phatima herself is no longer with us, but I still imagine her haunting all of us with anthuriums, arched brows, and smeared fuchsia lipstick.

The fourth issue of the magazine unfortunately never materialized, but the photos were published in *Vogue* the next year, to an audience FAR larger than *Velour* magazine! Everything happens for a reason, and it makes me happy to know that Phatima got a chance to see herself called "legendary" and "beautiful" in *Vogue* before the end of her life. From there, the project continued to expand and transform into the book you are holding now.

Drag is once again finding its way back into the cultural mainstream. Today, there are drag performers whose names are known all over the world. It's not the first time this has happened, of course—in the nineteenth and twentieth centuries, Du-Val, Barbette, Mei Lanfang, Divine, and Sylvester all grew to be world famous. But perhaps the question now is: do we have the privilege to be seen as part of a vital cultural legacy and tradition, or are we always going to be written off as a little bit of color, just for fun?

The seventy-nine portraits on these pages are the perfect example of how we use beauty to create lasting space and value for ourselves. Through our looks and images, we assert proud difference into the world, and by putting it in books like this, we leave a lasting mark, a clue for future generations. Our stories, our living legends, are vital. The faces in this book are just a small fragment of our radical past. Our legendary elders and ancestors fought for us and helped shape the very possibilities for our existence, our genders, our beauty, and our joy that we continue to explore. Their stories are the key to recognizing who we are and how we fit in to the big queer world out there.

Introduction

The night of the winter solstice 2017, we decided to go to church. For the uninitiated, "church" in the queer world often means "drag show." Harry, visiting Devin in San Francisco, wanted to see the local performers for the first time, so we dropped into Aunt Charlie's, a landmark of the Tenderloin neighborhood. Known for being irreverent, political, and unapologetically weird, SF drag revealed a more corporeal quality that evening: the median cast age of sixty. At the time, we knew few performers outside our own millennial generation, yet here was an entire ensemble of drag legends giving the children a run for their money.

These queens of a certain age possess an inimitable mastery of the art but often remain unsung heroines in an increasingly youth-focused drag culture. That night, we realized this was a deep well, filled with important stories. Everything happened quickly since then.

We followed the thread, and guided by the ancestors, found ourselves tracing an underworld comprised of dive bars and nightclubs, communes and punk houses. A subversive tradition emerged, tied up in the wandering history of what has come to be called drag. It's become a common understanding that queens—especially the most marginalized—were on the front lines of the riots that kicked off the gay liberation movement. We forget, however, that these fiery moments in history exist within a constellation of subversion going back millennia.[1]

Despite an array of persecution, ritual cross-dressing persists in bacchanals and carnivals whenever people meet to celebrate resilience and seek a shared freedom. During the Third Reich, queens like Denis Rake used their background in cross-dressing to evade the police and support the resistance. At Cooper Do-nuts, Stonewall, and Compton's Cafeteria, queens threw the first bricks. We venerate Sylvia Rivera and Marsha P. Johnson as saints for their street organizing as revolutionary transvestites.

No universal history of drag exists, and no two queens define the art form the same way. By highlighting this wide-ranging cast of queens, we intend to offer many entry points into this varied and category-defying tradition. We present an archive of stories and gestures: of care, code-switching, seduction, performance, survival, criminality, hostility, promiscuity, evasion, articulation, impersonation, devotion.

The upcoming generations of drag queens will take the art to places it has never been, and they do it because of the loving contributions of the previous generations. It is not uncommon for one of our subjects to bring an entourage of younger queens with them to our shoots. They share hopes of getting a new place or booking a new show with their daughters. They offer critique on panels judging youth drag performance. They march as the marshals of Pride parades and share histories of gay resistance. Our survival is all bound up in each other's. We've seen the tremendous amount to be gained by fostering intergenerational exchange.

The onset of the coronavirus pandemic in the middle of this project reaffirmed its importance for us. Beyond the demographic threat posed to the elders by the virus, it became apparent that the crisis of the moment demanded the wisdom of those who already survived a plague. Thankfully we'd already established the outdoor aesthetic, which easily adapted to a low-risk photo shoot and interview. We can't imagine a way we'd rather spend the apocalypse than meeting these queens and creating this time capsule.

We've asked every single queen in the book about their personal initiations into the art of drag. A very select few were lucky enough to have had their performative impulse nurtured by their families. Some discovered dressing up as a private, personal affair and only later connected their practice to traditions and communities. Nearly half the queens in the book make reference to a bet or dare to enter a competition as their point of origin. Given this collection depicts lifelong performers, we shouldn't be surprised our girls all won. Still, the form of the challenge points toward the risk involved. More than any other single festival or occurrence, our queens began their drag on Halloween. Beyond the permissive and carnivalesque energy of the celebration providing fecund space for experimentation, we might also consider that the thinning of the veil makes possible a more direct connection to the spirits of the traditions surrounding the art.

This self-initiation doesn't necessarily offer a coherent or collective identity. Our models identify variously as femme queens, showgirls, club kids, gender illusionists, transgender performers,

1. See page 234: Hell Hath No Fury: A Chronology of Genderfuck Insurrection

Our queens are members of the Gay Liberation Front, the Cycle Sluts, Queer Nation, and ACT UP.

female impersonators, pageant titleholders, tribute artists, ballroom children, drag nuns, vedettes, and chanteuses. Not mutually exclusive, queens take up any combination of these identities. Within these pages, one might very well find conflicting accounts of the way things were *back in the day*. For every insistence that drag requires a specific artifice or aesthetic, an even older queen will insist the opposite. If the tradition as a whole appears rife with contradictions, this illustrates that what's been homogenized of late is in fact composed of diverse lineages and orders that engage with and inform one another. This tome collects stories from the Cockettes, who gave way to the Angels of Light, who inspired the Radical Faeries, through which the Sisters of Perpetual Indulgence found one another. Our queens are members of the Gay Liberation Front, the Cycle Sluts, Queer Nation, and ACT UP. They've worn the crowns of countless pageants throughout entirely distinct systems. They reign as Empresses of the Imperial Courts of the various metropoles. Which is all to say nothing of the prestigious drag families and great houses to which many of the girls belong.

Despite the diversity of lineages represented by this collective, several peculiar details recur throughout the stories of queens who appear otherwise quite distinct. More than any other source, the most consistently cited reference points shared among all our models are Divine (who we'll return to shortly) and *Dreamgirls*. Whenever a queen brings up the musical, they exclusively refer to the life-changing impact of performing (or seeing a performance of) one of two songs: "And I Am Telling You I'm Not Going" or "I Am Changing." Taken together, these twin sentiments—staying and changing—speak to the paradoxes and complexities of participating in a living tradition. That traditions evolve allows them to persist.

Even with these queens shaping and bearing witness to monumental and groundbreaking events in the history of drag, the most ubiquitously cited force in the narrative of drag's transformation is *RuPaul's Drag Race*. Without question, *Drag Race* signaled a type of revolution for the drag-industrial complex, bringing one version of the art form to an exponentially wider audience while also promising previously unthinkable career opportunities for a new echelon of performers. Most queens have something to say about *Drag Race*, and their opinions run the whole gamut. Still, a common refrain repeats among the older girls. Many describe a sense of alienation at the solely competitive image of drag presented by the show. While competition surely factored prominently in the art form long before its television debut, televised drag largely omits the spirit of collaboration and transmission that makes traditional pageants possible. If the queens of a certain age express concern for an entire generation raised on YouTube tutorials and *Drag Race* skits, they do so knowing the importance of the drag mother-daughter relationship that the self-taught girls go without *en masse*. The prospect of upcoming generations of motherless queens rightly scares those who've so tenaciously cared for and sacrificed on behalf of these resilient legacies. Those same tradition-bearers need the support of drag descendants as well. Rather than yearning for an earlier epoch, a dialectical approach encourages the children to take up the inquiry into drag's history; it also suggests that the mothers make a return.

At stake in restoring the relationship between the children and their potential mothers is the possibility of a profound movement of reconnection to the ancestral currents that compose the collection of gestures we know as drag. The scope of the dilemma cannot be resolved by the one-to-one relationships that previously defined drag motherhood (as blessed as those relationships surely will be for those who successfully seek them out). And still, the infinite variations of drag produced by the individual experimentations of countless baby queens means that no one universal syllabus or source could suffice to meet everybody's needs. Our dilemma requires an approach that

holds in balance the unique currents carried by each individual mother of the art, while at the same time understanding those threads as not only part of a broader tapestry, but made stronger for their being interwoven. The return of the mothers also opens the way for their mothers and theirs before to share hard-won lessons and blessings with their living descendants.

Under the Roman Empire—after which the American Republic intentionally styled itself—various colonized and enslaved peoples found the possibility of continued worship of their unique ancestral traditions through the cultus of a collective of goddesses known as the *Matronae*[2]—the matrons or mothers. The Roman religious system annexed the gods of the people it conquered through a process called *Interpretatio Romana*, which syncretized indigenous deities with those powers already worshipped in the empire. Through worshipping the *Matronae*, the underclasses found religious common ground while still allowing for the specificity of and mutual respect for ancestral differences. Different epithets for the *Matronae* point to specific collectives acting as the patrons of various trades, regions, and tribes. Surviving inscriptions speak of the mothers of veterans, sailors, diviners, etc. Such a conception of divinity makes imaginable a formation such as *the mothers of drag* as an emergent collectivity.

In our work with these legends, we found a lineage of camp, an immaculate argot, an energy, tracing its way back into antiquity, where the classicists tell us that men wore masks and fine fabrics and exaggerated makeup to portray goddesses and heroines in the very origins of the theatrical tradition. People didn't only worship in the closed-off temples of the State, but also in the popular arena of the theater. They met their gods during the competitive performances of the Dionysia, the bawdy acts of Floralia, the excessive mourning of the Adonia, the upheaval of Saturnalia. In these festivals, courtesans and rent boys and queens played their part as mediums for the spirits. Drag, then, has to be situated as an archaic sacred art. These queens are the high priestesses of an ancient art of divine performance. This project has already taken us to the holy places of the drag underworld—the homes and hand-built stages of these elevated elders. They call it church for a reason, after all: drag, at its best, transcends.

If we've briefly needed recourse to theology to think through these issues, we find useful concepts in the writing of Pierre Klossowski.[3] In his 1968 text, *Sacred and Mythic Origins of Certain Practices of the Women of Rome*, Klossowski develops the concept of a theatrical theology. He argues that outside the temples and cults of the State, people encountered the gods in the debauched performances of the stage shows, put on by courtesans and mimes—the

2. On the *Matronae*, see the work of River Devora "Interpretio Romana and Matronae Iconography" and "The Matronae and Matres: Breathing New Life into an Old Religion."

3. Cousin of the poet Rilke and member of the secret society Acéphale.

first stars. "The mythic world spilled out well beyond the rituals of the temples, flowing out in torrents into the circuses and onto the theater stages. . . . In the mimes, the personae of the very sacred gods are made to appear amidst the worst obscenities, in such way as to incite the mirth of the carefree spectators." He cites ancient historians whose accounts report that these shows were instituted at the request of the gods, speaking through oracles, to rescue the empire from plague or famine. Paraphrasing the Christian polemics against the pagan gods, Klossowski says, "If [the gods] exacted through the worst sorts of threats the theatrical celebration of their turpitudes, it is because they take pleasure in being adored for their most shameful behavior; the more they are slandered and accused of crimes, true or false, the more delight they take in it. . . . The stage shows sanctify their gratuitousness and the apotheosis of 'useless' sensual pleasure." Empires fall, drag persists.

The image of divinity and depravity—comingling on the stage to the delight of the gods—brings us back to Divine. Many queens in this book draw inspiration from Divine, caught one of her performances, or even claim her as a friend. Included here, readers will find a queen who began her career by impersonating Divine and another who took on the role left unfulfilled by her untimely death. That such an iconic figure serves as so common a referent warrants further examination.

John Waters renamed Harris Glenn Milstead while reading Jean Genet's *Our Lady of the Flowers*, from which he plucked the name Divine. *Our Lady*, like much of Genet's best work, was penned in secrecy in prison. Divine came to Genet in that place and urged him to write so she might make a jailbreak. Genet later confessed that he was disappointed by the uptake of his work among homosexuals and *literati*—he preferred it be marketed more discreetly, so Divine could make her way into the minds of the children of the managers of proper society and its prison world. In the image of Divine, whom Anohni sanctified as the Mother of America and her self-determined guru, Genet's desire for subversion found a new vehicle. Divine died in 1988, the day before she was to begin shooting for a role on *Married . . . with Children*. Her taking up the role would have marked an unprecedented emergence of her underground queendom within the very heart of popular entertainment. The next year, the cartoonists responsible for Disney's *The Little Mermaid* (1989) based the

villainous sea witch Ursula on Divine's image, thereby encoding lessons in body language and feminine wiles from Divine herself.

The year following the release of *The Little Mermaid*, Judith Butler published what would soon come to be regarded as one of the foundational documents of queer theory: *Gender Trouble*. In her preface to that first edition, Butler makes explicit the title's reference to Divine's role in the film *Female Trouble*, and thus her force of disruption:

> *Female Trouble* is the title of the John Waters film that features Divine, the hero/heroine of *Hairspray* as well, whose impersonation of women implicitly suggests that gender is a kind of persistent impersonation that passes as the real. Her/his performance destabilizes the very distinctions between the natural and the artificial, depth and surface, inner and outer through which discourse about genders almost always operates. Is drag the imitation of gender, or does it dramatize the signifying gestures through which gender itself is established? Does being female constitute a "natural fact" or a cultural performance, or is "naturalness" constituted through discursively constrained performative acts that produce the body through and within the categories of sex? Divine not withstanding, gender practices within gay and lesbian cultures often thematize "the natural" in parodic contexts that bring into relief the performative construction of an original and true sex. What other foundational categories of identity—the binary of sex, gender, and the body—can be shown as productions that create the effect of the natural, the original, and the inevitable?

The image of divinity and depravity— comingling on the stage to the delight of the gods—brings us back to Divine.

While Butler's musings could be taken to regard drag writ large, her question remains worth answering, with specific attention to the self-declared "filthiest person alive." Divine singularly undermines the seemingly natural binary between the sacred and the profane, between god and the self. Her gestures of self-deification disrupted the prevailing feminine ideal, opening the door for the infinitely weirder and wilder. She declares herself the epitome of beauty, not in spite of, but because of her disposition toward crime. In doing so, she holds up a mirror to everything we might find ugly or shameful in ourselves and calls that divine too. Genet predicts Divine's reincarnation, her eternal return, at the end of *Our Lady of the Flowers* in a section titled *DIVINARIANA*:

Divine has repeated a hundred times that little gesture for detaching herself from the world. But, however far she may depart from it, the world calls her back.

She has spent her life hurling herself from the top of a rock. Now that she no longer has a body . . . she slips off to heaven . . . But then: She made some gestures of frightful despair, other gestures of hesitation, of timid attempts to find the right way, to cling to earth and not rise to heaven. This last sentence seems to imply that Divine made an ascension. That is not so. . . . She had to stand her ground, whatever the cost. Had to hold her own against god, Who was summoning her in silence. Had to keep from answering. But had to attempt the gestures that will keep her on earth, that would replant her firmly in matter. In space, she kept devising new and barbaric forms for herself, for she sensed intuitively that immobility makes it too easy for god to get you in a good wrestling hold and carry you off. So she danced. While walking. Everywhere. Her body was always manifesting itself. Manifesting a thousand bodies.

Following the death of Harris Glenn Milstead, just such a manifestation and repetition occurred. Though still limited in ways to the conscious devotion from those on the margins, Divine's apotheosis inspired untold queens to access their own starriness and channel the divinity unique to them. Far from reducible to one queen's impact, this power of evocation flows through the art of drag itself. Phatima Rude described the phenomena of recognizing the looks and gestures of long-dead queens in performances of younger kids on the scene who'd moved to San Francisco years after the deaths of their predecessors. That a look can leap from one generation to the next, unbeknownst to the recipient, speaks to the potential power of the intentional engagement between generations. Speaking of intergenerational transmission takes for granted that we and our elders are the living descendants of a genuine tradition; ours is a tradition that is also riddled with lacunae and traumatized by the death and erasure of entire generations of queer creatrixes. David Wojnarowicz, in *Close to the Knives*, recounts pinning a picture of Genet above his bed. This simple act, like the dismemberment of drag photo books we thrifted as teens to wallpaper our bedrooms, opens the book up into a portal.

Drag can be an entrance point for another being, or a doorway into another world. People step through the same door but end up in different places. Beneath the diffusion of different identity categories, drag problematizes even individual identities. Some experience a splitting of the self with the introduction of their drag persona. Others report a merging of previously distinct personalities over time into a coherent self. Drag continues to defy definition, but we might risk an attempt anyways. Drag is transformation, shapeshifting, ritual, gesture, magic. There exists a certain ephemeral energy, a spirit, accessible only on the stage or in the streets. We pray this book serves as a codex of various keys to the door—that wherever it leads them, everyone finds something that resonates within.

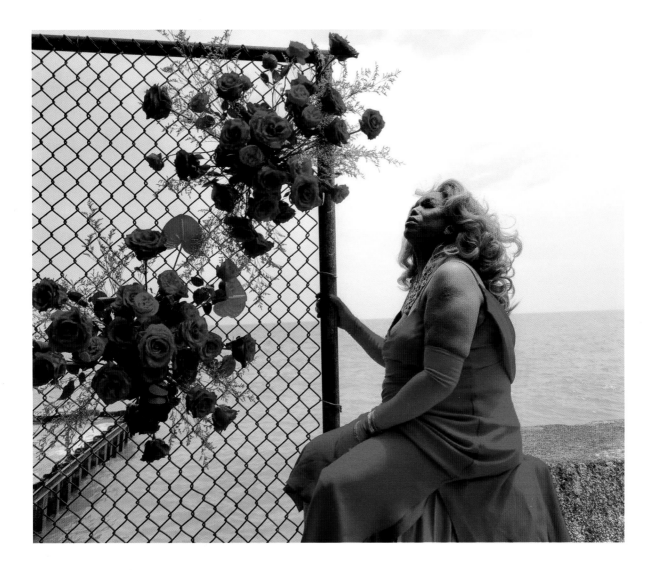

The inclusion of floral elements into our shoots is a way of personalizing each portrait to draw out each queen's uniqueness. As part of our preparation, we asked them about their favorite blooms, imagined how florals can accent or augment their planned looks. This added a sense of season and region to every shoot, each bloom bringing its own magic. Floral styling, like drag, traces its origins back to antiquity as well. A tradition within the classic myths tells of beautiful mortal lovers of the gods, like Adonis, being metamorphosed into flowers following their deaths. From these tragedies we get the anemone, the hyacinth, the crocus, the lotus. The ancients understood flowers to be necessary for proper worship of the gods and pious revelry in festivals. Even in our secular age, we require flowers at the

biggest ceremonies of our lives. They stand for both the eternity and impermanence of beauty. In adorning these queens with flowers, we desired to elevate their legacy as sacred shapeshifters and elegant bearers of tradition. As asked for in recent years, we want to give the girls their flowers while they're still here.

Not all the girls are still here. In the four years since we began this project, four of our models joined the ancestors: Phatima Rude, Lady Red Couture, The Goddess Bunny, and most recently, Tina Devore. May the collective of ascended drag mothers receive them lovingly into their arms; may this book honor their memory; may their starlight guide us all.

SAN FRANCISCO

Phatima Rude

SAN FRANCISCO × ARIES

I t was a very *"You shall not pass!"* moment, a truly liberating *experience, telling the cops that this was our space and they couldn't come in*, recounted Phatima Rude, sitting on a black leather couch holding her dog, Mary Kate. We met her at Station 40, the long-term anarchist space on Sixteenth Street in the Mission District. Phatima lived there in 2010 and infamously fended off the police while hosting one of the Queer Autonomous Zone parties, a tribute to chaos magician William S. Burroughs. That night Phatima stood down the cops for three hours while partygoers barricaded the door to the main performance space. SFPD ultimately acquiesced and the night continued.

While shooting with Phatima on Valencia Street that busy springtime Saturday morning, it was remarkable to clock the reactions of the straight world passing us by. One little boy turned back with a gaze transfixed by her otherworldly appearance and hand-painted mutant Mickey Mouse shirt. His parents hurried him along while sanctimoniously insisting that he pay us no attention. We know, however, the necessity of doing just the opposite. We asked Phatima what she'd say to that little boy and she coolly replied, *Welcome home; don't fuck it up!* San Francisco truly is home for many who've found a home nowhere else. Home: a place for the spirit to thrive and the body to rest easy, a world to be shared and protected. As Phatima put it while turning the corner off Valencia Street, *San Francisco really is like Hotel California—you can check out but you'll never leave.*

In her decades in San Francisco, Phatima welcomed countless neophytes to the city's underground. Many members of the nightlife community shared their personal stories of meeting her. From out of that cacophony of voices, a repeating refrain: For many she was the first queen to truly make them feel a sense of belonging. She cut their hair, painted their faces, dressed them up, introduced them to spaces and nights. A veritable psychopomp, she spent a number of years driving for Homobiles, a queer car service. Phatima shuttled performers and sex workers and partygoers safely through the night in her Toyota Previa, which she also called home for a time. She met each passenger with the consistent greeting: *Hi babe, where are you going?*

Her inviting service to those seeking refuge in the city derived its singular warmth from the potency of her own arrival. Born a freak in Staple, Minnesota, and later attending beauty school in

> ## *"Welcome home; don't fuck it up!"*

St. Cloud, she never had a closet to hide in and never truly felt at home until she arrived in SF. She fled Minnesota in secret, in the middle of the night, alongside her mother, whom she lived with and cared for in a dynamic that Phatima described as *ever increasingly Grey Gardens.* The duo crossed the Bay Bridge early one February morning in 1988. Phatima recalled the timing with such precision that one could cast an astrological chart from the very moment of arrival. Quite appropriate, given that homecoming inaugurated a lifelong process of recreating herself in a city that afforded her the freedom to do so. She brought with her only one drag look: *black silk everything.*

She performed her very first drag number at Deja Vu in the Tenderloin, and from that moment, she never stopped performing. She became involved in the Sisters of Perpetual Indulgence and the Imperial Court, bridging divides between different currents of the city's unique drag confluence. She discovered herself at Club Uranus—named for the planet astrologically known for shock value, upheaval, rapid change, and revolution—where she dove headfirst into a ferment of drag that was all at once confrontational, political, surreal, and trans. Phatima became known for stunts and gags that continuously startled audiences. She put several war resisters from Iraq Veterans Against War (IVAW) in drag for the first time for their Drag Not War actions. She brought a playpen to Burning Man from which she greeted revelers with psychedelics, condoms, and kisses. Her numbers frequently involved blood, staple guns, drills, piercing needles, live painting, diapers, feats of stillness, and contortion (she was double jointed everywhere). One night at the Stud she hosted her own funeral, sitting in a life-sized coffin with a lit cigarette and receiving offerings for her next incarnation.

Her cyclical dying and being reborn necessitated such ritualization of her own mortality. In the opening line of the 2014 documentary, *Ladies and Gentlemen: Phatima Rude*, she declares: *I've had many deaths in my life, and many rebirths.* Across the span of those lives, she moved through a flux of continuous becoming. She took many names and many forms. Phatima was a shapeshifter par excellence, a magical creature, a punk, a goth, a deathrocker, a club kid, a mystic, a witch, a crone, an artist, a guide, a caring child, a drag mother, a devotee of Leigh Bowery, Divine, and Kali Ma. Her best friend, Matt Flynn, called her an

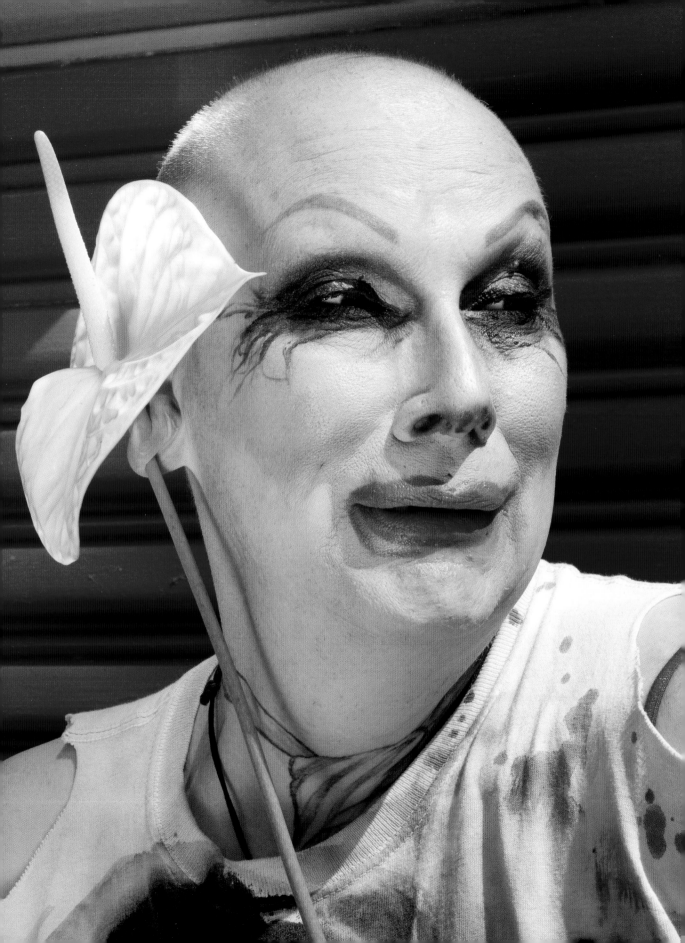

angel of death and mercy to those who truly needed one during the AIDS crisis. She tattooed Divine's eyes on the back of her head, a tie around her neck, her makeup on her face, and *Choose Death* on her palms. She stretched one of her earlobes for many years until she came to a point in her transition where she felt it wasn't feminine enough and asked a friend to surgically remove it. She was sober during the procedure and wore the severed lobe as a necklace the next time she went out, much to the dismay of the other partygoers. She often remarked, *Letting go of shit is divine*. This included parts of herself and her selves in their entirety.

In May 2021, after years of struggling with homelessness and mental illness, she passed peacefully from this plane while at home in Portland, Oregon. Fans, friends, and chosen family responded to the news with an outpouring of love, photos of her outlandish looks, and a litany of stories that would register as unbelievable if they weren't about such an otherworldly being. Glamamore, SF's crowned Emperor, wrote in a memorial post: "Phatima was one of very few people on the planet who carried Sister status." Rituals of elevation and tribute performances were held in several locales. A few months later, at the beginning of August, over a hundred members of her vast and varied kinship web donned masks and braved the COVID Delta variant to honor and memorialize her for an evening at Public Works in SF. Numerous portraits covered the walls of the club, the bar served filthy martinis and vodka with sparkling lemonade. Gorgeous altars were adorned with her drag, her infamous staple gun, and a tower of perfectly reflexed magenta roses.

The Sisters of Perpetual Indulgence's SF chapter made the night possible. Six sisters of the order (as well as one novice and one aspirant) invoked the nuns of the cardinal points along with their respective eternal delights in order to welcome Phatima into the ranks of the Nuns of the Above. According to Sister Roma, Phatima challenged the organization itself to transform and confront its own notions of purpose and style. Within the order she was known at times as Sister Hateful Sow. Phatima's mom joined the Sisters as well, taking on the name Father Mother. Money raised throughout the night will fund a mural of Phatima being cared for by the sisterhood.

Numerous legends of drag and queens of the upcoming generations were in attendance that night. Raya Light, who catalyzed one of Phatima's personal renaissances by bringing her out of semiretirement to perform a duet at Trannyshack, hosted the evening. Following a synth set by The Vivid, Raya said the music invoked Phatima's spirit and she saw her in a kiddie pool in the corner covered in nachos. Peaches Christ recalled first becoming aware of Phatima during the Trannyshack days, when Phatima would show up in the audience each night in such different looks that she was barely recognizable as the same person. Phatima herself hosted Trannyshack for her twenty-ninth birthday. The theme was religious cults. In a twist of synchronicity, the Heaven's Gate incident occurred earlier that week—*We planned this two months ago, isn't the timing great!?* That night marked the occasion of the debut of Phatima's own religious sect: the Cult of the Sacred and Holy Meat. After a night of depravity, meat from one of her performances was thrown against a wall in SoMa. Miraculously the meat stayed on the wall for months and Phatima led a procession from the holy site to Trannyshack.

The performances at the memorial each, in their own way, channeled Phatima's inimitable energy. Noveli tore off her red gown to reveal "Choose Death" scrawled across her body. Krylon Superstar threw marigolds (a flower known for its connection to the dead) to the stage floor and put a few stems up her asshole. Two daughters of the House of Rude, Kochina Rude and Hollow Eve, reprised Phatima's infamous staple gun techniques, affixing napkins and meat to themselves, respectively. Kochina performed "Institutionalized" by Suicidal Tendencies, a nod to Phatima's account of having grown up in the asylum where her mother worked and her long history with the designation

> *"I've had many deaths in my life, and many rebirths."*

"crazy." Of her drag mother, Kochina declared that nobody like her would ever exist again. For her part, Hollow shared that she'd "never been so freed by another human being" and never felt so seen and so beautiful as Phatima made her feel. She insisted that Phatima couldn't live in this society so she lived outside it and laughed at its absurdity.

Phatima's legacy was most poignantly demonstrated by her daughters that night, but her broader influence is truly unfathomable. San Francisco drag, and by extension drag globally, would appear unrecognizable were it not for Phatima's decades of contributions to the art. She pushed against the limits of drag's possibility and irrevocably transformed it. The avant garde queens of the up-and-coming generations owe an eternal debt to the transgressions and self-sacrifices that defined Phatima's career on the stage and in the streets. When we shot with her in 2018, she described the uncanny phenomenon of recognizing the spirits of long-dead queens in the very specific affects and aesthetic choices of kids who'd moved to the city at least a decade after their ancestors of style passed on. Surely Phatima, who never repeated a look, may carry out just such an eternal return to an exponential degree.

Juanita More, reigning Empress of San Francisco, described Phatima's life as having been filled with magical moments and demons too. To Juanita's nightly greeting, "How are you?" Phatima would reply without fail: *Lifelike.* As Juanita succinctly put it: "Phatima showed us who we are." Correspondingly, Trixie Carr sang one of her own songs for Phatima, encouraging all in attendance to look into the abyss and to not be afraid of the stars from which we were made.

In the spirit of such self-awareness of our own starriness, radical faerie elders put on a smaller memorial rite earlier in the summer at the Powerhouse bar on Folsom Street. They called the night Some Kind of Ritual Experience (SKORE): Ascendency of St. Phatima Rude. The ritualists handed each of the assembled mourners a pocket mirror and some lipstick to smear on their faces. Each of us was encouraged to look into the mirror and feel Phatima's loving gaze returned from the void; to hear her words of love and affirmation uplifting and soothing us. People shared stories and celebrated her defiance of SFPD during the Queer Autonomous Zone party as a gesture of tenacious abolitionism.

Throughout a lifetime spent in the drag underworld, Phatima understood herself and her body as a raw canvas on which other artists created their art. By way of ego death, she offered a mirror through which others found expression and reflection. We feel honored for her portrait to have been the first we shot in this series. Her makeup impeccably painted, her eyes conveying unspeakable emotion, a single anthurium penetrating her remaining earlobe; we couldn't ask for a better initiator for this project. It brings us no small joy to know that this portrait running in *Vogue* brought her a charge of hope that the multiverse had more blessings in store for her at a moment when she was otherwise at her lowest.

"Life is tenuous, we're all so blessed to be here, drag is the gateway to the world."

Amid the grotesque and the deranged, Phatima conveyed ineffable beauty. While always a provocateur, she simultaneously exhibited an unmatched kindness and compassion. Behind her larger-than-life persona, she remained humble and shy to those who really knew her. Hers was a paradoxical existence, and she lived it with grace and gratitude. She never hid her struggles and always found a way to overcome them in the service of her art and her ceaseless journey. Phatima prepared all her life for her own death, more intimately aware of her own mortality than anyone else we knew. For her, choosing death meant also living without fear or restraint. She is immensely loved and will be woefully missed, but she isn't truly gone. She'll assuredly return for any who need her in the days and years to come. As she put it: *Life is tenuous; we're all so blessed to be here. Drag is the gateway to the world.* Phatima stands at the doorway to that world, beckoning you to enter and find yourself therein.

Joan Jett Blakk

SAN FRANCISCO ˣ **CAPRICORN**

I don't really do drag anymore, Joan told us, in between puffs of a joint. Still, she found several wigs within arm's reach of her writing desk, at her studio apartment on Market Street. Her walls are decorated with an impressive collection of suit jackets. *My wardrobe is a cop repellent. They look at me and say, "That's not the one we're looking for." Black folks have to think about this shit, because it seems to be open season.*

A poster from her 1992 presidential campaign adorns her door, depicting Joan seated like Huey Newton in a rattan peacock chair and holding a nerf gun. It reads: "Joan Jett Blakk for President / By any means necessary." When asked if any of the Black Panthers ever commented on her propaganda she retorted: *Communists have no sense of humor.* Her campaign is only the most notorious episode in a long career of troublemaking, which has since made the jump to both stage and film: *Ms. Blakk for President* at Steppenwolf Theatre and *The Beauty President* (2021), respectively. *I better be on somebody's list after all I've been through.*

She got involved with the Gay Liberation Front as a teenager by attending the first gay Pride picnic in Detroit in 1975. *Everybody looked like radical faeries back then!* She claims an ancestral impulse to resist. *My paternal grandparents lived in an underground railroad house in Sandusky, Ohio. And I thought it was my time to get active.* She left home and moved into a GLF house. Her affiliation protected her in school: *Nobody could beat me up.*

Joan moved to Chicago in '77. She met John Calendo, a writer for Andy Warhol's magazine *Interview*, and he immediately wrote her into his plays as a woman. They put on a production at the infamous gay bar–cum–punk venue La Mere Vipere. *That's how the early punk movement and the early gay liberation movement got together—through music.* Interview *magazine took me from being a good little Catholic schoolboy to the complete opposite.*

She identifies sexuality as a common thread between all the radical groups she's passed through. *People involved were almost guaranteed to have a more open attitude toward sexuality.* She worked at a gay gym when HIV hit the newspapers as GRID (Gay-Related Immune Deficiency). *A few guys from the gym committed suicide and I knew I had to get back involved. So I called a meeting to start the Chicago chapter of Queer Nation.*

The group focused on aggressive self-defense. *Being in drag at all is a political act when you have people trying to beat on you for it. My friend Charlie and I wanted to create the queer jihad and go beat up straight people. We did security at one Pride event with miniskirts and baseball bats. Queers Bash Back!* Joan claims the title of president of the QRA (Queer Rifle Association). *Our motto is: "What did you call me!?"*

When Queer Nation needed a candidate for mayor, she volunteered. They went into city hall to register and made the news that night. *Nobody ran against Rich Daley and all of a sudden here was this Black drag queen. The mayoral race was fun but we already had our eye on the 1992 presidency. We wanted to stir up as much trouble as possible. It's great to be able to take politics and turn it on its head, to show what a farce it really is.* Her slogan then and now: "A vote for Joan Jett Blakk is a vote for total anarchy!" If a bad actor can be elected, why not a good drag queen?

After the campaign she moved to San Francisco in 1993. She found and lost a lot of family there. *I cannot walk down any street without seeing a house and thinking, "I know who used to live there." But I don't do it out of sadness. There's a lot of joy in what we were doing. And now another virus: we've been through this, honey; we know how to deal.*

She misses the comradery felt after an ACT UP or Queer Nation demo and believes we need to truly constitute *an army of lovers* like the Sacred Band of Thebes. *You really felt like you were part of something. There's not a lot of that now—people are being deprived of this important feeling. We have to take care of each other that much. It's one of the things I found very moving about SF—a real feeling of: "This is my tribe, these are my people."*

Joan is depicted as "Balance" in the major arcana of a faerie-oriented tarot deck, the Cosmic Tribe Tarot. Her advisory capacity extends far beyond that single card, however: *Be true friends to each other. I've had some friends for forty years. If I think about growing old alone, I just remind myself of this community that I'm a part of. That's why some of us survived.* It's how we'll survive again, too. *Mother nature has had it with us: "This experiment with you humans is not working out. You gotta go!" We'll go back to being worms or something. In the meantime, we have to find joy where we can.*

> "We've been through this, honey; we know how to deal."

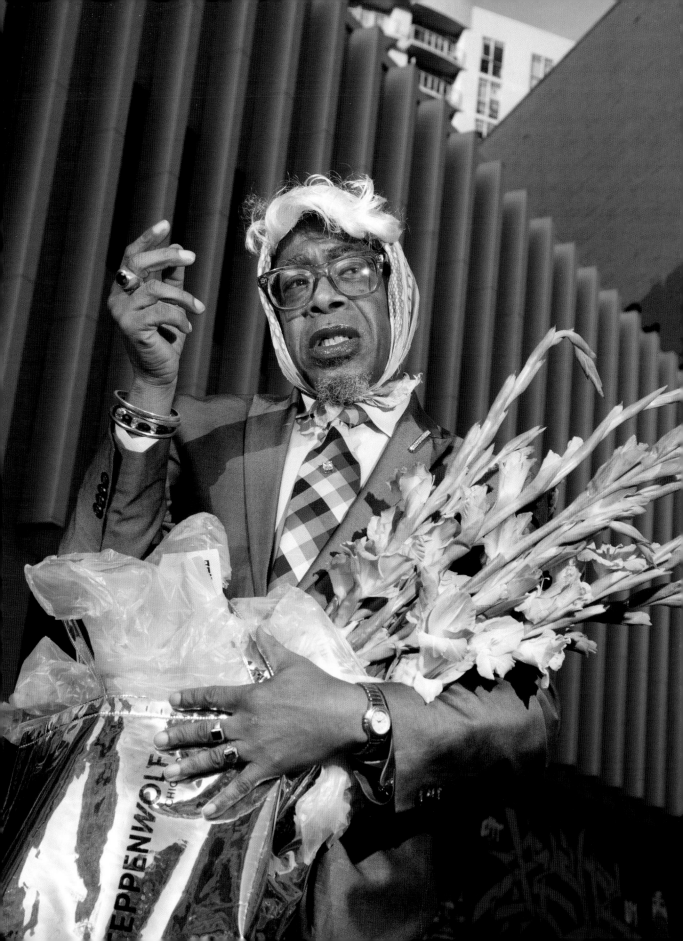

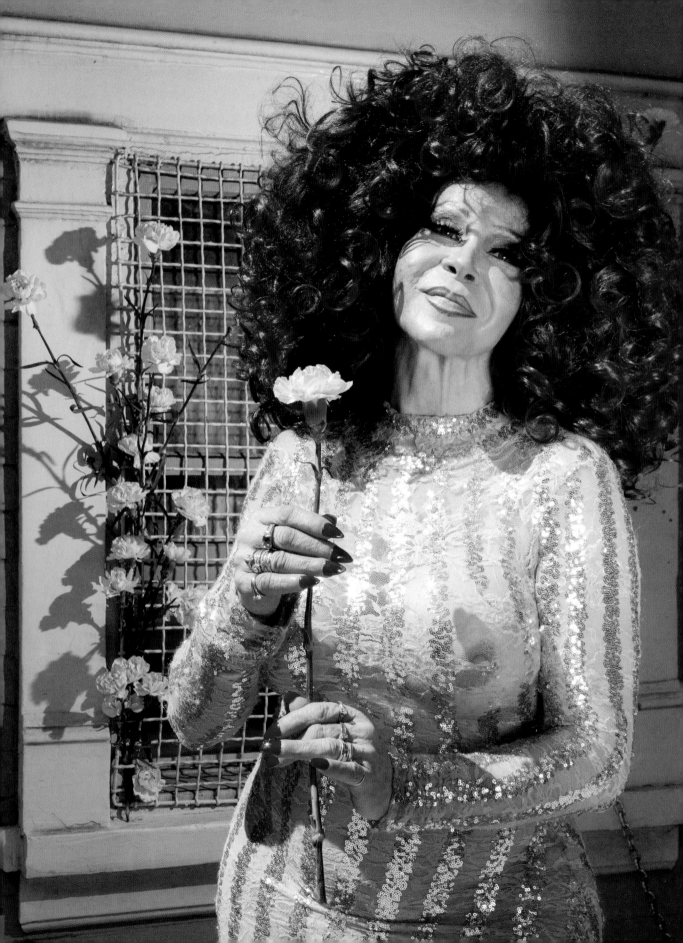

Carla Gay

SAN FRANCISCO × TAURUS

We met with four queens in the Mission throughout the first weekend in the spring of 2018, and a specific ethic—a willingness to fight for queer space—was a constant with all of them. Just across Sixteenth Street from where Phatima Rude stood her ground against SFPD stands the former location of Esta Noche, where Carla Gay performed for twenty-five years. Now a straight bar painted gentrifier gray and host to Tinder-themed date nights, the building and the space around it was once a thriving hub of the neighborhood's Translatina community. Esta Noche was the first queer Latina joint in the city. The space provided a safe place to gather and celebrate for the city's queer and trans people of color who otherwise faced discrimination and fetishization in the Castro bars. In 2014 the club shuttered its doors, another victim of the neighborhood's rapid and violent gentrification. *It was devastating*, Carla confided. *We—Black and Latina queens—don't have anywhere to gather anymore.*

She began her career at the age of fifteen in Acapulco and moved to San Francisco in '86. She says nowhere in the world compares to the city in terms of the drag scene, but also the healthcare and other resources that trans women have created for themselves here. In 2006, Carla founded El/La Para TransLatinas, an organization that has spent the last fifteen years "building a world where translatinas feel they deserve to protect, love, and develop themselves." Their world-building vision is clear: "El/La is an organization for translatinas that works to build collective vision and action to promote our survival and improve our quality of life in the San Francisco Bay Area. Because we exist in a world that fears and hates transgender people, women, and immigrants, we fight for justice. We respond to those who see us as shameful, disposable, or less than human. We are here to reflect the style and grace of our survival, and to make new paths for ourselves." Undoubtedly, Carla infused that style and grace into the organization from the very beginning.

El/La offers a range of mutual aid projects for the Translatina community. They provide HIV testing and prevention. Their kitchen is host to community meals. The organization holds space for the preservation and sharing of indigenous traditions. They also organize Translatina events and retreats and street presence within the Mission. El/La additionally maintains altar space to meet the spiritual needs of the women they serve. The altar there is lovingly adorned with portraits of Translatina ancestresses, offerings of food and flowers as well as prayer candles continuously burning for the protection, health, and well-being of the community at large. This spiritism finds itself at home in the Mission, known for its rich tapestry of storefront churches and *botánicas*. In spite of the gentrification, the neighborhood remains a haven for *Espiritismo* and other indigenous and diasporic traditions.

Carla now lives in the Tenderloin and still fights for space for herself and her sisters. *I will be in this city forever.* She continues performing as well and can be found every Friday and Saturday as the emcee for the Hot Boxxx Girls at the legendary Aunt Charlie's Lounge.

> "I will be in this city forever."

During our final round of photo shoots in San Francisco, we were lucky enough to catch one of the nights hosted by Carla. She first emerged from behind the curtain in a blond wig and a backless silver chainmail halter top complemented by rhinestone fringe shorts. She was the only performer in heels over three inches, but they didn't slow her down. A gregarious hostess, she made sure the crowd maintained a celebratory energy. A bachelorette party attended that night, but Carla saw that other causes for celebration received their recognition. *Any other special occasions? Birthdays? Sex change? Circumcision?* Ever relevant, she performed "If U Seek Amy" by Britney Spears to the delight of the Britney liberationists present. For added power, she lip-syncs with a mic. Her first outfit change that night (there were three!) revealed a beaded orange gown with sheer illusion panels and a giant foam wig that elicited an audible gasp from the crowd. Each of the queens gave four performances back to back, something unthinkable for less-seasoned queens. Between each number, the crowd responded to Carla's insistent refrain: *¡Applauso!* Carla's ongoing legacy deserves all the applause this city can muster, and she makes sure the other girls get their due in turn.

Renita Valdez

SAN FRANCISCO × **CAPRICORN**

Renita Valdez arrived for our shoot as we were still wrapping up with Carla Gay. *¡Cabrona!* Renita teased Carla, and the pair laughed as they exchanged barbs with the easy familiarity that comes from working together for years. Renita laid out a very matter-of-fact trajectory of San Francisco's drag scene and her place within it. She recalled how in her teens she used to take the 14 bus from Daly City to Sixth and Mission Streets, where she would pay off a Chevron attendant to let her get into drag in the gas station bathroom. *Back in the eighties we were Tenderloin girls—you know, drag queens, working girls. We had to be strong and we had to be tough, especially when walking the streets.*

From these humble beginnings, Renita ascended to the title of Absolute Empress Renita Valdez XLV of the Imperial Court de San Francisco. José Sarria founded the Court in 1965, making it one of the oldest LGBT organizations in the world. Legend goes that Sarria said, "We're all queens and why become a queen when you can become empress?" Thus she crowned herself Absolute Empress I, establishing the matriarchal lineage that continues today. The many Empresses, Emperors, and members of the Royal Family constitute the Imperial Council. The splendor of its annual charity balls is known across the land and typifies what Renita refers to as *old-school drag, not glamazons, just typical drag queens.* Beyond their charitable initiatives, the Court also functions as a vital social club and support network as venues for drag, and spaces for queer and trans people of color, continue to disappear. Renita spoke succinctly on the need for sites that foster intergenerational transmission: *I have done things that you have not done. Young people need to understand what we went through.*

In SF, those who hold the stories of the old city, quite literally ghost stories, are becoming rare creatures. Especially within those communities who've lost entire generations of elders to AIDS and the biopolitical nightmare the disease wrecked upon the city throughout its first decades. Having borne witness to the transformations and resiliency of the queer undercurrents over the better half of the last century, Renita stands as a mediator between the living and the dead. Even her day job, fashion manager for Community Thrift Store (which lent its hot-pink Valencia Street exterior to our shoot with Phatima), enmeshes her in the material and spiritual history of the city. Anyone who steps foot into the curated chaos can attest it's a veritable goldmine of books, looks, and ephemera donated by SF's many collectors of the weird. In short, it's haunted in the best ways. Renita echoed the sentiments of other staff there by referring to *the Thrift Gods* who ensure that one always finds the exact item they're seeking.

Even with the ancestors on her side, Renita has experienced firsthand the animosity of the new San Francisco. When ownership of her apartment building changed hands in 2014, her new landlords swiftly began attempts to evict her, along with the other tenants, including two other drag queens. The conflict escalated for years as the landlords deployed numerous underhanded tactics to force the residents out; they neglected repairs, creating substandard living conditions, including inadequate plumbing, persistent mold, and a roach problem. Some of Renita's drag suspiciously made its way from a communal storage unit into the trash, and one of her guests had their car towed. By 2017, Renita and her neighbors were left no alternative but to file a lawsuit against their landlords, alleging discrimination. The suit eventually settled in 2018, with the tenants being awarded $27,000 each and given an additional eight months to relocate. The settlement stipulates that the tenants formally retract their allegations of discrimination, but informally, Renita is not quite so gullible. As she told the *Bay Area Reporter*: *They didn't call us names, but it was the way they looked at us. There are many forms of discrimination. They may not admit it, they might say they weren't discriminating, but that's just [their] opinion.*

Many of our models highlighted the collective endurance required to stay in SF in the face of persistent difficulties. Yet they're committed to staying because of the hard-won safety, services, and sense of belonging enjoyed by the city's queer and trans community. Renita has since relocated to her brother's mobile home, where she keeps her drag in a storage shed. She keeps her many fans clued in to her life with frequent posts on Facebook, where she always keeps it real. *I may not be the prettiest girl to you, and not everyone's cup of tea, but I'm so good with me and my awesome self. I have scars because I have a history. I hope if our paths have crossed I treated you with kindness and was even good to people that weren't good to me.*

When we finished our shoot, Renita bade us farewell and set off in her gold slingback sandals to catch a bus to a fundraiser for the Institute on Aging. *Hosted by a drag queen much older than me!* she assured us. That queen just happened to be Collette LeGrande.

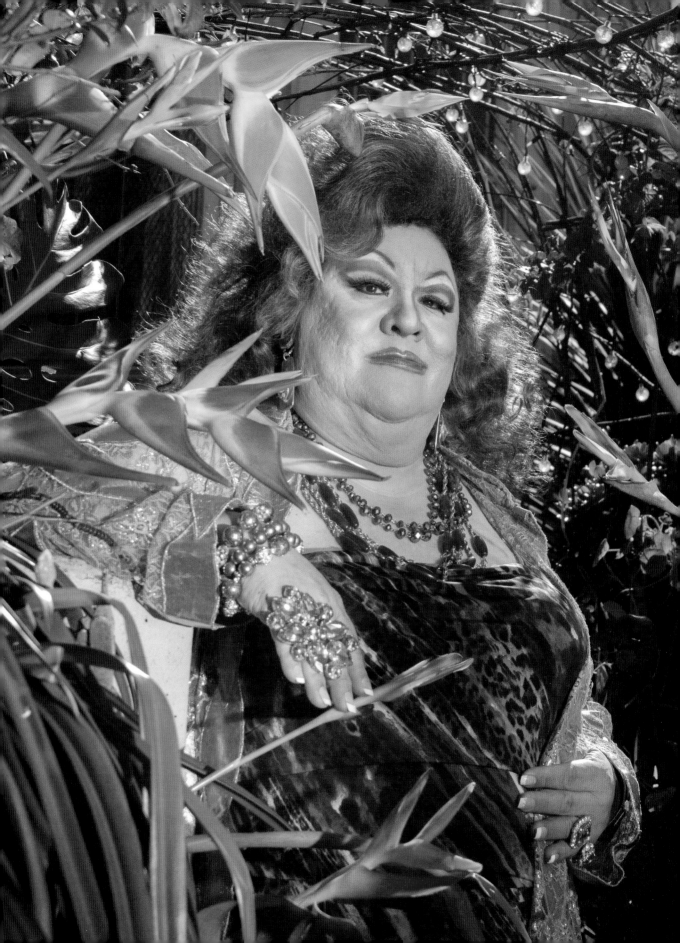

Collette LeGrande

SAN FRANCISCO × **CAPRICORN**

Collette LeGrande loves carnations—*they're more interesting than roses*, easy to look at. She appreciates all their varieties, but her favorite color is purple. Once reserved for monarchs due to the labor-intensive process of extracting the pigment, Collette dazzles in this royal hue. Collette is accustomed to the spotlight, but modeling is somewhat unfamiliar territory. When we remarked that her signature face comes off a bit severe, she coolly replied: *Oh, I know.*

She moved to San Francisco from Chico after finishing college in 1973. *The seventies and eighties were really crazy in the city. Polk Street and the Tenderloin were where it all happened. There were about twelve gay bars near Aunt Charlie's; you could walk between them. In those days, most of the bars were more oriented toward disco. Leather was just starting.*

She met Renita Valdez walking the streets and soliciting men at the Greyhound bus terminal years back. *Was I a hooker? Of course! I'm not ashamed of it; I made good money back in the day. We paid our rent, if nothing else. I'd still be doing it if I could.* Collette attributes many of her skills as a queen to her time as a sex worker. *Back in the day when I used to walk the street, we had a makeup style called slam bam. The faster you got it on, the faster you got out to make your money. We paint by numbers—one, two, three, four, five, and you're done. It never takes me longer than fifteen minutes to put my face on.*

She recalls a certain solidarity between sisters who walked the streets. *We still have it. We've been friends for a long time.* She and Renita became neighbors and both got involved in the Imperial Court together. *People in the Court were very conservative back in the day. It was an old boys' club. Hoes weren't really supposed to be there.* A downstairs neighbor, Connie, became Empress XVIII on her fourth run. When they finish their year, Empresses can award titles to those who helped them through their reign. Connie bestowed upon Collette the title of Imperial Countess of all San Francisco.

Collette holds the honor of winning Grand Duchess in the Grand Ducal Council of San Francisco twice, reigning as XVII and XXXIII. She remains involved, teaching the younger generations. *The Ducal Court had an event about a month ago at a club called OMG on Sixth. There is an alleyway nearby called Stevenson. I told people that Renita and I used to walk Stevenson Alley back in the day before going to the bus station on Seventh. We always made our change.*

Collette was always a workhorse queen of several trades, however. She worked at the Tenderloin's Black Rose, a trans hangout, as a cocktail waitress and then bartender from 1987 to 1990. In 1998, the late legendary Vicki Marlane—"The Lady with the Liquid Spine," whose portrait hangs in Aunt Charlie's—invited her to perform there. Vicki started the Hot Boxxx Girls and always ran a tight ship. Collette learned a lot from those queens and made frequent guest appearances before Vicki eventually hired her to join the show, working her way up to cocktail waitress.

One can still find Collette at Aunt Charlie's every Friday and Saturday nights. On our last visit, she wore head-to-toe leopard print while taking orders. Before her performance, she handed us a baseball bat and instructed us to give it to her at the right moment. *You'll know when*, she assured. She wielded the prop for a cathartic rendition of "Before He Cheats," to the ecstatic delight of the bachelorette party in attendance. While mostly attracting a straight crowd for shows, *Aunt Charlie's is a place that people think of as their home. It draws a great crowd during the day: old regulars and neighborhood people.*

She doesn't always dress up, but says, *Everybody calls me Collette whether I have a face on or I don't. There was a lot of confusion back in the day between drag and trans identity. We lacked education in those days regarding the different styles of living.*

Through her work as a playwright, Collette hopes to increase awareness of the history of trans resistance in the Tenderloin. She worked alongside Donna Personna on the play about the Compton's Cafeteria Riot. Of Compton's, she says: *A bunch of trans girls rioted and broke windows. It was a neighborhood insurgence, one of the beginnings of the trans movement in the city. I want people to have more of an understanding of the event.* Her next project will be a one-woman show about her experiences in the city.

While a mainstay as a performer, Collette remains humble: *I never considered myself an entertainer; it just came with the territory.* Several queens we've worked with detail discovering their trans identity through drag, but Collette reports the inverse: *The drag evolved from my transgender persona. I think of myself as a trans entertainer, but really I'm just an old ho from way back in the day.*

> "It was a neighborhood insurgence, one of the beginnings of the trans movement in the city."

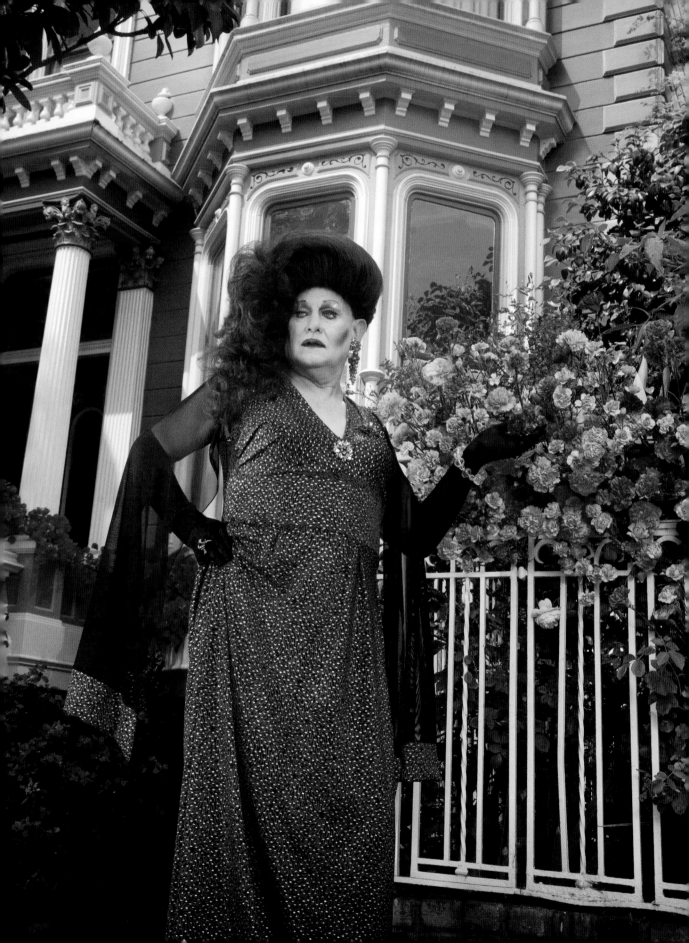

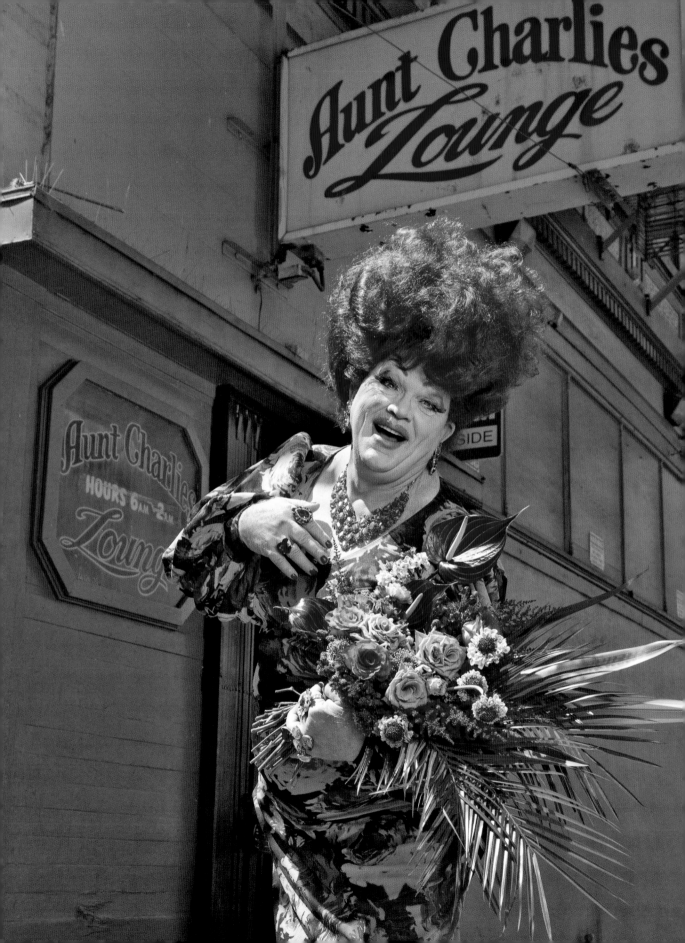

Olivia Hart

SAN FRANCISCO × AQUARIUS

If we understand drag as an illusion, Olivia Hart appears as a sledgehammer. This bawdy lady in red thrives on shock value and flagrant displays of turpitude, pushing her audiences over the cliff of titillation into a cesspool of grandeur. *I used to be so timid and shy, I'd sit in the corner of the bar all night long and not talk to anybody. Until I put a dress on—now I'm everybody's favorite redhead!*

Once the tigress escaped the cage, she made up for lost time. She boldly snatches the wig off her own head—one of Olivia's signature moves—*guess what buddy, I'm really bald!* She often takes it further. The night we saw her perform at Aunt Charlie's, she pulled her silicone cutlets out of her bra during a rousing presentation of "Boobs" by Ruth Wallis, and jiggled them mischievously at the audience. In one of her most iconic numbers, she bares it all: *I do "I Am What I Am," the Gloria Gaynor version, and halfway through I stop the recording and sing live. I slowly take my jewelry off, eyelashes, hair, take my tits out, and next thing you know I'm standing there in a thong. Back in the day I was very shameful about my weight, now I put it out where everyone can see it.*

It's my way of educating the masses, especially straight men. We often get straight men at the bar who are with their girlfriends, and they'll give me a scowl. But by the end of the night, they want a hug, a kiss, pictures, because they saw a real person up there instead of just a made-up doll.

Once shameful, now shameless; in her role as an educator Olivia occasionally flouts the professional code of ethics. *I do get a lot of interesting straight men who want to pick me up. It's a way that they can sneak off into a fantasy world and still make it look straight. But I don't have sex in drag. With my lipstick, and my makeup? Let me tell ya the hair is coming off cause you ain't messing it up! I paid too much money to style this. I'm not trans, I'm just a pervert.* Identity markers aside, Olivia rests easy with her embodied duplicity: *My male and female are the same people. Olivia has merged with—what was my real name when I was a boy? I don't know, but we merged together now. I would be doing this every day if I wasn't so lazy!*

> ## "If you walk alone, hold your head high."

Despite her propensity for deconstructing the medium, Olivia proudly upholds the tradition of drag philanthropy. *Every good drag queen knows that if you're gonna get your name out there you've gotta do fundraisers! In the nineties I was a part of an organization called FACT, Fighting AIDS Continuously Together, so raising money is in my blood.* Through her work with the Grand Ducal Council of San Francisco she has raised tens of thousands for the Castro Country Club, a sober gathering place for the queer community. Her charitable endeavors earned her the titles of Queen of Hearts in 2011 and Grand Duchess XLIII five years later. The Grand Ducal Council enjoys a friendly rivalry with the Imperial Council, as distinct dynasties with a unified goal. *The founder of the Ducal Council, Grand Duchess I, HL Perry, of the House of Cinderfella, had a tiff with Mother José of the Imperial Council, so she stepped aside and built her own empire. We do the same thing, raising money, but the Imperial Council is more regal. We're regal too, but we do it with more camp.*

Through the Ducal Council Olivia met Collette LeGrande: *She became one of my mentors right away. We have a lot of the same feelings about drag: you don't have to be very fishy to be a drag queen.* It was Collette who helped her get in the door at Aunt Charlie's, where the two have performed together in the Hot Boxxx Girls revue for nearly a decade. *Those Aunt Charlie's drag queens kinda wrapped themselves around me once they started to know me, and I just blossomed into this big beautiful rose bush!*

Olivia took the bus to our photo shoot; she lives just down the block from her home bar. Commuting in drag doesn't faze her: *My security is knowing who I am. If you walk alone, hold your head high and don't show your fear. It's like wild animals: if you show your fear, you're dinner.* Olivia stays more focused on dessert; as we attempted to settle up her model fee, she told us blatantly, *We can settle this in . . . other ways.* Indeed, her devotion to community service knows no bounds: *I could pop my teeth out and you'd never know! The boys like it when they're out. Quote me on that one!*

Glamamore

SAN FRANCISCO × **LIBRA**

Known as everyone's drag granny, Glamamore claims too many drag children around the world to count. *Every so often people want to do a family tree, but we can't figure it out.* She professes an open philosophy on drag, but demands: *If you throw yourself onstage, it better damn well be a good show. When I walk in a club, I want to be entertained. Selfishly, this is why I dress people and help them become better performers.* Her maternal instinct runs deeper though: *I'm actually invested in my family. Not just hair and nails. It's: "My husband left me," or "My husband died." Not just stage stuff; it's life.*

At our shoot, Glamamore disclosed the news that she'd be running for Emperor of the Imperial Court de San Francisco. *My goal in running for Imperial Court is to knit the whole city back together again after a year of police violence, trans slayings, and the pandemic.* She discussed her aim to make the Court a stronger organization, and how she wants everyone to feel a part of it. *I'm going to do anything in my power to help people feel safe and considered here.* She won the title in spring 2021, and we look forward to a benevolent reign alongside her daughter, Empress Juanita More.

Glamamore became a granny in San Francisco, but her drag began in New York. She took on the character Edie for her first three years in drag. *Edie was a debutante running around town, modeling, and dancing. My whole life was the show at the time. Morning, noon, and night I was just Edie. And I stuck out. I had an Edie Sedgwick look but with Diana Vreeland in the back of my mind saying, "Make it chic."* Edie wore big earrings, a little eyeliner, mascara, *and out the door she went. Sometimes you want costume and sometimes you want fashion and sometimes they blur together.*

My life was always leaning toward this. Edie didn't perform, but when I became Glamamore I went out on stage as a performing character. Glamamore debuted at the very first Miss Boy Bar beauty pageant in 1984 and placed first runner-up. She became the house mother of Boy Bar and known for doing Connie Francis. *It must be clarified that I don't care for her, but I looked good doing her.* She reprised Connie's "Where the Boys Are" for a recent show. *It felt good, like an old comfortable pair of shoes.*

Glamamore's success on stage was matched by her career as a rising star in the fashion world, where she designed under the name Mr. David. She calls the late eighties a *flurry*, making pieces for Cher, Lady Miss Kier, and Patricia Field's boutique before going into the more corporate fashion world, then ultimately dissolving her own company. *It sucked the soul out of me.*

I've never done anything for the money. I'm more concerned with if something's going to be unique and beautiful and be something people have never experienced before. I do it for that little gasp. My favorite thing to make for any human I've ever dressed is to make the dream outfit they had as a kid. They may have forgotten about it, but it's in the back of the mind.

In New York people told her to choose between being a designer or a drag performer. *Moving to San Francisco, I learned that I didn't have to sacrifice one side of myself for the other to grow. I have the freedom here to merge it all together. In NYC it was always hair, nails, hips, corsets. In SF I can go on stage with or without a beard.* Over the years the line between the two modalities dissolved. For example, she once made her own gown on stage for a Björk number. *Sometimes a costume makes the entire number. Pieces are coming apart here or turning into a flower.*

There is an energy in San Francisco that allows people to do a type of drag you don't see anywhere else. You get to figure out what it is you would like to do and then take it to the rest of the world. It's a great petri dish. There's something in the air and water and sun. She found that magic most abundantly in the SoMa neighborhood, known for its kink and leather communities, and calls the Powerhouse bar her home base. *I love it here more than anywhere else. I find it very fulfilling to be here, even when it's going through phases of dot com this or dot com that. We find a way to keep making art. If I can be so bold, you can do what the fuck you want here. You don't have to be fabulous for anyone but yourself.* She once delineated between Glamamore and Mr. David, but no more. *I feel like I'm always in drag and never in drag. This is what I want to look like today.*

> ## "If you throw yourself onstage, it better damn well be a good show."

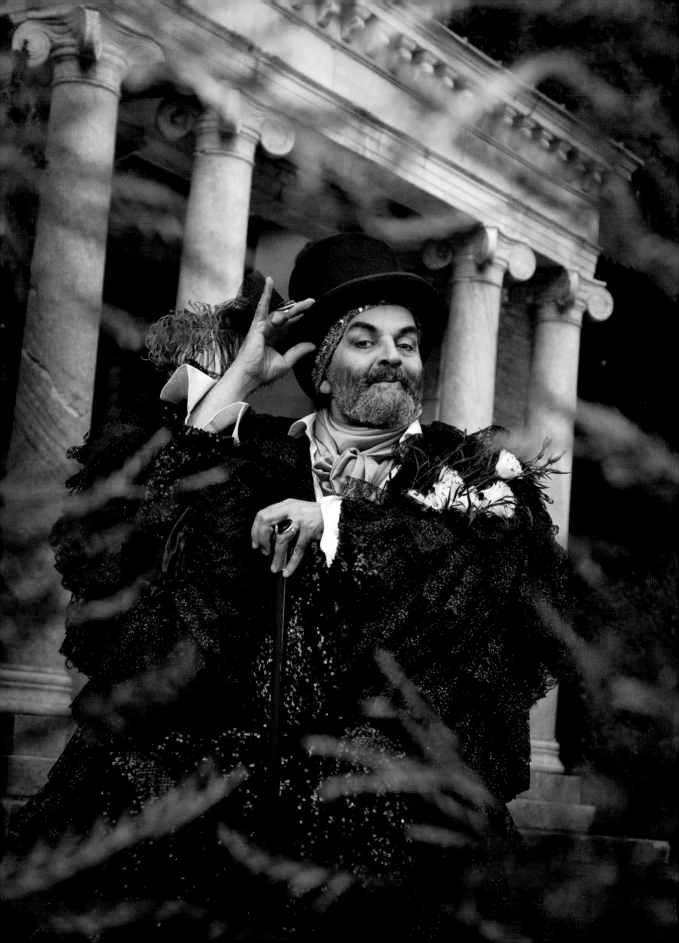

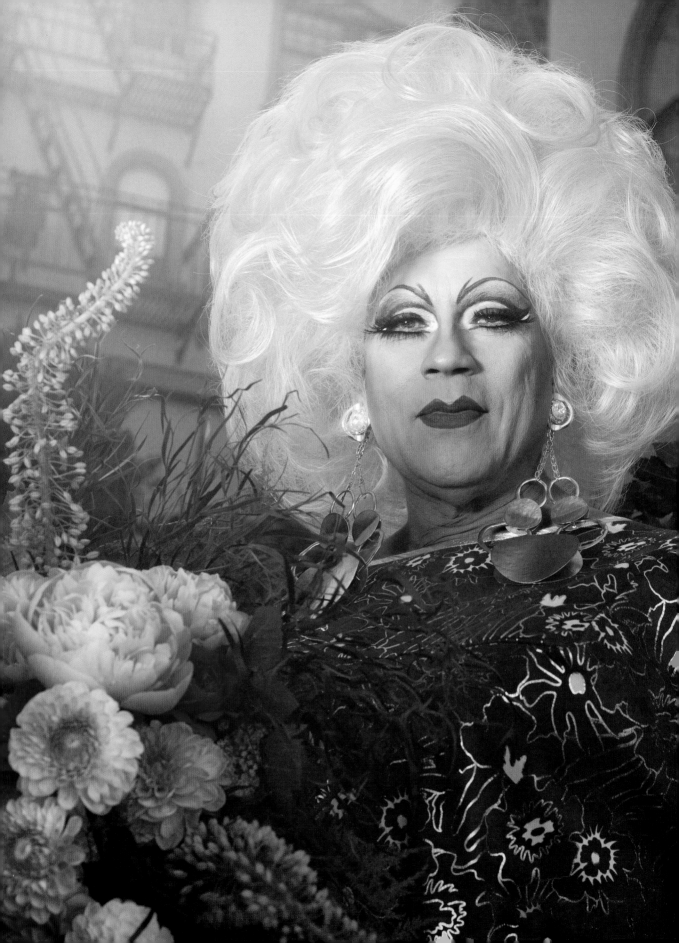

Juanita More

SAN FRANCISCO × **VIRGO**

Juanita More built her empire over the last thirty years, and she rules with a benevolent grace. Baby drag queens and civic leaders alike turn to her for charity and wisdom. Local to the Bay Area, her deep roots fuel a passionate dedication to her city and its queer communities. As we scouted a location for our shoot with her, we considered the Ritz-Carlton in San Francisco's Nob Hill. Its massive neoclassical facade felt a fitting backdrop for a queen of her stature, but ultimately we opted for a more discreet location across the street. As we wrapped our shoot, the valets at the Ritz caught a glimpse of her and immediately greeted Juanita by name as if she were the mayor. We expected the hotel staff to shoo us away from the entrance, but instead they offered to pose with her, holding open the door for their queen.

"I'm a champion of the underdogs."

In the spring of 1987, when Juanita was not yet a baby drag queen herself, Glamamore opened the door for her. She made a trip to New York City to feel out whether she wanted to move there and stumbled into Boy Bar on Saint Mark's Place without realizing there was a drag show happening that night. When Juanita saw the way Glamamore commanded the stage, she felt an instinctual pull: *Something inside me said this person is going to be part of your life. I didn't know how, but I knew. Glamamore captivated me in a way that no other queen had, and for a moment, it was as though I had never seen drag before.* Juanita felt a similarly intense connection to the boy working the coat check, Johnny. They locked eyes as he handed her a claim ticket, and the sweetness of his smile stirred her heart. She worked up the courage to ask him to dinner, but he declined, citing an existing boyfriend. Juanita slyly replied, *You're gonna be my*

boyfriend someday. She fell in love at first sight twice that night. Her instincts proved prescient.

Three months later, Juanita made the move to NYC in a misguided attempt to escape the dark cloud of the AIDS epidemic that enveloped the Castro. New York turned out to be just a lateral move, but nonetheless she quickly found herself a part of a community that changed the trajectory of her life. Juanita returned to Boy Bar, looking for Johnny, but he wasn't working the coat check. *Fuck! Where is he?* She sat at the bar by herself until she felt a sudden tap on the shoulder. Johnny stood there sweetly smiling. He'd split with his boyfriend and took her up on that dinner date. They went for Thai food in the West Village and became the loving boyfriends that Juanita envisioned all along.

Six months into dating, Johnny asked if she'd like to take a limousine to pick up his best friend, Mr. David, from the airport. Johnny described Mr. David as a couturier to the stars, whose creations had been worn by Cher and Diana Ross. When Mr. David hopped in the car, Juanita was shocked to discover Glamamore's alter ego—apparently Johnny left that part out. As Glamamore remembers it, Juanita posed just one question during that limo ride: *"'I have this pair of pants; would you hem them for me?'*—The audacity! I just finished doing outfits for Cher, and you want me to hem some raggedy pants? Sure enough, two days later she's at my apartment with those pants, and I damn well did hem them." Thus began their lifelong friendship and collaboration.

Juanita's tenure in New York lasted three years before San Francisco called her home once more. In 1992 Glama planned a vacation to SF over Halloween, and as they formulated their plans for All Hallows' Eve, an idea struck Juanita: *Oh my god, why don't you put me in drag?* Glamamore was less enthusiastic. "Can you please be my one friend who isn't a drag queen?" Juanita promised it would be just this once. *Then I literally made her put me back in drag the following night, and it never stopped.* Glamamore also never left. Her two-week vacation became permanent.

> ## *"Always keep your poppers in the fridge."*

Together with fellow queen Traci Gives, they formed The Fishstix and began performing throughout San Francisco's gayborhoods, in some of the very same bars Juanita snuck into as a teenager. *I was always a little South of Market kid. When I was in high school and coming into the city, we'd go to the Castro, but I always had so much more fun South of Market. Of course, there were a million places to just have sex in the street. Ya know, it was just more fun!* She speaks with particular fondness about SoMa institution the Stud. *I snuck in all the time. It was so eclectic and welcoming, especially when you consider I felt like the oddball growing up as a gay kid, and there I always felt so loved. That feeling never changed over all the years it existed.*

After The Fishstix sold out their first several shows, they conspired to produce a benefit show for AIDS Benefits Counselors. The introduction of the AIDS cocktail in 1995 meant new hope for people living with the virus, but many still lacked access to treatment. Community organizations provided care for the sick and dying, paid their rent, and implemented harm reduction practices, often without any government funding. These organizations functioned through the efforts of queens like Juanita hustling on the front lines. The benefit became an annual fundraiser for TARC, the Tenderloin AIDS Resource Center, which then evolved into her annual Pride party that's continued for eighteen years running. To date, Juanita has raised over one million dollars for local charities and community organizations, including the Transgender Law Center, AIDS Housing Alliance, LGBT Asylum Project, GBLT Historical Society & Archives, and the Imperial Court. She remains committed to supporting the most vulnerable among us. *I'm a champion of the underdogs*, she says with pride.

After working symbiotically with the Imperial Court for decades, in 2021 Juanita won a new role as Absolute Empress. She campaigned for the crown with a promise to leverage all her PR savvy, political knowhow, and fundraising expertise to continue the legacy of the Court and its founder, José Sarria. In

an article for *The Fight*, writer Brenden Shucart proposed that "if the late José Sarria has a spiritual descendent, it is without a doubt San Francisco's preeminent drag icon, the one, and only Juanita More! Arguably there isn't a queen in the country who more elegantly embodies the disparate disciplines of politics, philanthropy, and drag." In their official Court portrait, Absolute Empress Juanita More and Absolute Emperor Glamamore pose together swathed in matching purple velvet capes that appear to go on for miles. Leave it to the House of More to queer the aesthetics of monarchic imperialism.

Each month, the unstoppable duo sets aside their royal purples to get their hands dirty at Powerhouse, a cruisy SoMa bar at the intersection of leather and drag with an *anything goes* ethos. Together, they cohost the monthly Powerblouse, and for each iteration they select an embryonic queen and personally paint and style her in full view of the assembled partygoers. They don monogrammed cream silk beautician coats, designed by Glamamore of course, to apply the maquillage. They preen their fledgling with swift precision, wielding paint sticks, brushes, and eyebrow pencils in tandem. Staying true to sixties-inspired glamour, perfected in their Boy Bar days, their daughters always bear a strong family resemblance. Eye makeup *will* be seen by the last row of the audience, and hair must not be simply teased but outright harassed. The scent of powder in the air signals that their transformation is nearly complete. As each newly hatched queen steps into the spotlight for the first time, Juanita looks on like a proud mom.

Mother More doesn't just beat the kids' faces; her grassroots initiatives feed the children in both the literal and figurative sense. Juanita approaches cooking as another means of artistic expression and nurturing love. *Food is my love language.* With dinner parties on hiatus due to the pandemic, Juanita established a weekly pop-up where people picked up food to go, as she greeted them in full face from the balcony. On her YouTube channel, she dispenses bits of kitchen wisdom for the modern homosexual, such as *Always keep your poppers in the fridge.* In 2014, she started Juanita's List, a Facebook group with membership now numbering over ten thousand, to help queer people in the Bay Area find nonexploitive housing.

As much as she stays creating and preserving the legacy of queer spaces in a city where they are increasingly endangered, she takes time to mourn the ones we've lost. She hosts a yearly procession down Polk Gulch to visit those lost places, beginning at the former site of Gangway, San Francisco's oldest continuously operating gay bar, which closed in 2018. Polk Street flourished as a queer thoroughfare in the 1950s, and by the 1970s held the distinction of being the gayest street in SF. Of the nearly eighty gay establishments that have existed there since then, only one, the Cinch Saloon, is still open. In 2020, the Stud joined the ranks of these shuttered queer institutions. Juanita called the news of its closure a *huge loss for our community.* And still, she believes San Francisco remains a place for oddballs and queers to transform themselves. *You can come here and rediscover yourself or really be yourself, change yourself, whatever, no one is going to care as long as you're honest about it.*

She greets those who make that journey with her maternal gaze, whether at one of her innumerable public appearances or looking over them from one of her eight well-appointed murals scattered throughout the city. Despite her local fame, she still reports an uncanny feeling every time she sees her face across from Alamo Square, one painted lady among the rest. Ever devoted to her city, community, and chosen family, Juanita has forever altered the landscape of San Francisco drag.

> *"You can come here and rediscover yourself or really be yourself, change yourself, whatever, no one is going to care as long as you're honest about it."*

Mutha Chucka

Mutha Chucka only agreed to shoot with us after her Thoth Tarot deck affirmed our invitation. *There are decks of cards all over my house; I pull cards for everything. I wouldn't be where I am or do what I do if I didn't pull cards.* We arrived at her apartment in the Mission in the spring of 2018, and she received us in one of her signature monochrome ensembles, complete with a bubblegum beehive wig. A true vision of a hostess, she sipped a Bud Light through a straw as she beckoned us inside. *All the way at the back!* She moved to the Mission in the early nineties and was lucky enough to secure a rent-controlled apartment, where she lived for nearly thirty years. *All the baby queens and club kids have been through here. Half the kids you see performing are wearing something I gave them!*

Mutha serves an exuberant and accessible, but also unapologetically political, brand of drag. *I would get naked onstage just to encourage other fat people to do it. And I was decapitating Trump and pissing on him as soon as all that happened. I've never been afraid to look ugly or make a fool of myself. So many queens are so fucking worried about how they look or if their makeup is perfect. I'll play old ladies, the dregs, just to get a laugh—anything to make people smile or have fun.* She refined her performance style over the years: *I used to use all these props, but then I realized no one cares, so now I focus on a few key elements.*

When the pandemic shuttered all the drag bars, Mutha was determined to continue creating by any means necessary. She taught herself to shoot and edit video, and now she's exploring green-screen techniques and multi-camera setups. Since relocating to Palm Springs in the autumn of 2020, she's begun livestreaming dance parties from her pool deck. Each party ends the same way, with Mutha jumping into the pool. *It's become my signature move, because it's 110 degrees outside! At high noon!* The extra square footage allows her to flex her creative muscles with renewed zest and spontaneity. *Here, my canvas is ginormous. I have my dream drag closet! I can just run in there and be in drag in like fifteen minutes. All I have to do is shave and BING! I'll get in drag on Wednesday morning just to do a dance break for my coworkers over Zoom. I feel rejuvenated, and my creativity is rejuvenated.*

> ## "The first rule of drag is nobody owns drag."

In 2016 a parasite brought her to *death's door* and left her there for three weeks. She bounced back, suddenly seventy pounds lighter, which she describes as a very surreal experience. At that time, returning to drag facilitated a renewed bodily autonomy, even when her physique felt unfamiliar. That experience prepared her for both the collective psychic trauma and alienation wreaked by the pandemic. Besides, she saw it all in the cards. *I got hired by this hotel to read cards in early March—they were doing an industry night for people who work in bars and restaurants. It was packed. All night I had a huge line so I was doing a lot of quick five-minute readings, and I kept pulling the same cards consistently. They were indicating: you're gonna change jobs, change jobs, making money in a new way, you're going to work two jobs, find a new job. And everyone was like no, no, nope, not me, no plans to do that, no, don't think so. Five days after the party SF's economy shut down; all the restaurants and bars closed and all these people were out of work.*

Although she misses the community she'd built in San Francisco, she's blasé about the possibility of a return. *Who fucking knows? Why bother even making plans at this point?* As if by magic, her new neighborhood is home to at least five other queens, mostly from SF as well. *Heklina is like two blocks away!* Mutha emphasized that within the adjacent and interwoven drag spaces—from SF to Palm Springs, the punk bars to the Imperial Court—can be found sites of intergenerational transmission; the legends are able to transmit knowledge from the dead and nurture new legacies of camp, glamour, and degeneracy. Indeed, had our cover model not served sublimely uninhibited fuchsia euphoria during our shoot, it's possible this book wouldn't exist. By crossing her eyes, channeling divinity, and trusting in the spirit of collaboration, her face has launched a thousand ships. Choose your own adventure and the journey will reward you. *The first rule of drag is nobody owns drag and you can do whatever the fuck you want and you can be whoever the fuck you want! That's the point of the magic.*

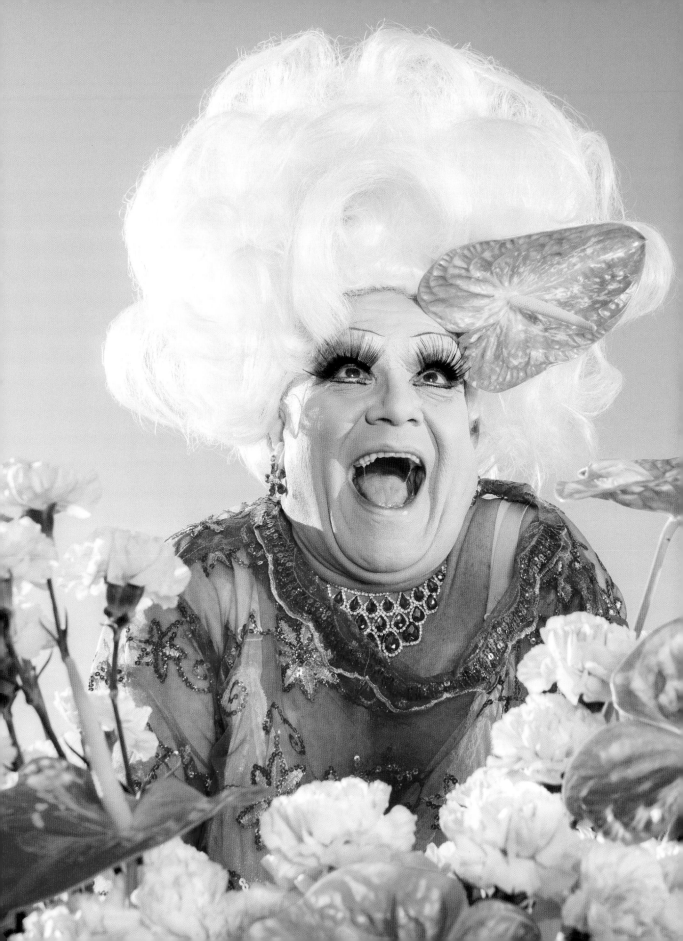

Tita Aida

SAN FRANCISCO × AQUARIUS

Tita Aida selected her pale blue eyeshadow to match the paint job on the Victorian house behind her. At first bashful, once the flashes started firing, she transformed into the quintessence of elegance and poise. She joked that her outfit made her look like a real estate agent, but with the addition of purple anthurium and green orchids, she's selling full beauty queen fantasy. Warmly received by the neighborhood, no less than three people cruised by and called her by name, including a mysterious woman in shades and an oversized hat driving a low-riding luxury sedan. A person camped out nearby came out to smile and watch, and even a bee attended to Tita's flowers.

Tita migrated to California from the Philippines in 1989. She landed in Los Angeles for a three-month stint working as a production assistant for her friend Maricel, "The Diamond Star" of the Philippine media. Family connections brought her to the Bay Area. She hadn't wanted to leave the Philippines or her family, but the Catholic ideologies of her home were at odds with her becoming.

She moved with just $300 from her family and a bit more from the LA gig. San Francisco fit her like a glove, and she quickly fell in with a community of Black street queens. *They told me, "You can make money if you hang out with us."* She calls them, collectively, her *painted ladies. They let me sleep on their couches, their floors. When I was hungry, they fed me. They took me in. I watched them put makeup on. I was introduced to a world of sequins and high heels. They had their pumping parties. I saw it all. People talk about words like "resilience," and they really gave that word meaning. They'd leave at eleven in the evening and return at four or five in the morning. They paid the hotels where everyone stayed and fed everybody.*

Tita credits the painted ladies with teaching her the art of drag, but also survival. *"Try this on, try this makeup." They loved Asian girls. We were like these little dolls they could dress up. They had a unique kindness, but they were also very strict. There were rules in the house. Things to do and not do. We were kids and these were our role models. Not only did they take people in, they defended people. I saw them fight in the streets with knives.* She recounts degrading treatment from the police who'd make arrests for jaywalking and public nuisance violations. *They'd take us to the stations over the*

> ## *"Before Stonewall there was Compton's."*

weekend and hold us till Monday morning when our beards would be growing in. More so even than her drag, those ladies inspired Tita's advocacy and struggle for Black and trans women, including producing the yearly Trans Day of Remembrance. *The women getting killed at an alarming rate are African American trans women who just want to live their authentic selves. It's cliché to say, "The struggle isn't over," or "The struggle is real," but the struggle is real! I've seen all the things they had to do just to be themselves.*

Tita didn't encounter trans identity until she came to San Francisco, which she calls the epicenter of the movement. She referenced Dr. Susan Stryker's rediscovery of the Compton's Cafeteria Riot—a trans uprising in SF's Tenderloin neighborhood—as a historical basis hidden in the city itself. *Before Stonewall there was Compton's. I'm sure there were things before that. It's been going on here.* Tita witnessed and participated in the creation of an identity category. She contributed to the 1997 Transgender Community Health Project study alongside epidemiologist Kristen Clements-Nolle, which for the first time studied the prevalence of HIV in the trans community, with an eye toward redesignating funding limited to MSM (men who have sex with men) to go toward trans women who were also contracting the virus.

In 2004, Tita participated in the very first Trans March, bringing her signature karaoke machine for the crowd of three hundred or so marchers who met in Dolores Park in response to an email call to action. *When I got involved with Trans March it was the most ripe moment. This is for everyone who identifies in that spectrum: gender non conforming, androgynous, gender benders, anyone whose identities differ from the binary.*

Tita holds space for nuance in identity. *I do drag but don't identify as a drag queen. I'm a transgender person who does drag. Drag is an art form—its own beast.* At Asia SF, Tita reigns as resident auntie and den mother. When she began performing there in 2000, the girls called themselves gender illusionists. *This was before trans identity caught on and political correctness kicked in.* She calls it a drag show, but says the owner insists it's a cabaret. As the art of drag continues to evolve, so too will the language used to describe it. For trans artists like Tita, drag is not about creating the illusion of a woman, but embodying one's intrinsic feminine power.

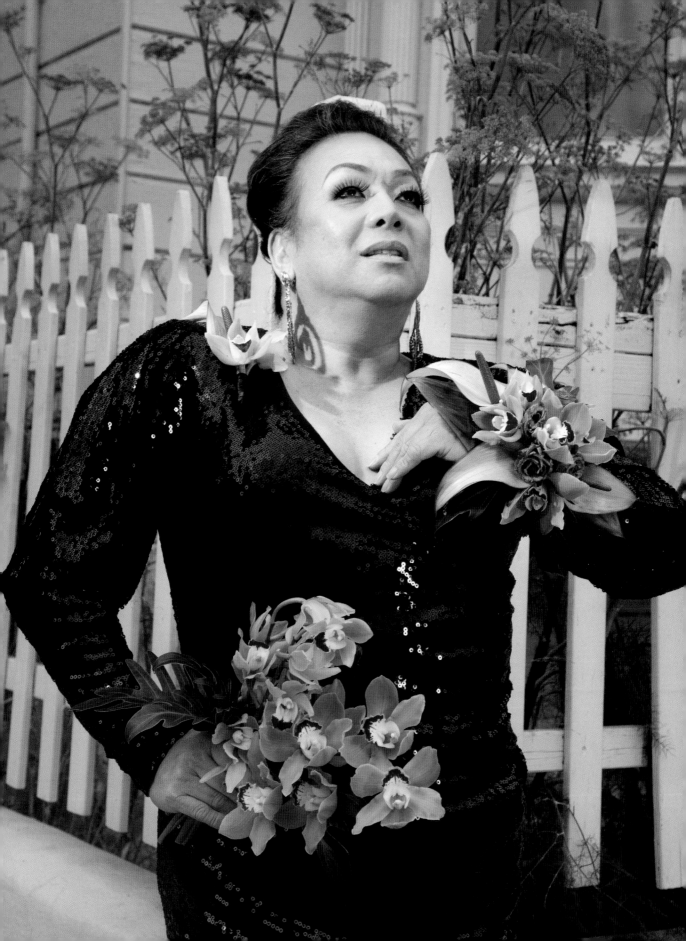

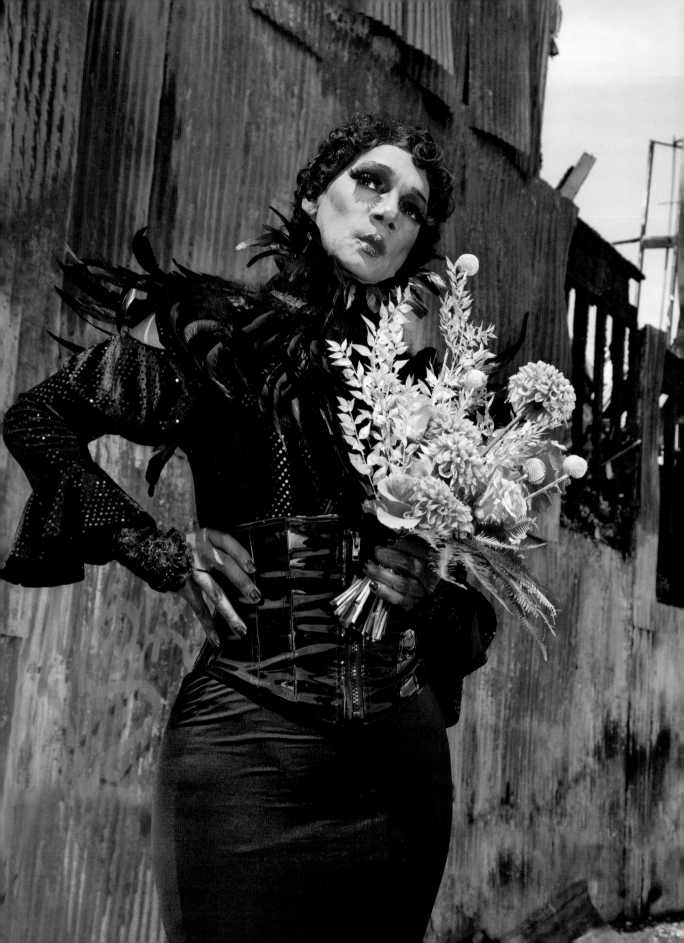

BeBe Sweetbriar

SAN FRANCISCO × ARIES

The morning quickly grew sweltering in the Mission, but BeBe Sweetbriar braved the heat in her head-to-toe black outfit of velvet, feathers, and patent leather. We love cocreating these portraits with our models, and BeBe took the lead on this collaboration. She proposed we shoot at both a site of dereliction as well as new construction; a juxtaposition meant to highlight the rapid flux of the liminal spaces in the city. Posed in front of a recently burned-out warehouse, she desired to convey a phoenix rising from the ashes and moving toward color. At least four cars slowed at the crossroads to remark on her beauty. One passerby leaned out his car window to tip us five dollars, an approach that we firmly endorse as an alternative to catcalling.

BeBe fell into drag by accident. Newly arrived in SF after fleeing Hurricane Katrina, she met the openly gay pastor of St. Aidan's Episcopal church while he was spreading the word one day at Badlands in the Castro. He promised the bar-goers they'd be welcomed with open arms at the church and invited them to worship, an acceptance unexperienced by BeBe in a religious context. The pastor became a friend as well, and BeBe involved herself in service whenever needed. In 2006, the church needed a parishioner to play a drag queen character in a floor-show fundraiser for the yearly celebration of St. Dymphna. (*The patron saint of anxiety . . . sounds about right!*) Despite having never done drag, BeBe volunteered. The show parodied *American Idol*, and the parish wrote BeBe Sweetbriar (a name derived from a discover-your-porn-name formula) into the script. BeBe performed a Whitney Houston song and never looked back. *People couldn't believe I had never performed in drag before. I got a lot of requests to do fundraisers and got involved with a lot of different organizations.*

From there her star rose quickly. Within a year she competed in and won two pageants back-to-back: first, Miss Desperate Diva on behalf of the AIDS Housing Alliance, and the next weekend, Miss Gay San Francisco. For Miss Desperate Diva, she lip-synced an Anastacia song dressed as an angel, drawing attention to the city's unhoused population amidst a cast of extras dressed as joggers and businessmen trying to ignore the crisis. She won the latter title by singing a medley of Billie Holiday songs. She wore an all-white, form-fitting gown and a gardenia in her hair, a reference to *Lady Sings the Blues*.

> "I didn't want people to think I was a title whore."

BeBe found a mentor in the late Cookie Dough, who wasted no time in taking BeBe under her wing when the two met at her infamous "The Monster Show." *She took one look at me and said "I don't know you! Are you new? Sit right here, I want to talk to you! If you ever decide to perform, I'd love to have you in my show."* BeBe accepted the invitation, which opened even more doors. She made her Trannyshack debut for a fundraiser for a long-time performer who'd fallen ill. The club's founder, Heklina, liked what she saw and kept inviting her back. BeBe performed in many of Heklina's opening numbers and *always played the pretty girl* in group productions. She also accepted an exclusive invitation to compete in Miss Trannyshack, but ultimately rescinded: *I didn't want people to think I was a title whore. I only ever did those two pageants, and that was enough.*

Regarding her drag persona, BeBe attributes influence to Whitney, Diana Ross, Gladys Knight, and Diahann Carroll. She calls her style *regal but showing a high regard for women in general. I didn't want to create an overexaggerated caricature. That's not the homage I wanted to pay to the female entity.* Her reverence for iconic Black divas motivated her recording career as well. BeBe's 2017 track "UNITY" spent nine weeks on the Billboard dance charts, and she's opened for acts including Kelly Rowland and Peaches. She picked up a few other tricks by carefully observing the reigning queens of the SF scene. *I went to drag shows to learn. I watched Heklina command an audience. I'd go watch how Juanita More would greet people at the Stud or the End Up.*

BeBe fatefully met Sister Roma one night while performing at Truck. After the performance, Roma introduced herself and predicted, "We are going to be great friends." BeBe describes the two of them as always being on the same wavelength. They were inseparable for years, frequently showing up to the same parties with accidentally color-coordinated ensembles. *I'd show up in white and gold, she'd be in white and gold. I'd show up in black and pink and she'd be in black and pink. It always looked like we had gotten dressed together. It still happens. We were meant to be friends.* BeBe received Sainthood in the Sisters of Perpetual Indulgence during an event honoring one of Roma's anniversaries in the order.

When BeBe learned we shot with Roma that same weekend, she joked: *I'm surprised she didn't tell me about this photo shoot, but then again . . . I didn't tell her either!*

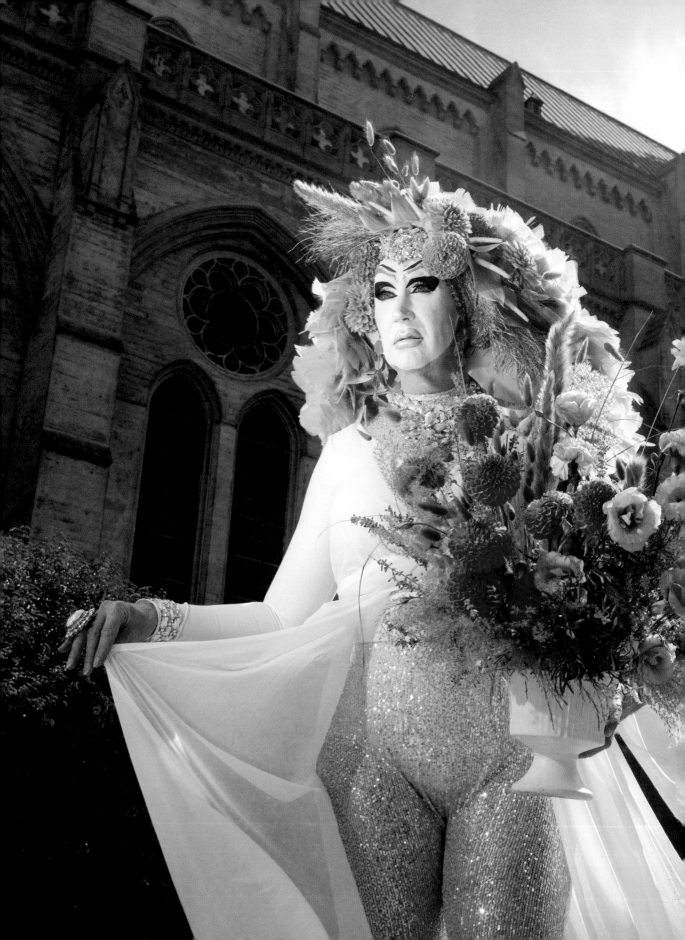

Sister Roma

SAN FRANCISCO × **CAPRICORN**

"Look Mommy, a Queen!" exclaimed a little girl who'd just finished walking the labyrinth in front of Grace Cathedral. Another child picked up a flower that had fallen from Sister Roma's headpiece and gingerly returned it to her. *How far parenting has come,* Roma quipped as the family went on their way. Multiple people stopped and asked for a selfie with her. Besides being her neighborhood church, the iconic cathedral served a fitting backdrop for the city's most recognizable Sister of Perpetual Indulgence.

Roma's path to sisterhood started early. She was born on the cusp of Sagittarius and Capricorn (the Cusp of Prophecy) and shortly thereafter taken into the care of the nuns running a Catholic adoption agency. Her mother recounts that *when our eyes met, she just knew.* Years later one of the nuns told them: *You look alike, love does that.*

There have been some badass nuns who've protected people during times of war and famine. Some nuns really fucking rock. A lot of them are lesbians. One of my favorite nuns worked with battered women. Very Bea Arthur. Roma didn't click with all the Sisters though. One particular Sister—*so insipid and superior*—who taught religion class, took offense when Roma inquired about her personal experience with the day's topic: speaking in tongues. *"Have you ever spoken in tongues?"—Oh the indignation that I would ask such a personal spiritual question! She went off. In retrospect, I realized that bitch never spoke in tongues and that's why she was so pissed about it!*

After Catholic college, Roma moved to San Francisco in 1985—*a crazy, horny, young, gay kid in a gay candy store. I was really living the dream here. Everyone always says "welcome to San Francisco, you missed it!" but even then there was a gay bar on each corner and sex in the streets like Sodom and Gomorrah.*

She'd seen her first drag show at nineteen or twenty at a dive bar in Grand Rapids, Michigan, called Carousel. *It was tiny and scary and exciting and I loved it.* An imposing queen named Odessa Brown performed "And I Am Telling You I'm Not Going"—*a drag standard; everyone does it at least once.* The performance had Roma screaming, pounding the stage, and throwing money. *That was the first queen to really make me go, "Oh my god!"* She never imagined herself doing drag, but a fateful encounter steered her back on course.

In 1987, Roma met a friend for a happy hour at Midnight Sun, a video bar in the Castro. *The front door blew open and in came this creature, a showgirl/clown/nun. For the first time that evening, all eyes were off the giant video screens and focused on this person. They knew everyone, greeted the bartenders by name, and then addressed me directly: "Hi Michael!" "Do I know you?" "It's me, Norman!"* (her then-nightly partner in crime). *He never mentioned being a Sister before—Sister Luscious Lashes. That was the most defining moment of my life. Norman took me under his wing and introduced me to the Sisters. I respected their work around HIV/AIDS. They were the first group to produce a safer sex pamphlet and the first to throw a fundraiser for the sick. I started volunteering with them as a boy.*

While preparing to cheer for the Eagle's gay softball team as *cheerleaders from hell*, Norman initiated Roma to face paint. *He put me in front of the mirror and said "Why don't you try the makeup?"* He applied the white face paint and instructed: *"Paint whatever comes out"—I painted bold, hard, sharp edges, almost like war paint with giant triangles, glitter on cheeks and lips, and the Sisters' signature giant eyelashes. I was hooked. I became the most fabulous amazing thing I'd ever seen. At brunch, I just kept looking at myself in any reflective surface:* even picking up a knife to catch a glimpse. She's held on to that feeling. *When you exude that confidence and energy, people really feed off it; confidence in your beauty, wit, ability to interact with people.*

Despite being immersed in religion from a young age, Roma insists she didn't begin serving her community until she joined the Sisters. *My head exploded—the Sisters changed my life. I'll forever be Sister Roma.* She joined the order, aware of the early Sisters and their impact. Sister Chanel 2001 had designed the rainbow flag, imbuing each color with meaning: pink = sexuality, red = life, orange = healing, yellow = the sun, green = nature, turquoise = art, indigo = harmony, violet = the soul. She learned about the influence they drew from the Angels of Light and the Cockettes and the Radical Faeries.

AIDS ravaged the sisterhood. When Roma officially joined in 1987, there were only five or six active Sisters. Over her thirty-three years in the sisterhood, she initiated a rebirth of the organization. Many credit her with being the first Sister they ever met or the one who inspired them to join the order. *I embraced it, took off running, was in habit every weekend. I worked nightclubs, wrote a column in the gay rag, emceed Pride and Halloween in the Castro. I just never stopped.*

There are just as many unique personalities as there are Sisters. We have Wiccans, Catholics, Baptists, Buddhists, agnostic, everything. I've traveled the world and met Sisters everywhere. When you're with a group of nuns from anywhere, there's a familiar feeling, a common respect, sisterhood. I feel these people. We all have this underlying current of compassion and action. It's a spiritual love for humanity and a desire to make the world a better place for having been here.

Following the 1989 Loma Prieta earthquake, Roma mobilized her gregarious nature and went out with a crew of Sisters, equipped with bullhorns and five-gallon buckets, to raise money for a relief fund. They became synonymous with donation drives, at the gates of the Dore Alley Fair or wherever the next state of emergency was.

The Sisters famously organized the Halloween revels in the Castro. *Halloween had always been the most complete and*

> "It's a spiritual love for humanity and a desire to make the world a better place for having been here."

utterly amazing chaos. After the earthquake, we brought in a flatbed truck and set up stages. We made it a big event: the most jaw-dropping costumes, 300,000 people living their best life, the most San Francisco, queerest, most beautiful thing.

But it got too big. Queerbashers would come, lurk outside the perimeter, and wait for drunk people or those walking alone and they'd pounce. The last year, 1995, there were reports of skinheads up the hill waiting to attack people. I was onstage and scream-ing into the mic: "You fucking skinheads! You wanna fuck with somebody? Come down here!" She called the scene a war zone, complete with bottles flying and the sound of shattered glass. Some Sisters were jumped that night. Their nonprofit part-ners bounced. They boogied. We decided to shut down the event. We couldn't guarantee peoples' safety. Roma never stopped put-ting on her warpaint.

The Sisters undoubtedly challenge the tradition of Catholicism: It's all very "I love your dress but your purse is on fire." The Church is still just the gayest thing ever. The incense, the chanting, the theatrics, it's so flamboyant. The early Sisters knew what they were doing the first time they went out Easter weekend, 1979. Imagine psychological car crashes wherever they went. Men, in drag, dressed as nuns: It was a triple gut punch to some people.

When we go out, some get offended, but nuns often come intro-duce themselves as Sisters and they really get that we are out here ministering to our community. We all take vows to promulgate universal joy and expiate stigmatic guilt. Beyond that, every Sister has a personal relationship with their higher power (and the world and life in general). Sisters are very in tune with what-ever that higher power is.

Roma built relations with other drag traditions in the city as well. After joining the Sisters, she began working with the Imperial Court. She became enamored of all the queens and empresses and trans women she met there. With particu-lar respect to two queens, trans women from Texas named Rhapsody and April, she recounted: They taught me everything about magic, transformation, jewels and makeup, authenticity. I never laughed so hard as I have with those girls. They are literally my biggest influences. They were sex workers, ruled the nightlife—worked phones by day, limousines and cocaine by night. It was the most glamorous thing.

Working one night as the hostess of the VIP room at 1015 Folsom, she saw a queen dressed as Wonder Woman and called out You go, Wonder Woman! The costumed queen turned out to be Shante Bouvier, newly of Falcon Studios. Roma had always loved porn and was immediately intrigued. She met Chi Chi La Rue and Steven Scarborough of Hot House Entertainment. She started working in the graphics department at Hot House and continued her sisterly work. I thought it was healthy to show hot guys having safe sex. Hot House was bought by Falcon | Nakedsword, and Roma came along. She became their art director and eventually creative director.

In whatever venue, Roma stands in her power when she's at the center of things. I'm not a traditional drag performer, I don't lip sync and I can't sing, but I can talk all day. Give me a mic! I love hosting! Roma dreams, builds, and defends spaces for fantasy to become reality. Drag is many things, but what it is most of all, is magic. And she intends to keep using that magic in the now ever-present emergency.

Roma's work stays vital and relevant. She appreciates evo-lution, change, growth. She loves the new queer aesthetics. She's optimistic about the future, looking forward to more travel, celebration, dancing. No matter what life throws at us there are plenty of opportunities to do the work we were put here to do. I'm blessed, humbled, and a little surprised they still want this old queen around, but I'm here!

> "You fucking skinheads! You wanna fuck with somebody? Come down here!"

Mrs. Vera Newman

SAN FRANCISCO × PISCES

We descended the serpentine rocks to Marshall's Beach for a surreal sunset with Mrs. Vera Newman just as all the typical beachgoers were packing up. *Here comes the green-faced buzzkill,* Vera joked as we approached the cruising section of the beach. Hardly a killjoy, Vera demonstrated a willingness to get wet for art, climbing on rock formations, waves crashing about her ankles. Adding a cherry atop the dreamscape sundae, a pod of dolphins followed us as we traversed the sandy shore. Mrs. Vera coyly confessed, *I hardly ever do this without my husband, but he had to work.*

Indeed, Vera created her character in partnership with her lover, and primary photographer, Michael Johnstone. She moved to SF in 1992 and met Michael in 1994. They developed an immediate connection. Both lived through the nightmare years of the AIDS crisis. Michael traveled with the NAMES project for the unfurling of the AIDS quilt in Washington, DC. Vera's time with ACT UP radicalized her in turn: *It was revelatory to stake some public space instead of just apologizing.* Vera witnessed the selfless care work Michael offered to the sick and dying—even as his own health failed him—and knew only love and art could save him.

As many of those Michael lost were artists and performers, Vera proposed an artistic collaboration to honor their spirits. *I wanted to do something he had the energy for, on an afternoon when he was feeling good, that would connect him to these people he had lost.* The pair dressed Vera up in outlandish costumes and snapped candid photographs of Vera's daily exploits while *spontaneously seeking out locations,* in a method similar to the Situationist *dérive.*

What started with his conception of drag became stranger very quickly because of my own perspective. We were just doing it to please ourselves, but we started getting these really interesting photos coming back. We found that we communicated in a unique way through the lens, and it captured that synergy.

The photo series became *Mrs. Vera's Daybook,* which the duo describe as: *examining everyday life, alienation, magic, and survival—with a spirit of fun, participation, and lots of color.* In 1996, an exhibition of the work hung at San Francisco City Hall. Eight of those photographs were vandalized one night, but Michael and Vera didn't let it discourage them. *Drag is provocative! Those who reacted negatively at least had a reaction.* Still, the series has enjoyed an overwhelmingly positive reception over the past quarter century.

> "It was revelatory to stake some public space instead of just apologizing."

Vera describes her approach to costumery as designing 3D objects to be captured in 2D. She made the jump back into the third dimensions when—along with Michael and a few of their close friends—she decided to bring the costumes out to the Pride parade in 1994. *The first Pride we went to, Michael had been in the hospital the week before. At that point none of the drag queens in SF really wanted to go to a parade. It was like the worst time for the AIDS crisis. Most people would leave that weekend. We didn't really know what we were celebrating, but we celebrated anyway and would figure it out later.* Thus began Verasphere, the gathering of technicolor misfits in Vera's orbit. In the decades since, what started as five people grew to include hundreds of participants—each decked out in otherworldly carnivalesque costumes: a veritable temporary autonomous zone. *When we come together it's a misfit parade. Celebrating our weirdness is an easy thing for people to respond to; it's a contagious spirit.*

As Verasphere outgrew Vera's personal capacity to create every outfit, she and Michael offered workshops on their unique approach to dollar-store couture. Vera insists it's easy enough: *It's like making a macaroni Mother's Day card in second grade. One just needs the right visually arresting materials in quantity—elements you can't really account for or figure out.*

Vera and Michael's high weirdness caught the attention of Rumi Missabu, who invited the couple to her artist salons. *None of the usual suspects and all of the above.* Vera situates her work within the lineage established by the Cockettes and the Angels of Light, predecessors of a *San Francisco feel*—what their friends call "drag anarchy." Like the troublemakers before her, she desires simply to *give people permission to do whatever they want.*

In recognition of her tending of San Francisco's queer legacy, the city honored Vera on several occasions over the last decade. In 2012, the Verasphere crew walked a runway show called "Beautiful Rebels" during the de Young Museum's Jean Paul Gaultier exhibition. The Harvey Milk Photo Center hosted a twenty-five-year retrospective of photography and costumery in 2018. The following year, Vera joined Donna Personna as a Grand Marshal of the Pride parade. Then came the release of the documentary *Mrs. Vera's Daybook* (2020). *The documentary changed things for us. Having the story told so well was very liberating. It lets us think about what we want the next chapter to look like.*

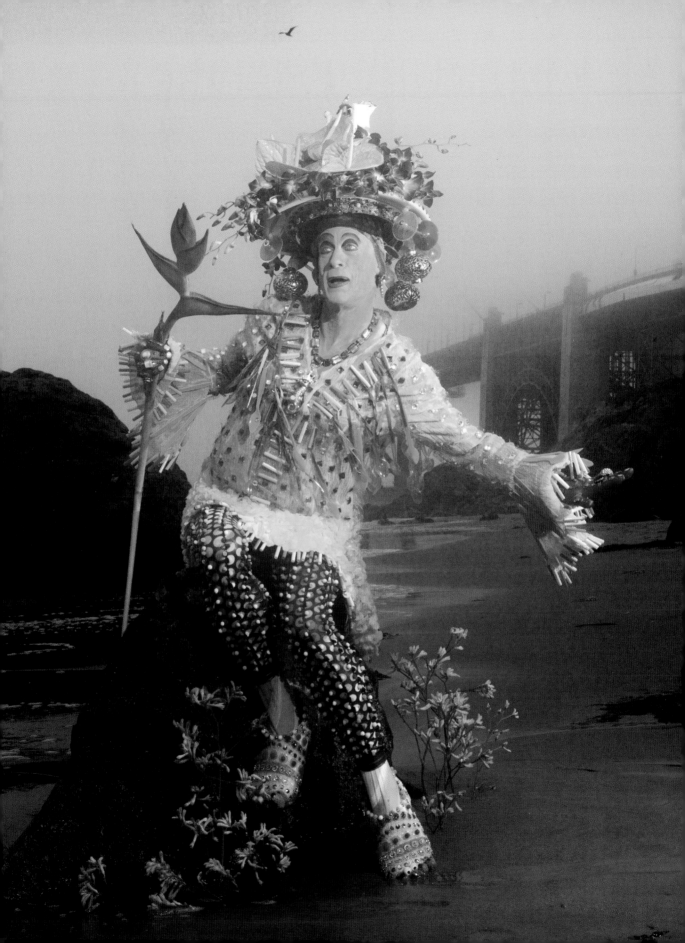

Donna Personna

SAN FRANCISCO × LEO

With a force of subtle persuasion and magnetic manifestation, Donna Personna exudes a palpable power. She cites Jackie O and Marilyn Monroe as major inspirations, lithely embodying that tension between wife and mistress: elegant, sultry, vulnerable. She starred in *Beautiful by Night* (2014), a documentary about the Hot Boxxx Girls at Aunt Charlie's Lounge in the Tenderloin. We shot with Donna in 2019, just before she served as the grand marshal of SF's Pride parade, whose theme was Generations of Resistance. Donna cowrote and is portrayed in the forthcoming play *Compton's Cafeteria Riot*. She shared the feeling of liberation and belonging she found as a teenage boy in the eponymous uprising of transgender sex workers, gay hustlers, and hippies depicted in the play. The pandemic deferred the slated summer 2020 debut and tour. In the meantime, she's already finished an adapted screenplay. Donna takes great pride in the work having received a stamp of approval from Susan Stryker, a historian of the 1966 riot.

I'll be pushing up daisies and something I was involved in will still be touching hearts and changing minds, and I adore that. Donna feels that impact on a more personal level too: *Trans women in particular want to talk to me and tell me their story, and want me to help them with their challenges. Sometimes it feels like a lot of responsibility. But if seeing me succeed inspires them, that's a wonderful thing. Look, I'm in my seventies and I'm still here. Not only am I still here but I'm a playwright, I'm a grand marshal, I'm happy, life is wonderful.*

The pandemic also canceled the corporate celebration of the fiftieth anniversary of San Francisco Pride, but the springtime uprising against police violence inspired a return to Pride's roots. A call circulated announcing a demonstration beginning in Dolores Park billed as "Pride Is a Riot." The anonymous organizers of the event described themselves to *SF Weekly* as: "an autonomous, multi-racial, collection of friends, acquaintances, and comrades momentarily joined in the struggle to destroy the racist death-cult that is policing, incarceration, and all systems that uphold white supremacy."

Several hundred queers turned up to Dolores Park that Sunday afternoon to see performances and hear speeches. The keynote was delivered by Donna Personna herself. That year, Donna did not wish the crowd a happy Pride. She instead reminded them of Pride's origins in conflict and to never take one another for granted:

I see a big crowd here, but back then I was all by myself. I made it though. I'm a strong bitch. She reported herself to be thriving and attributed her survival to the ways she was inspired as a young boy by fierce trans women she encountered at Compton's Cafeteria. Donna saw their attempts to live free and authentic lives and followed their example. She says they'd been through the shit but made it. She lays that shit at the feet of the police. *As soon as they made the attempt [to live as women] they were criminalized. Cops could do anything to them, and they did.* But her story was one of resistance and resilience. *I'm happy to tell you that trans women started that riot!* She described an emboldened transgender resistance throughout the Tenderloin in the aftermath. Donna aimed to engender empathy for choices they made—not just rioting but also sex work, theft, and everything else they did to survive. Donna called theirs the work of liberation. *Nobody gave them anything, they had to do it all for themselves.*

She hopes to give the younger generations a sense of their radical inheritance. *You come from somewhere! You had predecessors! We need to remember women like Bambi Lake. She inspired me. She was doing drag when it was the most dangerous thing you could do. You stand on the shoulders of those ladies. They're trying as we speak to make your life better.* She emphasized how wonderful the queens at Compton's were and what good care they took of one another. Donna warned that the fight isn't over, that the enemy is coming for us harder than ever, but that our collective care would ensure our continuation. She asked those assembled to care especially for their Black brothers and sisters. She encouraged everyone present to do something daily for Black liberation.

When the crowd took to the streets, the police violently tried to stop the march on Valencia Street but were overwhelmed by the emboldened demonstrators. An SFPD van, some banks, and other corporate targets were redecorated before the demonstration met with another abolitionist march led by Juanita More.

KQED reported that the day "called back the anarchist roots of Pride." Emma Goldman, described by the papers of her time as the High Priestess of Anarchy, gave inflammatory speeches in the very same Dolores Park a century prior. On that day, Donna was the fiery orator inspiring the next generation to action.

> "I'm happy to tell you that trans women started that riot!"

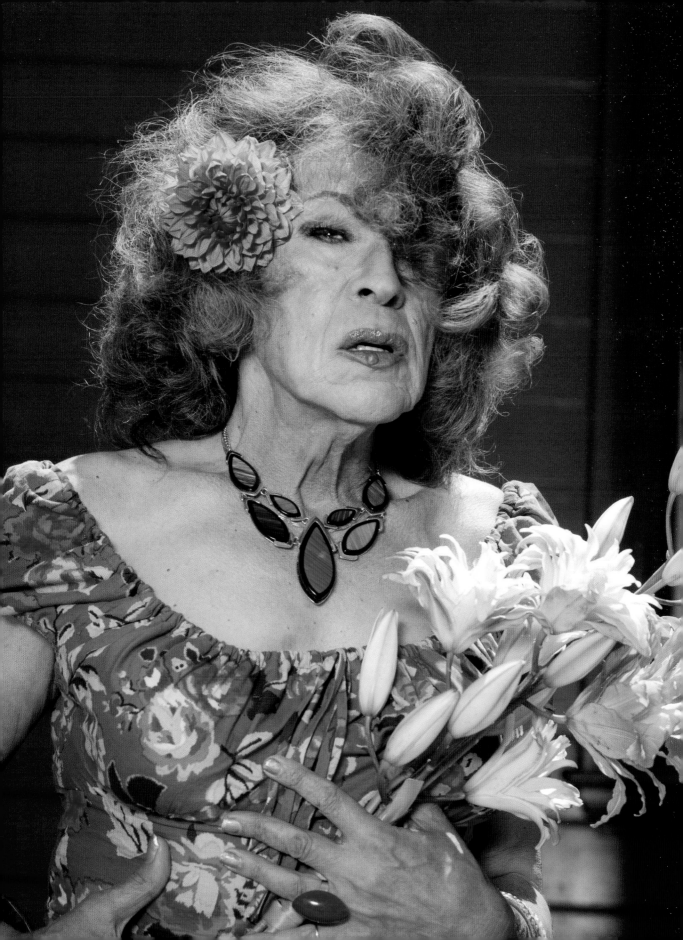

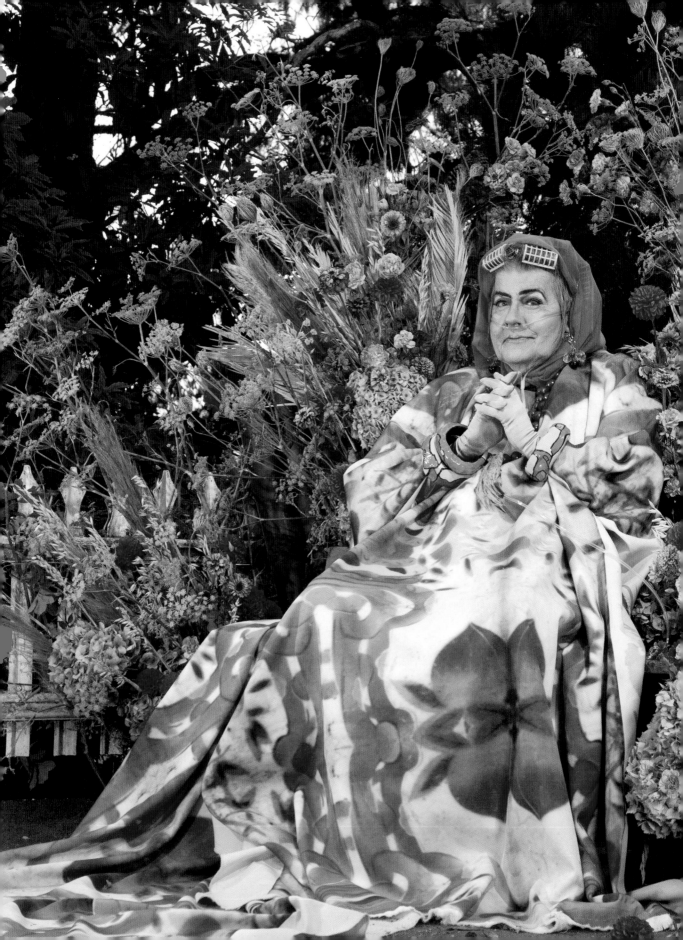

Rumi Missabu

OAKLAND × SCORPIO

Despite the Cockettes's reputation for chaos, Rumi scores nothing short of meticulous in matters of self-adornment. Her stylist, Jaime Garcia Castilla, prepared no fewer than three outfits for Rumi, who wore them all layered on top of one another. He made her jewelry out of *papier-mâché* and affixed her earrings with fishing line tied around her ear (an old Cockette trick!).

Below the multicolored garment featured in the portrait, she wore a sleek black number. *I'll stop wearing black when they make a darker color!* Still, she radiated vibrancy in the multihued caftan, enthroned and surrounded by Queen Red Lime zinnias and wild foraged fennel. Her caregiver Griffin described the scene as "an orgasm in the right color; all the gods in alignment." Channeling the mother of the gods, Rumi ordered a pizza for after the shoot from Cybele's—a shop named for the goddess whose castrated worshippers are known as *Galli*.

Rumi claims the rare honor of being an original member of the Cockettes, San Francisco's original revolutionary drag troupe, but her life in performance began much earlier. Born in Hollywood, she grew up surrounded by show business. She attended a public school alongside the children of various actors and celebrities. Some of her high school friends went on to be successful actresses in their own right: Sally Field and Cindy Williams among them.

Like so many teens in the mid-sixties, she began experimenting with psychedelics, taking, by her account, *copious amounts of LSD*. One day, while living with Cindy Williams in a back cottage, she went down to Hollywood Boulevard to catch a showing of *She Freak* (1967). The exploitation horror film depicts the story of a waitress who leaves her dead-end job to join the circus, eventually losing her limbs and getting thrown into a pit of snakes as the new main attraction. That movie forever altered the course of Rumi's life. She *totally lost it*, left Cindy a note reading, *"Can't take it anymore!"* and boarded a Greyhound bus on a spiritual quest to San Francisco.

There, she fell in with the Cockettes, with whom she performed for a year and a half. The group, led for a time by the messianic figure Hibiscus, aimed to transform dull and boring people into unique technicolor creatures. The Cockettes lived out of a

number of communal homes replete with extensive drag rooms, including the historic Kaliflower commune, and the house on Haight and Divisadero that at one point housed twenty-three members. For the Cockettes, communalism meant you do whatever you want and get whatever you need. Rumi recounted that communal living meant sharing everything: drag, boys, etc. *You'd bring a boy home for the night, and he'd disappear in the morning, and you'd assume he'd left. Turns out he would be there for two weeks going through all the other housemates.*

The Cockettes existed as a thread of a broader revolutionary tapestry of countercultural subversion. John Waters called them "hippie, acid-freak, drag queens. Very new at the time!" and described their art as "complete sexual anarchy; always a wonderful thing," amidst "a time of total anarchy in San Francisco." The king of filth himself met the group when he flew to San Francisco for a screening of *Multiple Maniacs* (1970) at the Palace Theater—the Cockettes's home stage. He brought Divine too, who received a frenzied welcome from the group as she disembarked the airplane. Waters recounts in the eponymous documentary about the group: "We had a cult, they had a cult. They loved Divine." He attributes an initiatory impact to that time with the Cockettes. "Divine hadn't switched over to being Divine all the time." After their SF trip, she was Divine forever, having been anointed by the acid-freaks.

> ## "I began to feel I was performing gay liberation through my art."

Nobody worked, everybody stole. Of that moment Rumi says: *I began to feel I was performing gay liberation through my art.* They imbued their art with ritual and magic. The magic happened onstage, but they ritualized every aspect of their lives. They thrifted while chanting. Hibiscus made bread infused with her own cum. Drugs continued to hold a central part of Cockette practices. Rumi readily confesses, *I personally never performed off drugs . . . I was always on LSD.* When many of the Cockettes fatefully turned toward heroin, Rumi got into cocaine instead—one of the choices she maintains spared her from AIDS.

She always demonstrated a penchant for sidestepping disaster. In 1971 the Cockettes received an invitation to put on a show in New York following a rave review from Truman Capote. Forty-seven Cockettes went to NYC, but Rumi opted out, citing artistic differences. They planned to perform one of their old standbys while Rumi preferred they debut something new. Her choice proved prescient, as the show infamously bombed. She herself moved to New York only after the rest of the Cockettes returned to San Francisco.

Rumi calls NYC her spiritual home and continues to perfect the impressive task of bicoastal life. While she prefers to live in the Bay Area, she'd rather work in New York. She has spent the better part of the last two decades going to NYC every April and October—*the months that agree with me best.* The first year she couldn't make the trip was 2020. She says the city's bigger venues only opened their doors for her when she returned to her Cockette ethics and began offering free shows.

Her focus in recent years has shifted from performance and more toward archival work, curating her personal archives: *The Rumi Missabu Collection*, housed in the New York Public Library for the Performing Arts at Lincoln Center. The collection is open to the public by appointment, but not online. By her estimation, she donated hundreds of pounds of ephemera, initially anonymously.

Beyond her public collection, Rumi's home overflows from a lifetime of collecting as well. In an email prior to our first meeting, she warned us: *Inside, my home is like a museum chock-full of hundreds of framed photos, artwork, designs, altars, memorabilia including an extensive periodical drag library.* Her pandemic projects included turning her home into a gallery. *If I'm gonna spend so much time at home, I want to see my friends, my lovers, and my shows.* She periodically rearranges everything to keep the energy fresh.

Above Rumi's bed hangs a custom tapestry based on her translation and performance work in *The Questioning of John Rykener* about a historic cross-dressing prostitute in medieval England whose favorite clients were avowedly priests and nuns (because they paid the best). Rumi found and translated his confession, but Rykener's fate remains shrouded in mystery. *They never found out what happened to him.*

Fully documenting such a varied and rich interior would amount to a hefty project, but on our last visit we observed adorning the walls: a Medusa mask; ruby-red platform heels; the infamous photo of Hibiscus putting a flower in a soldier's gun; covers of *National Geographic* and *Vogue* photoshopped to include Rumi's face; a portrait of Amanda Lepore; another of Divine colored over with marker; a painting of her muse, Sebastian Cheron, alongside its reference photo; her Certificate of Sainthood from the Sisters of Perpetual Indulgence; fliers for several shows, including: "A Cockette in Paris," the Living Theater, Mrs. Vera's *Verasphere, The Last Days of Pompeii* (starring Sasha Velour and Sebastian Cheron), and one reading simply: "Who in the hell is Rumi Missabu?"

Rumi spent a lifetime circling that question, but the answer remains in flux. Her journey of transformation began in the late sixties when she went to Northern California and dropped out. *I dropped my identity for the next thirty-eight years.* She left behind her name, held no ID, no bank account, no Social Security number, no birth certificate, no passport. The closest thing she carried to papers was a SF Public Library card that simply said: Rumi. *I had nothing. No paper trail, no family (they moved to Idaho).* She only reunited with her family a few years ago, when her long-lost sisters' children found her online.

She disappeared from the art world for several decades, living at residential hotels and working off the books as a domestic and prep cook. She credits her disability as allowing her to give up manual labor and return to making art. In 1994 she reunited with her Cockette family, too. She reluctantly attended the last day of the group's twenty-five-year reunion. Five years later she hosted the thirtieth at her home. Ten years after that she hosted the fortieth at SFMOMA. She boycotted the fiftieth, as the producers charged fifty dollars for admission.

Eventually she won her legal identity back as well, working alongside assistants to navigate the various state bureaucracies to piece together the paperwork that supposedly defines us in this life. Upon getting a passport for the first time, she flew to Oslo, Norway, to exhibit roughly six hundred pieces of her papers in a gallery show.

Rumi no longer identifies with the term "drag queen." *I find the label limited at best. Nowadays you hear the term and think of RuPaul and you get competitive because that's what the show's all about. It's become weaponized. I prefer to think of it as getting in costume.* Still, from her days with the Cockettes, she understands "drag queen" to be a non-exclusive term. *We had everything— men, women, straight boys in dresses, bearded queens, genderfucks, babies.* More recently she's taken on the titles "visual storyteller" and "identity curator"—the latter title coined by her friend, drag historian Joe E. Jeffreys.

Rumi sports an impressive IMDb page that she insists remains incomplete. *I'm probably the only queen whose career went straight from Disney* (Blackbeard's Ghost) *to soft-core porn* (Elevator Girls in Bondage). Never content with her self-archiving, she confessed: *Sometimes I draw the blinds, I dim the lights, and I Google the fuck out of myself.* Through this method she discovered a documentary and a French thriller she appeared in unbeknownst to her. Rumi's contributions to the historical record include *Ruminations* (2017), which is about her life. Initially self-censored for a debut on PBS, the biographic film celebrated a recent release to DVD complete with thirty-eight previously censored minutes of content. *They blurred out all the titties, ass, and dicks, but they're all back!*

Since her return to the arts, Rumi plays the role of mentor to countless artists. In our time together, she consistently joked about a rivalry with her drag daughter Donna Personna: *If she's in your book, count me out!* She casts her many shows with the veritable retinue of younger performers and eccentrics with whom she surrounds herself. She calls the resulting cacophony *a cocktail of glamour and anarchy.*

> "I'm probably the only queen whose career went straight from Disney to soft-core porn."

PORTLAND, OR

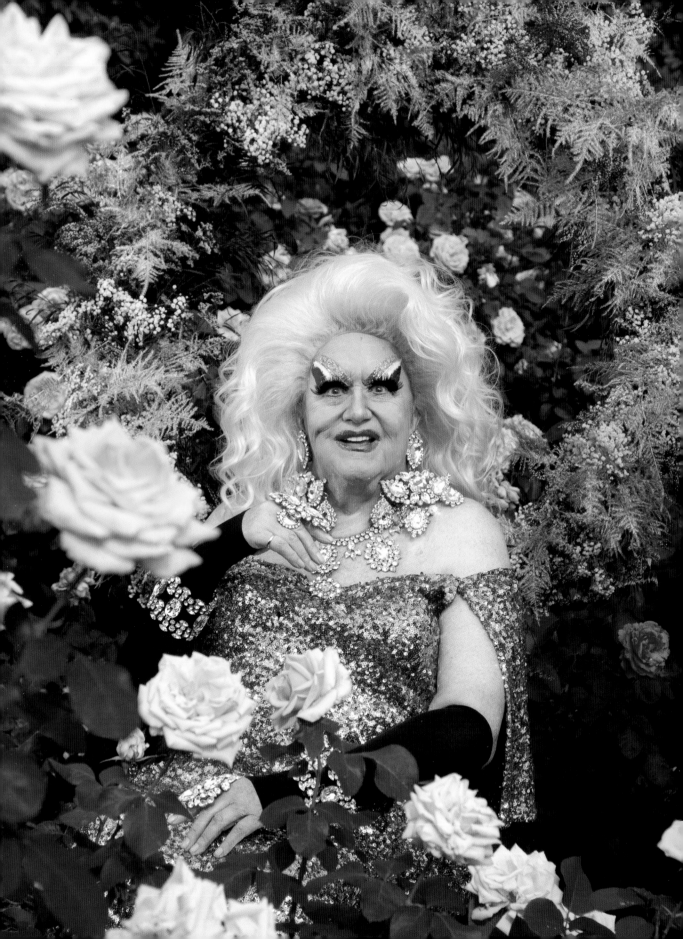

Darcelle XV

PORTLAND × SCORPIO

Darcelle XV holds the Guinness World Record for oldest working drag queen at the ascended age of ninety-one. She also stands out from every other queen we've worked with in that she owns her own club: the Darcelle XV Showplace situated in Old Town very near to the river. A relatively unassuming exterior—demarcated by a marquee (clearly not changed in a long while) that simply reads: "Female Impersonators"—opens up to a truly otherworldly interior. Inside one finds cabaret seating facing a stage, above which appears DARCELLE in two-foot-tall glittering capital cursive, and flanked by a proscenium covered in hand-painted stars. The walls are covered from floor to ceiling with portraits of pageant winners, a gallery of five decades' worth of queens, organized based on which contest they had competed in—La Femme Magnifique (1982–2007), La Femme Plus International (1996–2007), etc.—each crowned and with a presentation bouquet. Besides the theater, Darcelle ran Old Town Flowers for seven years and arranged many of the winners' blooms herself.

We toured the basement too: a labyrinth of sequins, wigs, and furs as well as a subterranean row of mirrors long enough for all nine of the regular showgirls to simultaneously beat their faces and determine who they'd be each night. We could have spent the whole day downstairs exploring the one-of-a-kind custom pieces sewn by Darcelle herself. She makes all her costumes as well as the pink pasties for the male dancers, the faux penises for the gag numbers, the wigs for her girls. She made the curtains, and she installed the lights. It's no exaggeration to say she built the place with her own hands in the more than fifty years since its doors opened.

The club opened two years before the Stonewall riots kicked off the gay liberation movement. Half rhetorically we asked what the walls would say if they could talk. *Oh, they better not!* she warned. She talked some though. The club initially functioned as a lesbian bar. *The lesbians kept me going for three years, but these weren't the lesbians we know now. These were tough dykes.* Fights reportedly broke out on the regular. They replaced the glass ashtrays with tin tuna cans to prevent them from being thrown as weapons in the brawls. *We started to put the shows on to keep them*

> "Don't build a fence around me. I'm not one person, none of us are."

entertained and keep them from fighting. Darcelle remains as tough as her earliest patrons. We've shot with Darcelle twice: once when the cold winds blew and also during record-breaking heat. Both times she braved the elements for glamour.

Their first stage at the Showplace was a simple four-by-eight-foot banquet table. Since those modest days, countless stars have passed through those doors. Christine Jorgensen, the first transgender woman to become widely known for transitioning in the fifties, worked there. Even the king of filth himself, John Waters, was a patron. *People always ask us where the other fourteen clubs are,* she joked in reference to the XV affixed to her name. The number itself comes from her fully styled title: Rose Empress Darcelle XV, a title awarded to her in the the Imperial Sovereign Rose Court of Oregon. She changed the name of the club to reflect this accolade. In addition to that title, Darcelle won an Emmy for a PBS documentary about her life.

Darcelle authored two autobiographical books, the most recent of which is titled *Just Call Me Darcelle*, a mantra she repeated when we met. She'd previously maintained a careful partition between Darcelle and Walter (her given name). She kept them apart for years but over time they integrated, merged into one. *It took a lot of money, balls, and nerve to be Darcelle all these years. Just call me Darcelle.* And yet despite this unity, she still insists on the possibility of multiplicity: *Don't build a fence around me. I'm not one person, none of us are. We fought to do away with labels; now there is a label for everything.* For her, the freedoms struggled for by the gay liberation movement were bound up in this possibility of radically remaking any aspect of one's life or identity. *If you're not happy—with your friends, family, job, self—move on!*

Given her ongoing nightly appearances, we can only assume Darcelle still derives happiness from gently roasting the crowd during her opening monologue and mooning them while performing "Rhinestone Cowboy."

Do you know how much balls it takes for a ninety-one-year-old man to show his ass onstage? Despite the jest, Darcelle knows her beauty. Before our second shoot together, seated amid the summer blooms of the International Rose Test Garden, she checked herself in a mirror and remarked: *Perfect.*

Poison Waters

PORTLAND × **VIRGO**

Nestled deep in the woods of Portland's Forest Park stands a structure with mysterious origins. *People call it the Witch's Castle because some wacky woman lived there 100 million years ago and snatched up children off the path and ate them, I guess?* In recent years, fearless teens use it as a clandestine party spot, decorating the mossy stone walls with vivid aerosol artwork. We may never know the true history, but for one day in August a new queen ruled the castle, Portland's own Rose Empress XLIV, Poison Waters.

Poison entertains the masses at the Darcelle XV Showplace, where she learned the importance of consistency. *There are more modern shows out there—we know we're the throwback. But that's what people expect, and they keep coming back because of that. The bulk of the show is anchored in history, and it's what we've always done. We're not trying to keep up with anybody else—we're just doing our thing.* Poison has performed her scintillating Diana Ross and the Supremes medley since she joined the cast over thirty years ago, and it never disappoints. On the night we attended the show, she opened with "Diamonds Are Forever" by Shirley Bassey. As the song reached a crescendo Poison revealed an enormous diamond magically spinning above her palm, effectively hypnotizing the crowd. As cohost, she expertly achieves the balancing act of putting the audience at ease while also keeping them on their toes. If Darcelle is the soul of the show, Poison is the heart. *I give so much to drag and drag has given so much to me. The work we do isn't just flippant, it helps people in the community who are suffering from cancer, or HIV, or heartbreak. When they come to our show it lifts their spirits. That's important.*

Poison's genesis can be traced to one night in 1988, when she witnessed four divas unlike any she'd ever seen: Lady Elaine Peacock, Misty Waters, Rosey Waters, and Ceresea XIV of All of Alaska. *They were wearing white gowns, all sparkly, sequined, and rhinestoned, and they did a big* Dreamgirls *musical revue. They looked like rich white ladies except they were all Black. I'd never seen drag performers with the same skin color as me, and I'd never seen that elevation of drag with the glitz and the glamour, which is my whole aesthetic in life.* Rosey and Misty became her drag mother and grandmother, teaching her gratitude and poise. Although all four of her inspirations have crossed over, she carries them with her. *They're all a part of me; I am the combination of all of them.*

Many queens claim they serve it to the children, but Poison makes a lifelong impact through her work with Camp KC, a week-long summer camp for kids who are living with or affected by HIV. She started as a volunteer over twenty years ago, and now serves as the camp director. *When we first started this camp, children were being born with HIV and not living very long. Each year we'd plant a tree for the kids we lost the year prior. The focus still remains to help erase the stigma of HIV in childhood, but now the camp is mostly kids who have family that's affected by HIV or AIDS, or has passed away. In fact, some of my youngest campers are the children of my campers from when I first started. It's great to see them grow up.* As much as she gives to them, they've taught her important lessons in return. *The resiliency of these children is the thing that really got me. I thought to myself, "OK girl, you really need to rein yourself in whenever you get worked up over small stuff. These kids have real struggles, you have no business being an asshole."* The difference between poison and medicine amounts to a matter of dosage. The children made a healer out of Poison Waters. *I learned to be a person from these kids.*

Drag has made it possible for me to challenge myself—I do all the scary things now. I rappelled down a twenty-four-story building in drag for a fundraiser. And I'm afraid of heights! These days I say yes to everything and worry about it later. When the Oregon Ballet Theatre asked me to be in their Nutcracker *as Mother Ginger, I was like, "Sure that sounds great! Wait . . . I don't know what that means—I'm not a ballerina." Now I've been doing it for eleven seasons. I've done opening acts for the Portland Opera and Oregon Symphony. I grew up very poor, so for a little Black gay kid to put on an evening gown and open for the symphony, it's so surreal. People ask, "Where'd you get this confidence?" I faked my way through it. I convinced myself that I was that person, and now I've adopted that personality. Drag can be all about hiding, but it's been the opposite for me. It unpeeled my layers like an onion. It's a lot, I'm a lot, I know I'm a lot!*

> "Drag can be all about hiding, but it's been the opposite for me."

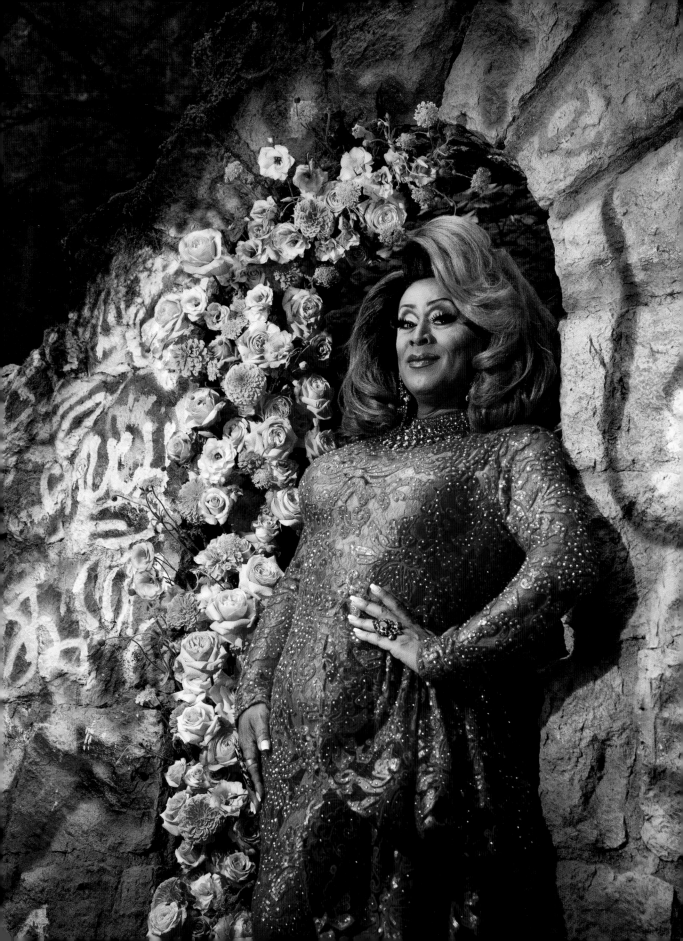

LOS ANGELES

Lady Red Couture

LOS ANGELES × GEMINI

Lady Red Couture lived up to her name, having hand-made the sequined hip-hugging dress she wore to our West Hollywood shoot. Mother Couture, as she was often known, described herself as *the largest live-singing drag queen in captivity*. She met us that sweltering Hollywood morning, got changed in a parking lot, and lit up Sunset Boulevard with her signature charm and an undercurrent of seduction. She called herself the *thug whisperer* and didn't separate her sexuality from her art. A mistress of duality, she worked a day job as a security guard, which she insisted paid much better than dinner shows, *That's fifty dollars, that's not even a wig!* Her life lacked not the Hollywood drama. In a personal Herstory-themed episode of her podcast "So Real With Lady Red Couture," she recounted an armed bank robbery during which she saved an ungrateful bank manager who went on to fire her a few weeks later for being a queen.

Lady Red's commanding presence warranted comparison to Patti LaBelle, with the addition of a lime-green tongue piercing. Beyond Patti (whom she called *the best drag queen in the world*) Lady Red drew inspiration from a wide array of sources, including the supreme divas Diana Ross and Linda Ronstadt. A diversity of influences allowed her drag to speak to anybody. *I've been around for a long time*, she told us, *so anything that sparkles or shines, I'm very good at*. More than good, at many things besides. As she put it: *I've always been an over-shooter. I'd prefer to shoot over the moon and miss*. By her account she always excelled at covering the rough bits at the edges of things. *As a Black girl, we have Black girl magic. Magic is an array of things. The way you do your makeup, hair, presentation—it's the crown, your glory, it's how you want to be seen by the world.*

Lady Red cohosted the YouTube show *Hey Qween!* with her longtime friend, collaborator, and roommate, Jonny McGovern. She met Jonny while performing at Hamburger Mary's with Calpernia Addams. Of the friendship, she emphasized how great it was to find someone who truly understood her. The pair interviewed all the top stars in the drag industry today. Lady Red's exuberant commentary, unmistakable laugh, and appetite for life solidified her own place within that pantheon. She credited the show with expanding her repertoire of skills: she learned how to read a teleprompter and to bridle her tongue, the energetic nuancing to ensure everyone in the room gets along.

On July 25, 2020, Lady Red Couture passed from this plane. We received the news while together on location working with the legends of Milwaukee, our hometown. This gave us the chance to process the tragedy together. It'd been almost exactly a year since we shot with her in LA, and only a month since her profile ran in *Harper's Bazaar*. In the weeks after, it was our tremendous honor to see this portrait used in memorial posts, crowdsourcing efforts, an obituary in the *New York Times*, and in a gorgeous roadside shrine in West Hollywood.

Her passing was a monumental loss to her widespread drag family and to queer communities at large. The internet flowered in the days after with countless tributes and testaments from the wide range of drag legends and *Drag Race* stars on the receiving end of Lady Red's hospitality as guests on *Hey Qween!* This cumulative outpouring of love and grief from her friends and sisters demonstrates the depth of her impact in this life. To the extent our work together contributed in any small way to exalting this new ancestor is an immense blessing.

> "*Magic is an array of things.*"

We undertook this project understanding the importance of documenting these ascending legends in their temporary forms. Lady Red's untimely death reaffirmed this importance for us. We almost passed up the opportunity to shoot with Lady Red; at forty-three she was arguably too young for a project focusing on elders. Thankfully we thought better; her prolific career more than qualified her as legendary.

The contradiction that our youngest queen was also the first we lost points to the deep fault lines underlying this society. In the context of the current movement for the liberation of Black and Trans life (and necessarily, by extension, all life on earth),

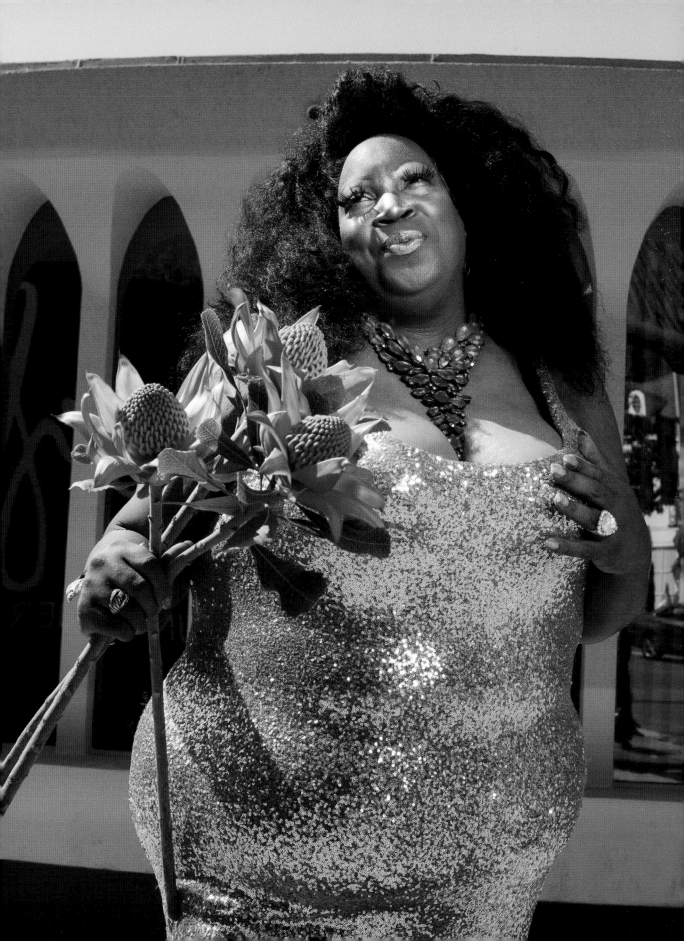

we count it among our major blessings to have had the chance to give Lady Red her flowers while she was still here.

She left the children a deep well of digital content and incisive advice, keeping busy during quarantine with her podcast and other digital drag offerings—*whenever the kids invite me.* When implored to elaborate upon her motherly role mentoring younger queens, she confessed, *I call it stealing their energy, because that's really what it is.* In return, Mother Couture made them dresses, beat their faces, and bestowed them little doses of well-aged wisdom. *I always tell them: don't live in muck and mire, because it's unnecessary. The devil is on his job, so why shouldn't we be?* She encouraged her drag children to be precise in what they request of the universe, because the universe will always deliver. *If you just ask for a boyfriend, you might get one who loves you but also loves to beat your ass.* She insisted on *projecting positivity* to her daughters, helping them navigate the labyrinth of life. When they'd come with negativity, she'd transmute the story and give it back to them. Having a strained relationship with her mother, a pastor, she attributed her spiritual approach to the influence of her grandparents.

She passed on other ancestral wisdom as well. The months preceding her death saw unprecedented uprising against police violence following the murder of George Floyd, the largest insurrection to sweep the country in generations. In that moment, when the doors of history were held temporarily ajar, she released an emotional statement transmitting a kernel of her own oral history. Her message to the movement began:

I want to let you know something today. Out of everything that I am, I am you. I am a part of this system of Americana. I am the grandson of a person who came out of slavery. My grandfather at thirteen years old hopped a train and left his oppression from his slave owner. Like everyone else, he was on the slave plantation being abused and he got sick of it one day. And he said "I'm gonna do something different." He hopped a train and came to California. When he got here, you know what he was greeted by? An alliance of great people: white, Hispanic, Black, mixed. He was welcomed and he was nurtured and taken care of.

Lady Red learned about that alliance, the abolitionists of the era, by attending closely to her grandfather's stories. She re-gifted those stories to all of us in turn. Sidestepping the identity politics du jour, she laid a strong ancestral foundation for the multiracial character of the Black-youth-led abolitionist fervor witnessed in the waning days of May. She continued:

Here's a secret you may not know: my grandfather just passed away a couple years ago, and he could not read a full paragraph. But you know how he made it? He made it with my grandmother helping him. And all the kids, we knew he couldn't read, so when we gave him cards, we'd sit and read the card with him. We'd never shame him, because we knew the stuff he had to go through to make a way for us. Now what am I saying? I'm saying I'm proud of my heritage. I am a Black American trans woman who is making a difference in this world. And all I'm asking is that you love me like I love you. I shouldn't be afraid to go to the store after a certain time because I'm Black. I shouldn't be afraid and neither should you.

Just as Lady Red intended her drag for everyone, she attempted to speak to any who could hear: *My call is to everyone— and I mean everyone—because the only way you can make black is to combine every color of the rainbow. I'm making it and I want you to make it. Let's lead in love, but let's also be very honest. We're going to have to be uncomfortable to be comfortable. White people stand up. You got a Black friend? Stand up. Hispanic people, you aren't left out either because after they finish beating on us, they're going to beat on you. So you are my sister and my brother. And we will all make it together. Let's stop beating on each other and let's focus our energy on what we need to do. What do we need to do? Stand together. The police are our creation. . . . Every time we lose a brother or a sister in this fight, it is because we are not standing together. I love y'all but I can't love you unless you love me back in all of my Blackness and all of my transness, in all of me just being a person and being a human first. Let's love each other for real now. Stand together. . . . We have to remind the police that they are human too. . . . nobody should be afraid to be who they are. Let's love each other. I'm so serious. Black Lives Matter. All lives matter. I love y'all. Please love each other.*

Lady Red emphasized the importance of joy to the revolution. This year, Jonny released a special episode of her podcast, recorded that summer, dedicated to expanding and clarifying our historical understanding of Juneteenth. The duo recorded the conversation en route to get fast food, and as they drove they commented on the boarded-up windows along Santa Monica, freshly painted with "Black Lives Matter." Lady Red questioned whether the money being raised was actually contributing in any way to the movement.

She described that as a kid Juneteenth was a hugely important thing for her family, who would travel to Alabama to celebrate for the entire month. *The reason we don't celebrate it in our high schools is because they don't want us to know our real history, they want to bury our history, as if it just magically happened.*

If it needed saying, she emphasized that Juneteenth celebrations were not started by the upper hierarchy of white men who wrote the Declaration of Independence. Rather, the celebrations were initiated by the enslaved West Africans and West Indians who were kept together and could only openly communicate through song and dance. Through these mediums, the Afro-diasporic traditions survived as a source of ancestral power. Her grandfather taught her that they were actively discouraged from religion, until their religiosity could be given a thin veneer of praise for a white savior.

Juneteenth started as a celebration in the slave quarters by those insisting on saving themselves. Some had heard the news of slavery's avowed abolition and conspired with the abolitionists to spread the word. The masters, grown long accustomed to ignoring the hymns and rites of the people they kept in bondage, paid no mind to the celebration. These ecstatic techniques shrouded the word in an opacity that allowed it to spread like wildfire.

> "This is a revolution for the people, and the revolution will be televised!"

Song was a crucial strategy in pursuit of freedom all throughout the nightmare of chattel slavery. Lady Red said her ancestors always had a song, songs about leaving, *go North to the star*. She says they sang songs encoded with keys to escape getting trapped in their own heads. Here we see the root of that inherited capacity to change the story in order to get free. But everything had to be explained through codes, even church hymns. They were subtle encouragement to keep going on. *Lift every voice and sing till earth and heaven ring with the harmonies of liberty. Let our rejoicing rise high unto the listening sky*. She instructs as she was instructed: *The sky don't listen unless you're singing*. This emphasis on the traditional, crucial, and subversive power of song comes as a needed parting lesson for those still here struggling. A songwriter herself, Lady Red surely encoded her own music with techniques of freedom still awaiting decryption by the next generation of abolitionists who'll know how to use them.

Lady Red wanted all of us to know that *we can change anything we want to, we just have to believe in it and walk in it*. She'd insist we sing while walking. She'd insist everyone look good doing it too: *This is a revolution for the people, and the revolution will be televised!* Her perspective on revolution required a joyful type of militancy: *Always remember to spread joy and keep peace in your heart*. Her perspective calls to mind a line from Diane di Prima's *Revolutionary Letters*—"All power to joy / which will transform the world"—as well as the maxim attributed to Emma Goldman: "If I can't dance, I don't want to be in your revolution." According to Lady Red's telling of history, the dancing makes the revolution possible in the first place. We owe immense gratitude for this parting lesson from the largest live-singing drag queen in captivity before she made her last break for freedom. May she be a guiding star for any seeking to free themselves in turn.

Dolly Levi

LOS ANGELES × VIRGO

Dolly Levi dances to her own drum and never misses a beat. Quite literally, we saw her play the tambourine, high kick, cartwheel, and do the splits at Hamburger Mary's in West Hollywood one night. She arrived at our shoot at the North Hollywood metro station with her flowing goddess dress concealed like a superheroine beneath tearaway boy clothes. The dress, designed by Gabriella Pescucci, was worn by a bride of Dracula in the 2004 film *Van Helsing* and won by Dolly at a studio auction.

The mercury passed 90 degrees on the day of our shoot, but Dolly never broke a sweat. Coming from a classical theater and dance background, her drag is inspired by old MGM films and the can-can dancers of Toulouse-Lautrec's Moulin Rouge. Before she began playing female characters, she was a dancer at Disneyland for five years, until 1981. She carries what she learned there to this day: *Disney didn't teach me just to dance, they taught me to act while I was dancing.*

While competing in the Miss Gay Los Angeles pageant, the manager of the legendary Queen Mary Show Lounge in Studio City spotted her and invited her to perform. The Queen Mary is often cited as the fertile crescent of drag in Los Angeles. When it opened in 1964, drag was still illegal. Performers were required by law to wear articles of male clothing underneath their costumes, in case the police raided the bar. For decades, the Queen Mary served as a hub of the drag, cross-dressing, and transsexual communities, who would mingle with celebrities like Anna Nicole Smith and Tori Spelling. Dolly remained a resident there for more than twenty years until their closure in 2003.

Losing her job of two decades left Dolly rattled, but she found strength and support from her sisters. A phone call to Shannel led to gigs in Vegas, where Dolly's rendition of "All That Jazz" became an overnight sensation, garnering two standing ovations on the night of her first show. She began performing with Chad Michaels's *Dreamgirls* ensemble, with whom she's now performed for seventeen years, and also serves as choreographer. Chad provided emotional support as well: *I got a very spiritual voicemail from Chad Michaels, it was one of the most beautiful things I'd ever heard in my life. Whenever I would get down, I would listen to that message and it gave me the reassurance that I was going to*

be OK. Dolly belongs to the House of St. James, the largest drag family in Orange County. Matriarch Pauline St. James bestowed upon her the following wisdom: *It's not important who you love or how you love, just that you love.*

Dolly only begrudgingly came to accept the identity of "drag queen," though she still prefers "professional female impersonator." *Back in the day it wasn't a term of endearment, it was an insult. People would say, "Oh you're JUST a drag queen."* Dolly truly is an eminent professional. She can give you the nitty gritty of contract law and a thorough history of the ever-growing drag industry at the drop of a dime. *The problem with most of the bar owners is that they treat us like men in dresses. They don't realize that we're businessmen first and foremost.* With all her savvy, ambition, and extensive IMDb credits, it might seem like *Drag Race* would be a logical step in her career. Not so. *I snapped this producer's head off because they kept harassing me, trying to get me to do season one. The guy gave me his business card, I tore it up and threw it in his face. I've seen the contract, it benefits the producers and the producers only. That's not talking shit, that's just common knowledge.* A few years later, several producers approached her with a confession. *They told me, "Out of all the people that we've wanted to get on* Drag Race, *you have been our number one."* Just to know that they wanted me was justification enough, that's all I needed. I don't compete. Dolly used to get asked to serve as a judge for local pageants, but the organizers stopped calling. *They said I was too tough.*

> "Believe none of what you hear and only half of what you see."

During our shoot, however, Dolly set aside the executive realness and channeled Mother Earth herself. When asked what mother would tell the children, she responded without hesitation: *Stop. Look. Listen. Live. Respect it. Believe none of what you hear and only half of what you see.* If it wasn't clear already, Dolly always cuts right through the bullshit. She says that once upon a time her success had gone to her head, but these days she knows how to check herself. *I just want kids to know that you have to put back in whatever you get out. You have to, or the art is going to die. I can tell you when somebody is going to be a success or a failure just by talking to them about their drag. Usually if they walk away pissed off, they're done.*

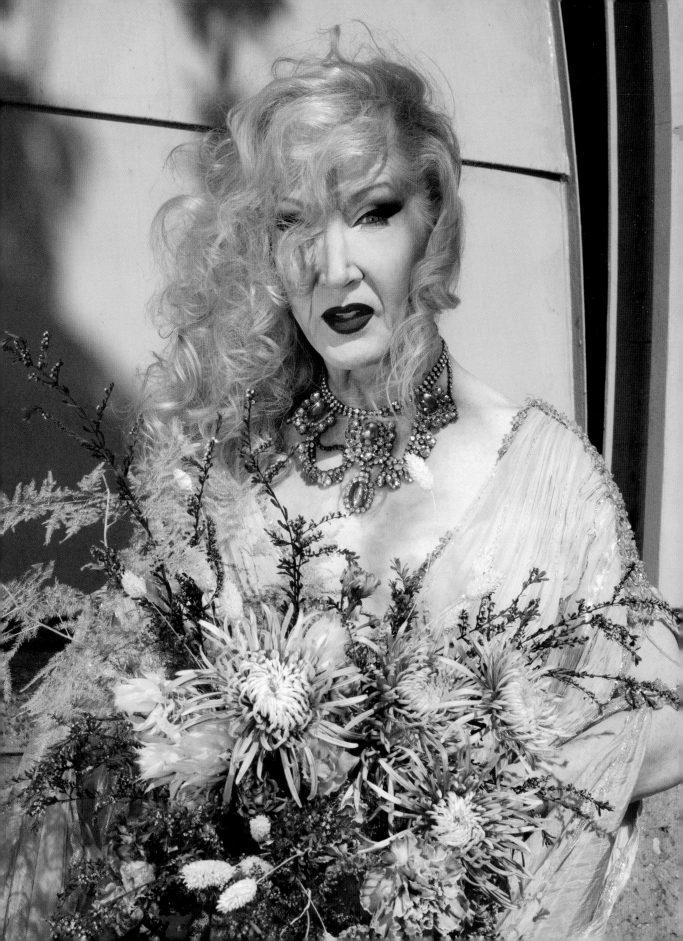

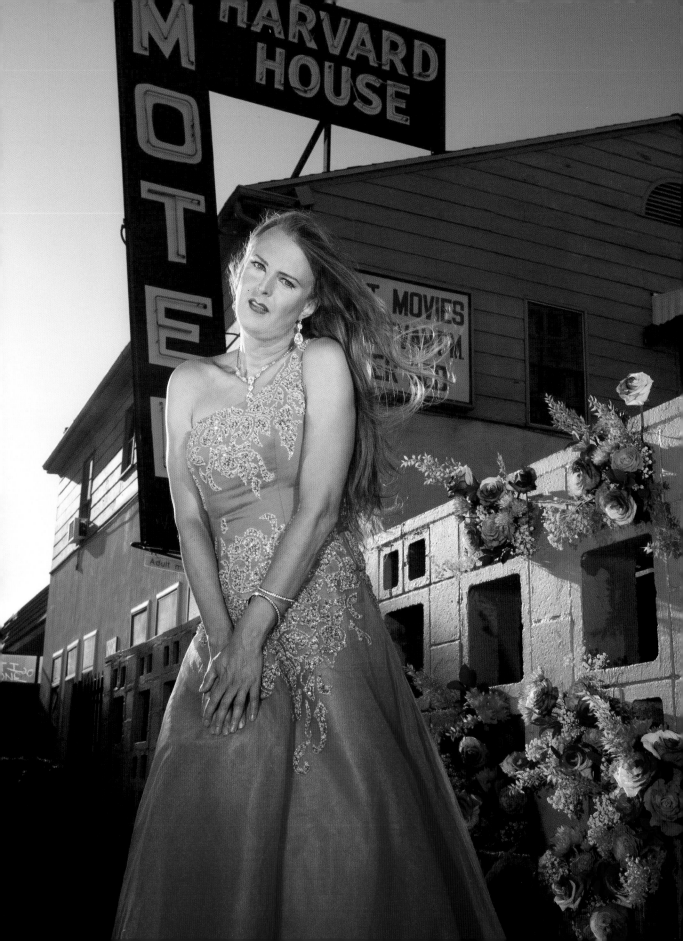

Maximilliana

LOS ANGELES × AQUARIUS

The sweet Southern twang in her voice jumps out as soon as Maximilliana starts talking about her Alabama upbringing. She makes no mention of a hometown, referring to the place of her birth as simply *the backwoods*. The first audience she ever sang for was the congregation of her Evangelical Southern Baptist church. *We were one step away from Mennonites basically. The only thing we didn't do was handle snakes and drink poison. For a long time, I thought I'd be one of those people who travel around with a quartet in a broken-down Greyhound bus, singing gospel in little churches across the South.* However, her theatrical disposition compelled a different path to stardom: Miss Macy's Charm School, where she learned the corporeal art of modeling.

After success at a modeling competition at New York's Waldorf Astoria hotel, and training at a camp for young actors during her final year of high school, she settled in Birmingham and began performing as Maximilliana in 1992. She describes the drag scene there as *phenomenal*, yet conformity reigned supreme, and Max found herself an outsider among outsiders. *My ideas of drag and their ideas of drag were two different things. I hardly won any contests, never placed in a pageant. Everyone there lip-synced—I was the only live singer, and it was not at all accepted.* Max's girlish charms and rich upper register resulted in a misinterpretation of her mimesis as something else entirely: *A lot of them thought I was a cis female singing in drag contests. They knew me out of drag, but they thought me and her were brother and sister. Literally. They did not like my sister at all, because she would come and take their money. One day I asked them straight up, "Why do you hate me so bad?" And they said, "Because we don't want girls in our drag shows."*

Passing was never the goal *per se*, but this case of mistaken identity led to a key change in Maximilliana's act, which has since become her trademark. *I developed a number where I do all these girly eighties songs: Madonna, Tiffany, Debbie Gibson, all in the original key. Then at the very end I sing Bobby McFerrin's "Don't Worry Be Happy" down in the basement, which garners quite a shocked reaction from the audience.* The act became a hit, but her favorability among the local queens was still lukewarm at best, and Max knew she'd outgrown Alabama. *I moved to the Valley because I figured if Valley girls could succeed there, how hard could it really be?*

In Los Angeles, she cracked open the phone book and called every bar in town to ask, *Where are the drag shows?* She got the same answer again and again: "You want the Queen Mary." The only catch: the Queen Mary didn't hold auditions. Max opted for a guerrilla approach, and attended karaoke night the following evening, when she knew the owner would be in the audience. Once she demonstrated her undeniable vocal prowess, he immediately arranged an audition. She joined the cast of the show the very next day. *I did my eighties mix for my audition, and they kept that number in the show for the entire six years I worked there. I was told by Butch Ellis, the emcee of that show for twenty-five years, that I was the only queen who ever showed up with an act ready to go. Everyone else developed there, but I did that work in Alabama.*

The popularity of the Queen Mary's floor show attracted industry types whenever they needed trans talent. Within her first year in Los Angeles, Maximilliana landed a guest star role on *Nash Bridges*, which led to the fictionalized Jerry Springer feature *Ringmaster* (1999), and small parts on *Gilmore Girls* and the *Clueless* TV series. Maximilliana is proud to be one of the first out trans actors to work in Hollywood, but these days she's much more selective about the type of roles she'll consider. *I'm a nonbinary person; for my day jobs I use they/them, but in Hollywood they don't really even know the difference between a trans woman and a drag queen. I walked away from a title role because the character gets murdered in the end, and I don't want to be part of any more negative portrayals of trans people. Luckily, I am working with a management company now, Transgender Talent, that has set out to help change that narrative.*

In 2007, Maximilliana brought a refreshing dose of queerness to *America's Got Talent*. She took the stage in an elegant purple dress, hair flowing behind her like Lady Godiva, then belted out a rich, throaty baritone. Piers Morgan quickly nixed her act with his buzzer, but Max got the last word. When he prompted her, "I'm a little confused, are you a man or a woman?" She responded, sweet as pie, with the voice of an angel, *Does it really matter?*

Krystal Delite

LOS ANGELES × VIRGO

Born on the Leo–Virgo cusp, the Cusp of Exposure, Krystal Delite feels at home among the stars. Growing up in Beverly Hills, the comparably *gritty and seedy* Hollywood always held a singular attraction. Though she left for New York in the early eighties, Krystal inevitably returned to the West Coast. *I spent eight years in New York—in nightlife and balls, at Danceteria, the Garage, the Saint, the Limelight. I brought all that back to LA with me.*

She began performing as part of Michaelangelo and the Cosmetics, a group of *over-the-top, colorful, drag performance artists. We headlined at a club called Peanuts in West Hollywood for a decade, every weekend. Drag wasn't so popular in the neighborhood in the late eighties. We opened up drag in West Hollywood. We were artistic, unconventional; we were club kids. We let the children know it was OK to be yourself, or to be someone else.* The group drew inspiration from Culture Club, Siouxsie and the Banshees, Grace Jones, and Madonna. The inspiration flowed both ways: *Madonna came to our clubs for our pose dance contests and commercialized it into "Vogue."* That time served as Krystal's drag boot camp. *Michaelangelo and I collaborated on designing for the group. I did the sewing and construction. Michael taught me everything—being a DJ, makeup artist, and designer extraordinaire—my first drag mom.*

When her decade at Peanuts came to a close in 1997, Krystal took her act on the road, performing for a stint at Finocchio's in San Francisco and then at the MGM in Las Vegas. *After that I took a break from entertainment and got into fashion design.* She started her fashion education at FIT in New York and finished it at FIDM in LA. She currently designs for two stores on Melrose: Cosmo's Glamsquad and Cosmo & Donato. *I've known Cosmo for thirty years—we met in an alley. We've been working together for twenty years.* There Krystal designs for *lots of celebrity clientele,* including looks for Nicki Minaj and the last five walk-to-the-ring outfits for Deontay Wilder. As a designer, Krystal references the work of Issey Miyake, Jean Paul Gaultier, Norma Kamali, and Claude Montana. *I look to the major designers and then interpret into my version. If I like it, I know it's gonna sell.*

She designed her outfit for our shoot, curating *ethereal,*

> ## "We let the children know it was OK to be yourself, or to be someone else."

angelic vibes. This angel carries a sword though. A heckler from a car daringly tried to interrupt our session, and Krystal told him right off. After the expletives, she informed us: *This tranny's got a foul mouth! Believe me, I was no saint. I had my dealings with drugs and alcohol, but I got clean. I've been sober for sixteen years.* Sobriety brought her *clarity, freedom, peace of mind, serenity. It taught me the mystic love of the universe, which you can't escape.*

Everything I do these days is from a spiritual place. I'm a spiritual being. It's truly the essence of who I am. Krystal attributes her sobriety to going through a twelve-step program—*if every human being went through the twelve steps one time in their life, the world would be such a better place*—and to Buddhism, which she picked up from a cute guy chanting at her sober living house. *I've been chanting ever since. Everything is different now. I have a connection with the universe and my higher power. Everything is bigger, brighter, more significant. I'm able to share that more freely. It's all about spiritual continuity in my everyday life. Attaining happiness here on Earth is not a selfish thing. It's about sharing your gift, sharing your love, helping others to achieve happiness and the ability to be their authentic selves.*

Sobriety also returned Krystal to drag, newly informed by her time designing. *My drag is very glamorous, very high fashion. When I do my drag, it's always the highest level. Fashion is everything to me. I spend day to day in drag, so my nighttime looks need to be elevated, over-the-top. If you don't make them gag, you're not doing drag.* Her drag renaissance unlocked further power. *I like being a mature queen and coming out and slaying all these itty-bitty queens. Older queens are fabulous, and that only comes from being in it for a period of time. With maturity comes experience, polish, sophistication.*

This queen advises the next generations: *If you have an interest in performing, study it, bring your very best to the table, express your own interpretation, do everything 110 percent! Drag is a manifestation of fabulosity; it doesn't matter what you are.* Following the pandemic, she insists, *It's never been more evident to me to live your life now. If you postpone the things you want to do, you do yourself a disservice. Live your full life today. Tomorrow isn't promised. Be in the present; enjoy what it is. You don't want to have any regrets.*

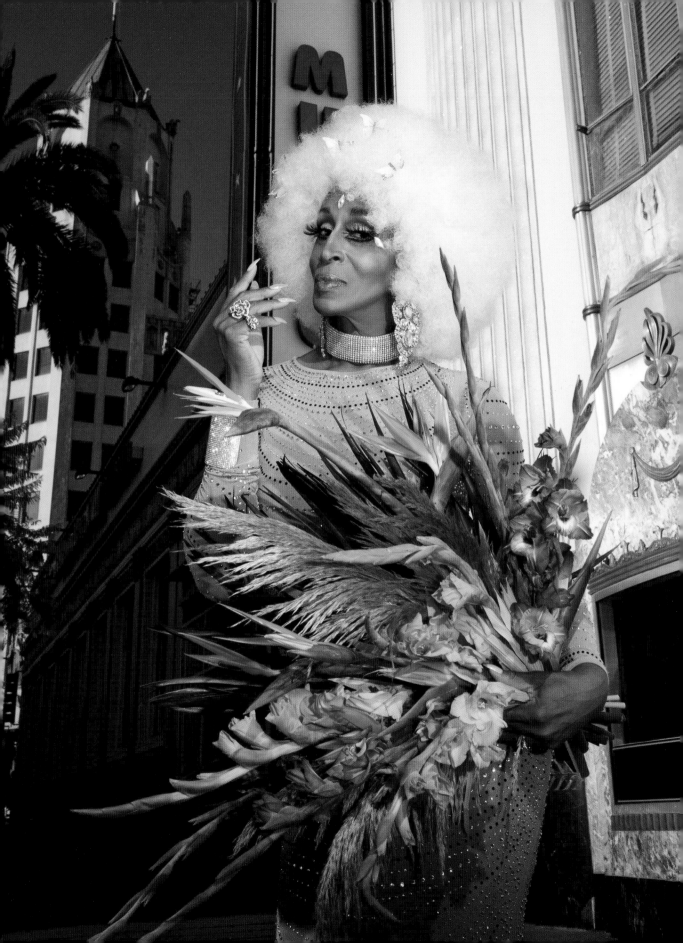

The Goddess Bunny

LOS ANGELES × CAPRICORN

We've only just begun to live
White lace and promises
A kiss for luck and we're on our way.

Karen Carpenter's voice echoed throughout the Haven of Faith in Hollywood Forever Cemetery. The translucent ceiling cast a soft pink light upon the old-school punks and outsider fags who gathered to mourn their fallen goddess. A peacock strutted by as a serene breeze swept through the sanctuary. *Before the rising sun we fly | So many roads to choose | We start out walking and learn to run | And yes, we've just begun.* Never one to shy away from controversy, The Goddess Bunny left several conflicting wills, with one consistency: The Carpenters must be played. As a self-styled deity, and avant-garde star of stage and screen, she possessed an intuitive sense for drama, even in death. The Goddess made the ultimate ascension on January 27, 2021, taking her place amid the pantheon.

When we reached out to her in 2019 about modeling for us, The Goddess Bunny wasted no time. Within two minutes of our first video chat, she told us her home address. *Just down the hall, room 4.* Her voice was distinctively raspy yet sweet. Her friends call her Sandie. The glow of her PC monitor illuminated her signature glamour makeup and diamante necklace. Despite her lack of pretenses, we couldn't help but feel underdressed. *Hurry up, I'll be ready*, she beckoned.

Her mystifying personal history only compounds The Goddess's cult status. By her own account, she descends from the Italian royal bloodline, was born atop the Santa Monica Ferris wheel, worked as Ronald Reagan's personal secretary, dated Ricky Martin when he was nineteen, and personally discovered Divine's body after her untimely death in 1988—and those are just a few morsels she divulged over brunch. It's nearly impossible to provide an account of The Goddess's life that doesn't sound sensationalized, because her life was sensational in every aspect. Even the more concrete biographical details read like the plot of a melodrama: born in 1960 in Los Angeles, she was stricken with polio as a child and subjected to a number of botched corrective procedures. A turbulent relationship with her biological mother found her in and out of abusive foster homes. The world tends to be most comfortable with disabled people when they're invisi-

ible, and most accepting of trans people when they're quiet, but The Goddess Bunny had other plans.

By the late seventies, she found her calling as an entertainer and began performing at underground Hollywood clubs. Her live performances synthesized a mix of live singing, lip sync, and tap dance into a truly one-of-a-kind act. She found her niche at the intersection of glam and punk; the audience may have come for a freak show, but her womanly wiles and unapologetic sexiness could—and did—charm the pants off any man. In one performance, she was carried onto the stage and proceeded to vomit green slime before launching into a medley of songs from *Grease* and Lesley Gore. Childhood doctors said she'd never walk, yet she danced circles around them, in drag no less.

When Hollywood came knocking, The Goddess just happened to be in the right place at the right time. *I was sitting outside of the hotel, and I was dressed up, minding my own business. I had a beer in one hand and a cigarette in the other. Penelope Spheeris was driving down Hollywood Boulevard, and she pulled over, got out of her car, introduced herself, and asked if I'd like to be in a movie. I said "Sure, who wouldn't?"* Spheeris went on to cast The Goddess in *Hollywood Vice Squad* (1986) as shit-talking secretary Charlene. On the set of the film she met fellow drag queen Glen Meadmore, and the two quickly became friends, roommates, and collaborators. The duo appeared in numerous underground films by John Aes-Nihil, including *The Drift* (1989), an adaptation of the Tennessee Williams novel *The Roman Spring of Mrs. Stone*, starring The Goddess Bunny as the Contessa. During one shoot for the film, an increasingly hammered Goddess went completely off script, creating her own narrative as both the heroine and the villain, resulting in the creation of a separate film, *Goddess Bunny Channels Shakespeare* (1989). These collaborations earned The Goddess her own section at Mondo Video (an institution among LA's most perverse cinephiliacs), where she made frequent appearances and occasionally performed fellatio in the aisles. With unreliable income as an actress, The Goddess at times pursued the *Pretty Woman* path to success. She once fucked the

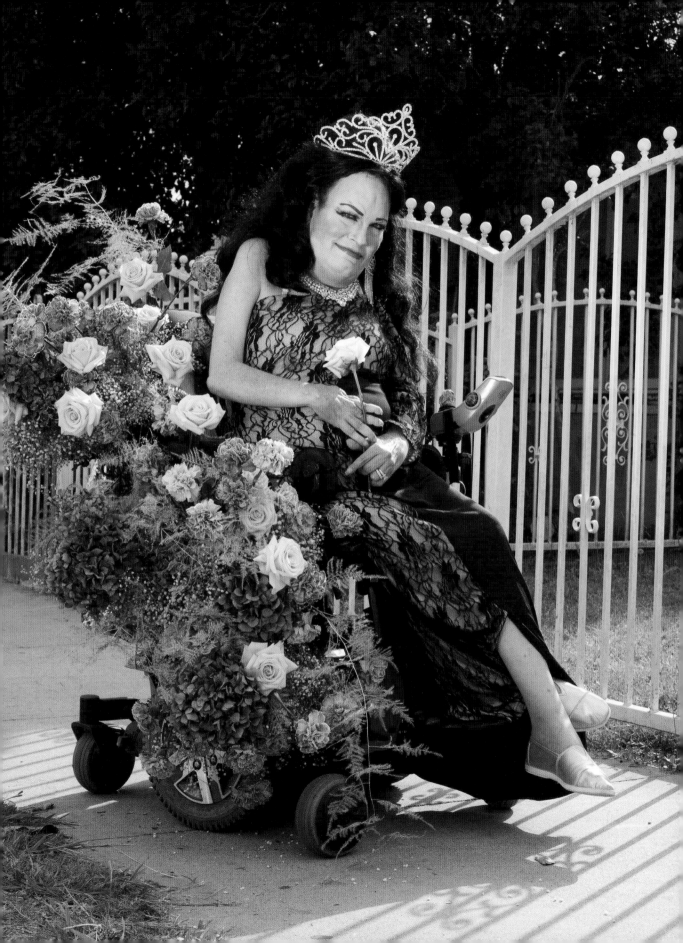

entire Glendale College football team, one right after the other, in the back of a van. When busted by an undercover cop and sent to jail for thirty days, she made the most of her captive audience by singing "Somewhere Over the Rainbow" à la Judy Garland to the guards every night.

The Mondo Video parking lot served as the venue for her wedding to Rocky Wilson. Rocky, so enraptured, proposed after knowing her for only three days. By her own estimation, The Goddess Bunny was the first transsexual to be married in the state of California. It was a white wedding, a Catholic ceremony; The Goddess made her own dress out of the finest satin and wore a delicate veil. However, married life was not quite the fantasy she envisioned. She caught Rocky cheating mere days after their nuptials, and not much later he went to prison. The Goddess always maintained his innocence; merely another casualty of a legal system that punishes poor people. After a decade, their union ended in divorce. The Goddess still professed her love for him, but he was ultimately not smart enough for her.

In 1994, director Nick Bougas released the biographical documentary *The Goddess Bunny*, catapulting her from underground it girl to underground star. The film included archival footage, shot by Meadmore, John O'Shea, and Keith Holland, of The Goddess tap-dancing in lingerie while twirling a parasol. She poses seductively as the camera tilts from her tap shoes to her impish grin, and the clown-shaped fascinator atop her head—a performance nothing short of miraculous. None of those involved, however, could have predicted the impact of its re-emergence online in 2006. Someone uploaded the footage to eBaum's World with a more jarring, psychedelic edit, and scored it with a distorted version of "The Itsy-Bitsy Spider." It quickly achieved proto-viral status, particularly among the new generation of countercultural youth coming of age on the internet. Rumors circulated that the video contained subliminal messages, others claimed a satanic cult in South America created it. The Goddess expressed mixed feelings about her viral fame: she adored being recognized, but neither she nor the filmmakers ever saw a dime from it.

"Do you know why I've never been on RuPaul's Drag Race? Because RuPaul is afraid to be shown up by a REAL queen!"

Further breakthroughs into the mainstream included music videos for Dr. Dre and Marilyn Manson. When she received the call from a producer about the Manson video, her first question was, *Who's she?* Although she'd never heard Manson's music, she appreciated that he was *a gender bender, like me*. The Goddess alleged connections with many top A-Listers, so celebrity never phased her. She claimed Michael Jackson personally hired her to do the prosthetics for the *Thriller* video, and she did all the makeup for *The Birdcage* and *High School Musical*. That's how she became such good friends with Zac Efron. Sometimes the verifiable details are even more incredible than her fabled accounts: A nude portrait of her by Joel Peter-Witkin hangs in the Louvre, and she lent her image to Rick Owens in 2011.

Despite her successes and legions of devoted fans, The Goddess Bunny was still waiting for her big break. Notoriety doesn't pay the bills. Frustrated by the lack of roles available to her as an actress, she recounted frequent derision from the narrow-minded Hollywood agents who refused to sign her. Born just a few decades too early to capitalize on the commercialization of inclusivity and diversity, The Goddess avowedly loathed identity politics, anyway. At times, she identified as a transsexual, at others she described herself as *a faggot with tits*. The Goddess's legal name was Sandie Crisp, but she sometimes used her birth name to audition for male roles and donned male drag to impersonate Jesus on more than one occasion. She never let her disability define her and refused to let others walk all over her because of it. When she got left at the altar in front of three hundred people, she went over to her ex-fiancé's house, climbed in through the window, and proceeded to smash every dish in the place before taking a dump on his front porch. She swore he never found her out. She wasn't supposed to walk, or tap dance, or enact elaborate revenge fantasies, or see herself as a star, but she did anyway. In yet another twist of fate, one of her polio medications contained similar components to the AIDS cocktail, allowing her to survive with the virus for decades. To call her a trailblazer feels cliche; The Goddess Bunny was a badass.

A month after our first call, we arrived at her home in Inglewood. A modest studio snugly accommodating her pink motorized scooter and equipped with all the essentials: a closet brimming with sequins, gowns, and fur-trimmed garments; her computer desk shared space with a vast collection of cosmetics; a value pack of ramen noodles sat beside her mini fridge. She was fully made up for our photo shoot, but there was more important business to attend to first. *Let's eat, I'm starving*, she insisted. She zipped off down the hallway, her silky black hair flowing behind her, tiara gleaming under the fluorescent lights like a beacon for us to follow.

At her favorite neighborhood diner, we were immediately ushered into a wood-paneled banquet room at the back, which was otherwise closed. What does a Goddess have for breakfast? Shrimp cocktail and a glass of white zinfandel. "Para la Reina," our waiter said as he served her. Dionysos would certainly approve. Although The Goddess is best known as an actress, model, and muse, her abilities as a storyteller cannot be overstated. Time dissolved into a nonlinear soup as we chatted with The Goddess about her life and career in between bites of shrimp. *Tony Danza came to see my show once. I sat on his lap and he got a boner. He still follows me on Instagram.* We snapped back into reality as the Beach Boys' "California Girls" came on the radio, and The Goddess burst into song. We came to take her photo, but The Goddess Bunny gave us a full show.

As we photographed her around the neighborhood that afternoon, The Goddess's magnetism effortlessly seduced passersby. Mothers with their strollers, ladies who lunch, men leaning out their car windows—whether they recognized her or not—were compelled to stop and pay their respects to The Goddess. She smiled and waved politely from her throne. *Just another day in the life.*

Despite her fame, The Goddess always saw herself as a woman of the people. In 2014, she ran for mayor of Inglewood. She used her platform to speak out against the criminalization of homelessness, drawing from her own experience of housing instability. Although her campaign received some buzz, and an endorsement from Rick Owens, she ultimately placed fourth in the race, netting 416 votes. She reprised her aspirations of holding public office in 2020, launching a write-in campaign for president. The Goddess billed herself as an equality candidate, the true outsider who'd listen to the people and heal our nation's deep divisions. She made frequent appeals on social media condemning police brutality, the federal response to the pandemic, and the mistreatment of actors in the adult film industry. She lacked the pedigree and the economic status required to obtain America's highest office, yet those very same factors also made her a true visionary. Her dreams were not naive, America simply lacked the imagination to see the beauty of The Goddess Bunny's reality.

In her eponymous 1994 documentary, John Aes-Nihil introduces her as "the last truly glamorous star left in Hollywood." The Goddess was always without peers. *Do you know why I've never been on* RuPaul's Drag Race? she asked us. *Because RuPaul is afraid to be shown up by a REAL queen!* There's simply no comparison.

The Goddess Bunny's death was a devastating loss, but in Hollywood Forever she remains, mere steps from the tomb of Judy Garland (there goes the neighborhood). Her memorial service occurred on Easter Sunday: another perfect day in Los Angeles, 73 and sunny. Sunflowers, roses, and lilies adorned a towering shrine alongside a framed portrait of her next to a pantsless young man, whose penis she tenderly cupped in her hand. Friends and chosen family shared their eulogies with more laughter than tears and recalled her triumphs, antics, and tales of fucking Tom Cruise and John Travolta at a bathhouse. Sandie didn't want any fresh flowers at her memorial; she preferred the less ephemeral plastic variety. A much more fitting tribute, however, would be to designate her tomb as a cruising zone, where she'd have front-row seats. Judy can watch too.

The last time we spoke, shortly after Christmas 2020, she told us that she'd just befriended the director of the CIA, a woman named Gina, and they'd met in the comments on Brad Pitt's Instagram. Gina was impressed by her genuine love and affection for Brad. *I've known Brad since he was a twink! We were both twinks!* She expressed a readiness to return to the stage and wanted us to produce a show together. *We need to find a theater where they can get me in a harness, so I can fly. And tap dance!* Her vulnerability was her power. Nobody manifested their own reality like Sandie did. She flies without a harness now.

The Goddess Bunny embodied superstardom of a caliber heretofore unseen and impossible to replicate, exempt from the traditional matrix of success and the architect of her own divinity. Her body is a temple, and once you've knelt before the altar, The Goddess will never leave you.

Glen Alen

LOS ANGELES × SCORPIO

A t the dawn of the eighties, MTV revolutionized the way youth consumed media and celebrity. *Kids around the world got the first visual of any entertainers. We never saw them besides the cover of an album, or a picture in a magazine.* Glen traces her initiation into the art of drag to the music videos of Boy George, Dead or Alive, Cyndi Lauper, and Duran Duran. *I was just a shy sixteen-year-old who wanted to put on makeup and a dress.* Emboldened by homemade suits of armor patterned after her New Wave idols, Glen pushed the limits of what she could get away with—sneaking into clubs, experimenting with drugs and alcohol, raising hell till sunrise. *You know those people that are just fuckin' born to do it, regardless of what others think? There's a piece in the brain that's just driven. I was born to take the initiative.*

Her early days of troublemaking led to Peanuts in West Hollywood, where a troupe known as the Cosmetics dragged celebrity impersonation out of the cabarets and into the club scene. *The vibe at Peanuts was very eclectic. There was joy, color, and flirtation in the air. People didn't want to look like everybody else.* Glen's first impersonations took the shape of synth-pop goddess Terri Nunn and Dale Bozzio in her "Words" era, complete with platinum hair streaked with pink and blue. By seventeen, Glen added "club kid" to her resume, taking style notes from Grace Jones, Nina Hagen, and the godmother of all party monsters: Leigh Bowery. *I loved all their bizarre looks. They were always changing.* True to the club kid ethos, she incorporated whatever materials she could get her hands on to create ephemeral fantasies. *You take the leftover scraps of fabric, cardboard, glue, and tape, and make an outfit.*

Glen completed beauty school while still a teenager and began doing hair professionally right out of high school. Over the next seventeen years she curated an elite clientele, managed a major salon, and traveled nationally as an educator. *I felt complete, I had success, but then it all started to feel like* Groundhog Day. *I gave up everything to build a career as a makeup artist.* After two decades, two Emmy wins, and an additional twelve nominations, Glen is now one of the most sought-after makeup artists in Hollywood. She painted the voguers for HBO's *Legendary*, and the Etta James impersonator in *A Star Is Born* (2018). Her latest big project is a series based on Angelyne, the "Billboard

> ## "I was born to take the initiative."

Queen" of Los Angeles. To share her knowledge and love of the craft, Glen created the Drag Makeup Academy, offering private and group classes that cover everything from facial contouring to proper glitter removal techniques.

This breadth of experience within the highest echelons of the gay arts equipped Glen with chameleon powers *par excellence.* Her roster of impersonations now includes Amy Winehouse, Cyndi Lauper, Annie Lennox, Barbra Streisand, Bette Midler, Bette Midler as Winifred Sanderson, and many more, which she showcases regularly in the *Dreamgirls Revue.* Glen's departures from reality are equally fantastic—her Instagram feed is a sumptuous feast of colors and textures used to create her original characters. In leather, studded ram horns, and spiderweb eyelashes she evokes the strength of Aries. Splattered in neon colors with a mass of gnarled rainbow weave she serves interdimensional Troll doll. As the "Redfeathered Ringleader," she appears as a retrofuturist harlequin concealed by clashing patterns that somehow create perfect harmony. Her most viral creation, "Upside Down Girl," literally turns drag on its head. Naturally, she makes all her own costumes as well; if she can dream it, she can be it. *In the eighties, we celebrated variety as the spice of life, and I've held onto that. Kids nowadays are obviously influenced by commercialism and replication. They get stuck in a look, a character, a style. It's not a bad thing but it's not where I come from.*

Glen lent her cosmetology skills to our shoot with Momma. The two met at Dragstrip 66 years back, and Momma's professionalism made an immediate impression. *Her outfits were always a complete look. Not thrown together like the rest of us ragtag drag queens!* Likewise, Momma spared no praise for Glen's talents: "I'm telling you, in LA there's no better drag queen than Glen Alen." Despite her hard-earned reputation, Glen shrugs off the praise. *I haven't seen much. There's so much out there to still experience. I'm at the beginning of my career.* Glen's clarity of purpose and eye to the future stem from lessons learned over nearly three decades of sobriety. *Getting sober is hard; staying sober is even harder. Recovery allowed me to discover my internal courage that previously I could only attain using drugs and alcohol. Courage comes from repetition of spiritual principles. Prayer, meditation, gratitude, and positive affirmations keep me in close contact with my internal courage.*

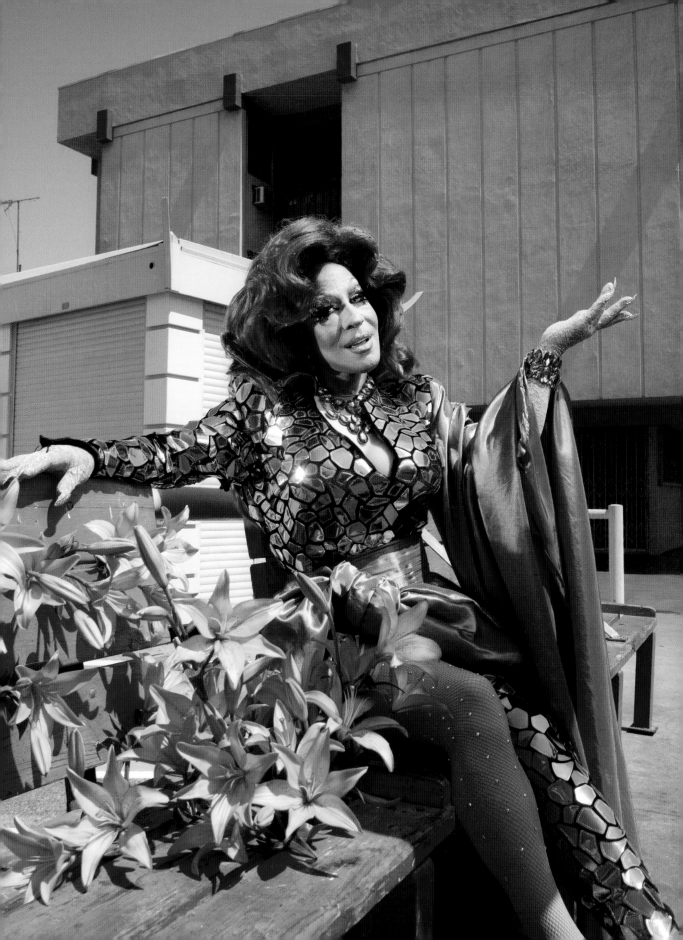

Momma

LOS ANGELES × ARIES

My friends pushed me up to the front and literally lifted me on stage. I was just terrified. Gina Lotrimin implored her, *"Tell us your name!"* I said, *"Well sweetheart, I'm old enough to be your mother."* Gina polled the audience: *"How many people think MOMMA should be in the contest?"* The contest that night awarded a $5,000 cash prize and a full year of bookings to host the monthly party Dragstrip 66. As the room erupted in applause, Momma's terror gave way to a sense of euphoria. The occasion marked Momma's first time on stage in drag—albeit *gorilla drag*—but her gift of gab and sober mindset proved a winning combination, and she prevailed in the contest. Although void of any experience in the art of drag, Momma was no stranger to bringing an audience to their feet. *I was a minister for many years, so I had no problem speaking on the mic.*

Momma's journey from Christian minister to matriarch of Tinseltown's *demimonde* is a tale of biblical proportions. *I was a born-again Christian and told immediately that I couldn't be gay. When I got caught, I was sent to ex-gay therapy, where I stayed for twelve years.* The AIDS crisis perpetuated the length of her sentence. By 1985, she lost her entire gay family. *I was all alone, stuck with these Christians. I stayed there until one day I realized everything I was being taught was a lie, and I needed to break away. So overnight I just disappeared.* Although she held few contacts outside her religious bubble, Momma scraped together an independent existence in Los Angeles. Through her Bible study group, she landed a gig as a personal assistant to a costume designer. Within two years she parlayed that experience into a position at Bob Mackie's costume house in 1992.

Despite her proximity to the godfather of drag aesthetics, Momma was reluctant to embrace the trappings of a homosexual lifestyle. When her coworkers extended an invitation to Dragstrip 66, Momma suffered a breakdown. *Within ex-gay culture, being a female impersonator is the worst thing you could ever become. "Who do you think I am, a pervert?" I had to leave work; I couldn't stop crying.* Over the weekend, Momma's soul-searching led to a divine intervention: *I felt that god was saying, "Why are you afraid of men in dresses? Men in dresses are funny, not scary." God said, "You need to go do this."*

She won the Miss Dragstrip 66 contest in a muumuu borrowed from Mackie's archives and *the rest is history*. She remained

> *"Men in dresses are funny, not scary."*

a core part of the Dragstrip family for the party's entire run, 1993 to 2013. The legendary, anarchic monthly hosted themes such as "20,000 Queens Under the Sea," "Night of a Zillion Jans," "Trailer Trash Love Shack," "Girl Gangs Gone Wild!," and "Naughty Nurses at Genital Hospital." Through the loving support and boundless creative expression she found in her new nightlife community, Momma underwent a renewed spiritual transformation. She won the Miss Temple pageant with an impassioned response to the Q&A portion: *I combat homophobia in my life by being my authentic self twenty-four seven. I'm a faggot at work, I'm a faggot at home, I'm a faggot as Momma. So I say to all of you who are afraid of being hurt: be your authentic self and find people that will support you.* Her win at Miss Temple propelled her to a hosting gig at a club called Pump run by the West Coast branch of the Xtravaganzas, Manny Rodriguez and DJ Eddie X. *Madonna would go when she was in town. It was totally a Studio 54 scenario.*

Amid all her work—*movies, TV shows, commercials, I've done all that stuff*—Momma considers her forays into opera her crowning creative achievement. Her talents were discovered in 1996 by director Franco Zeffirelli, who concocted a role just for her as a drag diva circus performer in *Il Pagliacci*, which she performed extensively around the country and at the LA Opera for two decades.

Momma felt called to channel her growing popularity into a force for the greater good and began hosting benefits for AID FOR AIDS International, which she describes as one of the few organizations prioritizing direct impact over bloated executive salaries. Over the past twenty-five years, Momma helped fundraise more than twelve million dollars for AIDS, breast cancer, and teen suicide prevention organizations. *Out of fear, I found my life. I found a way to help people live in their time of crisis. I'm just grateful I've been able to do something to help others, 'cause you know how messy most drag queens are!*

By embracing her inherent multiplicity, Momma abolished her fears and self-doubts. *I've always been a two-souled person, but never realized it. As much as I'm a male and love being male, I really do have this female side that always spoke to me and to the justice I'm always wanting. Momma is a great name for me because I always take care of people. It's nice to be nice. Wouldn't you like to live in a world where other people felt that way?*

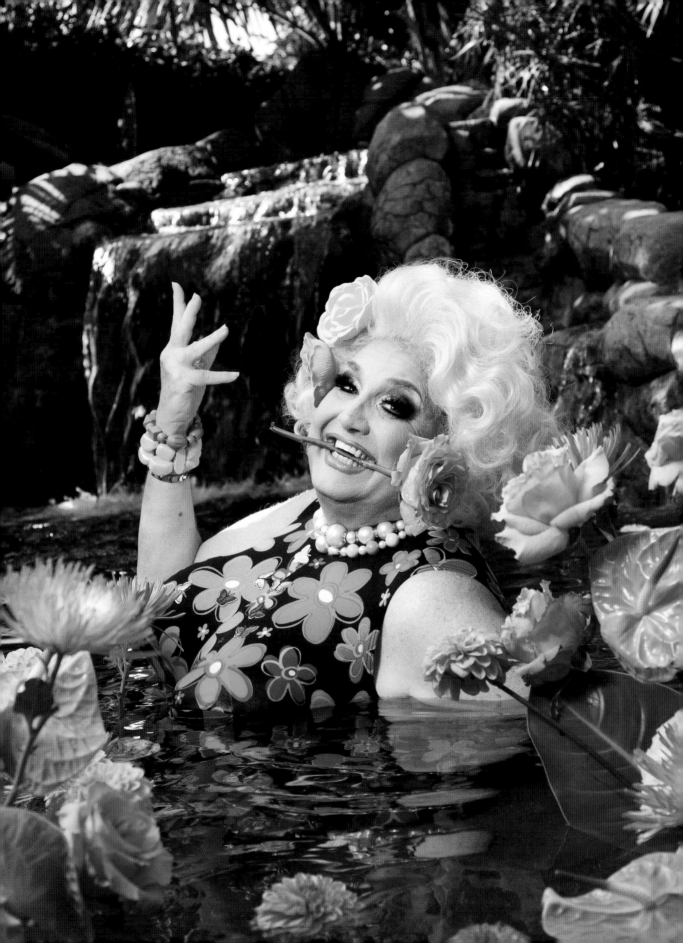

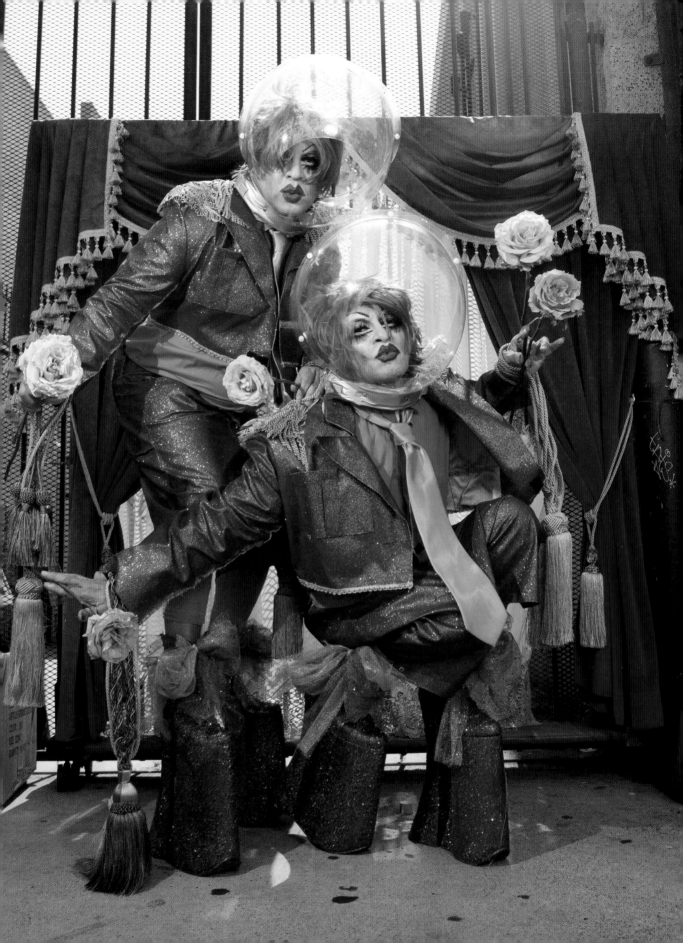

The Fabulous Wonder Twins

LOS ANGELES × LIBRA

That shoot was a dream come true. After seeing the blue suits in a dream, they commissioned their friend Merlin Castell—*one of our favorite designers; very space age, from another planet*—to create the costumes. If they selected their attire from the dreamworld, they suggested the Fabric District location for nostalgia's sake. *You know, there are a few of those fabric stores where the owners love to get their hands on some of them trannies. In the early nineties girls would go flirt with the owner or someone working alone. The guy comes onto you, and you end up in the back office with him. Friends, waiting in getaway vehicles, run in and run out with all the fabric while the one queen gives the man a blowjob.*

Born Louis and Carlos, fifteen minutes apart, the twins share a lifetime of shenanigans. It all began during their early childhood in El Salvador. *At the tender age of five or six, we snuck into the circus that came to town.* There they witnessed a performance by a burlesque dancer called *Piel Canela*. *With the lighting on her, everything was shining: her makeup, her wig, her costume, her heels, everything. She captivated the entire audience. We said to ourselves, "Oh my god! When we grow up, we want to be her." We've been doing this ever since.*

We were transplanted to Monrovia, California, in the eighties, at the age of eleven. Acclimating to a new culture, the twins relied on one another. *When we first moved to this country, we didn't know English, so we developed this weird language to communicate to each other in coded words. Throughout high school we began to experiment with our own little fabulous creations.* The pair took notes from Boy George, Nina Hagen, Pete Burns, Grace Jones—*and Divine, of course.*

In our view we were the cool kids, all dressed up, long beautiful hair. But people called us faggots and all sorts of names. After their picture appeared in the school paper, *someone put some nasty fliers—"NO AIDS IN HIGH SCHOOL"—on the walls all over the school.* One day walking home someone shattered their Culture Club record on the ground. *It was really horrific, but we were determined and unstoppable.*

At fifteen, they started hitting the underage clubs: Grand Central Station in Pomona, Marilyn's Back Street in Pasadena, the Network in Glendale, and Arena in Los Angeles. *There we met other fellow weirdos, a gathering of fabulous people. We felt at home.* They put together outfits inspired by anime and superheroes, *but always with a super gay kinda look. We'd show up at the nightclubs*

> "...very space age, from another planet..."

wearing bodysuits with laser guns. We knew how to accessorize, let me tell you that! Thus the Fabulous Wonder Twins discovered their superpowers. *Drag is all about empowerment. When you put on a wig and some makeup you feel so powerful. People enjoyed coming to our place—the Fabulous House of Wonder—to get dressed up every night of every weekend.*

Through the nineties the pair traveled to Spain—to party with Pedro Almodóvar, Lola Flores, Alaska from Fangoria, Rossy de Palma, and Carmen Xtravaganza—and also to New York to revel alongside Michael Alig, Richie Rich, Amanda Lepore, James St. James, and Susanne Bartsch. They recall a sense of family among the club kids. *We always felt like we belonged. Picture it: the Limelight, Disco 2000, packed with nothing but fabulous creatures. It was just amazing. You could be anything and didn't have to buy expensive outfits. You could put on plastic bags and look fabulous.*

Michael was the glue that kept things together. When all the drama was taking place, we went to Spain for a while. When we came back everything was different. We stopped going to NYC and stopped going out as much in LA. In both cities the nightclub scene changed. It became all about bottle service and being seen. Michael was in jail and other people were totally gone or not willing to go out. The pair dislike *Party Monster* (2003) because they disagree with Michael's portrayal. They remember him as *a sweet, caring, and loving friend. When our mother died, he took the time to send us flowers and a card.* He filled every space on the card with kind words. *The movie demonized him. People who didn't get to know him have the wrong impression.* The twins set the record straight in *Glory Daze: The Life and Times of Michael Alig* (2015).

The twins lend their otherworldly visage to a wide range of media. They've made several onscreen appearances, including *Jerry Springer*, *The Drew Carey Show*, *Beverly Hills 90210*, and *The Birdcage* (1996). They also make cameos in several music videos. *Our favorite was Diana Ross's version of "I Will Survive." People say to us, "You helped pave the way for other club kids and drag queens," but we didn't see it that way. We were just having fun and being fabulous. The phone kept ringing and our bank account kept growing.* The twins continue to explore new media, despite encountering recent censorship on TikTok. *One of our friends showed a little too much.*

Vancie Vega

LOS ANGELES × SAGITTARIUS

Vancie sat impatiently in her friend's bedroom, eager to see her face transformed by the pigments and powders procured from the most sacred aisle of the local drugstore. *I was astounded at how much I looked like a woman when she did my makeup.* Immediately, she felt compelled to enact her new persona upon the world. *I went out and walked her dog, and her neighbor tried to pick me up.* At just fifteen she began sneaking into Robert's Lafitte, the oldest show bar on the gulf coast of Texas. *It was old when I started doing drag in '86. I think they still smoke inside. After my first performance, it all hit me like a ton of bricks: the show, being dressed, the response from the audience. I knew without a doubt I was supposed to be on stage. It will be thirty-five years this year.*

She continued performing at Lafitte's until a bitter older queen ratted her out for being underage. Undeterred, she set her sights on the larger clubs in Houston, where she met the Fabulous Four and befriended Tasha Kohl. *I first came onto the scene when they were performing at Rich's, a massive disco. You couldn't get in or out of the dance floor; it was packed wall to wall.* The more competitive landscape in Houston propelled her to prove her stripes within the pageant arena. Scandal ensued when she won Miss Houston, a preliminary to Miss Texas USofA. Although she earned the crown through genuine talent, at just eighteen years of age she required falsified credentials to gain entrance to the pageant. *I altered a photocopy of my birth certificate and got an ID from the DMV that said I was twenty-one.* A "concerned citizen" wrote in to a local periodical denying the legitimacy of Vancie's win, spurring a series of op-ed rebuttals. Thankfully USofA owner Jerry Bird entered the fray in her defense, and she kept her crown. *Of course, they all knew, but I had the fake ID so they couldn't do anything about it.*

As Madonna's "Vogue" shook the world in 1990, Vancie increasingly garnered comparisons to the singer. She took the compliment and ran with it. Her budding impersonation caught the attention of a visiting cast member from La Cage in Atlantic City, who encouraged her to submit a tape to the show's producer. *I got an audition, went to Vegas, and got the job on the spot. That's my claim to fame, I was the first Madonna impersonator on the Strip*, a point of pride to this day.

While in Vegas, Vancie also performed in *Boy-Lesque*, helmed by the original queen of Sin City, Kenny Kerr. *Kenny was my mentor for most of my time in Vegas. He taught me how to be quick-witted, how to read an audience and make fun of them but also self-deprecate so it's an even playing field. He taught me how to character study, own the stage, be part of an ensemble, and how to believe in myself.* Vancie's first appearance as Dolly Parton occurred on the *Boy-Lesque* stage, after the regular Dolly called out one night. Inspired by the uproarious audience response, she dove deep into character study, and Dolly has since become her most popular impersonation.

I do her authentically. I don't do it over the top. I never allow anyone to tip money in my cleavage. It's not a joke or a caricature, I find that very offensive. If you want to impersonate someone, make them proud. Do it with honor. Although Dolly Parton herself is too egalitarian to declare it publicly, Vancie knows that she is Dolly's favorite Dolly. *When I met her, I said, "Thank you for my career!" She responded, "Honey, thank you for MY career!"*

As much as Vancie puts into her masterful impersonation, the character gives back to her in return. Regardless of whatever struggles she may be going through offstage, impersonating Dolly means channeling the boundless joy that she embodies. *One thousand percent of the time it turns my spirit and emotions around. It fills the void, and I'm no longer bankrupt spiritually or emotionally. While I do her, my well is full and overabundant with joy.*

The past ten years brought renewal, triumphs, and reckonings. After decades of addiction stretching back to her teen years, Vancie achieved sobriety in 2012. *I found my way back to sanity.* She rebuilt her career and emerged victorious at Miss Continental Elite 2013, but discovered the title did not guarantee acceptance or gratification. Her drag mother Whitney Paige offered sage advice: *"Baby, the only person you can count on is you. This is a dream YOU had—it's up to you to make it a happy one."* In 2018, Vancie relocated to Southern California, and reports she's never been so fulfilled in her personal or professional lives. She's ready to seize opportunities on stage and screen, but even as a triple threat she remains unfazed by the consequences of wider exposure: *Fame and popularity are not real. Human beings made it all up. Remember that!*

> ## "My well is full and overabundant with joy."

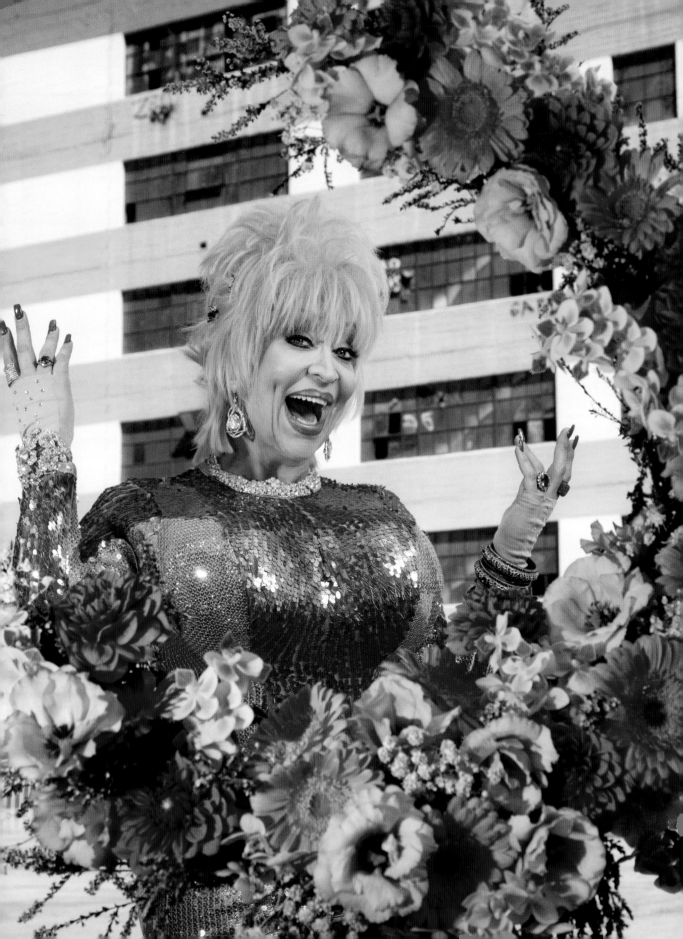

Fontasia L'Amour

LOS ANGELES × **SAGITTARIUS**

What am I known for? Well, I can only say what I hear. Most people refer to me as a glamour queen, or as the queen of dramatics. Fontasia masterfully delivered the drama on the set of our photo shoot and came prepared with special effects: of our eighty-one models, she was the only one to bring her own leaf blower. As a superlative pantomime artist, she executes monologues, ballads, and high-octane production numbers with equally flawless precision. *I'm blessed to be able to do a whole lot in the industry*—spoken with the confidence of a consummate professional and the finesse of a prolific pageant champion.

Fontasia possesses a soft natural elegance but keeps her focus razor sharp. *I've always had this tenacity and passion up under me to go for my goals. I know things happen for a reason and everyone has a season.* One particular goal eluded her for over twenty-five years: a national crown at Miss Continental. The pageant's appeal endures due to its *standards of excellence, and integrity.* She competed fourteen times, starting in 1990, including nine years consecutively. *Every year I did not prevail, I knew that it wasn't my time, but I never gave up.* With each renewed attempt, her talent presentations displayed an endless arsenal of showgirl magic. She employed dancing men in gold suits to lift her through the air, created costumes that transformed into set pieces, engaged in stage combat, wore three-foot-tall ostrich feather headpieces, narrated a stripped-down armchair soliloquy with only a box of Kleenex, and even delivered a personal devotional to Continental founder Jim Flint. Her efforts frequently earned top marks in individual categories, and she placed first or second alternate a total of five times.

In 2016, she took a step back to realign. Between her annual Continental campaigns, she entered Miss Wessland, a newer pageant with a growing reputation. Fontasia calls Wessland *family oriented; they're always behind you no matter what, even after your reign.* She emerged triumphant, reinvigorated, and fixed her crosshairs on the white whale once more. This time around, her talent featured Beverly Todd's fiery monologue from *Lean on Me* (1989) mixed with Anastacia's new millennium hit "I'm Outta Love." With a twirl, she shed her schoolmarm wrap dress to reveal a cobalt-blue fringed bodysuit. Flanked by four dancers, Fontasia's high kicks thrust over her head, emanating power to the very tips of her toes. As she leapt into a split the audience leapt to their feet, garnering a standing ovation

> ## "You have to do you and embrace who you are."

mid-performance. She cracked the code and earned her crown: Miss Continental Elite 2017. *After many years, and much sweat and tears—the physical, financial, and emotional investments have been worth every single moment. Every single day, and every decade.*

Each time I won a national pageant, it's when I finally decided to do what I want to do. I'm gonna do me. In this industry you have so many people who are in your ear. You listen to that and you're influenced by it, which is one of the things that got me started in drag. But at the end of the day, you have to do you and embrace who you are. Because you can sell yourself better than anybody else, rather than try to emulate something you're not.

Fontasia is eyeing one more pageant: Miss Black Universe 2022, but she's also invested in nurturing the next generation of pageant royalty. *I love it so much I still want to be involved in some capacity, but I'd rather help others who have the same kind of passion I did when I started. I've been judged many times. I learned from my own mistakes.*

Despite the long road to her coveted title, Fontasia counts abundance among her blessings. She currently reigns as the longest continuously performing cast member of the *Dreamgirls Revue*, Southern California's longest-running female impersonation show. *Everyone knows who a Dreamgirl is.* After a near-death experience, her *Dreamgirls* sisters threw weekly fundraisers to pay her rent while she was unable to work. *Having family here physically, it really has kept me very very strong. My devotion and my dedication to* Dreamgirls Revue *is insurmountable. I can't even weigh the amount of appreciation I have.*

When gigs dried up during the pandemic, Fontasia's lifetime of web weaving caught her once again, as she embarked on her 2021 Hott Summer Tour consisting of over twenty dates in nine cities. *I got on the phone, and I managed Fontasia. I took care of everything myself. Completing all of that made me realize, I'm feeling confident and validated as an authentic entertainer who has greatness on their own merits. Without a manager, without being on a TV show. It was just my name and my history of being part of the industry. I'm very proud of the tour.*

Her vast constellation of love and support extends beyond our earthly plane. In her abdication speech at the conclusion of her Continental reign, Fontasia shared that she draws strength from drag's *fallen angels, gone far too soon. But they all live within us and through us. Thank you for the legends, the legends who gave birth to Fontasia L'Amour.*

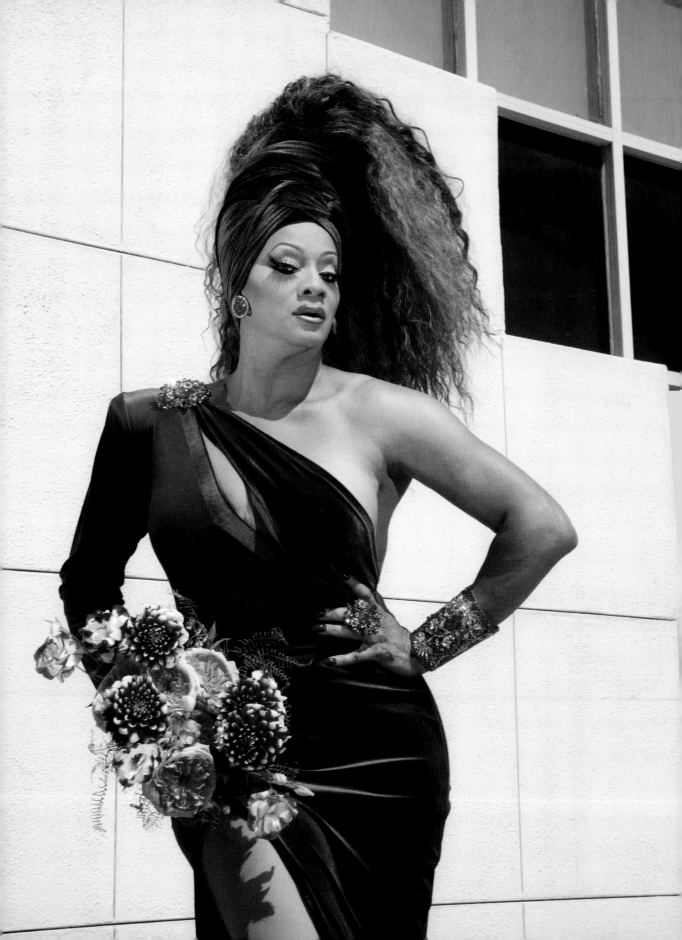

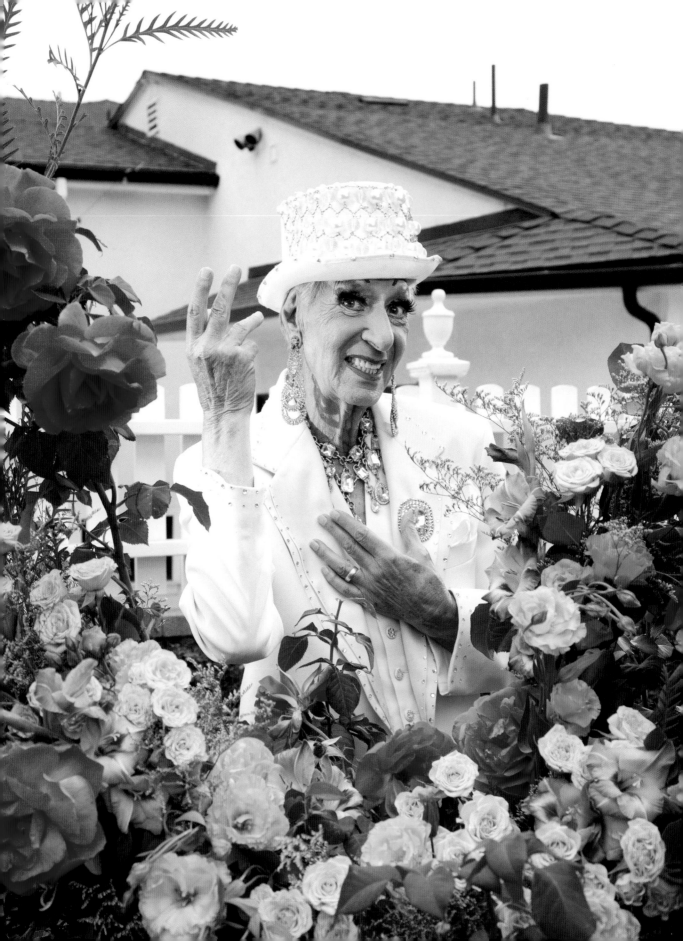

Gypsy

LOS ANGELES × AQUARIUS

At the age of ninety, Gypsy shows a spry and undiminished enthusiasm for—as well as an unrivaled catalog of memories from seventy years in—show business. As she told *Repeller: I was in New York for Stonewall and in LA for all the AIDS horror in the eighties.* Those riots in New York and the onset of that plague bookend the gay liberation movement. Gypsy recommends periodizing her almost unbelievable life (were it not so well documented!) by decades. She studied dancing in high school in the forties. *There weren't a lot of boys dancing in those days; maybe three of us in the ballet class.*

Her professional career began in the fifties when she landed her first job dancing in the chorus of a Broadway musical, which is where she picked up her name. During that era, casting directors used the word "gypsy"—a pejorative exonym for the Romani people—to categorize the chorus boys and girls who traveled with the musicals. It signified the precarity of gig work and of life on the road. *They called us "gypsies" because we lived from show to show.* Indeed, she spent that decade traveling the country, eventually also crossing the Atlantic to tour Europe. Life lived in motion takes a corporeal toll. *My dancing career came to an end in my thirties—my body wasn't well tuned.*

Some people came to me in New York and asked if I'd headline a cabaret and use my name for it. Thus she became the face of her own club through the sixties, with all the intrigue and danger that that entailed at the time. She kept house pianists on staff and equipped all three of her singing bartenders with their own spotlights and microphones. As proprietress, she delivered her performances from an elevated stage. *I didn't do drag, but for campy reasons wore a tux and high heels. I sat up there and created situations such as my version of* Carmen *or* La Bohème. *Famous people from the opera world came to see me.*

I closed the club in 1978 and came back to LA to retire. Vivian Blaine, of *Guys and Dolls* fame, brought Gypsy out of retirement by inviting her to the opening of a new club in Hollywood called La Cage aux Folles—*named after the movie but before the musical*—where she spent the 1980s hosting dinner theater. *I always got a list of the famous people in the audience. Lana Turner followed me everywhere.* Gypsy once answered a knock at her dressing room door, *"Who is it?"* and heard, *"Never mind who it is—don't*

mention I'm here," in response. The mysterious visitor turned out to be Madonna in a black wig and shades. *She looked like Elvira!* The Queen of Pop stayed for the queen impersonating her and then slipped away again. On her days off from La Cage, Gypsy opened for Joan Rivers and played backgammon with Lucille Ball. She remembers those as years of love and tragedy. She found her one real romance then but recounts: *The most beautiful stars of La Cage died of AIDS.*

A testament to midlife reinvention, her filmography began at age fifty-two when Mel Brooks invited her to appear in *To Be or Not to Be* (1983) over drinks at La Cage. *I didn't do drag per se until I was fifty.* She previously always referred to herself as "Mastress of Ceremonies." *I found it amusing that people thought I was a drag queen—that's very much gilding the lily. Drag queens are glamorous and beautiful, but I'm none of those things. My clothes were, but I wasn't.* Indeed, Bob Mackie still can't figure out how she got six of his gowns. *Two went to a museum but they won't show them until I tell them the provenance. The person who gave me those gowns is still alive, so I won't divulge that.*

When La Cage closed in 1991, she took up her travels again, touring Florida, South America, Europe, and Russia with a New York production company. Upon her stateside return, Dan Gore called, asking, *"Are you still working? Are you still alive?"* Gypsy answered affirmatively and accepted the starring role in the Carnival Cabaret at the Horizon Resort in Lake Tahoe. *He asked, "Are your gowns back from Europe? Ship them here, and I'll send you the contract." I spent twenty years with him. That took me to Oscar's in Palm Springs, and that's how I got my star on the Palm Springs Walk of Fame.* Our star certainly earned the recognition. To date, Gypsy has appeared in 126 television shows and over 20 films. She graced the screen most recently as *Miley's dominatrix* in the music video "Younger Now"—*we became friends, she was very sweet to me.*

Gypsy considered Divine a dear friend as well. She attended the wrap party for *Hairspray* (1988) three doors down from La Cage. *That's where Divine made the announcement of her upcoming role on* Married . . . with Children. *I saw her Friday and she was found dead Monday.* Gypsy ultimately took up the role of Uncle Otto on the show, fulfilling just a bit of her friend's unfinished business.

> *"The person who gave me those gowns is still alive, so I won't divulge that."*

Love Connie

LOS ANGELES × SAGITTARIUS

We shot with Love Connie at the In-N-Out on Sunset Boulevard, where prior to the pandemic, she could be found four times a week. A bayou-raised girl, she's lived in Hollywood for twenty-three years. Her extroverted and comedic style made quite the scene on the sidewalk that summer day. *You're just not going to get glamour from me*, she assured, but we beg to differ.

She believes in a strong character as the basis of any comedy routine. Such a character needs to be funny, whether in a dumpster or on a Parisian runway. *I've established enough of a look and a pop culture that people see who I am.* Connie stays true to her trademark blend of camp and high-octane antics. A champion for working women, she wears over-the-counter Revlon. Her character draws on a number of archetypes: Bond girls, Charlie's Angels, Playboy bunnies, the female leads in Brian De Palma films, babes in nineties music videos, vigilante Farrah Fawcett, go-go girls, Dallas Cowboys cheerleaders, and of course the "final girl" horror trope.

She borrows especially from the regional beauty queens. Connie recounted one particular Texan pageant called Miss Stockshow—*where you brought your prized heifer and prized sow. There were always a few really ramshackle country girls. I'd see them and see Carrie White from* Carrie *and think to myself "Girl, let me put some lipstick and hot rollers on you!" If I was a girl, I could have won a few of those pageants.* It turns out you *can* put lipstick on a pig.

These influences, combined with her background in sketch comedy, allow her to deliver on-the-spot drag. She calls her drag *rough around the edges*, but it's also endearing and of a childlike nature. She's not that innocent, though. When we spoke during quarantine, she confessed: *I'm so horny, I miss everything!* More than anything to come in *that whole new world thing*, she looks forward to the reopening of glory holes, perhaps well-stocked with hand sanitizer, as a pandemic-friendly sexual activity.

She took the time at home to install a new, much-needed drag closet in her cozy Hollywood apartment. That apartment greeted us as a maximalist shrine to two decades in Hollywood. Besides an impressive collection of blond wigs ranging in style from Farrah to Joe Dirt, she displayed a sizable collection of film ephemera. She gifted us a VHS tape of *The Goddess Bunny*

> *"If you're not the prettiest, get that body or learn to dance."*

(1994) and a bootleg *Videodrome* shirt. We complimented a large Debbie Harry poster and she explained Debbie's singular influence on her work.

Growing up, Connie loved Debbie's voice and the melody of her songs. She heard her music before ever seeing what she looked like. Her first vision of Debbie was informed by a report back from her best friend who'd stayed up late to catch her on television. *Even before the description I knew this was the pop artist for me.* That Debbie was a Playboy Bunny only intrigued her more. *Debbie proved you could make it in your thirties, despite people giving her a hard time for it. And she's still going today!* Connie admires that longevity and also Debbie's otherworldliness: *I loved that she was odd, an alien rockstar like David Bowie or Björk, as if from another planet.* Connie finds that oddness refreshing and fantastic.

She spent the pandemic resting, developing an addiction to blueberry Red Bull, and sampling fast food delivery. She tried out a shelter-in-place workout show—"Connierobics"—inspired by the twenty-minute workout videos of decades past. For the show, she drew on her background as an aerobics instructor to find a way of entertaining others with personal benefits. She ultimately realized, *if you want me, you have to see it live.* Other than this, Connie resisted performing in virtual shows. She believes her large expressive character plays better on a stage than it ever could on a screen.

Connie returned triumphantly to the stage in "Live from Conniewood" at the Cavern Club Celebrity Theater in August 2021. She described that theater as her true performance home. Her debut on Friday the thirteenth proved to be auspicious: the show sold out and so did the entire opening weekend. She captioned a video from the evening: *The art of pacing yourself in your 50s but still acting as if you're a preteen.*

To the younger queens, she encourages finding one's own talents and uniqueness. *If you're lacking in one area, accentuate another. If you're not the prettiest, get that body or learn to dance. If you can sing, sing. Do what you're good at but don't be afraid to fail.* She also warns: *The years will fly by and then all of a sudden one day you'll look in the mirror and see Connie staring back at you and say, "Oh my god!"*

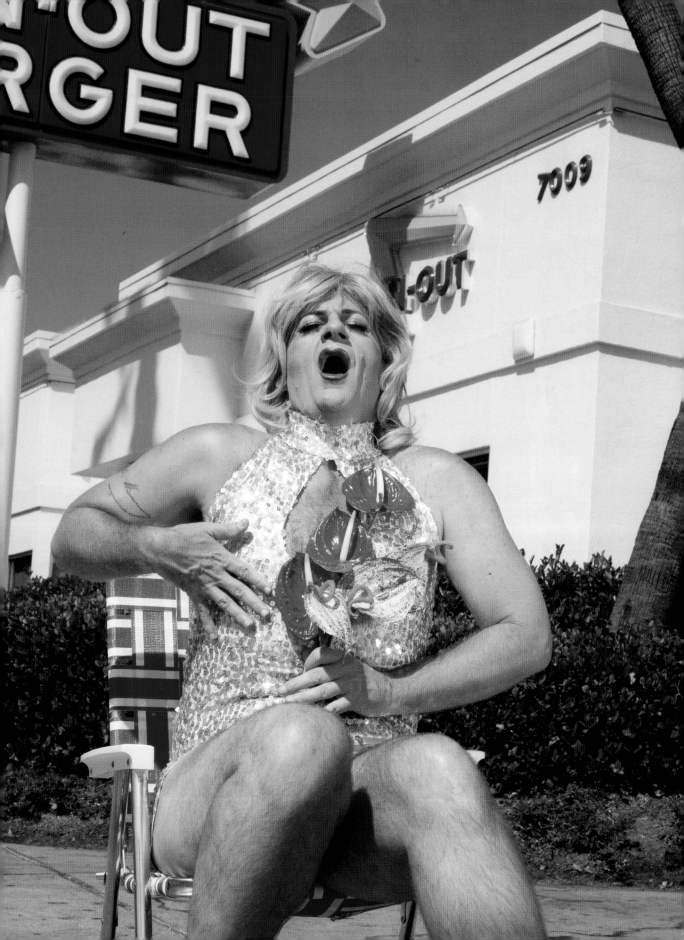

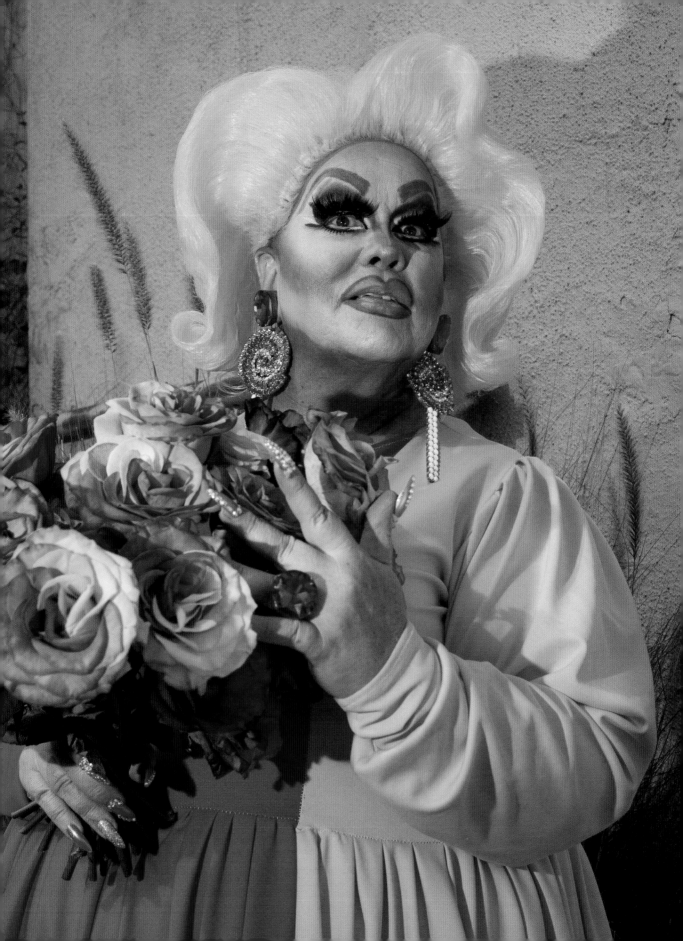

Psycadella Facade

LOS ANGELES × CANCER

Psycadella Facade took her name from the soundtrack of the 1968 sci-fi camp classic *Barbarella*, starring Jane Fonda. *I came home at 3:00 a.m., drunk from a night out, popped in the movie, and the rest is history.* Her fully styled name is Princess Psycadella from the Lost Land of Color of the House of Facade. *Back then in LA you had to belong to a house; if you didn't belong to a house you didn't perform.* So, alongside her friend Madame Allegra of the Land of Shade, she formed the House of Facade. *When we booked gigs, we'd say we were the House of Facade. There were only two of us, but they didn't need to know that.*

Between her sculptural wigs, maximalist makeup, and bejeweled talons, she truly strikes a vision from some other polychromatic dimension. She commissioned the custom tricolor dress she wore to our shoot after she saw it worn by Kelly Clarkson on *The Voice*. It wasn't so much Clarkson's celebrity that inspired Psycadella, but rather that the colors match the pattern of the pansexual pride flag.

Psycadella's drag benefited from the example set by a couple of formative queens, namely Chi Chi LaRue and local legend Pauline St. James. Chi Chi always had pointed feedback to offer Psycadella when she started out. Pauline epitomized the glamour to which Psycadella aspired. Psycadella saw Pauline perform every Monday night, in a show that also included Dolly Levi. During each opportunity to see Pauline, Psycadella would gaze on in admiration and think to herself, *That's who I want to be. That's me. The gowns, the jewels, everything. You couldn't touch her. Back in the day, if you were a St. James, you really were somebody.* She described the pride in seeing their photos side by side and realizing *I became the person I wanted to be. Drag is a facade; it's what we do.*

More than any other drag inspiration, Psycadella gives a singular place to the notorious Divine. If Pauline brought the glamour, Divine gave the attitude, which Psycadella certainly emulates. Psycadella saw her perform in LA just a few weeks before her untimely death. Never afraid to shatter conventions, Divine broke a table at that performance. Psycadella daydreams about a timeline where Divine had lived to portray her unfulfilled role on *Married . . . with Children*; she speculates we might

> ## "I became the person I wanted to be."

have gotten *Divine's Drag Race* instead of *RuPaul's* if the former's star had continued to rise. She speculates that in that alternate reality there would be even more support for wild performers and divergent forms of drag currently underrepresented on the screen. *There is so much more to drag than what you see on television.*

Known as a friend of the friendless and a mother to all, Psychadella humbly accepts the titles. In fact, she currently claims eight drag daughters, a small crew of whom came as her entourage to our shoot. As a Cancer, she takes her maternal duties seriously. *I'm going to do whatever I can for them: emotionally, financially, however I can help.* Psycadella helps them prepare for and promote their shows, lines up work opportunities, and isn't afraid to share where she buys her most treasured pieces. The support flows both ways. When her father died, a number of queens (including Delta Work, whom Psychadella mentored through her *Drag Race* process) attended his funeral to hold Psycadella in her time of need. She's proud of her children. About her daughter Moanalot Fontaine she says, *When I first saw her I thought, "That woman right there is everything; that's a diva!"*

Her daughters and granddaughters encourage her to take the opportunities life lays before her. They talked her through her hesitancy before our photo shoot. *They are the ones who push me the most. I wasn't sure if I should do it, but they told me, "You're doing this no matter what."* We're grateful for their insistence!

She's shared a stage with stars like Cher and Madonna, but Psychadella says she's more interested in charity than celebrity. Her charitable work extends beyond her drag family, including a long-running show at AltaMed Health Services, which she cites as a highlight of her drag career: *We had no budget, we bought our own microphone, we performed outside in the courtyard, and people could come get tested and access information about their community programs.* Families and kids attended the 7:00 p.m. show and always left entertained and enriched. She also organized monthly shows for the residents of a hospice center, raising money to buy them televisions or whatever else they needed. Her ethic of reciprocity, which she inherited from her mother, is not just a facade—it's a foundation for her community.

Sir Lady Java

LOS ANGELES × **LEO**

After a life headlining shows and making headlines, Sir Lady Java has become more reclusive in recent decades. Where once this star wandered, like the lion-drawn chariot of the Tarot, seekers must now come to her, seated like the High Priestess or the Empress. Our initial efforts to contact her proved fruitless, but in a moment of pure serendipity, she happened to call and invite us over just as we arrived in Los Angeles. Her retinue greeted us at the gate: Lori—*she's my girl, she takes care of me, she knows everything*—and her faithful guard dogs—*Poodle and Pomeranian.* She's divinely protected as well. *All my life I've believed in god. All my life, I pray to him.* Glass angels, spread through her home, attend to her as well. Light filters in through the diaphanous silk curtains, giving the whole interior a pink glow. Prismatic beams bounce from the intricate bejeweling on a wide array of surfaces: plumbing fixtures, light switches, mirrors, picture frames displaying portraits of Java through the decades. A breakfast nook—booth seating on either side of a table dressed in iridescent pink vinyl and beaded fringe, electric candelabra, urn overflowing with plastic grapes and an ornate doll—waited all set for tea, but Java entertained us in the fur-detailed front room.

I'm eighty, child, that's not to be played with. It's important to know our history. That's why we're here, isn't it? Lori laid out binders and boxes containing the archive of Sir Lady Java's illustrious career. That priceless collection includes countless photographs of Java with the people she's known: Richard Pryor (*he was a friend, used to come over to my house to see me*), Jackie Shane (*Java clocked her immediately*), Linda Hopkins (*a star out of New York*), a queen named Stevie (*she liked to dress from time to time; liked fucking the boys*), Miss Dakota, Lena Horne, Redd Foxx, and many of her younger siblings (five brothers and a sister). Piles of ephemera, sporting full-bodied portraits of a scantily clad Java, promote shows at different clubs throughout the sixties and seventies. One advertisement calls her "The Prettiest Man Alive!" Some take on an incredulous tone, but

> *"I didn't choose this life, it chose me."*

Java doesn't mind. *Those pictures don't mean as much to me as they would to someone else, because I lived them. As long as I was beautiful, it didn't seem to matter. Look at me here!*

My mother worried and worried about me. She asked me, "why do you choose this life?" I told her, "Mother, I didn't choose this life, it chose me. I've always been thinking about boys, even when I was seven or eight years old." At that same age of eight, Java arrived in Los Angeles by train with her family, relocating from New Orleans. A few years later a chance encounter outside a market at Western and Santa Barbara initiated Java into the life.

I was twelve years old. I was coming out the grocery store and I noticed this woman had on a dress but there was something about her. She walked funny. She didn't look right. She passed by me and she said, "Hi, cutie!" and I said, "Hi, are you a man?"—"What makes you ask me that question?" I said, "There's something about you . . ." She asked *"Well what is it?"* and I replied, *"I don't know, but there's something about me. I feel like you but I can't be you. I have to be me."* She said to me, *"Oh cutie, you have to come by and see me and I'll tell you everything."* Oh I couldn't wait, I went to see her the next day.

Java began gracing the stage at nineteen, taking inspiration for her name from one of her many admirers. *He said, "You look like java: deep, dark and delicious." I asked, "Java?" and he said, "Yes baby: java, because you grind so fine."* He blew a kiss and started laughing, and I started laughing and before you know it, it was my name. *The first time I went on stage, they had to help me off and walk me to the dressing room where I wouldn't cause a disturbance with the people drinking liquor.* Java honed her force of persuasion to secure herself spots on stages throughout the city.

I called a club I wanted to be in and I told the owner I was a female impersonator. He said, "Well we don't hire people like that here. People like that don't come in our club." I said, "I don't draw people like that. The people who come to see me are all straight." He hung up on me, so I went down to see him and talked to him for an hour. He hit on me and everything, saying, "Oh, you're so pretty!" I told him, "I'm the man you hung up on." He demanded, "Who are you?" and I

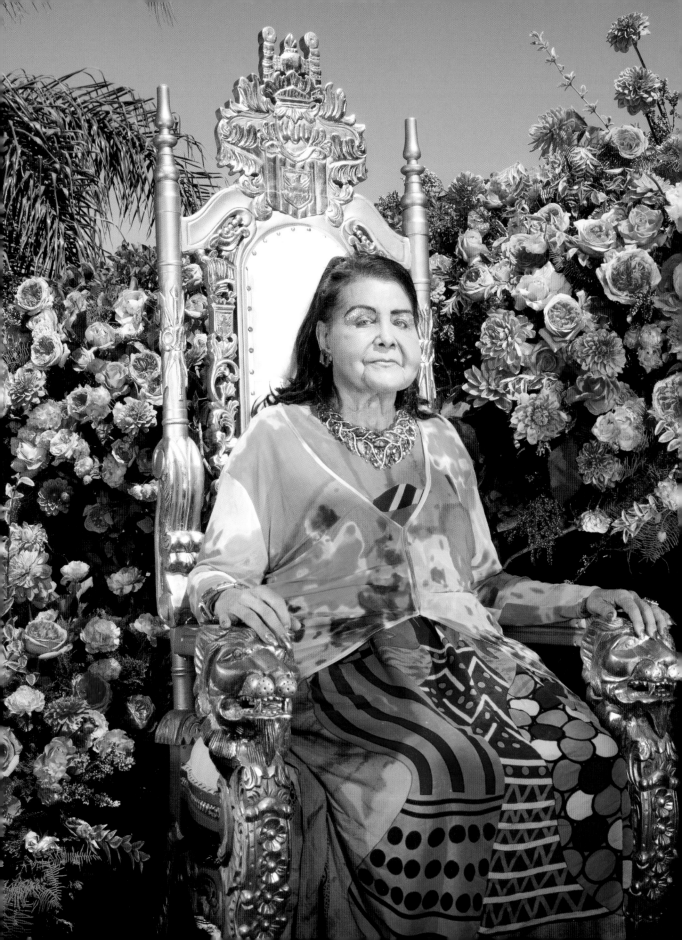

replied, *"I'm Sir Lady Java."* *He got off the barstool and I thought he was gonna hit me. He went into his dressing room and closed the door. I got ready to leave and was almost at the door when he came out and said, "I got over my madness that you fooled me. When do you wanna start?"* Once he agreed to publicize her show as widely as other clubs had, she signed on to appear. *I was always the headliner. He had more people at his club. He had never had people dressed up like they were when they came to see me.*

Java reports she exclusively performed for straight audiences. On the rare occasion gay people came to see her, she'd invite them onstage to show her gratitude. *People came out and they couldn't believe me. I always came out in a beautiful cape with a headdress on.* She'd open the cape to reveal a bikini, inspiring the crowd to "ooh" and "ahh!" *I twirl around and the cape hits the ground and they scream. I take off the headdress and my hair would fall down. Some people would run out of the club. It was shocking. I sang popular ballads and the blues, and danced and did comedy—I was very good at comedy. People used to laugh.*

Java's incredible appearance inspired drama at times too. *Once a man yelled, "I think you're lying, I know a woman when I see one!"* He demanded to see the club owner, who said, *"I couldn't put this on if it wasn't true. I told Java I would not let her on this stage if she could not show me proof that she was a man."* Java obliged that owner who, recounting the proof, proclaimed to the whole gathered crowd: *"Goddamn it, I don't care what she is! I like her a little bit myself."*

Fliers from the archive announce Java's return from traveling the country and touring internationally—"Sir Lady Java is Back!" and "Direct from an extensive tour of Canada and Mexico . . ."—with a seven-piece orchestra, "Sir Lady Java's Six Million Dollar Band!" When our hometown of Milwaukee came up, she shared the tale of performing for Frank Balistrieri there. *He wanted to open a club for me in Milwaukee. I didn't know he ran*

"... someone had to say something for us."

the mob. Balistrieri ensured she always received his protection and the best treatment in Milwaukee, but Java encountered trouble elsewhere on her travels. A man once challenged her belonging on a then still segregated train.

I have Black blood in me: French, Indian, and Black. This man looked at me and said, "What are you?" and I told him and he said, "Oh, you can't be here!" I told him, "Mister, I have too many clothes and I'm not bothering anybody, so why don't you let me stay?" When he insisted, Java refused to move and told him to go get the conductor. The conductor happened to know Sir Lady Java, and came to her defense: "Don't you bother her, she's an entertainer and she's a legend." The man left her alone. *I was just happy he knew me, even at that young age.* "I don't only know you," the conductor said, "I've been to see you at Memory Lane Supper Club!"—where Java began performing at age twenty-one. A flier for Memory Lane gives the address at 2323 W. Santa Barbara and bills Java as "The World's Prettiest Female Impersonator!"

Java gracefully bore the burden of her designation as the world's prettiest and used the mixed blessing to great effect. *Someone had to be at the top, someone had to represent us, someone had to say something for us.* That visibility made a target of her, but she views the challenges as unavoidable. *Look at the other girls and look at me; I look so different.* Even sitting, she stands out. *People say most impersonators sit on a seat different than a woman.* Java surely sits upon thrones like she's born to them. *I have a chair made like a throne with a high back and rhinestones on it. At the sides, each arm is the head of a lion. Leo.*

Enthroned and flanked by lions, Java bears a striking resemblance to ancient depictions of the goddess Kybele, the mother of the gods who receives supplicants to her sacred grove in the mountains. The myths say she gave refuge to her grandchild Dionysos there when the young god fled persecution. She kept Dionysos safe by disguising him as a girl and raising him amidst her nymphs. Java's sanctuary readies her to hold court. *I sit in my*

chair, *with not a peep in the house, to get ready to talk.* From her seat of power, Java relayed the details of her survival through her own near-mythic persecution.

After enduring police raids and the forced closure of her show at the Redd Foxx Club in 1967, Java sued in attempt to overturn the city's Rule #9, which forbade clubs from employing female impersonators. *They said men couldn't wear dresses. I went to court for four years. They said, "Sir Lady Java, you have been back and forth and back and forth again."* Java relayed the image of herself walking a gauntlet of cops into and out of the courthouse. *All these policemen at the side of me—I walked through them in a form-fitting dress. I'd walk so slow because I was scared of what the police might do. They wouldn't touch me, but I heard them talking. They said, "Man she is out of sight!" and "I dig her." One said, "If all the punks look like that, I guess I'm a punk." But I didn't pay any attention because I thought they were gonna jump on me or hit me with a billy club. They'd beat the shit out of you and there was nothing you could do.*

Despite initial defeat, a subsequent lawsuit overturned the rule. Java glowingly remembers the day a judge looked down at her and said, *"Lady Java, your people, as you call them, have the right to wear dresses." Something released inside me. I was so happy. For them, not for me. I could wear dresses already, but this wasn't for me.* Java insists she often avoided trouble because she looked too much like a woman for the police to beat her. *I was glad because I know what they did to my sisters.* Java recounted instances where all the girls were arrested but her.

Java wants everyone to know she did it for the girls. *I'm still here to do something for the girls! I want the younger generations to know how much I love them. The girls used to be so happy to see me, and it made me feel important. It made me feel like I'd done*

> "I'm still here to do something for the girls! I want the younger generations to know how much I love them."

something and it was accepted. I did it for them. People that I know have been so appreciative, so overwhelming, so glad to see me when I went to every city. I always felt good about being recognized. They were accepting of me. And maybe that's the reason why the queens said they could come out.

Java insists that acceptance came at a high cost. *I want my sisters to know I've sacrificed my life for them. I wanted people to be proud of them, not insulting them all the time. I love them so much that I wouldn't have men. They were always waiting for me, saying, "Oh, I'm gonna have her" or "She's gonna suck my dick," but none of that happened.* In Java's estimation, her high profile required her to sacrifice her own love life. *I didn't want a boyfriend, I just wanted to do right by my people. I could have had so many fine men but I didn't. I didn't want them to say, "Oh, anybody can fuck her." Can you imagine all these fine men looking at me and wanting me, and I wouldn't do nothing! I've got to be crazy. I ought to kick myself in the rear. I should have had those men and thought nothing of it, but they'd talk about my people so bad.* She had her fun, but only with men she met outside the club who didn't know her as Sir Lady Java. Visibility and desirability put Java in a precarious bind. *When a person says, "Oh we can have her," it makes you feel like you're nothing.*

I know the young girls are the queens of today. For them to think that I'm nothing would hurt me. The young people of today can maybe understand that there are those who really care. I hope they really think of me and my sacrifice. I never once thought that it was a terrible thing to sacrifice for them, you see. I don't know if I've been successful, but the girls seem to be able to hold their heads high and feel proud. Maybe it's because of the things I did. All the girls come over on my birthday every year. They don't kiss my hand, but they bow before me now. They make me feel like a queen.

LAS VEGAS

Hot Chocolate

LAS VEGAS × **CAPRICORN**

We met Hot Chocolate at the original Las Vegas sign early enough to beat the crowds (known as they are for fighting over photos at that location). Hazy clouds still hung over the morning before the sun burned through. *I'm the sun!*—Hot Chocolate declared as she reached for the sky, radiant in head-to-toe orange. *I think sunshine, the light, brightness, happiness when I see orange.* She originally commissioned the dress from designer Savannah James for a billboard photo shoot for Piranha, the nightclub where she reigns as celebrity host. The pandemic prevented that billboard, but the 'fit found its perfect place at the center of this portrait: *The orange, the sign, it says it all.* As we set off to join Hot Chocolate for dinner that evening, the sunset illuminated the purple mountains in electric orange light, a striking complement to the birds of paradise she specially requested for that morning.

Though now synonymous with the city, Hot Chocolate arrived there by way of a winding path, living and working all throughout the Southern states. Originally from Fort Myers, Florida, Hot Chocolate's drag career began in Atlanta, Georgia. While studying fashion merchandising at Massey Business College, she celebrated the weekends at Atlanta's renowned drag club, the Sweet Gum Head. *They featured the top female impersonators in the South. I thought, one day I'll be on that very same stage, and I'll be among Rachel Wells, Roxanne Russell, and all these names I look up to. I wanted to be one of the drag queens.*

I studied their character, studied what they did. At the time my name was Tanya, until Roxanne Russell told me, "Honey, you can't use Tanya. Call yourself something people will remember! You need something fabulous, fun, festive. Let's call you Hot Chocolate!" So Roxanne Russell, my drag mother, created this Hot Chocolate character in 1974. Roxanne also hailed from Florida and was crowned Miss Florida that very year. Her example led Hot Chocolate to enter and win Miss Florida in 1976. *Roxanne taught me to always be on the top of my game: upbeat, high energy, fun but trendy, relevant, fashion conscious.* As fashion inspiration, Hot Chocolate cites Iman, Naomi Campbell, and Grace Jones—*so many I idolized and found unique.*

> *"I thought, one day I'll be on that very same stage . . ."*

That energetic and fashion-forward approach gave Hot Chocolate a place among the undisputed early eighties it girls of Texas, a crew known as the Fabulous Four. An ad for the Copa in Houston depicts Hot Chocolate opposite her idol, Grace Jones, for the latter's appearance at the Fabulous Four's home base in 1982. The group underwent several lineup changes throughout their run, which Tasha Kohl clarified: "There's a lot of misinformation on that history. The original Fabulous Four was Hot Chocolate, Donna Day, Naomi Sims, and Tiffany Jones. Tiffany was one of the first people I knew to contract and die of AIDS. When Tiffany was still alive, I did a guest spot. I went over so well they hired me on, and we became the Fantastic Five. Then it changed to *Tiffany Jones Presents: The Fabulous Four*. When Tiffany died, we went back to just being the Fabulous Four." Each girl brought their own unique powers to the group. Electra recounted Tiffany's nickname, "The Texas Tornado." Tasha Kohl informed us Donna possessed the best beat, and Naomi the most sparkling personality. Hot Chocolate, of course, brings the high vibration.

Tiffany Jones died in 1985, and Hot Chocolate's path took her from Texas to New Jersey the same year. *I got a job offer to work at Atlantic City's La Cage.* She spent two years there until an opening in *An Evening at La Cage* brought Hot Chocolate to Vegas in 1987. She joined the cast alongside Frank Marino, Crystal Woods (doing both Diana and Whitney), as well as *several Chers and several Bette Midlers.*

Though going on thirty-five years in the city, Vegas's dazzle has never dulled in Hot Chocolate's eyes. She points to the city's star factor as the source of its unending charm: *I've met Paula Abdul, J.Lo, Janet Jackson. It's all about entertainment; everybody comes to town!* Hot Chocolate stays in *the entertainment capital of the world* because she knows inevitably all her friends and family come to visit too. *I just love showing people around.* If Vegas deserves its reputation as an underworld, Hot Chocolate surely acts as its psychopomp.

We certainly received the blessing of her hospitality, spending quality time with Hot Chocolate both before and after our shoot.

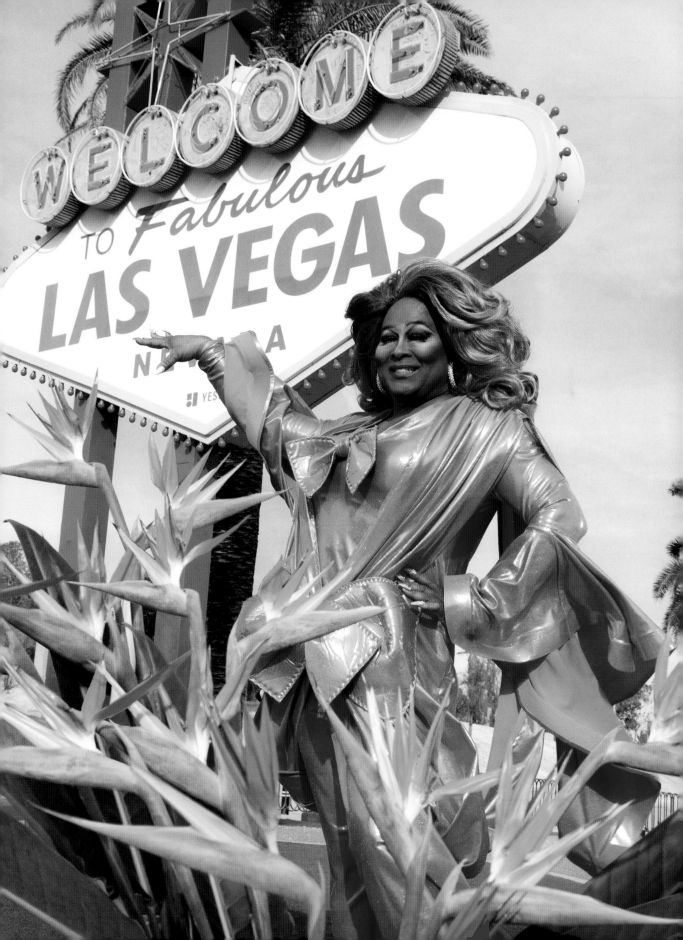

When we arrived in Vegas, she met us at the Bellagio to show us the impressive Chinese New Year themed floral display. As we admired the giant bulls and figures made of carnations and roses, Hot Chocolate informed us who to meet, where to go, and which paths not to walk. She demonstrated her maternal instincts by giving us a ride back to our hotel in her steely blue Fiat convertible, worrying in the most motherly way whether we were properly attired for the brisk February air. In our week there, she also took us to her favorite restaurant—the Peppermill, where all the staff knew her—and her personal relaxation spot—Stadium Swim, the rooftop pool above Circa, where we enjoyed the sangria. Hot Chocolate displays her superpowers as a hostess nowhere better than Piranha. We joined her there on her day off and received the VIP treatment, watching the evening's entertainment from the roped-off balcony where she once entertained Janet Jackson.

Shawnna Brooks received the same treatment when she and her daughter Nicole Paige Brooks visited Piranha during a work trip to Vegas. They sat upstairs and talked about the old days in Atlanta whenever Hot Chocolate took a break from her hostessing duties. In addition to Shawnna, Hot Chocolate *goes way back* with many of the *Grand Dames* of the Southern cities: she knew Kelly Ray from Hawaii and introduced us to Dina Jacobs as well. Years traveling and receiving travelers gave Hot Chocolate a full rolodex. Even the fabulous Sylvester—who had a thing for her roommate in Texas—stayed with Hot Chocolate *whenever passing through town. After whatever show, Sylvester would go knocking on Otis's door at the end of the night.* A survey of her social media shows Hot Chocolate to be friends with no less than twenty-five of the other legends featured in these pages, positioning her as a nexus point in the overlapping circles of the nationwide drag scene. This project required a whisper network of performers in various cities, and we'd be remiss to not acknowledge Hot Chocolate as a crucial source among them.

Hot Chocolate secured her place on the national stage by claiming Miss Gay America 1980. Besides the prestige that comes with the title itself, she names that pageant as an especially important moment because her mother came to see her win. *She was so proud seeing her son up there on stage and winning the pageant: something*

I will always cherish and remember as a highlight of my career.

In the book *A Night at the Sweet Gum Head*, author Martin Padgett sets the scene:

> Larry Edwards's mother sat nearby, hoping her son would win it. The Miss Gay America pageant would be the first place Larry's mother saw him perform. She had confronted him with her trademark blunt questioning: "I heard you do impersonations. Do you wear female attire?" He confessed, and turned it back on the mother he loved. "I'm getting ready to enter this contest," he told her with nerves jangling, "and I'd love for you to fly out to Miss Gay America." "I'd like to see that," his mother agreed after a pause that ended not a moment too soon. "I want to see what it's all about."

Padgett goes on to detail Hot Chocolate's winning number:

> She got up on stage and then ripped it apart with choreography Larry had plotted for maximum controversy and effect. A gorilla—Larry in costume—sprang onto the stage, then a second one followed. They fought, while a trainer snapped a whip in the air, cracking it inches away from Hot Chocolate and ushering her into a cage. She took a cue from Rachel's Jesus reveal and in a split second, dropped out of her gorilla costume to display her sequin-studded gown that glimmered while she performed her go-to rendition of Brainstorm's "Lovin' Is Really My Game." . . . The audience at Miss Gay America rose up in enthusiasm to give her a huge standing ovation. There was little doubt who had won. . . . HC had done her best, wowed the judges, and finally won Miss Gay America. While she cried through her makeup, her mother hugged her and told her how much she had loved her performance.

In her account of that performance, Hot Chocolate explains that the audience expected her to appear and tame the gorillas. Defying expectations, she emerges from the wild, rather than banish it. She evades her captors and refuses to become them. She

> ## "She'd be the goddess of love."

describes her sequined reveal as the epiphany of *an African goddess* engulfed in *disco fever*. When we asked this goddess's power, Hot Chocolate responded: *She'd be the goddess of love.* Uplifted by her mother's love, she undoubtedly captured many hearts that night.

A national title could figure as the pinnacle of many a pageant girl's careers. For Hot Chocolate, MGA functioned as an important stepping-stone on the path to far wider exposure. *In the South, if you didn't have a title, you couldn't get recognition or gigs at any of the major bars. So I got my titles: Miss Atlanta, Miss Florida, Miss Texas, then Miss Gay America. After I got that title, I thought I need to do something else to move me forward to enhance my career. I ventured off from pageants to do a tribute of Tina Turner.*

Hot Chocolate's favorite Tina song is easily "Simply the Best." *I love the meaning behind it. Any party, any wedding, anything; whoever you're singing to is simply the best. It says it all. The impersonations made me more mainstream. Heterosexuals and housewives can appreciate my talent just as much as my gay following that loves my wild disco I did in the past. To become mainstream, you have to do an act that people understand and appreciate.*

She doesn't get tripped up on the identity question. *I identify as a tribute artist because I impersonate Patti LaBelle and Tina Turner. I've also been known as a female impersonator; I like the professional sound. When I'm Tina, I'm a tribute artist; when I'm dressed as Hot Chocolate, I'm a female impersonator. I'm not opposed to drag queen either—it's something everybody knows. Identity only matters on an individual basis.*

Few queens work both the gay clubs and the impersonation shows, with their primarily straight audiences. Hot Chocolate, however, offers something for everyone. She also derives a special satisfaction from opening unsuspecting minds. *I just enjoy seeing someone come into a showroom, quiet and inquisitive, not knowing what to expect. I love seeing them go from the arms folded—"What is this all about?"—to seeing them standing up clapping, giving a standing ovation, or laughing out loud. It means more than anything to me to change someone's whole being inside of a showroom.*

Before long, her Tina tribute landed her appearances on *Sally*, *Donahue*, and *Leeza* among others. In 1993, she made the jump from television to the silver screen with a cameo as an uncredited Tina Turner impersonator in *What's Love Got to Do with It*, a biopic about Tina's life. *Having the opportunity to be in Tina's movie was unbelievable—I didn't think they knew who I was. Their casting director got ahold of the entertainment director at the Riviera and asked if I could be part of the scene.* After they shot together, Angela Bassett came to see Hot Chocolate's show at the El Rey Theater. In 2005, Hot Chocolate again appeared on film as Tina in *Miss Congeniality 2: Armed and Fabulous*. She loved working with Sandra Bullock, despite the scene where Bullock snatches a wig off her head.

Being the world's foremost Tina Turner impersonator became a family affair. Hot Chocolate befriended Tina's sister, Aileen, when she visited Vegas. Tina's cousin also came to see Hot Chocolate's show at the Riviera. She knows Tina's guitarist too. Hot Chocolate even had the opportunity to meet Tina herself at the airport in Chicago after an appearance on *The Oprah Winfrey Show*, which Hot Chocolate attended in the audience.

With the release of the documentary *Tina* (2021), Hot Chocolate made yet another appearance on screen. To her surprise, the film shows footage of her ecstasy while watching Tina on *Oprah*. *I really didn't expect that. She's been my idol for so many years. All of a sudden, I got a call from a friend who saw previews. What are the odds to have Oprah present that footage, of all the footage she's got? She traveled with her on the road! To present that clip of me in the audience and zoom in on me, I'll never forget. I guess I'm just lucky. After all the years portraying her, to be in one of her final documentaries—just to be seen—is such an honor.*

Demonstrating the reciprocal power shared between a star and her devotees, Hot Chocolate and Tina became bound up in each other's stories. *I'm in both of her movies, even if they're just little appearances.* Those little appearances pack quite a punch. Whether fleeing a casino alongside Crystal Woods in *Sharknado 4*, or escorting Theresa Caputo to her seat at Divas in *Long Island Medium*, Hot Chocolate always delivers a perfect, if brief, moment. In a single gesture she conveys variously: guidance, devotion, homage, compassion, escape. In elevating her impression to tribute, Hot Chocolate taps into the word's older meaning—"gift, offering, token"—with its etymological ancestry in the Latin word *tribus* (tribe) and the Pre-Indo-European root *treb* (dwelling). In mirroring another's starriness, Hot Chocolate unlocks her own. The far reaches of her starlight remain to be seen. Through recognition she finds her people. Liminal figures and trickster gods, weaving their webs of connection by way of their wandering, indeed make the world.

Crystal Woods

LAS VEGAS × **ARIES**

Though initially contracted in Las Vegas for just six weeks, Crystal Woods remains a beloved figure in the city thirty-six years later. *That's longer than Sammy Davis Jr.!* She reigns supreme as the strip's undisputed Queen of Motown, starring in all the top female impersonation revues past and present: Kenny Kerr's *Boy-Lesque*, Kenneth Blake's *Cherchez La Femme*, Frank Marino's *Divas* and *An Evening at La Cage*. Aside from her uncanny resemblance to Diana Ross, Crystal reaches deep to channel the soul of the music, embodying her character with every syllable, gesture, and toss of her hair. She's not some one-trick pony, either; her catalog of celebrity impersonations also includes Whitney Houston, Dionne Warwick, Eartha Kitt, Natalie Cole, Rihanna, and Ciara.

More than the glamour or the spotlight, Crystal cherishes the bond she feels with her audience. *It always blows my mind that I can go out and do "I'll Always Love You" by Whitney Houston and see the tears come out of people's eyes, that I can conjure those emotions as an entertainer.* In fact, her fans motivated Crystal to pursue drag full time. *I didn't take it serious at first, but the fans started taking it really serious. And then things progressed so fast.*

An older boyfriend took Crystal to her first drag show when she was just sixteen, at a leather bar in Fort Lauderdale called Tacky's. The showgirls performed so flawlessly that Crystal had no inkling they were anything other than cis women, until her boyfriend dared her to knock on the dressing room door for a closer look. Once she got to chatting with the queens, they directed her to *Vogue* for makeup inspiration, and just one week later she made her Tacky's premiere. *The very first woman I performed as was Natalie Cole. I'd never walked in heels or put on makeup, and the heels were so high I went out there and fell down! But everyone thought it was part of the act, so I made all this money in tips.*

Driven by a desire to hone her art, Crystal attended the 1976 Miss Florida Female Impersonator pageant, to see top queens compete from across the country. Once again, a friend dared her to knock on the dressing room door, and this time it was none other than Hot Chocolate who answered. Hot Chocolate won Miss Florida that year, and the two have forged a lifelong friendship through parallel careers. With a few more tips from Hot Chocolate, Crystal cultivated a reputation as a rising star within the South Florida scene, and soon found herself booked for two years solid.

In 1978, she accompanied a friend to audition for the show *The Hottest Ticket in Town* at the Windward Resort Hotel: "Where Gaiety Is a Very Natural Thing." Crystal had no intention of auditioning herself, but her reputation preceded her. *I was sitting at the back of the theater, and the producer walked right by my friend and said to me in front of everybody, "You've got a job for life if you want it."* Not just a job, but a residency: the ensemble of a dozen performers all lived at the hotel, creating a sorority that was one part *Real World* and one part *Real Housewives*. Crystal made her debut as Diana Ross on the Windward stage, and after collecting more tips than she could possibly stuff in her bra, she recognized her destiny as henceforth intertwined with Diana's. From Vegas to London to Ecuador, *Jay Leno* to *Maury*, concert halls to private parties, the gigs never stopped.

Despite drag's nature as outsider art, Crystal's perpetual momentum proves an enduring mainstream appetite exists for fully realized celebrity impersonation. *We have a great time with straight audiences; they freak out and wind up becoming bigger fans than the gay community. They've never seen how a man can perform as a woman and really pull it off. Gay kids, you've really got to work 'em because they've seen it all. You know what I mean?*

Whenever Diana comes to town, Crystal exercises caution stepping out in drag—she's been mobbed by hordes of mystified fans on more than one occasion. In a true testament to her showomanship, Crystal counts Dionne Warwick, the late Whitney Houston, and even Diana Ross herself among her admirers. The latter was so impressed by Crystal's tribute that she brought her on stage at a concert in 2017, completely fooling the audience until the real Miss Ross made her entrance.

Ross's endorsement carries tremendous responsibility, and Crystal is committed to maintaining certain standards as an impersonator. *The kids today are not wearing breasts—to me that's incomplete, but to each his own. Every generation has their thing. That's their thing: death drops and no breasts. I give great respect and love to it. But some of the girls go out there looking cheap, and we don't like that. If you want to look cheap, at least put rhinestones on it! Like Dolly said: "It costs a lot of money to look this cheap!"*

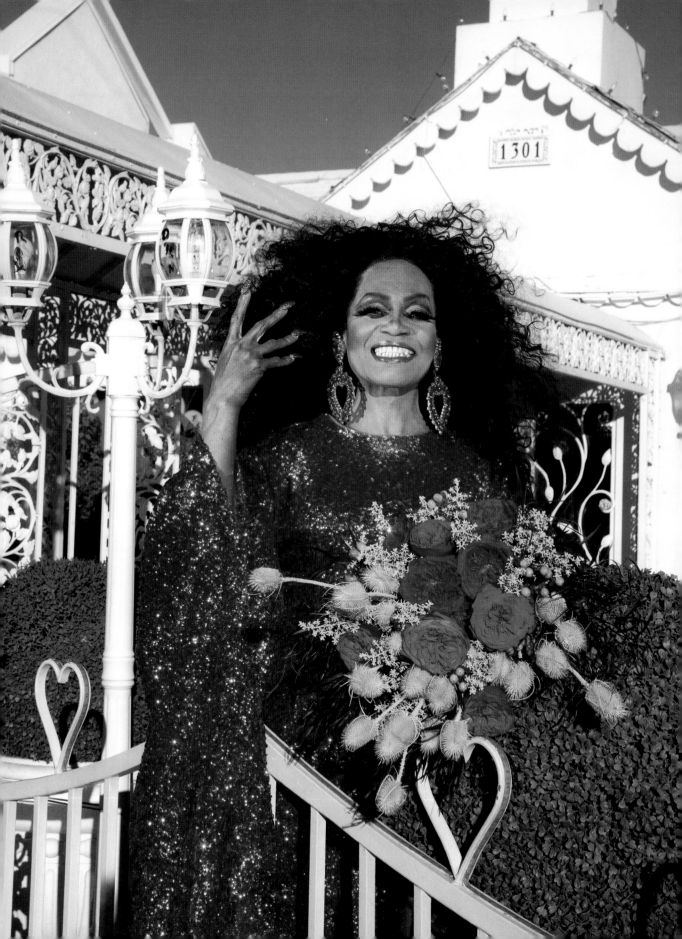

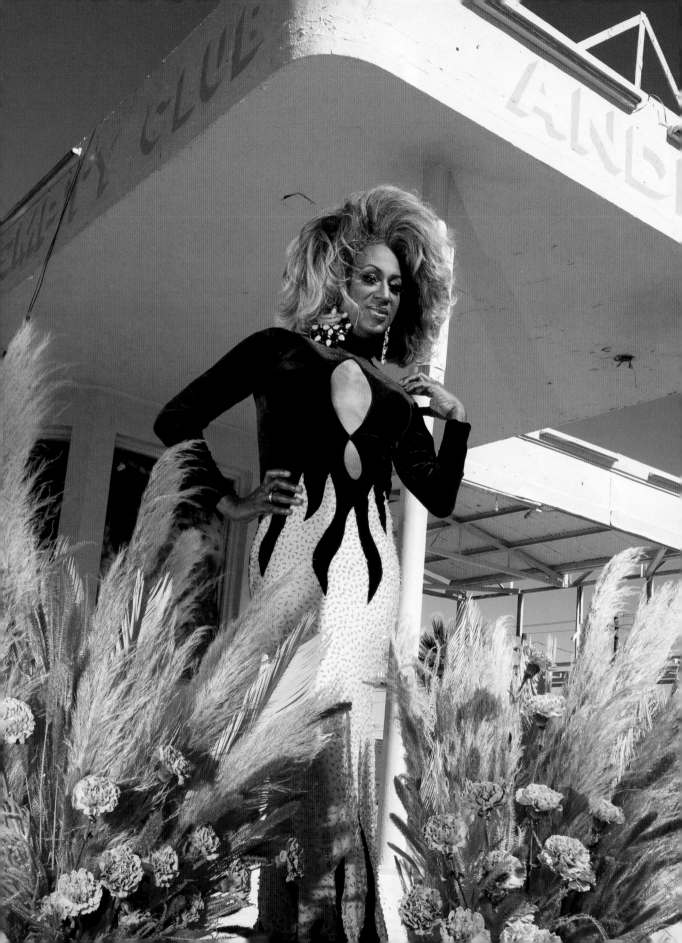

DuWanna Moore

LAS VEGAS × ARIES

As a flight attendant, DuWanna Moore jet-sets at a different pace. We shot with her the only day her schedule with Southwest Airlines allowed; she returned to Las Vegas—her home of thirteen years—the day before and flew out again the next day. When last we spoke, she had only just come off a weekend performing with Crystal Woods in Palm Springs and was preparing to go work on her tan in Maui.

Being on a flight is like being on stage; you always want to give people their money's worth. Arlie Russell Hochschild's 1983 book *The Managed Heart* first introduced the concept of "emotional labor" to describe the unique form of service expected from flight attendants. That expectation—to simultaneously meet every guest's needs while presenting a seamless sense of emotional authenticity—leads many flight attendants to cultivate the image of connection, keeping themself safely elsewhere.

Drag already prepared DuWanna to present just such an outward illusion. *At one point in my career, I wanted to be acknowledged as a female impersonator. When it comes down to it, I'm someone trying to create someone else. I'm out there to entertain—you can call me what you want. I'm creating an illusion of someone else for an evening. I considered hormones at one point but decided against it. I didn't want to become what I was trying to create.* The self that remains hidden behind the created mask offers DuWanna a source of strength. *I know what I do, and I do it well.*

She's been doing it well since 1992. After losing a bet to Ivana Black—who would become her drag mother—DuWanna entered the Miss 219 pageant at Club 219 in Milwaukee. Ivana dressed DuWanna, and the rest is history. *I did a Mariah Carey number and I won. That started the career of DuWanna Moore.*

DuWanna joined the cast of 219, giving her the opportunity to perform with and learn from such legends as BJ Daniels, Mary Richards, and Dominique Mahon. She became a showgirl there and started entering national preliminaries in 1993, winning Miss Black Wisconsin and Miss Gay Great Lakes USofA.

She remembers Milwaukee drag in the early nineties as *no holds barred, always something different, and always a lot of fun. I couldn't tell you a queen who was mad at another queen; we all got*

along so well. *If we had an issue or problem, we'd talk it out right then and there. We were all there to support each other and have each other's backs.*

The USofA system initiated DuWanna's life on the road. *I traveled throughout Wisconsin performing in different bars and having a blast.* She accepted invitations to perform at bars in Madison and Green Bay before moving to Appleton, Wisconsin, to join the cast at Pivot Club. Pageantry also offered her a powerful sisterhood. *I love being around my USofA sisters and getting to meet the new ones coming in. It's always shenanigans with those girls.*

In 2008, DuWanna snatched her first national title: Miss Unlimited Classique in North Carolina, started by Nancy Newton, a former Miss USofA at Large. DuWanna credits her success to her many role models. *Ivana taught me to never doubt who I am as a person or as an entertainer. She showed me that I have a lot to offer and how to give that to every audience when I'm out there on stage. Ivana moved away, but I'm lucky to have had BJ, Dominique, and Mary.*

DuWanna gave us her account of a teaching method we heard about from BJ: *I'd come to the bar early, and BJ would paint me before the show and then paint herself. One day she painted half of my face, it was looking lovely, and then she said, "OK, you get to finish the other half." She taught me that if I wanted to do this as a career, I'd have to learn to rely on myself.*

Then there's Dominique, she's passed on now, but was always there and in my corner from day one. DuWanna honors the dead in her drag. Whenever the USofA girls get together, they always strike *a quick kitten pose in memory of Sage LaRue,* a departed sister known for the pose. The flame dress DuWanna wore for her portrait (after fetching it back from Coco Montrese) belonged to another friend who passed, Vanity Starr. *Whenever I wear it, I think about her. I will always keep that dress in my closet. When I pass away it will be passed on to a friend and they'll have the same memories I have when I wear it. I love Vanity dearly and miss her immensely. She was one of the girls who took me in and supported and advised me. She's always watching over me.* DuWanna describes the healing power of the stage in the aftermath of deaths in the family: *When you hit that stage and the light hits you, it's like, "I'm doing this for them, maybe they're looking at me now."*

> "We were all there to support each other."

Lawanda Jackson

LAS VEGAS × **AQUARIUS**

When Lawanda first walked onto our set to assist for DuWanna Moore's shoot, we recognized immediately the presence of two legends, and couldn't leave town without photographing her, too. Lawanda met DuWanna through Coco Montrese and though the pair's friendship only spans three years, Lawanda happily obliges the girls when needed. *This is what I always used to do—style all the girls for their photos. Some of them have been using those photos for twenty years!*

Between continuously touching up DuWanna's bronze lipstick and hair, Lawanda shared bits of Vegas history. Lawanda told us that we currently stood at the old Vegas segregation line, which only changed in 1968 when the Rat Pack intervened and told the mob they wouldn't perform unless it lifted. *That was them risking their lives. Back in the day if you were African American or any persuasion besides Caucasian, you had to have three or four forms of ID. These days we'd call it racial profiling.*

Lawanda first saw drag when she accompanied her gay uncle to Black drag parties at private homes. *He did house drag since there weren't places to perform. At the time in Oregon, you had to have two articles of men's clothing under your drag or you'd go to jail immediately.* She herself first got into drag for a talent show her senior year of performing arts high school, 1979. *My best friend said to me, "You're the lead dancer in the school, you should enter in drag!"* Entering under an assumed girl name, Lawanda sang "Star Love" by Cheryl Lynn and staged a dramatic reveal upon the announcement that she won the contest. *I tore off my wig in front of the packed auditorium; they were gagging!*

Later that year she won her first pageant for gay youth, Miss Rosebud 1979, and from there she went on to claim Miss Oregon 1980. Following this early success, Lawanda auditioned for the Darcelle XV Showplace. *Darcelle named me!* While she enjoyed her time there, she describes *a certain way everyone looked alike. I wanted to be current and edgy, so I worked there as a boy for three years doing Prince and Michael Jackson.* Her Michael impression evolved into a *half-and-half, Janet-into-Michael* illusion that Lawanda calls her specialty.

At Darcelle's, a girlfriend encouraged her to go to Texas to seek out the state's big drag pageants. *Miss Houston America, Miss Texas America—Texas launched me into the pageant world.* She arrived in Vegas in 1992 with a reputation preceding her and secured a spot in the cast of *An Evening at La Cage*, without so much as an audition. She stayed with La Cage for the next nine years. *La Cage was the crème de la crème of drag and I can honestly say I was one of them.* The Vegas spotlight opened the way for Lawanda to travel internationally; she names a contract in Tokyo and another in Brazil as her favorite residencies.

Four decades in the industry yielded her over thirty titles as well. She won the state prelims to Miss Gay USofA in Louisiana, Florida, and Texas before ultimately taking the national crown at USofA Classic in 2009, and USofA in 2012. A year after the second USofA win, her competitive arc met an abrupt interruption when Lawanda suffered an inexplicable medical tragedy: a simultaneous stroke and aneurysm despite no preexisting conditions. Hospitalized for four months, the doctors told her she'd never walk or talk again. Miraculously, seven years later she's walking, talking, and performing with gusto.

The stroke paralyzed her whole left side, but she demonstrates a graceful adaptability. *I've gotten more avant garde as I've gotten older. With me not being able to do a lot of stuff I used to do, I compensate with my aesthetic and my style.* At her performances since the stroke, Lawanda does more with one mobile arm than most queens do with two. She serves fully choreographed movements, reaching to heaven, pounding her chest, ripping off her wig, dropping costume reveals. Between gestures she fields hugs and kisses from family and admirers in the audience, while collecting a steady stream of tips.

Lawanda began coaching other pageant girls shortly into her recovery. *Shae Shae LaReese came to my hospital bed when I was in my critical state and said, "Lawanda, I want you to use your voice if you get it back. If you pull out of this, I want to be the first one you coach." She stood by me in my darkest hour. I survived because of that. I trained her and she won Miss Gay USofA with a perfect score in the interview.* Several came to call Lawanda mother in the years since. The growing drag family refers to itself as the Jackson Dynasty.

Little by little, Lawanda surely reclaimed her voice. *I get to use my voice and understand my dialect and diction, my tone and timbre. I'm getting it back. It goes back to my calling. If you're in drag and have a microphone, you have power. I use the mic spiritually now. I was saved for a reason. I have some bigger purpose. I use my voice to lift up those going through something. It reaches people. Pageantry gave me the platform to use my voice. It's my biggest joy.*

> *"I've gotten more avant garde as I've gotten older."*

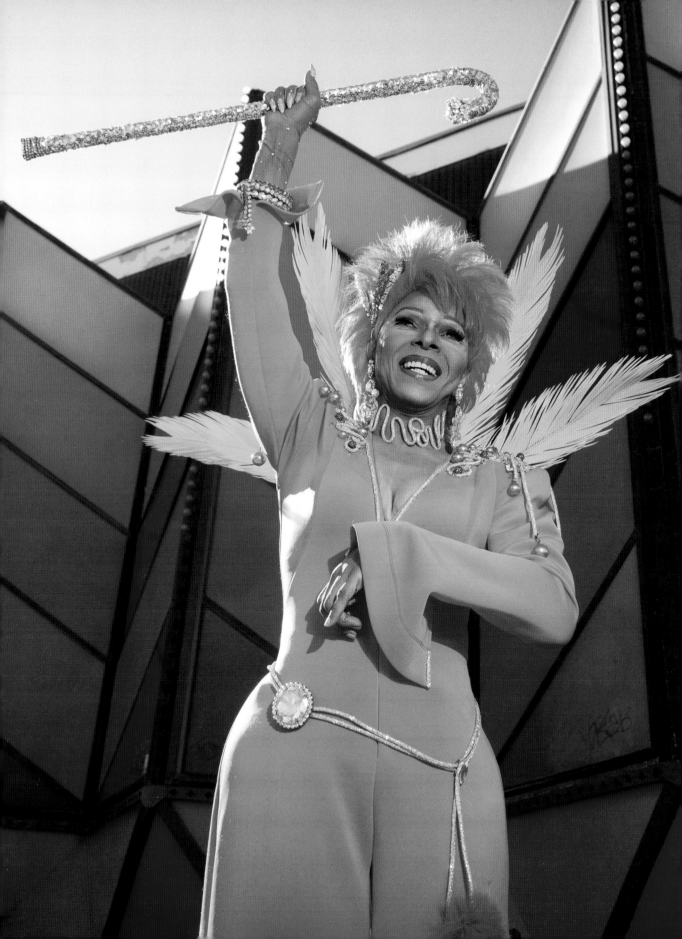

TEXAS

Tasha Kohl

DALLAS × PISCES

Any drag queen worth her salt will tell you that one wig is *never* enough. The higher the hair, the closer to the goddess, and Tasha takes this mantra to heart. A conglomeration of memories, late nights, laughter, ghosts, magic, and dreams constitutes the behemoth mass of tendrils atop her head. If that wig could talk, she'd have stories to tell. *When other wigs die, I add them to it. It's like the mother loaf.* Her career as a baker remains to be tested, but within the arena of drag, Tasha is a bona fide juggernaut. Within five short years of her drag debut, she was crowned Miss Gay America 1984, exalted by many as the most prestigious title in the industry.

Very early on, the bar was set high. *When I first started out, I was introduced to—and forced to work with—some of the best entertainers on the planet. I went from doing an amateur night to working four nights a week in three different clubs practically overnight. Those clubs used to fly people in from all over the country. Michael Andrews, Rachel Wells, Lady Shawn, Naomi Sims, Hot Chocolate, Donna Day, Tiffany Arieagus, Dana Manchester—you name it—I worked with all of them.* Although it was de rigueur for queens to cultivate a specific niche or style and stick to it, Tasha defied convention with what she calls *a shotgun approach to drag.*

I decided I wanted to be pretty, but I still wanted to do comedy, country, rock 'n' roll, tearjerker ballads, freakish characters, so I just started doing it all. As a pageant girl, the initial feedback I got was, "You have talent but you're not pretty and you're never going to be pretty." So I focused my energy on being a beauty queen, and the next thing you know it's, "Oh she's beautiful but she has no talent." So I figured out from an early age that you can't let other people define you; you have to define yourself. People like to peg you in a certain place, but I won't allow that. Tasha's winning talent routine at MGA illustrates this point: The curtain rises, revealing Tasha seated in a wheelchair, wearing a nightgown and a fright wig. She lip-syncs Millie Jackson's lament "I Still Love You (You Still Love Me)," articulating each syllable with gut-wrenching emotion, her fingertips trembling. She throws herself to the ground in a fit of delusion, and a doctor rushes to restrain her as she lets out a bloodcurdling shriek. The stage lights switch to purple, and smoke rises behind her as the music crossfades to "Dreams" by Grace Slick. A legion of ghouls, witches, and grim reapers appears on stage, and Tasha joins them in a ritualistic dance. As the smoke dissipates during the final verse, Tasha sits alone, still trembling, eyes bulging with intensity, trapped within her own mind. When she took the stage later for the crowning ceremony, Tasha was once again the vision of a beauty queen. Despite Miss Gay America's conservative reputation, Tasha's demonic freak-show beat out all the glamour girls that year.

Tasha is open about her own demons and struggles with anxiety and depression. *I was a desperate alcoholic and addict. I disappeared from the craft for a decade because of that. Then the late eighties and nighties hit, when all my friends dropped dead around me, and it took me to a really dark place. When I finally got some help, I had to learn to reprogram my brain when it tries to go to those dark places.* She sees drag as integral to her healing process: *When I get creative and put myself to work, there's no room for the darkness.*

Although MGA may be her grandest title, she holds Texas Entertainer of the Year 1985 as an honor very close to her heart. *This was before social media; people had to go out to the clubs and vote for you, statewide. We'd fly all over the state and go to these vote nights in Odessa, Abilene, Austin, everywhere. To win a traditional pageant means that five judges think you're the best that night, but when the people bother to come out and vote for you, that's truly amazing.* When the National EOY was formed in 1991, the organizers badgered Tasha into competing. *As a former Miss America, I felt a huge amount of pressure—I was terrified. Because what if I don't win?* Spoiler alert: she won. In addition to the crown, the prize package included a car, which she smartly traded in for a chic convertible. *As much as I always wanted to be Miss Gay America, I really am more suited to be an Entertainer of the Year, because EOY is all about what you do on stage. Winning a pageant is great, but if you can't go to a club and entertain people, what does that say? There's no better high than making an audience laugh or receiving a standing ovation. My mantra is: you're only as good as your last performance.*

> *"You can't let other people define you."*

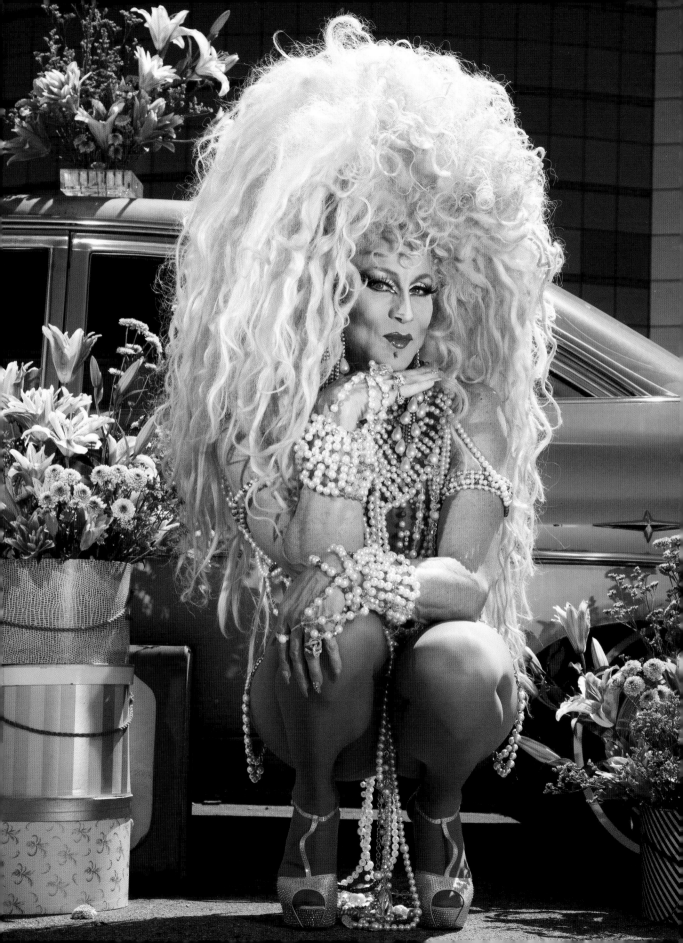

Dina Jacobs

HOUSTON × PISCES

If you don't have honor in yourself, you have absolutely nothing in life, Dina says with unwavering resolve. Dina locates her honor in the pride she feels as an entertainer, a drag queen, and a trans woman. *Who fought hardest for our gay pride? The drag queens. And they were drag queens—I don't care what anybody says. Who was there doing all the benefits for AIDS, back in the eighties? The drag queens.* Dina has no patience for attempts to sow discord within the queer community. *Let me tell you something: back in the day, we were all just gay. There wasn't trans, he, she, they, whatever. We were just gay, and we were happy and closely knit because we felt like we were subjected to the same ridicule. There were so many trials and tribulations back in the sixties, but we didn't care. We'd get beat up by the cops and all that. It was a nightly thing. But we didn't worry about the repercussions—we just did what we wanted to do with our lives.*

In Dina's childhood home of Hawaii, individuals with an intrinsic transfeminine energy are known as māhū, which translates to "the middle," and which Dina likens to "fairy." Indigenous Hawaiian culture regards māhū as a third gender category that also encompasses sexuality. Pre-colonization, nonbinary identities were broadly accepted. Gender Theory 101 instructs us to think of gender and sexuality separately, but this paradigm shift did not occur until the nineties. In practice, gender and sexuality are inextricably linked. Within straight society, the notions of "becoming a man" or "becoming a woman" are expressly tied to sexual viability. Only queer and trans people are forced to analyze and justify how their gender relates to their sexuality, a struggle that can last decades. Dina's early conception of māhū gave her the framework to understand why she always felt like one of her sisters, without the need to pathologize her identity or desire. Several of Dina's cousins were māhū as well, and they emboldened one another to embrace their sissy inclinations: *We were just gay boys, gay as could possibly be in high school, in 1963. The loudest ever—didn't care! Not a care in the world!*

While playing hooky in Waikiki one day, Dina and her cousin Shawn encountered a woman, Brandy Lee, who presented a new, exciting potential. *We saw this woman—well, we weren't quite sure*

because she was so glamorous, you know—she had long red hair and all these boys with her. When her car passed us at the bus stop, I was like, "Hmmm." Then a few months later we passed this place called the Glade in Honolulu—that's when we saw all the drags, and I wanted to become part of that right away. The cousins' drag debut occurred on Valentine's Day 1964 for a party in the Mayor Wright Homes housing project. Dina swiped her mother's red chiffon dress and overdrew her eyebrows. In retrospect, she laughs at their sloppy trial run, but at the time it felt like a full fantasy.

By her senior year of high school, Dina's mother had kicked her out, and she went to live with friends in Waikiki. With her five roommates, they only had three wigs, so they'd rotate the hairpieces among them to pick up guys at a bar called Yappy's. Dina always attracted attention from men—football players, sailors, an Air Force sergeant, a priest—from the onset of her teenage years, whether she was in drag or not. As Dina further refined her cosmetology skills, she found ample opportunities to leverage sex for power, pleasure, and financial security.

Performing in drag wasn't on her mind until she caught wind of auditions at a bar called the Clouds. They cast Dina in the role of emcee, and she also sang sixties pop standards. Before long she became the hostess at the Glade, billed as "Hawaii's foremost female impersonations show." Once Dina's mother saw her shine on stage, they reconciled, and she became a frequent Glade patron. *That whole time period was my growing into a performer and acceptance from my family, all at once.* Despite the glamour of her new profession, being perceptibly gay or trans still carried the implication of sexual deviance, a criminal offense in many states. In her 2020 biography, *Forever Her Mother's Son: The Dina Jacobs Story*, Dina recalls the draconian methods used to police the queens:

It was required in Hawaii that men performing in drag had to wear a sign that said, "I am a boy." One time, Dina was walking down the street and a vice cop shouted "Hey! Where's your fuckin' sign?" The police officers knew all the girls by name because they were always on the same street. Dina replied, "Here it is! Right here!"

> "Who fought hardest for gay pride? The drag queens."

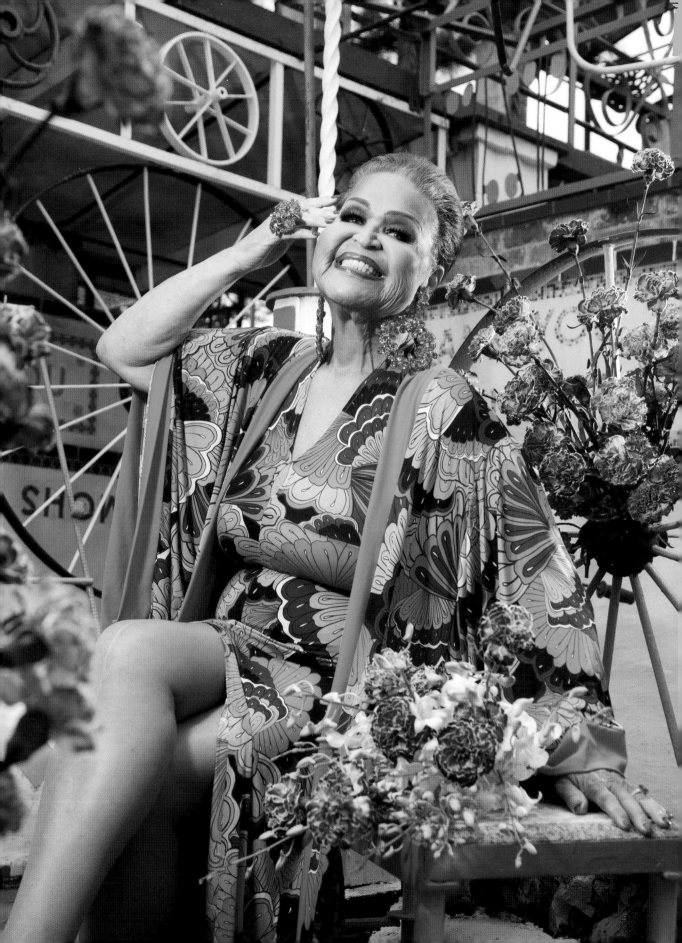

The policeman responded, "You didn't have it on," and punched her in the back of the head while she was walking away.[1]

If queens were caught without their "scarlet letters" on display, they faced hefty fines due to an "intent to deceive" clause in Hawaii's disorderly conduct statute. Private spaces were not necessarily safer: the clubs were subject to frequent raids, as were the queens' homes—the cops knew where each of them lived. Dina reveals that the violence was accompanied by more complicated sexual politics: *The cops were really ugly to the drags, but there were some cops who were going with the drags at the same time. As long as nobody saw, they were good with it. I want people to know what we went through in the sixties, because it wasn't just my life. It was everybody around me. We all went through the same thing. We were fighting all of this bigotry before Stonewall; we were doing all of it.* The mandate that queens wear the "I am a boy" badges was eventually dropped in 1972 thanks to Charles Lizares, a.k.a. Lisa Lauren. *She went and fought with the city board to have the tags removed from us, "because we are human beings," she said. "We have rights, too."*

In 1967, Dina took her drag to the mainland: San Francisco, Kansas City, Los Angeles, Minneapolis, Edmonton, Calgary. She toured with a rotating cast of performers, including her cousin Shawn Luis and Brandy Lee, the red-haired beauty from Waikiki. During this era, she encountered queens lip-syncing for the first time, and incorporated pantomime acts into her routine as well. In Esther Newton's seminal ethnography *Mother Camp*, Newton describes a semi-rigid hierarchy among the American drag communities she observed throughout the sixties: Female impersonators who sang live were at the top, lip-syncing "record acts" were below them, and at the bottom were street queens who did not necessarily perform on stage but wore drag to turn tricks. Throughout her career Dina has oscillated between these modalities, a testament to both her multifaceted talents, defiant determination, and love for her art. *Honey, I am so good at my craft because I honed everything I did. I sing live, so when I do pantomime it's like I'm really singing the song. I know when to breathe, when to pause, how to express emotion, and*

> ## "As long as I can walk in heels honey, I'll do drag."

I just love it. I love when people stand up and applaud me and scream for more. That's the best medicine that I could have. As long as I can walk in heels, honey, I'll do drag. It's just that simple.

Weary of life on the road, Dina landed in Chicago in 1971. Her girlfriend Roski Fernandez worked as the show director at the Baton Show Lounge and arranged an audition. *The owner Jim Flint had this little apartment above the Baton back then. When he heard me singing, and the people screaming, he came downstairs and hired me on the spot. That's how I got my big start in the States.* She won Miss Gay Chicago in 1975, beating out several local favorites. Performing at the Baton introduced her to a new level of professionalism and production value, but the environment lacked the camaraderie she felt in Hawaii.

Armed with a boost of confidence from her pageant win, she untethered herself once more and relocated to Atlanta that same year to take a job at the Sweet Gum Head. *Every big-name entertainer was in Atlanta for a period of time: Tiffany Arieagus, Naomi Sims, Hot Chocolate, Lady Shawn. All of the big stars. And Rachel Wells, she WAS the Sweet Gum Head, let it be known! Baby, in the seventies, Atlanta was the gay mecca of the whole country.* If so, the Sweet Gum Head was its most holy site, the type of venue that comes around once in a generation. *I don't care who you were: straight, gay, lesbian, drag, tranny, whatever—when you walked in there was a feeling of comfort. A feeling of family. It was like magic. And if you left alone, that was your fault!* Queens and patrons alike took part in the vibrant cruising scene in the Gum Head parking lot. Dina describes her role in the cast as *filler queen*, but she also worked as the show director for a short time.

Dina rocked an androgynous daytime look for many years, and occasionally incorporated genderfuckery into her drag, experimenting with bald and bearded looks. By the time she turned thirty and ascertained that her hairline would not recede, she felt comfortable moving through the world as a woman full time. Among the myriad changes that accompany medical transition, she found that purely transactional relationships with her johns no longer provided the same validation, and she stopped tricking around the same time. *I was falling in love with men, because now they saw me as*

1. *Forever Her Mother's Son: The Dina Jacobs Story* by Larry Dwayne Ponder.

more appealing than when I was a boy. That feeling of somebody wanting me, I didn't have to get it from tricking. Tricking was only for money, but some of the guys were so gorgeous I was falling for them, and then I'd get hurt. I was the worst whore ever! Sometimes I would not even charge them: "Just stay a little longer pleeease." I'd be making dinner for them!

Despite her comforts and successes in Atlanta, Dina felt a sense of restlessness. She craved new doors to walk through, new audiences to entertain. In the late seventies, her wanderlust led to residencies in Argentina and Brazil. In South America, drag flourished during Carnival celebrations, when *travestis, transformistas,* and *mariconas* were free to adorn themselves in feathers and beads. Outside of Carnival season, the drag scene remained underground. By her estimation, Dina and her friends China Nuyen, Andrea Nicole, Shalei Eleneke, and Brandy Lee were some of the first American drag queens to perform in the extravagant nightclubs of Buenos Aires. They received a warm reception from the civilians but faced multiple confrontations with the police. Their crime? Being trans in public. The troupe refused to go incognito to avoid harassment, instead cutting their contract short. Unfazed by this experience, Dina embarked for Brazil just a few months later. She discovered Brazilian culture to be much more open and took full advantage of the topless beaches and beautiful men. For a fleeting moment, a love affair convinced her she could stay in Brazil forever, but heartbreak led her back to Atlanta in 1980.

Upon her return to the States, Dina set her sights on the national pageant scene, commencing a decades-long crusade that continues today. She feels the competition keeps her young. Throughout her career, Dina has won over seventy titles and competed in all of the "Big Three" national pageant systems: Miss Continental, Miss Gay America, and Miss Gay USofA (formerly Miss Gay USA). She holds the title of Miss Gay USA 1981 and consistently placed in the top five at Miss Continental and Miss Continental Elite over the span of forty years. Contestants in regional pageants were known to drop out if they heard Dina was coming to town.

Her entry into the Miss America system was more fraught: Dina refused to don male attire for the interview portion of the pageant, also in 1981. When the judges pressed her on this,

> ## "I don't take nothing for granted, baby."

she responded, *This is Miss Gay America and this is how I live MY gay life.* Following the interview, Dina overheard the pageant owner, Norma Christie, remark, "That's why I don't let those kind of queens in this pageant." One of the judges later admitted that scores were tampered with to oust her from the top five. This particular brand of disgraceful gender essentialism persists in some drag competitions even today, a cruel consequence of transphobia and misogyny.

During her second chapter in Atlanta, she became an inspiration to the young RuPaul and Lady Bunny. Ru once confessed to Dina that she only considered singing live after she saw Dina do it. Lady Bunny recalled Dina's rendition of "Lucy in the Sky with Diamonds," when Dina revealed two giant rhinestones glued to her palms. Ru and Bunny literally beat the walls in a fit of euphoria.

Although Dina always continued working and competing, she remembers the latter half of the eighties through the nineties as a dark time. As her own drug use escalated, she parlayed her reputation for always having the good shit into a business and used the profits to help support her friends who were dying of AIDS. She returned to Hawaii in 1999 to heal and reconnect with her family, who she counts among her biggest fans. After a decade on the island, she resettled in Houston, where she became the undisputed *Grand Dame* of the scene.

With over half a century in the business, and her many far-flung adventures, it's no small feat to shock Dina. Yet when she set foot into the Orange Show for our photo shoot, she expressed bewilderment at the landscape of painted wrought iron all around us. The site was constructed over the course of two decades by Houston postal worker Jeff McKissack, who conceived of the immersive folk art installation as the next Disneyland. As Dina sat for her portrait amidst the technicolor wagon wheels and tractor parts, her regal beauty was outshined only by her quick wit. When we asked her zodiac sign, she responded: *Fish, baby, what else?* Fishiness denotes an unclockable feminine essence, a prized quality within drag circles, and Dina always serves it fresh, like the catch of the day. She knows her power, and she owns her legacy. *I don't take nothing for granted, baby. Coming from Hawaii and touring the world, doing drag? You come up with a better story!*

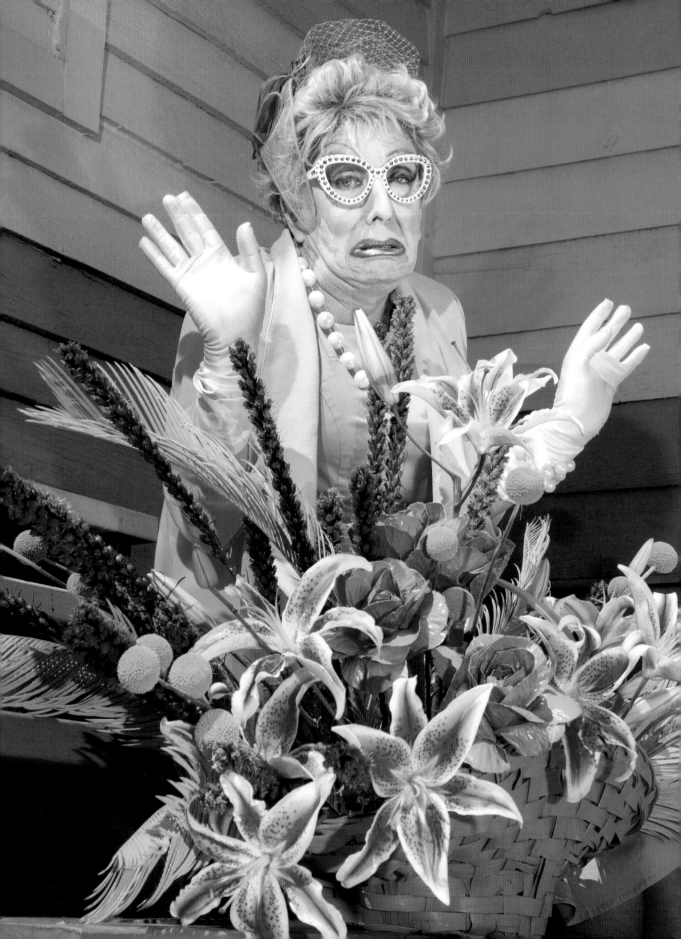

Kitty Litter

AUSTIN × GEMINI

Kitty Litter walked into her audition for the second season of *Camp Wannakiki* with a piece of toilet paper stuck to her shoe. When the Sugarbakers called it to her attention, she replied: *Usually when there's something white and unpleasant following me, it's the KKK—I do a lot of shows here in the South, you understand.* Her quick wit won her a spot on Season Two and proved more prescient than she imagined. After making it to the series finale, she accepted an invitation to appear at Austin Public Library's Drag Queen Story Hour, igniting a controversy wherein she was accused of, among other things: prostitution, pedophilia, witchcraft, and cannibalism. While the latter two accusations make her sound like something out of *Grimms' Fairy Tales*, she's still laughing about it: *When you cook those kids, you have to bake them at 350 degrees; those little brats ate my gumdrops!*

As she tells it: *This guy was at the library with a camera. He introduced himself as a documentary filmmaker and asked me if I was aware of any sexual improprieties during the Story Hour events. The library already smelled a fish and asked him to leave. An hour after getting home my phone was pinging like a Vegas pinball machine. It was all over the internet. Alex Jones of* InfoWars *sent this guy in to cause a scandal because nationwide they'd been raging against the Drag Queen Story Hour. They went through social media and found all my old leather pictures from when I was a title holder. They really tried to get people frothing at the mouth about this drag queen trying to seduce their children into homosexuality. I continued to do my thing and the news crews started coming out. I received death threats online for a year.*

The local witch hunt was led by a group called Texas Family Values—*I thought it sounded like a discount department store*—and another called Mass Resistance, a one-woman crusade against queer and trans people inspired by the leader's husband leaving her to become a woman. Kitty questioned whether continuing her drag career was worth all the trouble but was reassured by supporters from the Austin community, who told her: *"You were kicking ass!"*

Kitty readily deserves the title "veteran drag queen" after thirty years performing and another decade in the military prior

> "... everybody thought, 'She's not queer—she's just new wave.'"

to that. She calls her time in the service *a different kind of drag. Back then I was so closeted I could see Narnia. The CID, an investigative command, would do these witch hunts. If found out, they could imprison you at Fort Leavenworth.* Despite the risks, Kitty still found other queers, especially while stationed in Germany in the eighties. *I was able to be myself more; everybody thought, "She's not queer—she's just New Wave."* She had the opportunity to see Divine perform in Frankfurt at a construction site. Kitty picked up trade on both sides of the Atlantic, but she picked up her delicious Southern accent while stationed in Georgia and Louisiana.

After being closeted for ten years I wanted to go somewhere accepting of my lifestyle, so I chose Texas: the button-fly of the bible belt, such a strange place. She lived for a time in Houston, getting involved with the Debris Sisters—Ginger Vitus and Blanche Debris—who became her unofficial drag mothers. She found more drag family in the Chain Drive Girls in Austin. *Austin was all hippie freaks and artists. When I moved here, this was all just fields*, she told us while gesturing to some new condos. She calls the Austin drag scene pretty diverse—*we have drag monsters and girls from TV here*—compared to the broader Texan drag landscape, heavily dominated by pageantry. Kitty respects pageants as *an art form unto itself*, but reports they're ultimately not her gig. She does, however, claim the title of *Miss Silent Trailer Park, third runner-up.*

Kitty epitomizes camp drag. In fact, her own drag started as a joke at a campground where she got dolled up with some friends *in pink tutus and beards* and performed "Diamonds Are a Girl's Best Friend." *I went to sit on a table I mistook for a bench and fell ass over heels on the stage; people just roared!* She draws camp inspiration from John Waters films, B movies, and the Cockettes. *I just loved the concept of a rebel drag troupe!*

Camp notoriously evades definition, but Kitty is ever game for a fool's errand: *I've seen pageant girls who thought they could put on a dime-store wig and mess up their makeup and they'd be camp. No, honey. The whole thing is taking something normal and making it larger than life. It has to be so over the top that it's comedic and ridiculous.*

Like Dame Edna said, *"If you can't laugh at yourself, you might be missing out on one of the biggest jokes of the decade."*

MILWAUKEE

Karen Valentine

MILWAUKEE × GEMINI

She's hot, she's loaded, she's ready, start the show! Karen Valentine met us at her Victorian flat on Lavender Hill. Her home of eleven years, decorated in superlative drag queen maximalism, displays a lifetime's collection of ephemera. An entire wall stands dedicated to autographed portraits of the celebrities she's met through her work in advertising and philanthropy. *Soaps, game shows, talk shows; I met them on the way up or the way down.* Many surfaces house a growing population of dolls. An Iris Apfel doll arrived that very day.

Among the toys and icons, statuettes of several gods find hospitality: a statue of Artemis and multiple statues of Hermes. *You can never have enough gods.* Karen believes in the power of prayer, and she wields an impactful power herself. Local bar rag *Quest Magazine* proclaimed their utmost devotion: "In the Pantheon of Milwaukee drag goddesses, Karen Valentine takes her place in the uppermost ranks." Her portrait ran on the cover of that issue and afterward she reported, *The young people said I look like Adele!*

Karen Valentine's origins can be traced to the spring of 1985 and the M & M Club—*our nucleus at the time; people to this day still mourn its closing.* She joined a gay chorus set to provide entertainment for the extravaganza and loved it so much she kept performing. *Just as we were flourishing, the AIDS crisis was also flourishing. Chorus was an outlet for those going through it. Singing was the safest outlet. We lost a lot of wonderful performers to AIDS.*

At M & M she met Rhona—*one name, like Cher*—a Miss Gay Wisconsin, whose birthday occasioned the drag show where Karen made her debut. That night, Karen performed Vikki Carr's "It Must Be Him" while frantically running up and down the stage answering a dozen or so telephones. Only she received an encore that night, and she went on to play that number in every gay bar in the city. At La Cage Niteclub and Club 219, *the dueling discotheques,* she performed in amateur nights and won whenever the chorus came to cheer her on. She insisted on bequeathing the grand prize ($500) back to the chorus.

Karen's method probes the dreamworld for inspiration. *I'll go to bed thinking, "What number should I do? What should I wear? etc." I wake up in the morning with all the answers. I always go with it.* Her dreams instruct her to perform an array of classic singers: *Karen Carpenter, Shirley Bassey, Doris Day, Peggy Lee, or Julie London, if I'm feeling seductive. Drag is education; we have to keep Judy Garland and Liza Minnelli alive.*

KV brings in specialists to style her makeup and hair. One stylist told her: *Putting Karen together was like playing with a big Barbie doll.* Karen is a creation, a fantasy. As she told *Quest: Karen Valentine lives onstage. I don't want to take the magic away and dilute the mystique of it all. I don't want people to think KV will show up when they invite Michael Johnston to brunch.*

Karen believes strongly in drag's capacity for magic. She saw this clearly during the height of the AIDS crisis. In those times, *drag was a way of suspending reality, taking people away from the humdrum. We were fighting something we didn't really understand: the gay plague, the gay cancer. Gays, prostitutes, drug addicts, outcasts, the disenfranchised, the island of misfit toys. Who cared if our loved ones died?*

Drag offered Karen a way to demonstrate community care and much more. *Drag has always been a hobby, an avocation, an interest, a thrill, a whatever. But I never did it for the money. I did it for the art. I'd do a show and then turn over the tips.* For Karen, those tips are charged with a powerful energy, which she's elated to pay forward. *A tip is a nod of approval, it's love, it's better than an orgasm. It's a connection that reminds me of the Michelangelo painting where the two fingers meet.*

Beyond donating her tips, Karen also founded the Valentine Fund for the Arts. Through that fund, her love of the arts takes material form. *As long as I can still contribute. I want to leave a legacy. I'm not sure what it will be—perhaps it's not for me to know.* Her legacy continues to be defined. Karen says she's still learning every time she leaves the house. *When I stop learning is when I'll hang it up. Sometimes you worry, what is my reality? I wonder how long I can keep this charade going? As long as I'm asked to appear, somebody wants to see me.* For those who want to see her, she prefers a formal invitation. *Life is the best party I've ever been invited to.*

> "A tip is a nod of approval, it's love, it's better than an orgasm."

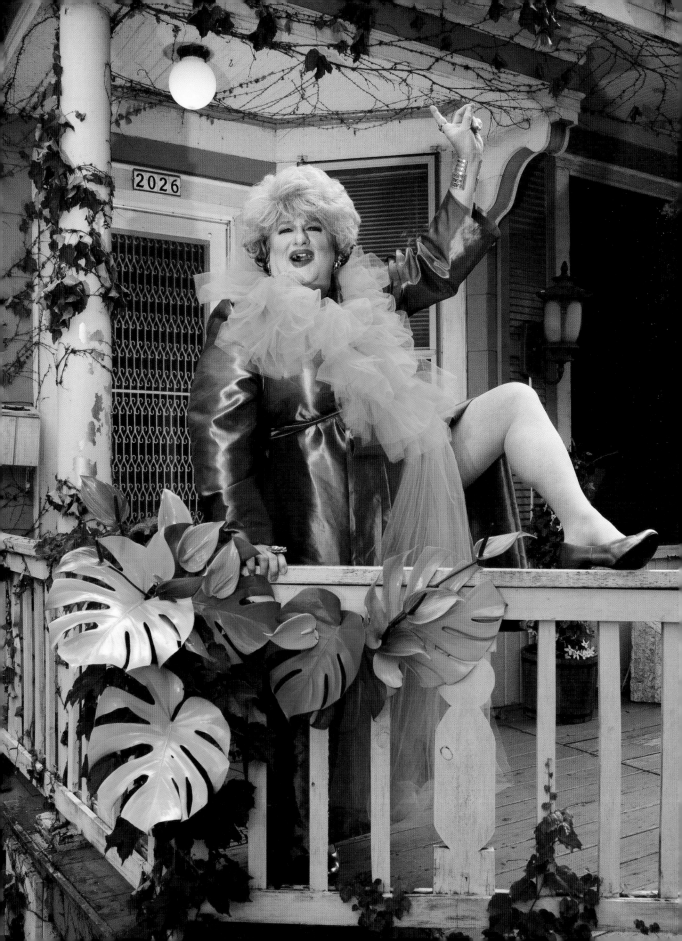

BJ Daniels

MILWAUKEE × TAURUS

BJ Daniels commissioned her dress for our shoot together. Made from TrueTimber Camo's "Conceal Pink" fabric, she wanted something *eighties but couture* with reference to her rural roots and lifelong commitment to fashion.

BJ's career on the stage spans forty-three years, including a stint singing in a punk band and a seventeen-year hiatus before making a comeback at the age of fifty-two. For her second debut she reprised one of her earliest—"All that Jazz" from *Chicago*—for a production number at a charity fashion show. She wore an old dress that still fit after all those years. Even so, she reports the hardest part of her comeback was adjusting to how her body changed. It took five shows to figure out how she looks now. Even with the requisite adjustments, she rediscovered her spark immediately: *It's just magic; you never lose the connection with the audience. There's something innately in me. You can't dim it. It's still here after seventeen years. The moment I locked eyes with the audience and they saw me I just knew I was doing this again.*

As a child she loved the old sixties variety shows (the music, the costuming, the big hair) and always wanted to perform. She joined musical theater in high school and one fateful evening the hot choreographer of their production of *Li'l Abner* invited the cast out for a drink at a gay bar in Madison. There, BJ saw a drag queen for the first time and thought to herself, *Oh my god . . . I would be so much better. I knew it!* She moved to Madison for school in 1977 and *started going out in drag to attract attention almost immediately*. At the time there weren't many shows, so her drag was primarily for the streets. She'd dress up and hit the town. Her first performance in 1978 was "Fame" by David Bowie. *I wanted to be famous and thought, this is how I'll become famous. I thought I was magical and this is what I should be doing.* She went on to spend thirteen years performing at Club 219 and even saw Divine there.

During her hiatus from drag, she focused her attention on hair styling and the fashion world. She modeled for photographers J. Shimon & J. Lindemann and retailers like Bruce Paul Goodman. She bought a camera, went to NYC, showed up at

> ## "If you wanna be a star, act like one."

Fashion Week, and simply began shooting. There she met people from all over the world, shooting a *Project Runway* finale and interviewing Tim Gunn.

Her interest in fashion began in the country, where she'd go to rummage sales looking for old prom dresses and anything with a sparkle. When she first moved to Madison, she supported herself by thrifting and reselling to the early vintage stores. She currently does business as Fashion Farmboy—*a name that tells you everything about me; encapsulates everything I've done in my life. When you're from an unincorporated town in the middle of nowhere, you dream big. At ten years old I knew I wouldn't stay. Fashion Farmboy is a nod to that.*

She considers all the Milwaukee drag legends to be girlfriends. She performed as Sophia in a yearly Christmas production of the *Golden Girls* with Ruthie Keester, who plays Dorothy. All the other girls work at Hamburger Mary's too, but BJ is the eldest. She participated in the Legends Brunch and made an impressive $400 in tips that afternoon. *I love my queer family!*

BJ mentors many younger queens, sharing wisdom with an eye toward longevity. *I tell them: if you want a long career, find your look and work within it so you're immediately recognizable. Always be glamorous. If you wanna be a star, act like one.* She gives this advice because she's lived it: *I'm the star I wanted to be. Part of it is for that little farm boy I was. I'm living my variety show fantasy. Your dreams don't go away, they don't ever really leave you.*

She insists one can't just do drag; you need other things. She blames *Drag Race* for creating a false sense that one can make a career out of drag alone. Still, she celebrates the Milwaukee queens who've succeeded on the show. Joey Jay, who competed in season thirteen, got her start in BJ's drag basement. She recognizes there's something special about Milwaukee. *It's a working-class thing. Good performers are hard workers in and out of drag. Truly magical people.* A historian herself, BJ works to explore, preserve, and share the legacy of the city's drag communities. Those interested in that regional magic should look out for BJ's forthcoming book, *The Golden Age of Milwaukee Drag.*

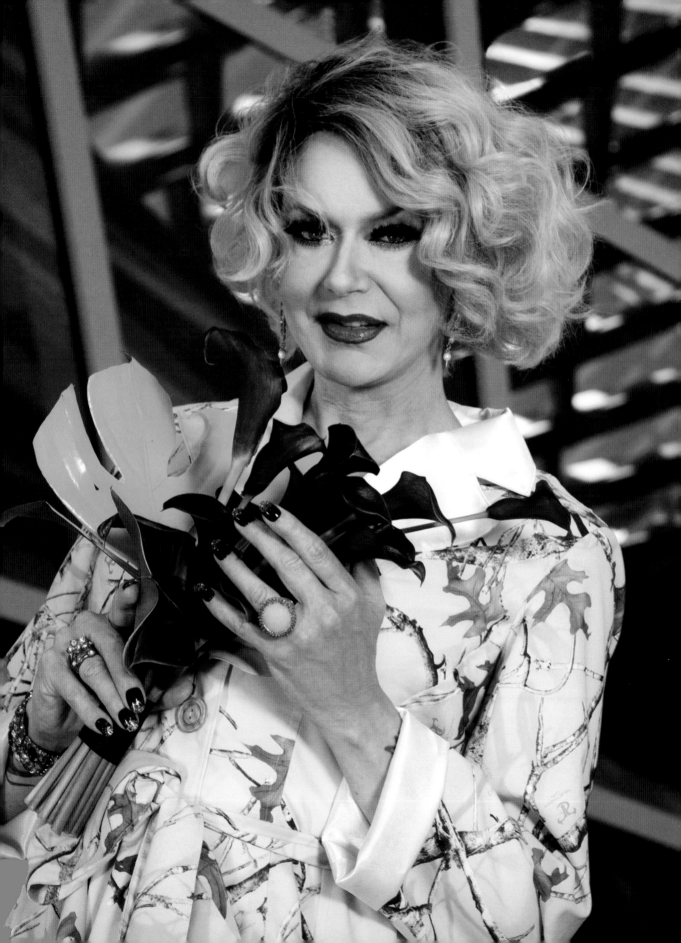

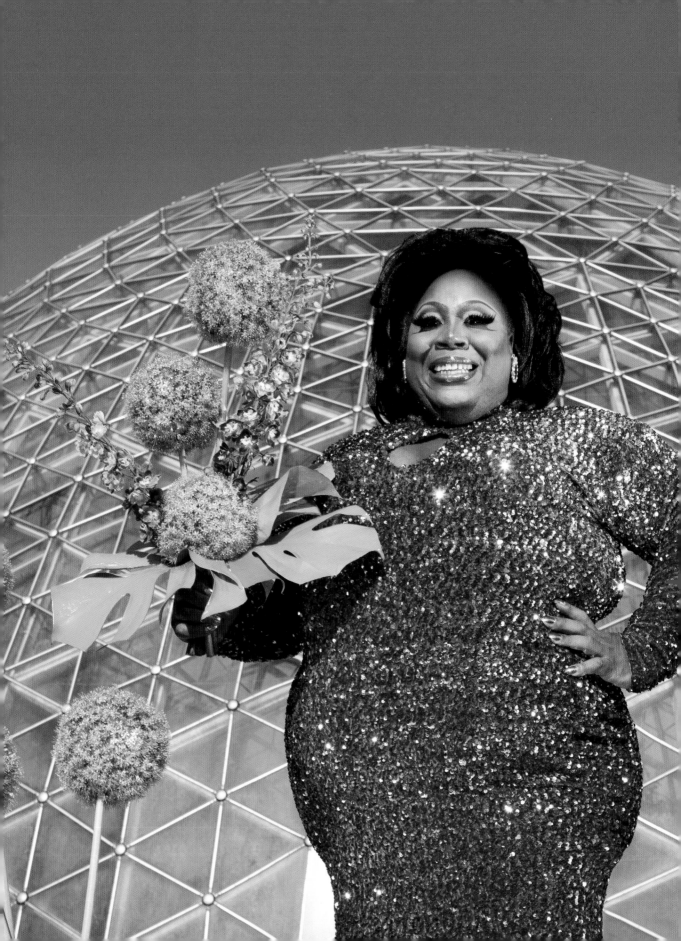

Shannon Dupree

MILWAUKEE × AQUARIUS

W e met Shannon Dupree in front of the iconic Mitchell Park Horticultural Conservatory, commonly known as the Domes, a futuristic triad of bio domes built in 1955 to replicate unique ecosystems in order to cultivate rare flora otherwise ungrowable in Milwaukee. We can't think of a more fitting place to shoot with Milwaukee's own rare flower who's flourished in the city's small gay scene, a microcosmic climate in its own right.

You don't have to hold that umbrella for me; I'm not a celebrity, Shannon insisted as our assistant tried to shelter her from the summer heat. It's true that Shannon avoids shadiness in all forms, but her long and decorated career certainly warrants being attended to, regardless of her insistent humility. Shannon has been performing in clubs and competing in pageants for three decades. And while the titles came later on, they came in abundance. *I've got them all.* Shannon claims the distinction of having every title in the USofA system—*Except Mister!* Prior to the pandemic, she was working toward Miss Club. *I've only got one more pageant in me.*

Like a surprising number of the queens we've met, Shannon got her start in drag on a dare. In 1988 she attended a talent show, as an audience member, at Club 219 in Walker's Point, Milwaukee's gay neighborhood. One contestant in the show was particularly bad that night and overheard Shannon critiquing her for being messy. After the show, that contestant confronted Shannon and challenged her to get up and compete if she thought she could do it better. *Game on,* she replied. The next weekend she got painted up by a friend—Traci Ross, the now headliner at the Kit Kat Lounge in Chicago— and performed "And I Am Telling You I'm Not Going" from *Dreamgirls.* She didn't expect to win, but she did. *I was really feeling my Cheerios! How do you like me now?* She loved the applause, the spotlight, and of course the money. *And that was the birth of Shannon Dupree.*

Shannon's philosophy of looking and learning before indulging in anything began there. She draws inspiration from a number of fellow drag legends—Tasha Long, Mimi Marks, and the late great Ginger Spice, *the queen of 219 and La Cage*. She described seeing the thin white woman successfully perform songs by Black performers and knew she could turn it out even better. Beyond the legends, Shannon claims to be inspired by anyone practicing the art who remains personable, positive, and respectful.

Shannon reminisces about the days when the girls were supportive of each other. She misses that sense of cohesion, of comprising a unit together. Like many seasoned queens she remembers when collaboration was as important as competition. *These days everyone is out for themselves. Everyone is so cutthroat now.* When last we spoke, she lamented the way *Drag Race* has, in her words, *diminished the art form. Everyone wants a shortcut but doesn't want to use the foundation—the padding, the tucking, the paint—we've established. They think we are old school, but it's just the right way to do it.* She worries about new girls modeling their performances off what they see on television, rather than learning the actual craft of drag.

Shannon claims no drag daughters—*Daughters? Hell no! Daughters are a handful. I have sons who love their mama*—though she acts as something of a drag auntie, most notably for Jaida Essence Hall, Milwaukee's own winner of *Drag Race* season twelve. Despite her trepidations about televised drag, Shannon still prayed for Jaida to win. Fresh off Jaida's win, the pair celebrated over dinner just a few nights before our shoot. Shannon described the pride she felt in seeing Jaida's growth as a performer from the very beginning. *She found her way, perfected her look, transformed seemingly overnight. She showed the entire world who she is.* Shannon called Jaida an amazing seamstress and credits her as one of the queens of the upcoming generation who truly took the time to learn and perfect the craft. She described feeling honored when her niece told her: "I learned from you and I applaud you."

Throughout her career Shannon has always had a day job, working as a server at Maggiano's, an Italian restaurant, and as the show director at Hamburger Mary's for a decade. Both jobs began the same year and she's been a mainstay presence at each ever since. She also worked as a ticket-taker at Universal Studios during her six-year stint (1996–2002) in Orlando. While in Florida she performed too, having the opportunity to grace the stage of the now-shuttered, legendary Parliament House. She traveled from Florida to Chicago to compete in Miss Continental and Miss Universe. Despite her time away, she inevitably returned to Milwaukee.

Her home in Milwaukee was always Club 219. She called it *the show* for her. She recalled Sunday night shows with lines around the block just to get into both 219 and La Cage. The entertainment value at the former was unmatched, especially the Monday nights when they brought in male strippers and locked the doors. *We had a great time—these guys were supposed to be straight*, she chuckled, *but it got buck wild in there.* She took it all in with a bird's-eye view from the upstairs dressing room.

When we asked her to speak on the differences between Club 219 and La Cage, she put it this way: *La Cage had a history—and I don't sugarcoat anything—of being a little more racist and having more drug use. So I gravitated toward 219.* She did work on cast at La Cage for a while and said that things changed some during her time there. *They know I don't bite my tongue for anyone. I didn't want anything around me that resembled a drug so they kept it away from me if I was working that night.*

Shannon's aversion to drugs actually kept her from serious trouble during a particularly dramatic incident that occurred at her very first pageant in North Carolina. She placed Top 12 (seventh overall) out of forty-four queens. The pageant organized the girls into competition groups and she

> "They know I don't bite my tongue for anyone."

was put in a group with a queen who always won. That queen underestimated the newcomers and was dismayed when Shannon advanced instead of her. In retaliation, she called the police and claimed that Shannon and her dancers were on drugs. The police responded by raiding everyone's rooms. They found drugs in every room but Shannon's. Titleholders and board members alike were arrested, and everyone had to be bailed out before the show could go on. The queen who snitched judged Shannon in a pageant years later and apologized for the incident. Shannon reflected on it as a *bittersweet entrance to the pageant world.*

Shannon tries to not get caught up in the foolishness, though. *I had some hateration early on but it only makes me more relevant now.* She still prefers to hang with the girls who remain drama-free. She discerns the real from the fake. *You can always tell when someone is blowing smoke up your ass. People will always tell on themselves.* Again, her philosophy of patient awareness and observation serves her well. *Just sit back and observe. Even in the dressing room while painting, people will talk and they'll inevitably tell on themselves.*

Among the drama-free girls, she counts many of Milwaukee's drag legends as sisters. She's known BJ Daniels for thirty years, since the Club 219 days. *BJ has always been team Shannon and I just love her.* Shannon met BJ alongside Ginger Spice, as the two were good friends back then. Shannon recounted the honor of crowning Christina Chase Miss Gay Wisconsin when the latter won the title. After our time shooting in Milwaukee, and mid-pandemic, Shannon joined a handful of the legends (including BJ, KV, and Ruthie Keester) for a Legends Brunch at Hamburger Mary's. Shannon described a cute, intimate crowd on the rooftop patio that afternoon. She said it was great to get together with the other girls to do what they do best.

Shannon identifies more as an entertainer than a pageant girl. She reported having those moments with a Patti LaBelle song or "I am telling you . . ." where the performance becomes spiritual, but more than anything she loves to move and have fun. *I love to move, roll on the floor, kick off my shoes. I want the audience to be captivated, enthralled, entertained. My body may be tired or I may be sick as a dog, but once I get on that stage and the lights hit, you'd never know.* She gives it all to the audience, but derives her own enjoyment too. *The day I stop enjoying it, I'll be done.*

Shannon doesn't follow trends. Born on the cusp of Capricorn and Aquarius—known as the Cusp of Mystery—she's independent and creative, but with a reverence for the traditional. Those born on that cusp are energetic, expressive, and charismatic. Shannon hits all those marks. It took her competing in twelve pageants before she won a title, but her endurance paid off. *The titles came later.* She expressed some skepticism with regard to the systems. Over the years she's seen promoters grooming contestants they wanted to win. Still, though, she maintains that *if you have your ducks in a row, and go in with tunnel vision, and do what you need to do, they simply cannot deny you.*

A celebrated and crowned Black performer in a city known for its racism and segregation—Shannon's majesty truly cannot be denied. After our shoot she confided: *I'm getting older and want to take a step back and just have fun.* Whatever form that fun takes, it'll surely be infused with the mystery and mastery of craft that Shannon exemplifies.

> "If you have your ducks in a row, and go in with tunnel vision, and do what you need to do, they simply cannot deny you."

The Sugarbaker Twins

MILWAUKEE × **SCORPIO**

The Hamburger Mary's brand earned a reputation for serving up burgers and drag in equally hefty portions, and Apple Brown Betty and Cherry Pi Sugarbaker reign as Mary's matriarchs. Their career as drag restaurateurs began in 2006, when the twins opened a Hamburger Mary's franchise in Chicago. A few years later they took the opportunity to purchase the brand nationally, which at the time had only four locations. The joint didn't begin with them—the first opened in 1972, the year the twins were born—but they redefined it. They grew the four locations they inherited to twenty at the peak of their success including Berlin (Betty speaks German fluently and Cherry gets by). The business took a hit during the pandemic, but they currently claim sixteen locations.

Their approach to drag is as fastidious as their approach to business. The twins arrived early for our shoot, fully dressed and wearing matching Keds. We staged their flamingo fantasy scene at one of Milwaukee's most distinctive lawn art installations, in front of the Riverwest home of Anthony Balistreri and David R. Jones. The bisected Cadillac emerging from the ground is one of three automobiles that decorate the yard. Balistreri owns Downtown Auto Body, whose slogan—"If we can't fix it, we'll bury it!"—adorns a weathered bumper sticker on one of the Cadillacs.

Regarding the subtitle of this book, Cherry Pi retorted, *Well, SHE'S of a certain age, but I'm ten minutes younger!* The identical twins, born Ashley and Brandon, recounted the story of the order of their birth: *A comes before B; Ashley before Brandon. Also B comes before C; Betty before Cherry.* Their parents thought surely they'd have daughters, so only finalized girl names. When the nurse turned to their mom and said, "You have two beautiful baby boys! What are their names?" their drug-induced mother responded, "Laura Angela and Tara Yvette." The nurse determined, "She's not ready for these yet," and sent the twins home as Baby A and Baby B with one of their toenails painted red. *It explains a lot.*

The twins grew up in Austell, Georgia, and attended Auburn University in Alabama. After college, they parted ways for a time: Cherry moved to Chicago and Betty moved to DC, where the firstborn first got into drag. She managed a bar called Cobalt and needed a drag queen to fill in for a karaoke hostess on vacation. She acquired a beehive wig, named herself Apple Brown Betty

(she loves to bake) and filled the position herself. Betty became so smitten with her new role that when the former hostess returned from vacation, she fired her and kept the job. *And she's been a bossy bitch ever since!*

When her sister came to visit, Betty compelled her: *Why don't you buy yourself a wig and I can do your makeup and we can cohost karaoke.* Cherry worked as a chemical engineer for a decade and so she took the middle name Pi as a nod to her scientific background. *Betty would host the show and Cherry Pi would get drunk at the bar. That's our schtick, and it's been going for twenty years.*

The sisters again expanded their drag empire when they hatched the idea for *Camp Wannakiki*, the first drag competition show to focus explicitly on campy, comedic drag. The campers compete in physical outdoor challenges, but winning the challenge is less important than doing it with panache. The Sugarbakers figured their role as owners of the world's largest

> *"That's our schtick and it's been going for twenty years."*

drag restaurant franchise qualified them to serve as judges. The show does offer opportunities to promote Hamburger Mary's, but their primary goals are to have fun and spread joy, not make money. Now in its fourth season, the show is bigger and better than they could have imagined, and as the global demand for drag content increases, their audience continues to expand. Their previous television experience was limited to an episode of *Undercover Boss*, but they insist that episode remains among the most syndicated of the whole series. *The gay angle, the twin angle; there's drama in it. It's a good episode!*

The twins are extremely proud of their ability to have an idea and see it through. Ruthie Keester agrees: "Once they set their mind to something, it's amazing what they can accomplish. There's also two of them, so I guess that helps." They don't wait for permission or for others to steal their plans. When the pandemic hit, Hamburger Mary's quickly pivoted to offering drive-in drag shows before everyone else was doing it. The Sugarbakers never had drag mothers or mentors; they built their style themselves from fifties and sixties mod and the influence of America's most iconic campy queens: Miss Richfield 1981, Miss Coco Peru, and Varla Jean Merman. Within the canon of drag queen names, the twins' are truly phenomimes: their Southern homemaker style is pure saccharine confection, with all the trademark hospitality and none of the judgment—unless you're a camper.

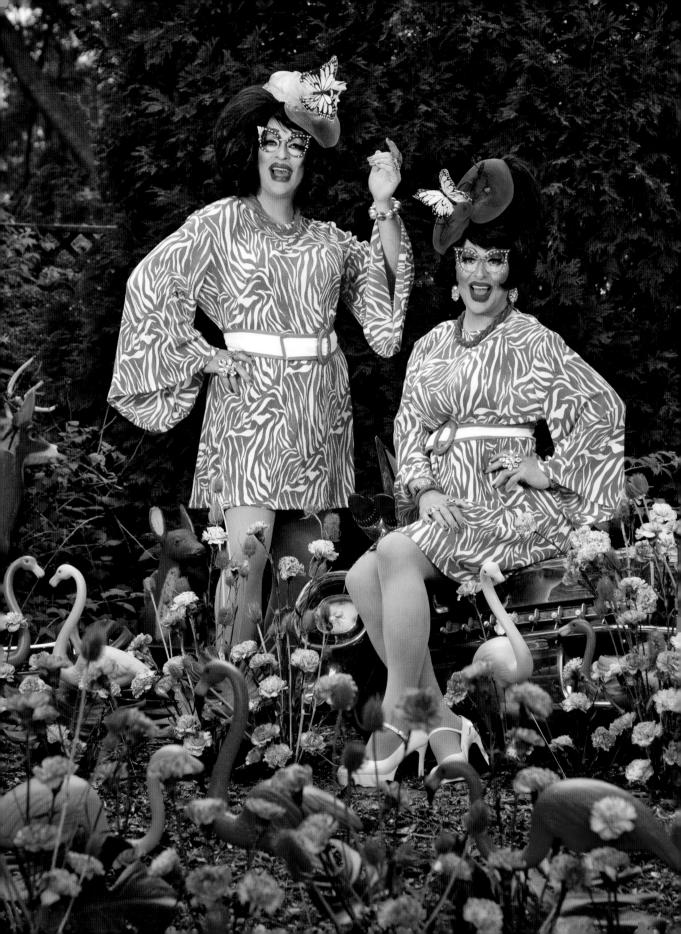

Ruthie Keester

MILWAUKEE × PISCES

Most queens begin their careers onstage; Ruthie's began at a typewriter. In 1997, she pitched an advice column to *Wisconsin Light*. To add an air of authority to her writing, she selected a photo of her in drag on Halloween as her author portrait. There wasn't another local advice column in town at the time, so *Dear Ruthie* became an immediate hit. Her signature toothy grin, retro glasses, and sixties hairdos appropriately suggest the cool aunt you can ask about fellatio or the neighborhood raconteur who dispenses advice over the fence in between drags of her cigarette—whether you want to hear it or not. Even in her early years, Ruthie always carried herself as a *queen of a certain age*.

Initially, she didn't plan to pursue drag in the flesh, until the paper started receiving requests for appearances. She made her debut at the Madison Pride parade, in the back of a pickup truck. *I was absolutely shocked by the response! This huge crowd kept stopping the truck to take photos with me.* Soon after, Karen Valentine presented her with the opportunity to perform at the fabled M & M Club in Milwaukee, and Ruthie figured, *Why not, what the heck?*

She opened that night with a Bette Midler standard, but wasn't fully feeling the fantasy. For her second number she gave a comedy routine poking fun at the Clinton administration, and then it clicked: *Oh my god, I need to be the funny girl. There weren't a lot of comedy queens in Milwaukee at the time. At my next show I did two comedy numbers, and then I started getting bookings everywhere. I've always stayed true to my funny campy, bawdy style. If I tried to be the beauty queen, I wouldn't have made it. People said you've gotta take off the glasses. No! That's the look! And now I've got dozens of red wigs, because when people go to see me, they want to see ME!* She's right, of course: an icon requires a well-articulated iconography. If you're wondering whether the carpet matches the drapes, she's had it replaced with hardwood floors.

After establishing herself on the scene, Ruthie expanded her media empire to the small screen, picking up a roving reporter gig with *The Don and Bo Show*, airing weekly on the local CBS affiliate. She then went on to host her own YouTube cooking show, *Ruthie's Bitchin' Kitchen*, focused on preserving sacred Midwestern traditions such as repurposing fast-food hamburgers into casserole, putting cheese tortellini on a stick, and how to cream your own corn in a slow cooker.

Hamburger Mary's Milwaukee opened in 2011, and once again the will of the people scored Ruthie the booking. *I'm told they were getting a lot of calls from people just assuming that I worked there, so I got a call from the manager who said, "Milwaukee seems to think there's a place for you here."* She hit it off with the Sugarbaker Twins right away, and started hosting bingo once a week, then twice a week, then weekend shows, brunches, charity nights, and special appearances as her alter ego: Sister Mary Ruthie, the ventriloquist nun.

When the Sugarbakers devised the concept for *Camp Wannakiki* in 2018, they called Ruthie first, inviting her to be a camp counselor. Ruthie armed herself with a bullhorn and a watertight girdle, and they put the entire first season together in just six weeks. *People don't realize we're actually camping when we film it. There's no going back to the hotel after the shoot. We're in the woods in drag for ten days straight, fourteen hours a day. It's very "in tents."* To Ruthie, the audience's reaction determines superlative campy drag. *It could be burlesque, stand-up, or a show tune, but overall, the end result is laughter and happiness. It's got to be fun!*

Shortly after our shoots in Milwaukee, Ruthie produced a Legends Brunch, starring alongside the hometown legends. *When we added it up, I think it was like two hundred years of drag performing on one stage? It was a little overwhelming. As we get older, our audiences get older, so it was nice to see some of the crowd that maybe doesn't come out to the bars at night.*

Offstage, Ruthie still writes her advice column (now as a weekly for the *Shepherd Express*) as well as a local events roundup, keeping her finger on the pulse of the city. Over the years, she estimates she's helped close to a thousand lovesick queers, insecure virgins, neurotic sugar daddies, bear chasers, and nosy exes (or as she calls her readers, *sugar-boogers*) get a grip. The problems they write in with change very little, but she keeps *Dear Ruthie* fresh by always staying *sincerely Ruthie*.

> "If I tried to be a beauty queen, I wouldn't have made it."

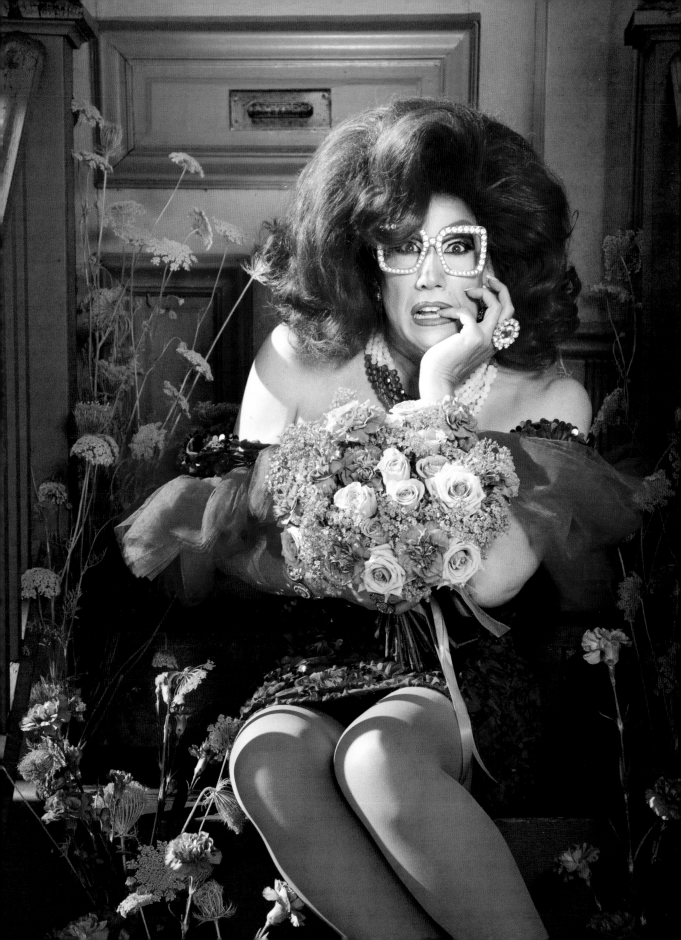

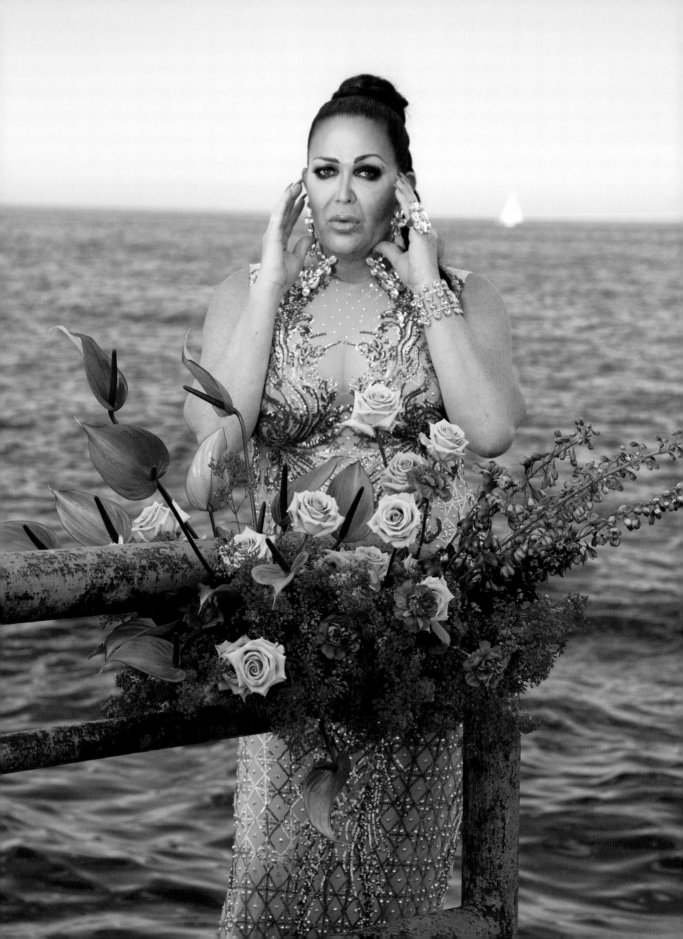

Christina Chase

MILWAUKEE × **AQUARIUS**

Can you hear her siren song? The femme fatales of antiquity, the sirens were known to lure young sailors to their deaths with their music and irresistible beauty. And what sailor could resist the vision of Christina Chase? She emerged from the water in her shimmering iridescent sequin gown, embellished by hand with thousands of aurora borealis crystals. Her domain is not the Aegean Sea, but rather the waters of Lake Michigan. When she told us she'd always dreamed of doing a photo shoot at the lake, we were determined to help her realize the fantasy. She clearly brought the drama.

On land, Christina turns heads wherever she goes, especially when cruising the streets in her silver Mustang, complete with a rhinestone-encrusted vanity plate. Sunglasses on, hair blowing in the wind, blasting AC/DC on the stereo, she's truly fast and fabulous. It's no wonder she calls herself Chase, and you better be prepared to keep up.

Christina always had to forge her own path. She told us a tale of a wicked drag mother, *one of those old-school evil shady drag queens who wanted to make you look bad to make herself look better*. But she failed to stop Christina—*Once I saw how good I looked in drag, I never got out*. She primarily learned the tricks of the trade on her own. Once she'd broken free from the clutches of the evil queen, in 1987 she started working with a troupe in Philadelphia, the *Dollhouse Revue. I was just a chorus girl in the production numbers, because all the good characters were already taken. My first character was Carol Channing, believe it or not.*

When she got a job working for an agency in New Jersey, she left the Channing drag at home. The gig involved stripping for bachelor parties and birthdays. *I'd ask, do you wanna see my tits? Then I'd pull down my bra and my fake tits would fall out. Later, when I grew my own tits, I had to pull my G-string down.* The drag striptease dates back to the vaudeville era, and primarily entertains straight audiences, for whom the performer's ultimate revelation shatters the illusion of heterosexual desire as an impenetrable dogma. When a cis male drag queen performs a strip, there's an implied element of trickery for comedic effect, but when a trans queen removes her G-string she reclaims the power denied to her by a society that says she must hide or conform.

> ## "I was ready to spread my wings and compete."

The line between doing drag and doing sex work is often blurred, though many pretend just the opposite. Christina repeated a familiar maxim we've heard from many of our models: *Drag was something I had to do because I didn't want to work the streets. When I first started performing, you were either a showgirl or a hooker.* The theatrical tradition of drag affords a layer of protection that the oldest profession does not.

Making good money, Christina started going out in Philly more, and getting booked for guest spots. She gravitated toward performing old-school musical numbers. *Then I found out about pageantry, and I was ready to spread my wings and compete. It was 1990, Madonna's "Vogue" had just come out, and I was working at a club called Stars. Joey Venuti owned Stars, and I was his beauty queen.* Venuti appears as a pageant organizer in *The Queen* (1968) wherein he consoles eventual winner Harlow during her pre-pageant meltdown. *I crossed paths with Harlow all the time. People used to tell me, "Oh, you're gonna be the next Harlow."* That turned out to be a mixed blessing: when Christina won one of Venuti's pageants at Stars, she ruffled feathers within the local scene. She learned the hard way to *stay humble, because when you're pretty they hate you.* With a laugh, she added, *and they'll do anything to destroy you!*

Christina competed extensively in the Miss Gay USofA system, first in Pennsylvania then Massachusetts, Iowa, and finally Wisconsin when she moved there in 1999. She won the crown at Miss Gay Wisconsin USofA in 2008, beating out twenty-four other contestants with a performance of "Big Time" by Linda Eder, which she recalls as one of her proudest moments. Despite her beauty and determination, Christina never snatched the national title. By her estimation, it boils down to the same shady politics that caused Crystal to read Harlow for filth in *The Queen.* *It's all about who has the sponsorship money, who likes you, and what you can do for them.*

When she won Miss Wisconsin Continental Elite in 2019, she nonetheless expressed excitement at having another shot at a national title. The pandemic interrupted those plans, and between the uncertainty of COVID and family obligations back home, she chose to step down. Now, she's keeping an open mind while pursuing opportunities outside of drag and plans to audition for plays or commercials. *If I need to play a pregnant woman or an eyeglasses model or somebody's grandma, I'll do it! It's certainly been a wild ride.*

CHICAGO

Chilli
Pepper

CHICAGO × LIBRA

At the center of Grant Park between Queen's Landing and Congress Parkway stands the regal behemoth, Buckingham Fountain. The Art Deco masterpiece is one of the largest fountains in the world, modeled after a water feature at the Palace of Versailles. Eight bronze seahorses adorn the quatrefoil basin made of elaborately carved pink Georgia marble. The central geyser at its zenith reaches over 150 feet, and hundreds of lights combine to produce symphonic displays. More than just a spectacular feat of design and engineering, this mystical lagoon is also known as Chicago's front door. Who better to stand guard at this portal than the Windy City's own sovereign queen, the incomparable Chilli Pepper? Two local landmarks juxtaposed, the landscape forever altered by their splendor.

Buckingham Fountain also happens to be one of Chilli's favorite spots, and she conveyed a clear vision for the portrait. *I have so many Bob Mackies, but why would I wear them during the day? At the fountain? No, I'll wear something simple, a crisp white blouse and Chanel.* Far beyond mere daytime realness, Chilli adeptly manifests her own reality. She can always count on a little help from her friends too. *Oprah thinks we should use peonies.* How could we refuse? A rain shower interrupted our shoot, but Chilli fearlessly braved the elements. Her luminance broke through the clouds.

She invited us to dry off over a drink at the nearby Peninsula Hotel, within The Magnificent Mile. *It's the best hotel in the world.* Though admittedly underdressed for a five-star hotel bar, only a fool turns down an audience with Chilli Pepper. The Peninsula staff justly treats her like royalty, and she knows each of them by name. In a scene reminiscent of Harmonia Gardens, the waiters in their penguin uniforms flit about and dote on her majesty, always on hand to top off her glass of rosé. Every woman in the room carried a Chanel purse, though Chilli was the only one to sport matching earrings. As we laughed and chatted over drinks, the full velocity of Chilli's power came into focus. Her fierce aquamarine eyes, almost feline in their intensity, annihilate any airs of pretension. Her sharp tongue

and sharper wit will make your head spin. She can read you for filth and you'll love every minute of it. *I like to carry on,* she offers coolly. Hold your own amidst her torrent of seduction if you wish to prove yourself worthy.

We reconvened after nightfall at the Baton Show Lounge, where Chilli performs three days per week, three shows a night. A larger-than-life portrait of her hangs in the lobby. In contrast to Chilli's daytime modus operandi, Chilli Pepper the entertainer commands the spotlight with ostentatious flair. That evening, Chilli showed off her killer legs in a jaguar print mini dress, cut with an asymmetrical neckline to expose her supple shoulder. She performed "Real Man" by Bonnie Raitt, imbuing the lyrics with confrontational archness. For her second number, "Rescue Me" by Fontella Bass, her black fringe dress created a frenzied, kinetic energy as she swung her arms and gyrated to the soulful rhythm. Above all others, Chilli loves to perform Millie Jackson—her lyrics rife with double meanings that unmask hidden truths.

Chilli gives you just enough to tantalize without revealing too much. She thrives by waltzing that imaginary line, enveloped in a cloud of intoxicating perfume, in total control of her deftly crafted persona. A mistress of illusion—*my own cartoon*—Chilli reveals a gilded two-way mirror transcending space and time. Each new audience a freshly plucked batch of initiates ready to be subsumed. As Chilli works the room collecting tips from her many acolytes, she anoints each of them with her ambrosial essence—spicy and sweet.

The Baton's legacy dates back to 1969, its first stage constructed of plywood and sixteen beer crates. Founder Jim Flint still runs the joint, without question the premiere destination for female impersonation in Chicago. Chilli attributes the Baton's staying power to the strength of the sisterhood behind the scenes. The tight bonds forged with castmates including Maya Douglas, C'ezanne, Mimi Marks, and Dana Douglas (each legends in their own right) fortifies her loyalty to the establishment. *It's the people who have made that business a success, out of necessity. The performers who also created their own cartoons, and survived.* Over the years, Chilli bore witness

> *"It was just a campy thing."*

to a demographic shift within the audience, now a mostly straight crowd. *They were curious. As we gain more exposure, it becomes fashionable. It all becomes mid America.*

Chilli's hyperterrestrial sentience results in a glossy view of her personal history. *I was a teenager, and I won a little tiny contest, a little thing. You do a gig for fun, you know?* She lives in the present, but a lifetime of tenacious iconoclasm hides beneath the mantle of glamour. *You just start doing it, trying to find your music and your place in this business. I guess I got the fever.* Chilli settled permanently in Chicago in the early eighties by way of the Detroit suburbs. She derives her name from a sunburn acquired on a vacation to Chilé, her skin so ardent red it warranted comparison to the fiery fruit. The alias twice earned through her piquant persona endeared in the hearts of millions. Victory at Miss Gay Chicago 1974 illuminated her path to stardom, and afterward she booked a few guest spots at the Blue Dahlia. There, Flint saw her for the first time and knew she belonged at the Baton, her home ever since.

Beyond her longevity, Chilli's mythic status is compounded by her distinction as the very first Miss Continental—the prototype, the blueprint, the original. Linda Clifford personally bestowed Chilli with a tape of "Red Light," then unreleased, and Chilli's superlative pantomime bested all the other talent. Each year since, audiences eagerly anticipate her appearance in the parade of former Miss Continentals during the opening ceremony. The previous champions parade in spectacular costumes all surrounding a theme: alien queens, Egyptian goddesses, feathered showgirls, gothic beauties, flowers personified. Without fail, Chilli dominates the catwalk. Though her successors represent top talents in the industry, many seem timid in comparison.

Flint founded Continental in 1980, after he witnessed discrimination and a lack of professionalism within the Miss Gay America system. Unlike MGA, Continental permits contestants with surgical enhancements below the neck, and those who take hormones. The third of the "big three" national pageants, Miss Gay USofA, began around the same time, and is likewise inclusive of contestants who live as women. Many entertainers compete in both systems, though Continental

has a reputation for crowning showgirls with a winning combination of beauty and personality, versus presentations that showcase higher production value, more sequins, bigger hair. The reciprocal relationship between Continental and the Baton further distinguishes it from any other pageant system. The two institutions form a unique ecosystem wherein the success of each bolsters the prestige of the other, both lovingly guided by Chilli's transcendent superiority.

As the cult of Chilli Pepper grew, her devotees expressed veneration in increasingly creative ways. For Hugh Hefner's birthday one year, the Bunnies presented Chilli herself as a gift, emerging from a giant cake. *It was just a campy thing.* In Flint's biography, *Jim Flint: The Boy From Peoria*, fellow Miss Continental Dana Douglas recalls the opulence of rituals both public and private:

"Chilli performing in her heyday could go on stage and just say 'bring me' and make a gesture with those fingers and rings, and they would come with hundreds of dollars and diamonds and bracelets. Her birthday parties were legendary and always at some estate. There would be a throne set up, and she would literally be showered with gifts, mostly jewelry . . . The one who gave Chilli the best gift would then be her companion for the party, so it would become these great competitions between a lot of very powerful and influential people."[1]

Chilli's reputation earned her invitations to all the top talk shows of the eighties and nineties: Oprah Winfrey, Phil Donahue, Joan Rivers, Jenny Jones, and Jerry Springer all interviewed the legend during her meteoric rise. At a time when queer and trans portrayals in media were ignorant at best, and openly antagonistic at worst, Chilli always remained unflappable. *Some people don't understand your way of living, maybe they never will. But they allowed me to speak.* As she confidently told Oprah in 1987: *I'm a bionic woman.* She frequently used her platform to advocate for AIDS awareness, both on talk shows and performing at charity events during the early years of the epidemic, before Ronald Regan publicly acknowledged its existence. *I'm not trying to be Mother Teresa, honey! But I saw the devastation going on.* For one benefit thrown by Donna Karan, Chilli served as a living mannequin. A fundraiser she hosted for Bonwit Teller received press in *People* magazine, constituting their very first coverage of the issue.

Though at times outspoken, Chilli conducts her personal affairs with the utmost discretion. Chilli does not text or email, preferring to communicate only via her landline. *I don't want my conversations ending up in the* National Enquirer. Even Divine herself, seeking advice on where to buy size 13 pumps while in Chicago, experienced difficulty obtaining Chilli's number. Consequently, her Rolodex is one of her most powerful assets. Chilli's friendship with Oprah dates back to the mogul's first month in Chicago, and the pair never miss a birthday. Her connections extend far beyond entertainment, into the highest echelons of politics and industry, but Chilli isn't fazed by celebrity. It doesn't matter who you are, she won't hesitate to call you *Mary.*

> *"I've never done a character. I am the character."*

In each of the arenas where queens test their valor—on stage, on television, and in pageants—Chilli proves an indomitable force. Inducted into the Chicago LGBT Hall of Fame in 2007, her associated bio correctly states, "She has become a Chicago institution, much like the Water Tower, only with better jewelry." Her singular career set a precedent for mainstream success long before drag entered the zeitgeist, and she wields her power unapologetically. *If you don't understand it, you don't like it, you don't get me, I'm sorry to hear that. That's your problem, Mary. I'm going to be OK, I'll look in the mirror tomorrow and love myself. Most people are afraid of themselves.*

The root of her confidence runs so deep that she professed she'd never stopped to think about it. *I really don't know, maybe it's the injection of love from the people that I entertain.* That love is a bottomless well, a fountain of youth, the source of Chilli's greatest wealth. If perception is reality, Chilli Pepper exists in infinite deviations, each containing subjective truth and ineffable mystery. *It's my illusion, but it's still the real me. I've never done a character. I am the character.*

1. *Jim Flint: The Boy From Peoria* by Tracy Baim and Owen Keehnen.

Maya Douglas

CHICAGO × VIRGO

Following our shoot with Maya out in front of the Baton Show Lounge, we caught her performance there that same evening. She wore a bedazzled pink and blue dress of undulating neoprene ruffles for her 4 Non Blondes remix—"*And I pray / Oh my god, do I pray / I pray every single day / for revolution*"—Maya's performance electrified the audience. Backing her prayer with action, Maya revolutionized the art of drag from her very beginning. *I love seeing drag's evolution over the last forty years. I'd like to think I was part of that evolution too: I wasn't like the other girls in my hometown.*

Maya's drag career began at the age of eighteen in Rochester, New York, on Valentine's Day 1980. She made a kimono-style dress for her first public appearance. *I was a hit.* The bookings haven't stopped since. Rochester in the early eighties functioned as a regional hub for drag, with performers coming from Buffalo, Syracuse, and even Toronto. *All the other performers in the area were still in that seventies look: big, teased hair, etc. I came out in a nylon jumpsuit—electric purple with red patent leather boots and belt—doing "Do or Die" by Grace Jones. The performers did not care for me much, but the audience ate me up. It was current, new. I started doing shows once a month and eventually became accepted by the other performers.* Maya earned that acceptance, in part, by way of pageantry. She won the title of Miss Jim's 1981, *a stepping-stone to Miss Gay Rochester,* later that year. From there she went to Syracuse to claim Miss Central New York in 1983.

In 1984, at the encouragement of her gay uncle, she entered Miss Continental, placing sixth. She returned the following year with an *Egyptian-inspired* interpretation of Afrika Bambaataa's "Planet Rock"—complete with *a throne effect: two people behind me with their arms out* creating the illusion of a *goddess with six arms.* To everyone's surprise, the *young and unknown* queen from Rochester took the crown. *I was twenty-three, the youngest winner at the time. It catapulted me into the national spotlight. It was a quick learning curve*—including the art of applying makeup in airplane bathrooms!

Her entrance into pageantry initiated lifelong friendships. She met Dina Jacobs at Continental in 1984. That year Dina placed first runner-up, and the pair reconnected at Miss Gay USofA 1987 in Columbia, South Carolina. *We had a whole week together to get to know each other. We still talk every day,* and Maya actually made the dress Dina wore for her own portrait.

Through Continental, Maya also met Chilli Pepper. *Coming from Rochester, I was clueless to the national scene. She had a big name, but I didn't know who she was yet. After the pageant we went out to grab a late-night bite at a diner on State Street called Tempo. I've known her ever since.* Their friendship remains a daily presence in her life: Maya drives Chilli to work every day. If Maya demonstrates an ongoing devotion to her sisters, she does so knowing the precious quality of their time together: *We've seen so many of our sisters pass, most recently Tina Devore; it has not been easy.*

Maya joined the cast at the original Baton in 1987. *When I first came there it was all wood with just a little window. People loved it, but it was still taboo.* She befriended Shanté (Alexandra Billings) and Kelly Lauren, and the three became roommates. *At the club, we were the three new kids on the block. Doing three shows a night, you really hone your craft. I'm more laid-back and easygoing now, but back then I was doing Grace Jones and Eartha Kitt, not afraid to look people in the eyes—an almost intimidating force.*

Winning Miss Gay USofA 1995 required Maya to take time off from the Baton. In 1996, before departing on a six-week tour, Maya *got into a huge fight* with Baton owner Jim Flint. She walked into the lobby and used the payphone to accept a job offer from the Rose Room in Dallas. *He said, "Don't come back," and I didn't for twelve years. Texas just catapulted my career even more: Entertainer of the Year, Universal Show Queen.* Maya made up with Jim in 2008 and returned to Chicago to be closer to her parents. Today her portrait hangs alongside Chilli's on the banner in front of the Baton.

Maya shares the experience gleaned from four decades on the stage and five national titles with the next generations as a loving drag mother and as judge for both Continental and USofA. *Girls ask what we're looking for, but I tell them we don't know until we see it.* Maya advises that an aspiring queen needs humility and spirit. *I see girls who can be beautiful on stage but there's no life to their performance. You need that little bit of magic in your eyes, that it factor; it makes all the difference in the world.*

> "I wasn't like the other girls in my hometown."

JoJo Baby

CHICAGO × ARIES

JoJo Baby's biological mom played double duty as drag mother, a rare circumstance that opened the door to a lifetime of mischief and magic. As JoJo puts it:

My mother was a Playboy Bunny at the Bunny Club downtown. She made her money with Playboy *and put herself through medical school. She started working for an HMO for the Teamsters; her first boss was Jimmy Hoffa. She would always tell my dad: "I had princes and kings and actors hitting on me all the time, and I chose you!" I'm sure she had some stories to tell. She did have a wig room. I always wanted to be in there trying on all the wigs. She taught me how to sew. She gave me my stage name too. She'd wake me up every morning: "JoJo baby, wake up!"* She inspired JoJo and her brother to become performers, beginning by enrolling them in Polish dance classes at a young age.

My mom always said if we wrote a book about our lives, nobody would believe it. I still don't think people would believe some of the things I've lived through. Sure enough, JoJo survived ordeals that could make the toughest drag queen squeamish: she once woke up in the middle of an operation with a doctor's hand inside her. *"How's everything going down there?"* she joked in the moment. She once stitched herself back up after slipping and falling on the job. *I don't think I could do it sober, but I did it then. I've lived a crazy life.*

Gory details aside, even JoJo's resume defies the ordinary limits of belief. *I get really weird gigs all the time.* When last we spoke, she just agreed to work as a ghoul at a haunted drive-in theater for three weeks in October. *I get to change my style though; they trust me to be scary.* Reliably freaky, she's worked parties for the likes of nightlife notables such as Susanne Bartsch and Paige Powell. Not solely reserved for the club kid elite, however, JoJo shares her otherworldliness with the masses too. The Museum of Contemporary Art Chicago asked JoJo to dress up as David Bowie and guide people through the collection during their Bowie exhibition. Bringing her inimitable style to the silver screen as well, JoJo appears as an extra in—and contributed her own wardrobe to—the film *Party Monster* (2003).

When she first heard about the film, she first reacted with incredulity at the omission of her part in the story. *We hid Michael Alig here in Chicago. We didn't believe he could actually kill somebody.* Eventually the producers thought wiser. *Somebody from their crew reached out to me and said, "We understand you're a club kid. Do you still have any of those clothes?"* to which she replied, *"I do, but it's all made to fit me."* They followed up by asking if she'd ever thought about being in the movies. *"I'm a star in my own head,"* she told them. *"We're getting you a plane ticket." It cost me $7,000 to ship all those clothes back and forth. They never paid me, but I got an honorable mention at the end of the film.* The experience paid off in other ways though. *My first day on set, I had Macaulay Culkin and Seth Green dancing around me in their Fruit of the Looms and thought, "I cannot believe my life right now!"* JoJo reputedly told Seth she'd like to fold him in half, put him in her suitcase, and bring him home. He politely declined the trip.

JoJo's flirtations with the boys on set exist within a varied constellation of encounters throughout her life: *When you have a certain energy in your body you draw certain people toward yourself, and I always get stars drawn to me—all the time!* She once bumped into Angelo Moore of Fishbone on the street and said, *"I love you. Can I buy you breakfast?"* While running to catch a flight, she crashed into Barbara Eden. She met Debbie Harry and appeared on *The Jerry Springer Show*, *Leeza*, and *The Jenny Jones Show*. Moby once tapped her on the shoulder and asked to take a picture with her. *"Let's take a whole roll!"* When she ran into Leonardo DiCaprio in the bathroom at Boom Boom Room, she made a point to tell him *Total Eclipse* (1995) ranked among her favorite films. *It's one of the movies he regrets doing; he hated that he did full nudity.*

Beyond the chance encounters, JoJo counts meeting two of her three heroes among the best moments of her life. *I met George Michael in the VIP room when he was still in the closet. He was playing pool, and someone was sticking a pool cue up his ass. The*

> *"I still don't think people would believe some of the things I've lived through."*

second, Clive Barker—director of *Hellraiser* (1987) and *Candyman* (1992), and writer of *The Midnight Meat Train* (2008)—produced a feature-length documentary about her life called *Clive Barker Presents JoJo Baby: Without the Mask* (2010). While working on the film, JoJo confessed her hero worship to Barker. *I told him, "I've met both of you but will never meet my third hero: Jim Henson, because he's dead." He told me to "grab a shovel."* Barker recounted to her that he heard the news of Henson's death while at a radio station to record an interview with John Cleese of *Monty Python's Flying Circus.* Upon hearing the news, Cleese became so inconsolable they couldn't proceed with the interview. *Clive told me, "I'm glad you put me with the caliber of those people."*

On the experience of getting to meet her heroes, JoJo says: *My fourteen-year-old self is doing cartwheels without underwear on! My advice for my younger self would be to be nice to everyone you meet because you never know how they're going to help you in the future. My friend Rusty Nails introduced me to Clive and changed my life. The film became part of some collection about gay icons. I guess I'm a gay icon now?*

"Icon": derived from the Greek *eikṓn*, meaning "likeness," as in a work of art fashioned in the likeness of a god. Following that etymology, JoJo achieved icon status in the mid-eighties at the very inception of her drag career. *A bartender friend of mine thought I looked like Divine and asked if I'd do a Divine impersonation at the club Kaboom. Some people say my Divine is more than Divine. I did a caricature, so I overdid him.* She performed "Native Love," *which got the whole club going. That started it all—I was fourteen at the time. Nobody ever suspected the queen painted blue with a wig tied to her dick was underage.* While the beard obscures the baby-face Divine, JoJo channels her all the more for it. In a moment of surreality, easily at home in any early John Waters film, some snot-nosed kid interrupted our photo shoot to heckle—"Stinky drag queen!"—from behind a bush.

JoJo's affinity for divinity predates her drag. Before becoming a queen, she wanted to be a priest. *I wanted to give sermons*

> "I used to rip up outfits after wearing them once so I wouldn't do them again."

with black lights and puppets. Idolatry by other means, everyone told her to go into show business instead. Though never joining the church fathers, JoJo did become a sister. She founded the Chicago chapter of the Sisters of Perpetual Indulgence, though she reports notable stylistic differences from the other chapters.

Coming of age in Chicago's club scene, JoJo benefited from the mentorship and sisterhood of many of the city's drag legends. *I was doing guest spots as a teenager at the Baton Show Lounge. They were shocked when I asked to host my twenty-first birthday there. "But you've been performing here for quite a while!?"—"Yeah, sorry!" At the Baton I was doing more fishy drag, but still with an edge to it. I'd do Nancy Sinatra's "These Boots Are Made for Walkin'" while wearing three-foot-high platforms on stage, holding onto the ceiling! I got to perform alongside all the legends of the Baton: Monica Munro (my official drag mother), Mimi Marks, Sheri Payne, Chilli Pepper.* Chilli always tried to give JoJo makeup advice. *She said the way I painted made me look like I'd been beaten up. I told her, "That's what I'm going for."* JoJo also appeared in a staging of Charles Busch's *Vampire Lesbians of Sodom* alongside Honey West and Alexandra Billings.

Of Chicago drag, JoJo says: *We can give you the same caliber of drag as New York, but with less attitude. Whenever people come to visit, they comment on how all the queens here are so nice.* Which isn't to say she never received any shadiness. *I sometimes had queens that were like, "Miss JoJo, why are you looking so ugly today? You could be so beautiful. Snap out of it, girl!" My line is that I know I can be beautiful tomorrow; why not live ugly for a minute? I'm a Leo rising with a Libra moon, so that lets me know my shit stinks. When you look at me without makeup, I think of myself as a pile of clay and I'm very vulnerable. When the drag comes on it's like armor. I can cut you with my eyebrows. I can be ugly for five days of the week and be beautiful the other two.*

Indeed, we witnessed JoJo's immaculate looks on two occasions during our week in Chicago. She played hostess for a party called Queen! on the Sunday night before her shoot,

dressed like an acid freak druid in a leather tunic and heavy eyeliner. She never repeats a look. *I used to rip up outfits after wearing them once so I wouldn't do them again.* She's unlikely to destroy the yellow jacket worn in her portrait though, as a close friend bought it off Sylvester at a garage sale. She considered having it repaired but didn't want to lose any of its character.

Though not featured in the final portrait, JoJo brought her own entourage to our shoot: Peanut, an anatomically correct oversized doll. She created him out of old false breasts with inspiration from "The Babysitter" in *Scary Stories to Tell in the Dark*. Besides Peanut, JoJo's doll collection easily numbers in the thousands. *They've helped me through the pandemic. Friends were worried about me living alone, but I never get lonely. I constantly have a party going here because I'm surrounded by thousands of faces. The dolls are always there for you. My mother's godmother had a doll collection when we were growing up. She traveled so much and had dolls from all over the world. That's why I collect dolls from all over the world—I wanted to recapture what I saw as a child. I was always bugging my mom to see her collection and finally she said, "Why don't you start your own collection?" I don't think she knew what she was feeding into, but it's never stopped since.*

The collection includes several haunted dolls. Friends often report the sensation of things moving around her home. JoJo once asked her brother to dog sit, but he abandoned ship. *He said, "JoJo, I don't know what was walking and talking in your house, but I couldn't take it anymore. I had to leave." I should have mentioned that you just have to tell them to go to bed and it stops! Some of my dolls are portraits of people I love that I want to live forever.* She plans to recreate a family food-fight on a doll-sized *Jerry Springer* set.

JoJo shares her collection with the public, maintaining gallery space for over twenty years. *Eventually I put a line in the floor and said this is the collection and these are the dolls I make. My place has been used to demonstrate to art history students that you can make a gallery out of any space.* Fray Baroque, an editor

of *Queer Ultraviolence* (Ardent Press, 2011)—which chronicles the Midwest's homegrown queer anarchist youth network, Bash Back!—describes the impact of meeting JoJo at her home gallery as a teenager: "I was amazed. Mannequins, dresses, freaky shit, makeup and jewelry, pictures of all sorts of insane shit, headless things, stuff with only heads. There was absolute insanity everywhere you looked. I had never met a queer person like this before. I thought, 'Oh my god, I've finally found a person like me.' I finally found queer freaks. That was really my first exposure—outside John Waters films—to the real-life queer underground."

JoJo learned the art of doll-making from renowned artist Greer Lankton. *I first saw her stuff at the Alley, a punk rock store where she did the window display. One of her dolls said, "Please don't touch," but I had to. It felt like she stuffed a skeleton inside the fabric! I thought, "What the fuck is going on? She's killing people and hiding the bodies inside dolls."* When Lankton died in 1996, JoJo fashioned a doll out of her likeness for a show at the MCA. *I put her on a pink cross lined in pink lilies with a crown of syringes on her head. I wrote on the gallery floor: "Jesus died for somebody's sins but not for mine." They censored me and took off the syringe crown because children were present. They didn't know when they could give it back to me, so I ripped Greer off the wall at the opening and dragged her down the stairs and out the door. Being shown in a museum was always crazy to me. I thought you had to be dead to be in one.*

Whether making dolls or costumes, JoJo draws heavily on dreams, nightmares, and magic rites. *I do a lot with ritual. I take baths to draw love to myself. I hang old keys over my bed for good luck and protection. I'd love to be on* Dragula *because I'd be one of the real witches on there.* She confessed, coyly: *I dabble in a bit of witchcraft.*

> "Being shown in a museum was always crazy to me, I thought you had to be dead to be in one."

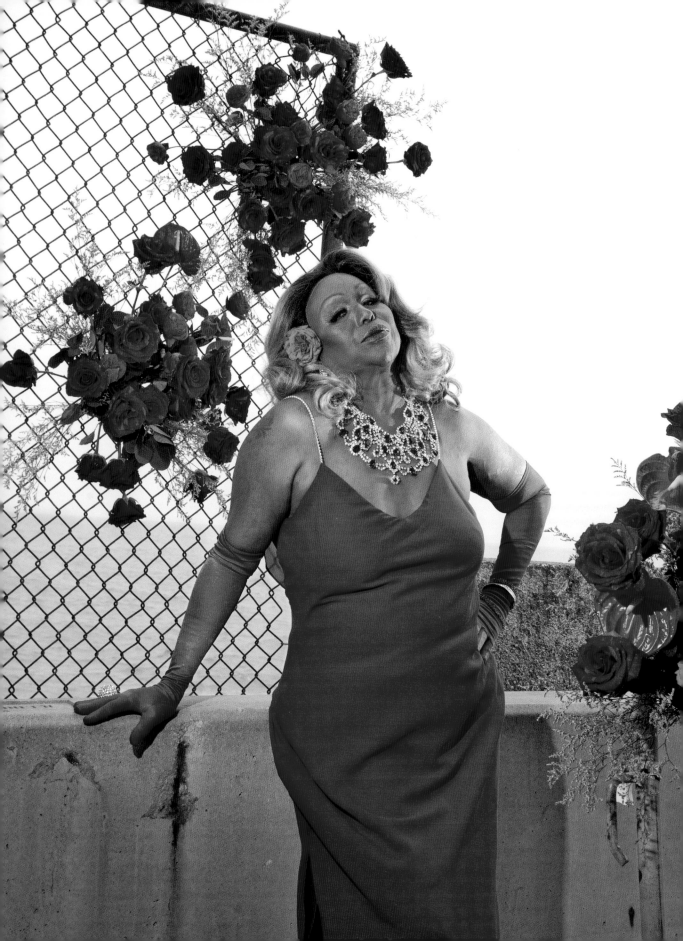

Capucine Deveroux

CHICAGO × **CANCER**

Capucine Deveroux stepped out onto Paradise Road to catch a cab. After clocking out late, she'd missed her friend's drag show, and felt ready to go home. Plenty of drivers worked Las Vegas's Fruit Loop, but the golden chariot that arrived at 3:43 a.m. was unlike the others. She had seen the cab in the area lately, tailed by a van with a conspicuously large satellite dish affixed to its top. *When the guy pulled up, I knew. I said, "Lord have mercy."* Against her better judgment she entered the portal. As she made herself comfortable in the back seat, a *truth serum* took hold—prescribed by her surgeon after a recent breast augmentation—and Capucine delivered an unforgettable performance, every moment captured by the hidden cameras of HBO's *Taxicab Confessions*.

"Do you dress in drag twenty-four seven?" the driver probed. *What do you call drag? I'm transsexual so that's a couple of steps up, honey.* The conversation quickly turned to her personal history. Capucine recounted her father's abuse, her early sense of girlhood, and her mother arming her with a butcher knife as defense against schoolyard bullies. *If you're feminine, people will try to take advantage of you because they think that you're weak. I used to carry a meat cleaver in my purse.* The cabbie fished for more details, "Did you ever have to use it?" *I taught a lot of people a lesson, honey. I had to literally cut my way through Chicago—cut, slice, stab.* After a stop at the Jack in the Box drive-thru, the discussion shifted to sex. *I'm a size queen. I'm not satisfied if it ain't thirteen inches, honey.* She answered the driver's invasive questions with blasé nonchalance. *I'm just a plain old simple little transsexual call girl, honey.*

A year later, Capucine had completely forgotten about her late-night confessional until the producers called to ask where they should send her $500 check. She signed a release the night of filming, so there was no backing out now. When the episode premiered in the summer of 2000, she was pleasantly surprised by her segment. *I said, "Wow, this is so funny!"* It resonated with HBO's late-night audience as well; she felt the impact immediately: *I couldn't go anywhere. I'd go to Red Lobster and the kitchen staff would come out talking like, "That's her, that's her!" People would come to the table and ask for my autograph.* Capucine became a root for many queer people: *They'd say, "You changed my life,*

you made my life better. Ever since I saw your interview, I came out the closet, out the pantry, out the basement." Although she never received any residuals, Capucine reflects on the opportunity to tell her story with a sense of pride, calling the episode *my documentary. Anybody that knows me knows—it's all true.*

At the heart of Capucine's story, an age-old quest: *We all want love, and we try to find it wherever we can, but you have to be careful where you look, honey. Sometimes hate disguises itself as love, and there's a lot of hate in this world. We have to be strong and stick together and love one another to overcome the evilness.* Beyond the purely transactional, she sees in sex work the potential for transformative healing. *You become almost like a shrink, because a lot of people are lonely. A lot of them just want companionship; that means more to them than anything. Sometimes you can see yourself in them. A lot of sex workers themselves are lonely; they want to find someone that they could spend a lifetime with. But until then, the game goes on*

> *"It's all about survival. Only the strong survive."*

and life goes on. It's all about survival. Only the strong survive. Capucine walked away from sex work, because of the risks attached. *I made it this far without getting hurt or ending up in prison, but there's not many sixty-eight-year-olds around to tell the tale.*

Over the years, Capucine's views on drag evolved as well. *I used to look at drag queens as the lowest form of transsexuality. But I learned to appreciate the art of drag because it is a profession. And I love being entertained!* Capucine's own performance credits include Gipsy in Las Vegas and Hamburger Mary's in Chicago. She occasionally performs at the behest of friends, or for fundraisers. However, she remains an enthusiastic spectator at Miss Continental every year; a tower of Continental VHS tapes holds a prominent place in her living room. *Everybody loves a winner! I love to see the girls compete in all their glory and all their beauty! I know how much effort and time it takes.*

Capucine identifies as a *god-fearing woman*, but nonetheless considers herself *not a very religious person.* Through the ten commandments and the spiritual guidance of gospel music, she stays right with the lord. *I don't trust nothing no man says. Men have changed the Bible so many times over the years, you just have to go by faith and go by what your heart tells you. A lot of things are common sense, but many people don't really have that.*

Honey West

CHICAGO × TAURUS

In the tarot deck illustrated by Pamela Colman Smith, the nine of pentacles depicts an ornately dressed woman standing in a well-kept garden. She wants for nothing. Through discipline and hard work and sacrifice she cultivates around herself a beautiful environment where she finds the peace necessary to nourish her art. Where the card's matron holds aloft an exotic bird, two dachshunds accompany Honey West. Honey credits her home's gorgeous front yard to the green thumb of her roommate, an event planner. After swallowtail butterflies kissed the roses adorning Honey's arch, the roommates repurposed the flowers for a friend's aunt's memorial following our afternoon together. Neighbors came outside to watch the photo shoot and consistently called out to her, "You look fabulous!"

Despite her humility—*I'm a very casual kind of gal*—we found this regal beauty far from the exception. When we dropped in on Honey earlier in the week for a quick hello and some lighting tests, she answered the door in sweatpants while somehow still giving old Hollywood glamour, like Mae West with hair perfectly coifed and eyelids dusted in silver smoke. This casual elegance comes as no surprise after a lifetime in the limelight. *Growing up, I always dreamed of being in the business.*

Honey studied musical theater at Indiana University. Her first class, Theater Ethics, taught her to *love the art in yourself, not yourself in the art. Being a shy person when I started, I just wanted people to like me, and I wanted to like them back.* After graduating in 1982, she embarked on the revue circuit singing in quartets and sextets and octets at resorts and on cruise ships. In 1987 she landed in Chicago and continued to sing.

I'd get work and I'd create work for myself. I had a marketable voice, though technically considered unmarketable—even by the people who hired me—for decades. Regularly cast as a chorus boy, she remained *never boy enough.* At twenty-seven, with her thirties approaching, she developed a new strategy. *I took all my considered deficits—being softer, more feminine, having a perceived higher voice (even though I'm a tenor)—and I turned them into assets. I created a character: Honey West.* She debuted her one-woman show—"A Taste of Honey"—in 1990 to rave reviews of her rendition of "The Music and the Mirror," complete with Fosse-inspired choreography. From there, Honey never stopped working. She hosted brunch at Feeding Frenzy Cafe followed by two hours performing at Carr's cabaret (*fifteen years singing in the same space*) before rounding out the night with another two-hour show at Madrigal's in Andersonville. *I performed twice a week. It adds up.* By her estimation she's put on two thousand shows totaling more than three thousand hours of cabaret in Chicago.

People didn't know exactly what to do with me. I identified as a drag performer, but it was never billed as drag. I wasn't a pageant girl, and I wasn't a camp queen. I was doing a cabaret act. True cabaret goes beyond the piano. You say something, the audience responds, you respond to them. It's like a ball being thrown back and forth. Cabaret is so close that you get to know people. That ball starts to create its own entity. In its purest form, you and the audience are creating the show simultaneously. You feel their energy and they feel yours. Spontaneous, intimate, spiritual, exciting—there's nothing quite like it. If you're really singing to them, instead of at them, then the exchange of energy and laughter is very healing. Being in front of people for two, three, four hours—it's a different experience than doing a few numbers and going backstage to change.

> ## "You feel their energy and they feel yours."

Honey admires the girls at the Baton Show Lounge: *They put themselves together so exquisitely that they intimidated me, though I was always friends with them.* She worked with the Baton's Alexandra Billings in Charles Busch's *Vampire Lesbians of Sodom.* She met Busch years later when he came to see her as Bernadette in a stage adaptation of *The Adventures of Priscilla, Queen of the Desert.* In community she found herself and her power.

Putting on makeup as a mask, as well as a couple well-mixed drinks, I would melt into this world and lose my inhibitions. It really was euphoric. I didn't know yet that was going to be ultimately who I was. I didn't start transitioning until I was forty-one. I buried myself so deeply: emotionally, physically, spiritually. Back then the bars were an oasis. You couldn't wait to get off work and go to the bar. Once behind those doors you could breathe, smile, celebrate who you were. Through drag, Honey taught me who I was.

Honey serves as cabaret director for the Venus Cabaret Theater adjoining the Mercury Theater. The Greeks knew Venus and Mercury as Aphrodite and Hermes, the parents of a being named Hermaphroditus. A nymph, like those in a painting above Honey's living room sofa, saw the beautiful boy bathing and prayed to be joined with him forever. The gods answered and the two merged into one complete being, divinely queer.

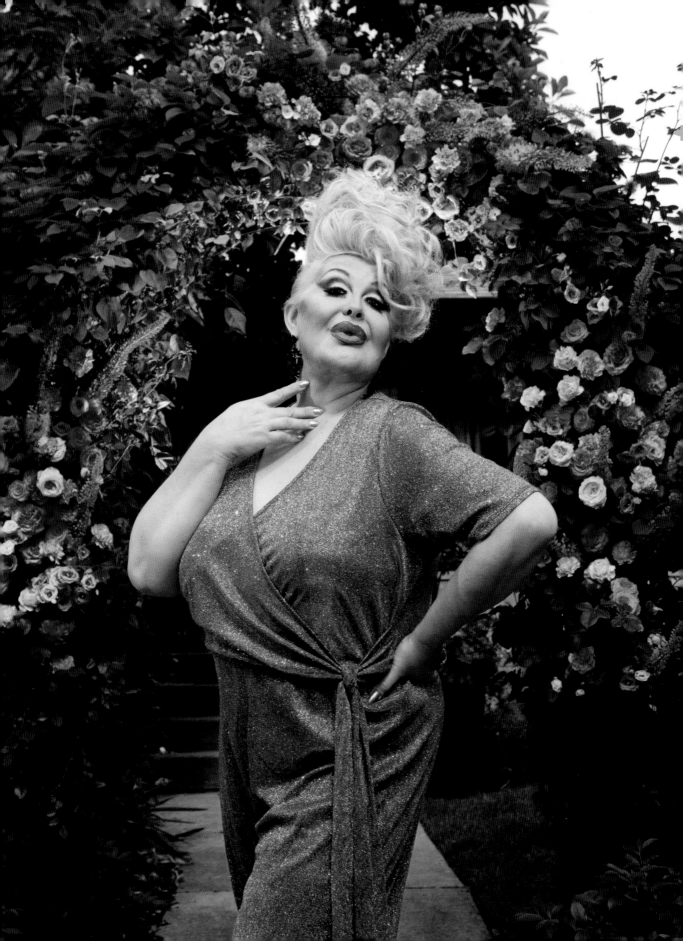

NORTH CAROLINA

Ebony Addams

RALEIGH × LEO

It was a bright autumn day, and peak season for the resplendent jewel-hued fruit known as beautyberry. We foraged branches from the woods outside of town, selecting only the most vibrant beautyberries for the beauty known as Ebony Addams.

Ebony drove more than two hours for our shoot at the JC Raulston Arboretum in Raleigh. No stranger to taking her drag on the road, she sometimes travels up to five hours for a gig. Her town of Jacksonville, North Carolina, boasts no drag bars, but she views this lack of a hometown scene as an opportunity to collaborate with entertainers throughout the region. A free agent, she's guided by her sharply attuned ability to sense good vibes. *If I don't get a good vibe, I won't do it girl. I will not do it, honey!*

Before she ever got in drag, Ebony knew there was something special about her. After high school, she moved in with some gay friends two hours from home, and it was with them that she discovered the transformative power of dressing up: *It really fascinated me, because I knew being gay, you'd get called sissy or queen, but I didn't know anything about drag.*

She laughs as she describes the *little balloon titties* she used to wear around the house, before progressing to femme attire, adding hip pads and makeup. The makeup ignited a spark. *Girl, I just fell in love with who I was! When you first put it on, you're feelin' like a girl and you want to look like that girl that you're feeling inside. You just want to bloom, you just want to be who you are! 'Cause most people, you're already trapped in this body, you don't know who you really are, and then when you can match that body with your mind it feels good, you know? So I matched it all together, girl, and started going out!*

The mother of the house when Ebony arrived in 1990 was Adrienne Ashe—*everybody in North Carolina knew Adrienne*—and Ebony credits Adrienne with teaching her the art of drag. Out together one night, she saw queens doing shows for the first time and became immediately transfixed. The balloon titties opened the door for Ebony to step into her womanhood, but she also wanted the glam and glitter. *When I saw you can win prizes and money, I knew I wanted to go that route! I didn't*

> ## "I wanted my respect, honey!"

want to go the street route or be a hooker; I'd rather be a pageant girl. Back then, you had to choose: are you gonna be a street girl or a showgirl? Street girls didn't get no respect and I wanted my respect, honey!* This incarnation of the Madonna-whore complex neatly illustrates the impossible choices many trans women face, when the structure of society stands at odds with your survival.

These days, Ebony believes fiercely in self-determination when it comes to drag styles. *I've learned to respect every type of drag in this business. Some girls don't wear wigs, some girls are bald. And I respect them being bald! That's their style. Their drag is anything they want to do. It took me a while to learn that: you've got to respect that drag is anything you want to do.* Even when it comes to her own children—seven, and she has since had her tubes tied—she's happy to teach them, but insists they cultivate their own style and provide for themselves. *Only time I'll paint my daughter's face is if it's her first time, and if I've got to I'll help with a pageant. But if she's doin' a show, if she's ugly she's gonna look ugly. I had to look ugly so you're gonna look ugly! I didn't start out lookin' pretty. You think you're gonna come back in ten years and look at your pictures and think you're beautiful? No ma'am! You gonna be ugly honey!* In drag, even beauty is earned, and a seasoned queen always sees right through a counterfeit.

The revelation Ebony describes, of finding her people and becoming herself, came through the mirror they held up for her to see. Drag houses are often synonymous with balls, but the formation of these close-knit cliques is born out of necessity, not pageantry. The skills Ebony learned from her gay family made her a fabulous entertainer and function also as tools of survival.

Even with her decades of experience, Ebony continues learning new tricks. She enjoys seeing what the babies on *Drag Race* are doing because *sometimes babies have good ideas too!* Like all great artists, her approach synthesizes creative elements to create an aesthetic truly her own. Staying focused on that singular vision remains her strongest directive: *If you stay focused on yourself, girl, you will see the good come out of you.*

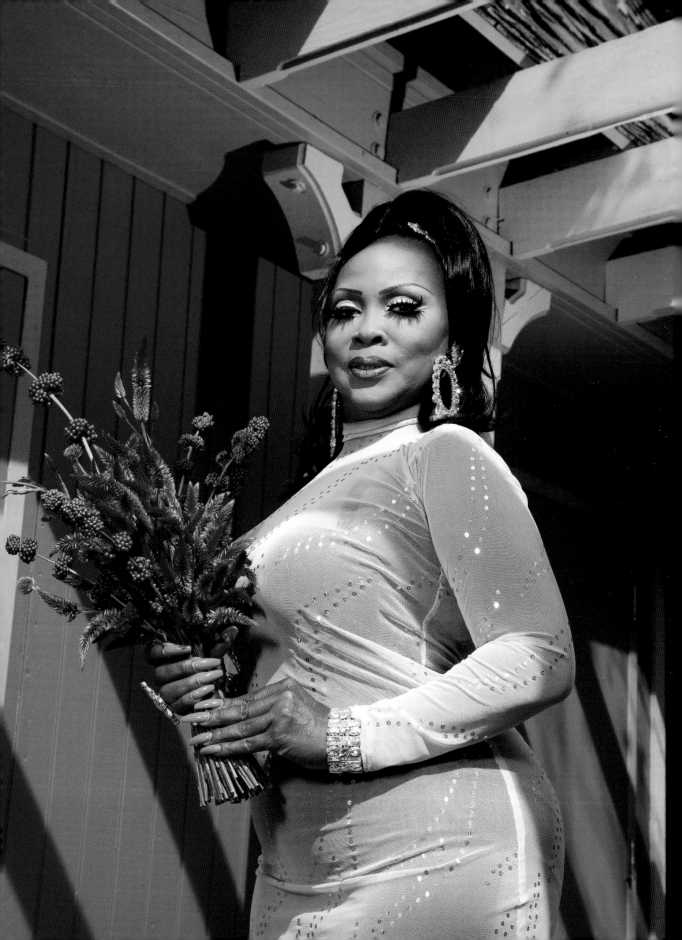

Dana St. James

RALEIGH × CANCER

I'm easy, I'll do anything you want, just tell me what to do! Dana St. James assured us during our first call. We wouldn't dare contest. She pulled up in her sporty luxury sedan and was ready to go from the moment her heel touched the pavement. She hit her mark immediately, knew all the poses that would accentuate her knockout hourglass figure and signature showgirl sparkle. A handsome businessman crossed our path and she didn't miss a beat: *Oh here comes my husband, he just doesn't know it yet.*

Dana's drag began in 1994 at Appalachia State University. A friend on the color guard put her into a uniform for Halloween. Shortly thereafter a lover brought her to a drag show. That moment she decided that was what she'd do. With a theater background, this new opportunity to perform was an intuitive trajectory. She competed in talent shows at Legends and won her first. They crowned her Miss Legends 1995. She also worked at the infamous Power Company where she won Miss Gay North Carolina USofA 1997.

A St. James of the House of St. James, she arrived at the name in a roundabout way. A makeup artist who assisted in her early transformations met Jacqueline St. James of Johnson City, who struck a lasting impression. When Dana needed a surname, he suggested St. James. The night of that first performance, her lover gifted her a compact mirror with "St. James" engraved on the back.

Years later she learned about the prestigious drag families on the road. She met Jacqueline, for whom she was named, and they became lifelong friends. Dana performed at Jacqueline's recent retirement show. *There are a lot of St. James girls; it's a big family.*

Dana considers herself blessed for having two drag mothers, the first being Victoria "Porkchop" Parker, with whom she worked at Legends. After Porkchop moved away from North Carolina, Chelsea Pearl of Kentucky took Dana on as a daughter. Dana celebrates this fluid model of kinship: *You can come and go with your drag family.*

Beyond her mothers, she says she's learned the most from her sisters in the pageant world. She got into pageants because *North Carolina is old-school* and one needed a title to

> *"You take pieces of everybody and develop your own persona."*

get booked. She identifies as old-school too and passes this sensibility onto her two drag daughters. She credits the pageant tradition for all her drag skills. Despite originally identifying as a female impersonator, she never impersonated anyone in particular; she doesn't think she looks enough like anyone. *You take pieces of everybody and develop your own persona.* Like many of the girls in the pageant scene, Dana knows and has worked with all the queens in North Carolina. She spoke fondly of Ebony Addams: *Big jewelry, lots of makeup and hair, glamour, under the spotlight. She's old-school like me.*

Dana forged her extensive network of connections through years spent traveling. She worked up and down the east coast. In each town she'd get contacts for the next city. Despite certain archetypes repeating in each town (*the butch queen, the feminine queen, etc.*), she reminisced about the unique things one could find in each locale. Before the internet, seeing someone do a number might be the first time you'd hear a song. You could take a routine on the road and in each town, everyone would see you doing it for the first time. She says any one queen could make an entire career with just a handful of numbers and a few costumes. Despite the bad hotels and long nights driving, she misses it.

Even with her impressive itinerary, her home base remains Legends, where she reigns as *Grand Dame.* Each night she turns out six looks, one for each number. *It's no fun to repeat.* The exertion of hauling her looks to the club keeps her fit though: *Drag it in, drag it out . . . I guess that's why they call it drag.* She says she's spent way too much on her outfits over the years. She maintains quite the archive, replete with plenty of feathers and hand-beading.

In the pandemic winter, arbitrary citywide curfews shut down the evening shows at Legends, but she still worked the brunches. The break from nightlife proved an opportunity to explore her underdeveloped Cancerian homebody tendencies. While self-motivation can be difficult, she's found one must keep reinventing oneself. *Drag, nightlife, society—nothing's going to be the same and you have to be ready to change with it, evolve.* And still, she hopes the next generation remembers drag's old-school roots.

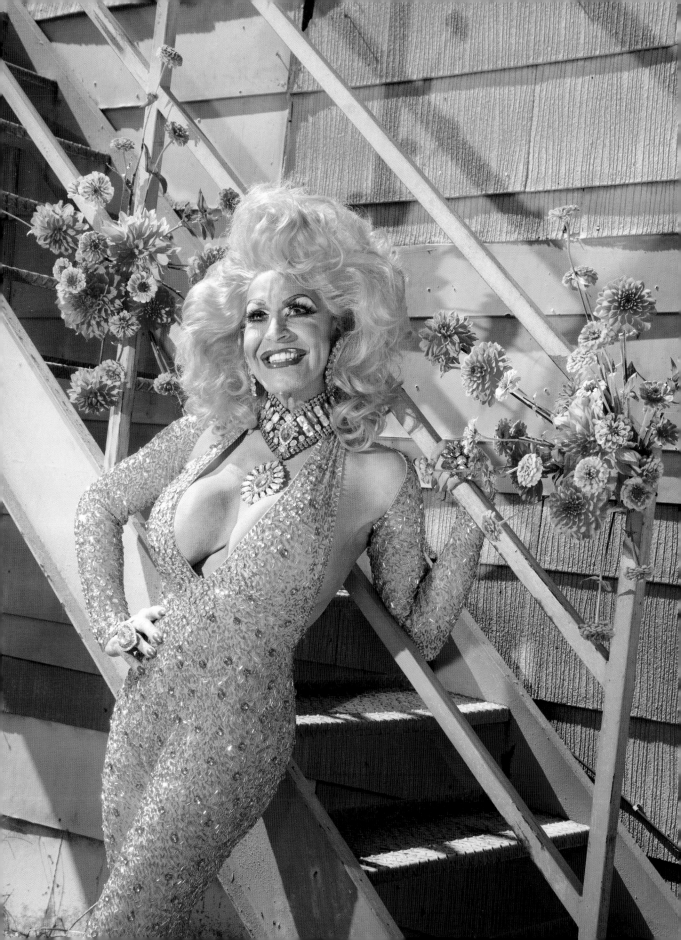

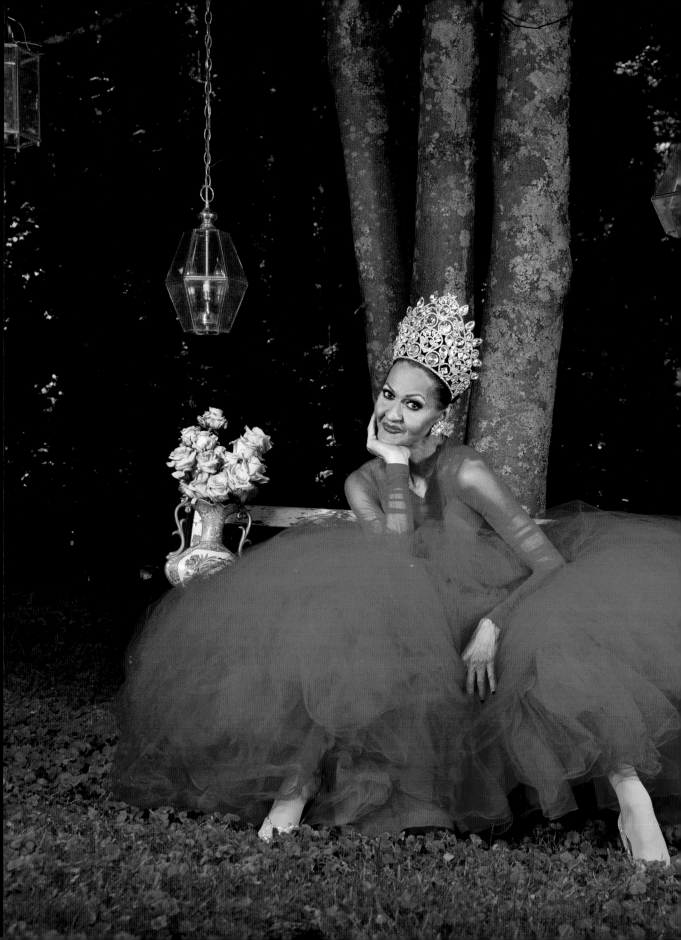

Kelly Ray

DURHAM × **SCORPIO**

It's impossible to forget an afternoon with Kelly Ray. She won a crown at a competition the weekend prior, but with a drink and a smoke she still turned it all the way on. A steady rhythm of her own maxims—*keep it sexy; say it slower; say it again*—built over time, keeping the pace quick and fun and contagious. Before long, we were under her spell, though she feigned submission; *I love to be told what to do.* When she knew she was hitting her mark (she reportedly knew because she was turning herself on!), she'd instruct Harry behind the camera: *click, bitch!* We shot with her in the forested yard of her gracious friend Gerald's home, previously owned by Big Band singer Peggy Mann and assuredly host to many a revel. The sprawling property boasts a pool, hot tub, statuary, glass sculptures, and various mirrored lounges, but Kelly Ray's energy filled the whole space. Her red cloud dress, inspired by Diana Ross at the Grammys, also served a Kate Bush fantasy.

The fantasy continued after the camera turned off. We smoked poolside and listened to Kelly Ray tell stories about other queens—*Ms. Divine, that bitch could stir shit up!*—or discourse about art history—*Who was that man? Who wore the wigs? With the soup?*—or the origins of drag itself—*Shakespeare started drag!* Over dinner (a thing Kelly Ray insists is sacred: *Anytime you eat together is a blessing, a thanksgiving, a whole other kind of thing*) the inquiry turned to the Holocaust and the AIDS crisis, those moments in the past century when thriving queer subcultures survived near-eradication. About the fascist nightmare in particular, Kelly Ray expressed a redemptive desire to *go back to that era and flip it . . . but it's gotta be sexy.* In the year since our shoot, her approach to history stuck with us—to imagine from out of the horrors inflicted on generations past some sort of jubilee of reversal. Revolution is a type of flipping, a turning of the wheel, and Kelly Ray insists that the world to come after all this could be shaped by desires and pleasure. *Everything is a story, and everything is about sex, and that's the truth!* She's a ceaseless flirt, too. Before parting ways, she told us very kindly: *I wanna thank your Mamas . . . and your Daddies!*

This project has again and again affirmed what mastery decades of practice (four in Kelly Ray's case) at an artform can yield. But Kelly Ray possessed her unique charms from the beginning. The first time she dressed was as a freshman at Methodist College. A theater and music major, she knew she wanted to do something performative, but didn't see drag coming. Her first time was a contest called Methodist Monarch, where the boys got in drag and had themselves a little pageant. *I don't know why or how but I was all up in it and before I knew it, I had a dress and a wig.* She performed "Long John Blues" by Bette Midler, as Ms. Foxy Roxy Love. Kelly Ray was sponsored by her fraternity, Lambda Chi Alpha, and of course won. Her identity was still in flux—*The whole gay thing. I was dating a girl named Gay. Weird.*—but when she attended her first drag show shortly thereafter, she walked in and knew she was home. Before long, she'd befriended everyone at the bar and they adored her. She continued to find herself: *I could tell that I wasn't a gay guy anymore. People were calling me "she" and "her" and "Miss Thing."*

From that moment on she was a queen, a drag queen. *Now I'm an old drag queen. This was forty years ago, right before AIDS was really hitting all of us. Life got foggy. Partying, moving, gigs, money, boys, drugs, titles.* Of the latter, she has many—Miss Gay North Carolina America, Miss Gay New York America, Miss Gay Heart of America, Universal Show Queen (*but being the people's choice is bigger and mightier than the crown!*). She moved to Atlanta (*long hair, overnight success, blah blah blah*) when AIDS really hit.

In 1988 she was living with a nurse who got a job offer in Hawaii and decided to go along. She cut her hair and found work at a gay hotel, Hotel Honolulu, where she had to wear boy drag: shorts and a shirt every day. She was there for the brunt of the AIDS crisis, and there learned she herself was HIV positive.

In her estimation, being there meant she missed a lot of the tragedy. She fell in love, and in that love she found everything she needed. *I was Bible Belt, going to hell, but I found heaven there, it was spiritual. You don't need much to live good.*

She says that the most difficult thing about being her age is having survived everyone. *You'd see people at the club and they looked wrong, were shaking. Or you wouldn't see someone and you'd hear, "Oh he got that thing."* For her, the coronavirus has been extremely reminiscent of that time. *We were all struggling and then this virus. Those of us who are still alive have to bury our sisters.*

She used shelter-in-place to work on a dressing room for herself, something she's never had before. She got a closet update and bed update. But still, by her own admission, it has been a hard time for her. Throughout 2020, she'd only gotten in drag three times the whole year: for that pageant, then our shoot, and then a little something for Halloween. *Honey, I can't do that Zoom drag with the tech stuff and the horrible backdrops.* The simulation can't provide what she's missing the most: the audience. *I love the audience. I don't care if it's ten or ten thousand, I'm gonna be all up in everybody and demand your attention.* She's felt distant from Kelly Ray and her power, and thus felt at her weakest in a world without affection. She reported being healthier than ever, but still, it's hard for a star not to shine. She insists *it's not a healthy thing for those of us used to feeling sexy to be unable to be together, to hug, touch, love.* She thinks this virus will change the way we show affection, the way we fuck; that there will be repercussions we can't yet imagine.

But Kelly Ray knows that a time of immense joy and hugging and revelry and sex is to come. She knows it's coming, but more than anything she wants to be there for it: *I hope that I'm onstage. Microphone in hand; in drag, out of drag; teeth in, teeth out, whatever;*

> "Those of us who are still alive have to bury our sisters."

long hair, gray hair, whatever; hip pads, titties, cock-ring, whatever; I hope I can speak my truth about it. She insists we need to celebrate; insists we need a tidal wave of love, sex, pleasure, acceptance.

In the time that remains between now and then, she's reflecting on who she is, what she's done, what she wants to do, if she'll ever do drag again, how she'll do it differently, how she'll reinvent. She doesn't know if her next chapter is in writing, stand-up, television, or art directing high-fantasy porn. She says it will take her a while to really appreciate whatever she was supposed to learn through this experience, but she is proud of herself for holding on and hanging in.

Kelly Ray became more spiritual through the pandemic. She prays for those she loves and knows that we get just what we need. She grew up religious, which was often a source of contention. *My favorite line to all of them, especially when I'm ready to go, keys in hand: "And you call yourself a Christian!" and I dash all dramatic.* She clarifies, *I'm no Oprah or Maya Angelou but I've been reading my books about angels and the day you were born.* She has especially felt connected to the archangels. She experiences them as a daily presence that makes her feel protected, never alone, and that help is available in spite of the sadness, stress, drama, and imposed celibacy of the pandemic. Surely, she is blessed.

As she tells it, *there is a magic to Kelly Ray that happens and has happened from the get go.* She told us on our day together, she felt *very Kelly Ray,* and we certainly felt the magic too. Drag has served as an outlet to do exactly what she wanted and go where she wanted to go for forty years. That journey has changed her, but she's remained consistent: unrehearsed, in the moment, sexy. She calls drag *a different feeling.* Through chasing that feeling, Kelly Ray stays transforming.

> **"There is a magic to Kelly Ray that happens and has happened from the get go."**

I'm not the same person. I don't know when I'll get to do drag again. I don't know what that will be like. I don't know if it will ever be how it used to be. I'm more lost. I'm questioning: who am I? I don't know who I am, I don't need to know, what I need to know is how I made you feel.

For our part, she made us feel hopeful, inspired, loved, and at ease that magical afternoon. We felt held by a queer ancestral force bigger than any of us. Her grace, levity, poise, and razor-sharp wit will stick with us always. Kelly Ray's survival and presence is an unspeakable blessing, assuring that some other life remains possible. She thinks about how she'll be remembered. We can assure her that everyone we've spoken to on the matter credits her with reinventing North Carolina drag. Dana St. James called her the *"Grand Dame"* of North Carolina Drag." Kelly Ray was away when Dana got onto the scene, but the latter was lucky enough to witness the occurrence of Kelly Ray's return: "Everyone was talking about it: Kelly Ray is back! Kelly Ray is back!"

And still, it's hard to know just how much you mean to those you've encountered in this life while you're still here. She sees *young'uns* heading into the scene and she wants to *guide 'em, steer 'em.* She hopes through her looks and words she has contributed to that active work of memory and guidance. *One day y'all gonna be sad because I'll be gone. But my words will mean something. Maybe not now or not to my family, but to someone they will.*

She's threatened to haunt us someday far from now. We're already haunted in the best way though. *I don't know about life after death, it may sound spooky or witchy, and I don't know if I'll get to come back, but baby, you will know.* A Scorpio through and through, she imagines it would be the plot of a great porno.

ATLANTA

Tina Devore

ATLANTA × SCORPIO

I'm primarily known as a nurturer, more so than an entertainer. Make no mistake—Tina Devore entertained the children *and* brought them up right, but the humility to eschew her own ego distinguishes this legend from the herd. Tina spent forty-five years nurturing generations of Atlanta's drag community before her sudden passing in September 2021. She spoke of her own legacy with profound clarity. *I see my responsibility as more than just a drag queen but a leader. As someone who can be trusted, who makes a difference. Life is fleeting. Time is not promised to us, things can change in the twinkling of an eye.* We met only once, an afternoon now suspended in time as the entropic universe churns on. A sweet gardenia in her hair, eyes gazing into the distance, Tina found the light.

Tina's story begins farther south, in the small town of Live Oak, Florida, halfway between Tallahassee and Jacksonville. Her theatrical disposition presented itself early on. Her best friend Tony DeSario remembers Tina as "a boy with a little too much sugar in his tank." At age eight she taught herself to play piano by ear, accompanying the church choir for years. Tina recalled a void of glamorous Black role models in her childhood until she discovered Diana Ross & The Supremes. She used to put money in the jukebox at the local five and dime just to see their album cover pop up when the record played. Tina went on to play flute and clarinet in the high school marching band, then enrolled at Florida State University to study theater. In the summer of 1974 Tina earned a coveted role at Disneyworld as one of the Kids of the Kingdom, an ensemble composed of music and theater majors from around the country. The troupe performed four shows a day at Cinderella's Castle and attended classes teaching the principles of showmanship and entertainment.

Partway through their summer session she discovered a deeper kinship with her castmates. *Somebody at the bus station tried to pick one of us up, and we were talking about it on the way home. One boy said, "Well, I wouldn't have minded if he hadn't been so ugly!" It was like an icebreaker, and everyone reacted, "Oh, well are you—?" It turns out we were all gay.* The next night they sought out a gay bar called the Palace in Orlando, and fatefully found a

> ## "The scene was hot, the energy over the top!"

drag show there. Between her theatrical training, natural storytelling ability, and supreme fascination with Diana Ross, Tina sensed intuitively, *"I can do that."* Then it's that typical story: *they were having a talent show next week. We decided one of us would do the show and the others would support. Of course, I was the one chosen. I entered the talent show and I won.*

Following the summer stint at Disneyworld, Tina resolved to *introduce Tallahasseeans to what I learned in Orlando: this drag show thing. It went over pretty big.* Tina's local celebrity soon attracted the attention of a skinny young thing named Pee-Wee. Infamously, Pee-Wee went on to become The Lady Chablis, The Grand Empress of Savannah. In her autobiography, *Hiding My Candy*, Chablis admits to a crush on Tina. Out dancing one night, Chablis asked Tina for her number.

Later on that week she calls me, wants to know if she can come over and visit. I'm thinking, "Oh my goodness I don't want to be bothered with this girl . . . but OK." I've always been one who has a place where everybody comes to eat and congregate and party. So she comes over and during the course of the conversation, I found out she's not a girl at all. But you simply could not tell! "Miss Pee-Wee" is what they've called her all her life. We became really good friends after that because I'd never seen anything quite like her. Tina's motherly instincts kicked in, and she cast Chablis in her very first show.

In 1977, Tina ventured to Atlanta for a weekend getaway, which *took things to a totally new level. Drag is serious business; the people are living! A couple months later I was back lock, stock, and barrel. The scene was hot, the energy over the top! Even more so than the show—the men. There were some beautiful men, unlike I had seen anywhere else. I was like, "Girl I'm sorry I love y'all but I gotta go!" Atlanta called.* They call it Hotlanta for a reason. Despite successes in Florida, Tina professed she still didn't know much about the art of drag upon her arrival. *I looked horrible, but I was happy.*

Tina brought her headshot and resume around to all the Atlanta bars, but soon discovered *nobody cared about any of that.* Her course changed when she caught wind of a talent night—*here we go again*—at the Onyx, a predominantly white bar. Tina took the audience to church with a stirring rendition of "Operator

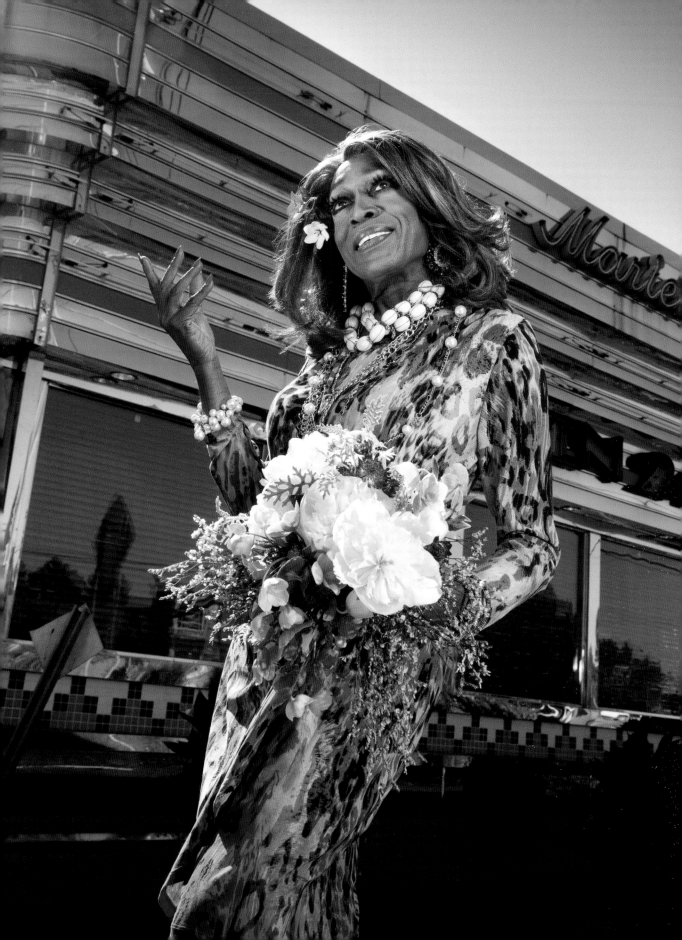

(Give Me Jesus on the Line)." Jesus seemingly got the memo, because that very same night two regular cast members quit, leaving the bar in a pinch. *I was hired there, making $125 a week, working five nights a week. So that's where Tina was truly born, and it's been uphill ever since!* Tina became the first Black cast member at the establishment.

The Onyx promoted Tina to show director in just six short weeks. An opening on the cast occasioned a reunion with her sister-daughter, Miss Pee-Wee Chablis. In her autobiography, Chablis remembers Tina inviting her to move during a return visit to Tallahassee. *If you ever want to make something of your life and career you gotta leave here, girl. 'Cause if you stay, you're gonna end up bein' a wino and a barfly.* The two hopped in Tina's yellow Pinto to start a new chapter together in the Big Peach. Chablis describes feeling uncertain how she'd survive in Atlanta until Miss Tina informed her of a talent contest at the Onyx after her arrival. However Tina recalled knowing all along that Chablis would join the cast. Mother always knows. On the Onyx stage, Tina christened Chablis as *The Lady* for the very first time. *I used to call her "The bubbling and sparkling Lady Chablis." Maybe that was a stretch!*

Throughout the late seventies and early eighties, Tina and Chablis took their act on the road to Nashville, Charlotte, Roanoke, Columbus, and towns throughout Georgia. They'd bring a few newcomer girls along too. *Sometimes it would be six of us in a Volkswagen with all our drag. We were determined to make that money! One time we were all jammed up like that and the hood of the car blew up and we couldn't see, swerving across the interstate. Who had a driver's license? I don't know. Who had insurance on their vehicle? Nobody. We were doing everything we could to survive in those days. It was not easy but it was a lot of fun.*

Through Atlanta's thriving drag scene, Tina learned from the very best. *Rachel Wells was THE Atlanta icon and just overall good people. I loved and worshipped her.* Tina loved Hot Chocolate as well, *she was the dancing disco diva at the time.* She remembered Lisa King as *an ebony goddess who could stand still and just mesmerize. Those three in particular stand out, though many others came and went.* When the stars aligned, their power coalesced to form an indestructible megalith. Clubs such as the Sweet Gum Head, Illusions, the Answer, LaVita's, and the Armory were more than just gay bars with drag shows, they were *show bars. In those days we had costumes and choreography, very unlike today. We were putting on a SHOW. Back then, the show was the star and the star was the show.*

As Tina refined her stage persona she cultivated a reputation for bringing a level of class to the craft. She contrasted her style to that of Charlie Brown, the legendary mother of Backstreet nightclub. *She's very in your face: "Hey motherfuckers! I may look like mama but I'm hung like daddy!" That's not my approach. I want to be respectable. I see how the crowd reacts to it; it still doesn't make me want to do it.* Tina desired to make her audiences feel comfortable, rather than intimidated. *I always entertained this idea I could bring my mother to the show and she'd enjoy it. I'd never bring my mama anywhere they say "motherfuckers" or "assholes."*

Tina's ladylike graces proved a crucial asset as she launched her pageant career. Among a litany of conquests one always stood out as her crowning glory: *Once I won Miss Gay Atlanta 1983 I really felt like I'd arrived.* Tony DeSario recalls, "At Miss Atlanta she brought the house down, and upset the children *bad.*" The list of former Miss Gay Atlantas is a veritable who's who of Southern drag: Hot Chocolate, Dina Jacobs, Lisa King, Rachel Wells, Lady Shawn, all of whom went on to win national titles. *I always, always, always wanted to be part of that legacy because that put me in a sorority that absolutely represented the best of the best.*

Although she held her local title dearest, Tina competed at a national level as well. She achieved Miss Black America 1985, the second queen to ever win the title. *Some people didn't understand the need for MBA, but it was a time when entertainers of color frequently did not get their due.* Throughout her reign Tina cherished the opportunity to connect with Black audiences more deeply. Working in the Onyx and other white clubs, she felt at times like an outsider in the Black community. MBA brought her into the fold. *It was an acceptance that I strived for.* Tina also competed and judged within the USofA system for over four decades, holding the emeritus title of Miss Gay USofA Classic 2003, among many others.

Regal as she was, Tina possessed cunning wit and impeccable comedic timing too. She cowrote and hosted *News Beat*, a satirical gay interest news program that debuted on local access cable in 1984. Portraying reporter Louise Marie Goodman, Tina

condescends to cohost Rachel Wells in her very best over-articulated white lady voice. The duo keep Atlantans in the know on a range of hot topics, from suspicious gatherings of homosexuals downtown to *homo poachers in Piedmont Park*.

Barely recognizable in "Cooking with Esther" segments, Tina dons country auntie drag complete with a cigarette hanging out of the corner of her mouth. She instructs viewers to *keep your husbands at home* with her neck bones and rice recipe. *First you take four pounds of neck bones, get the young tender kind like I use. They only cost 87 cents*. Through Esther, Tina showcased her genuine love for cooking to comedic effect. Kelly Ray confirms the authenticity of her material: after spending what little money they had on rent and fun, they'd pool change to buy neck bones, and "Miss Tina would feed us all." Tina's drag daughter Terry Vanessa Coleman relayed the miraculous: "She could take a can of corn and feed a thousand people."

As the autumn leaves reached their vibrant crescendo in early November, Tina's chosen family gathered in Atlanta to celebrate her life and legacy. The community she nourished came out in full force for a tribute show at the Heretic nightclub, its lineup stacked with eighteen veterans of the Atlanta scene. Throughout the decades, Tina performed at every single show bar in the city. As show director of numerous venues and producer of her own talent contests, she birthed dozens of disciples, many of whom matured to become legends themselves. Her very closest associates knew her as "Tina Coquina Consuela Deveroux Devore." All that talent together in one room, united in their devotion, put the tremendous scope of her life's work on display. Before the performances began, we overheard one guest remark, "Ain't enough chairs in this room for every homeless transient little hustler boy that she gave food n'shelter to."

Paula Sinclair, Tina's successor at Miss Black America, delivered Natalie Cole's "This Will Be," and the crowd lined up to tip her as if taking communion. Tony DeSario recounted Tina's unwavering commitment to AID Atlanta, raising hundreds of thousands over the years, and volunteering in hospitals to provide comfort to those abandoned by their families.

> *"The future depends on each of us."*

Tiffany Arieagus took the stage for the first time in two years, covered in crystals and shrouded in a silver cape trimmed in white ostrich. Preceding her performance of "Imagine," she testified: "I know she's an angel. This song says everything we used to talk about, and still talk about in our dreams." Dressed in glittering gold filigree, Tasha Long performed Tina's signature song, "Here's to Life." She praised Tina's deep influence: "You, Tina, were to me what Maya Angelou was to Oprah." Niesha Dupree reflected on Tina's dream of owning a restaurant: "She fed us all with her love, her performances, her gracious spirit." Kelly Ray stormed the stage with arms outstretched to the heavens. The stomping of her heels left a hole in the floor and sent reverberations throughout the room. She recalled how Tina comforted her while at her lowest: *Anyone can be Miss America but nobody else could ever be Kelly Ray.*

The catharsis continued at Friends on Ponce, where Kelly Ray climbed atop the bar and the pool table, then beat her fists against the ceiling to Natalie Cole's "I've Got Love on My Mind." Alicia Kelly channeled Patti LaBelle with such explosive power she fell to the floor and kicked off her heels, wailing "You Are My Friend." Shawnna Brooks paid tribute with one of her signature high-energy dance routines, her daughter Nicole beaming with pride. Shawnna calls Tina "the reason I'm in Atlanta. Her true beauty was in her personality." The room shook with thunderous applause, dollar bills rained down in a flurry. Tina loved seeing that light in the eyes of her audience. *That lets me know I've somehow made a difference in their lives.* Tina's radiant light shines on through those she inspired and entertained.

I run into people all the time who say, "You're the first drag queen I ever saw! You gave me this bit of advice when I was seventeen! I'll never forget it." It makes me feel so good when I see younger performers achieve and succeed, because I know somewhere there's a little piece of me in there. It touches my heart. That's what we need to continue to do: pass on little pieces, because the future depends on each of us. I'm glad to be here but I've earned my seat in the shade.

Shawnna Brooks

ATLANTA × **VIRGO**

One cannot simply slide into the DMs of Shawnna Brooks. First, we required vetting by her most prominent drag daughter, Nicole Paige Brooks of *Drag Race* fame. After clarifying our intentions, Nicole offered her forested backyard as a private scenic location for the portrait and baked apple fritters for our crew. The dappled sunlight illuminated the scene in enchanted hues of green, Shawnna's favorite color. Besides the Southern hospitality, we owe Nicole our gratitude for encouraging her mother every step of the way. In response to Shawnna's initial hesitation, Nicole insisted: "Mama, there's no reason you're not going to be in this book about the old ladies of drag." The mother-daughter duo teases one another and hypes each other up; the love and support emanates between them and fortifies the foundation of the House of Brooks.

The Brooks dynasty formed by circumstance rather than intention. *I wasn't looking for a house; I was just doing me, and a bunch of kids, like Nicole, started following me around. I was at a club one night and told her she needed to take my name. There's Destiny, the baby of the family. I initially told her she wasn't ready. Tara Nicole Brooks was my first. There are countless others—I don't even know half the kids with the name.*

Shawnna instructs her children to stay true to themselves, but to maintain the utmost professionalism. She expects any daughter of the House of Brooks to demonstrate prowess in all the technical skills of the art. *You must know how to make all your own things to be in my house. Study everything: hair, makeup, costumes, shoes, all of it.* Nicole joked about weigh-ins and wrinkle checks too. Mother offers tough love, and pointed critique, but *at the end of the day, we're all there for each other. If they need something, they know to call. These times clarify who your true friends are. A lot of people just want to be near you because you're a star.*

That star power manifested in Shawnna from the very beginning. Born in Baltimore, she began performing at the age of two: *dancing around the house, doing little skits, and impersonating Michael Jackson. I made everybody stop what they were doing to watch.* The Duke Ellington School for the Arts gave her formal training in diverse forms of dance: ballet, modern, jazz, folk, ethnic, tap. In 1988, her drag career began when friends encouraged her to enter a talent show in Fayetteville, North Carolina. *I did*

> "These times clarify who your true friends are."

"Eaten Alive" by Diana Ross. I went out there barefoot, sliding all over the floor in pantyhose, but I won.[1] I got bitten by the bug; I loved everyone cheering and screaming . . . and you could get paid for it!

While performing in Myrtle Beach, Shawnna was recruited by Tina Devore to move to Atlanta and work at LaVita's. She found a thriving drag scene upon her arrival—shows every night of the week and a proliferation of venues, far more than operate today. Shawnna worked at Backstreet for the legendary Charlie Brown for fifteen years. *Charlie handpicked her cast. I was always the dancer. She was very strict, but you did your job. We bumped heads several times—I was young, hardheaded, and partying.*

Shawnna named Tina, Charlie, and Naomi Sims as mentors among a long litany of queens she met and came to respect in the club scene and pageant circuit. As Miss National 1999, Shawnna traveled all over the country, and she's still traveling. The week after our shoot, Shawnna and Nicole took a trip to Vegas to perform with Lawanda Jackson and see Hot Chocolate at Piranha.

Shawnna says Vegas is easily her new favorite city. *I had a ball; didn't want to come back. The energy, the color, the Bellagio: I was captivated by all of it. The money was insane too.*

While famous for her breathtaking beauty, electrifying dance routines, and glamorous showgirl costumes that leave little to the imagination, Shawnna's true power lies in the intensity behind her eyes. *I have great eye contact. I can make you pull some money out of your pocket just by looking at you a certain way. I'll take your last dollar and keep it moving. I'll tear your dollar up and you'll go crazy. I give somebody the finger; they'll give me twenty dollars.* In one of her signature numbers, "Running Up That Hill" by Kate Bush, Shawnna looks god right in the eye and makes him deal.

She makes it look easy, but a lot of preparation goes into that moment of connection. *I'm an artist. I sketch it out. I make all my costumes. A song will inspire me to start working on it immediately. I put on some good music and let it flow. I pray and ask god to guide me in the right direction. I know what I bring to the table. I stay focused, keep my craft updated. I might do an old song, but I'm definitely going to have a new look. I love the fantasy, the transformation of it all. I'm not real grand acting. I just like things to run smoothly, get paid on time, and leave right after the show. I'm all about energy.*

1. *Good Judy* podcast, episode 56, July 20, 2021.

168

NEW
ORLEANS

Regina Adams

NEW ORLEANS × CANCER

In 1971, while bussing tables at a private club in the French Quarter, a teenage Regina Adams befriended the performers at a racy female impersonator club called the Gunga Den. Every night after work, she and the girls went for cocktails at the UpStairs Lounge, a nearby working-class gay bar named for its second-floor location on Iberville Street.

Eventually the owner of the Gunga Den asked Regina if she ever considered female impersonation. Regina auditioned, pantomiming "Goldfinger" by Shirley Bassey, and secured a job offer. Thus began Regina's fifteen years on the burlesque stage, including a stint at a straight club called the French Casino. *I got my breasts done and I was twirling tassels—just one of the girls.*

The drag scene was still all behind closed doors in those days. We were supposed to get out of drag before hitting the street. A police officer stopped Regina one night while walking to her car. *He snatched the wig off my head and said, "Boy, I better not see you out here again; you're not supposed to be out in drag." I had a brown wig on. I switched it to a blond, walked right past him again, and he didn't even see me.*

Regina refused societal constraint in her love life as well. She and her lover Reggie went out as one of the only interracial gay couples in New Orleans, in defiance of the then harshly segregated bar scene. *There weren't a lot of Black and white couples; it was taboo. But I went to the Black bars with him, and he came to Lafitte's with me. At the time, Lafitte's on Bourbon didn't allow drag queens or Blacks. (They went to Lafitte's in Exile instead.) He was the first Black person they ever let in. Everybody loved him. He'd wait every night for me to get off work and join him at the bar.*

My life was going pretty good. I had a lover who loved me just the way I was and was gonna marry me. When he first met me, I was still going home and getting out of drag before we'd meet. In those first two years I started living in drag. Regina took her new name after Reggie's. *We had been together three years and had set a date. We were gonna celebrate my birthday in July and then get married in August in a commitment ceremony.*

Tragedy struck just months before that ceremony could occur. Pride weekend 1973, Reggie and Regina invited a couple of friends, Buddy and Adam, out for dinner to celebrate Adam's birthday. The group met at the UpStairs Lounge, where Buddy tended bar, for a pre-dinner drink.

My lover drank Johnnie Walker Red. I drank lemon Coke at the time. Neither of us had enough cash for dinner so I told Reggie, "You're having a good time, I'll go home and get the checkbook. By the time you're finished with your drink, I'll be back." We lived eight minutes away. I walked home, grabbed the checkbook, and walked back. I got two blocks from the bar and saw there was all kinds of commotion up the street. I looked up and saw the flames coming out the window. The fire department said, "You can't go past this point; we're trying to get people out of there." People were jumping out of windows.

The UpStairs hosted a theater in the back, where Regina had once put on a Christmas cabaret show, and nearly thirty people managed to escape out the backstage door. Reggie was not among them. Regina's mother later told her, *"You were getting up in the morning and fixing him breakfast and setting out his clothes for work for days afterward."* It took a week or two to finally realize he wasn't coming home. Thirty-two people died in that arson, making it the biggest mass murder at a gay bar until the 2016 Pulse shooting. The tragedy also mirrors the Ghost Ship fire in Oakland the same year.

For the next two years, I was lost in a daze. I met a lot of guys but didn't want to get attached. I didn't want somebody else to die on me.

Two years after the fire, Regina competed in the Mystic Krewe of Apollo's first-ever Miss New Orleans pageant, winning the top prize: a chalice made of solid silver. In the myths, Apollo also lost a lover, Hyakinthos. In his grief, the god created a new flower—the hyacinth—from his lover's spilled blood. Regina too transfigured her grief into beauty by way of flowers. She'd worked in a flower shop in high school and used her skills at Reggie's memorial. She surrounded his casket with white roses and hearts of palm, with a single red rose in the very center. She gave up arranging after that but built a greenhouse at her Bywater home. Purple and peach roses grow in her yard.

> *"The drag scene was still all behind closed doors in those days."*

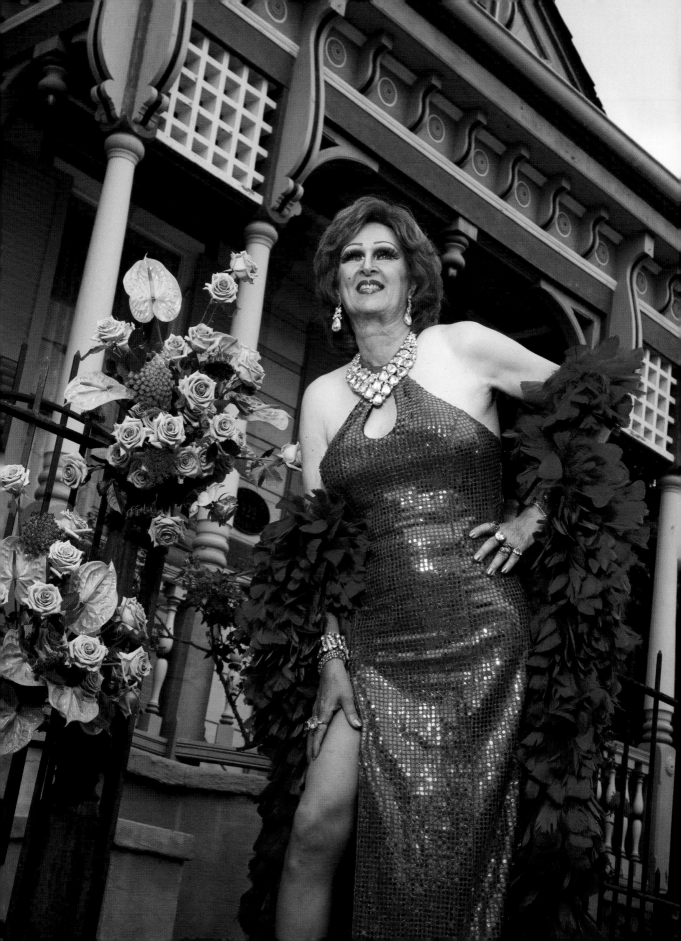

Teryl Lynn Foxx

NEW ORLEANS × **LEO**

Southeastern folklore advises painting your porch ceiling blue to ward off evil spirits. Beauty rituals prescribe blue eyeshadow as a camp signifier: the unnatural hue famously worn by Divine and Elizabeth Taylor evokes unbridled feminine power and affords the wearer protection from the unglamour of daily life. Armored with this protective magic, Teryl Lynn sparkled under the sunlight as the thickly sweet scent of gardenias hung in the air. On the day of her birth, Teryl Lynn's mother received a prophecy that foretold her daughter's strength and resilience:

We almost lost my mother during childbirth. While she was unconscious, she had a dream that the doctors took me away from her, and she followed them. They went to this large body of water and threw me in the water. She stood on the banks screaming, "What are you doing with my baby!" But she saw me swimming back to her, and from then on, she knew I would be a survivor.

As an effeminate child growing up in the sixties, Teryl Lynn recalls the moralistic judgment thrust upon her long before she could claim her own identity. *I remember my mom going to the parental conferences in elementary school, and I would eavesdrop from the coat room. The teacher told my mother that I was too nice of a boy to grow up "that way," and she should seek help for me. Hearing this, I'm thinking, "Do I have a third arm growing someplace? What was the deformity that she saw?"* Although Teryl Lynn's innocence clouded her teacher's not-so-subtle insinuations, she recognized that effeminacy made others an easy target of ridicule. *In the neighborhood where I grew up, there were these "sissies," they were called. I remember throwing rocks and laughing at them. And they'd say, "Oh, we're gonna GET you!" I know what that means now! Sometimes we bully people because we see ourselves reflected in them. I was actually one of them, but I was fighting it.* When a friend put her in makeup and a gown for the first time, a teenage Teryl Lynn stopped resisting her destiny. *I saw myself in the mirror and I started to cry. I thought, "Oh my god, that's me!" From then on, I started doing the drag shows.*

While drag opened the door for spiritual healing, the New Orleans scene remained starkly divided along racial lines. *In the seventies and early eighties, you had your Black clubs and your white clubs, and the only time the two would merge was when they'd have a competition, like Miss New Orleans. Then you'd have the Black girls*

going into the white girls' territory, as they'd call it. That wasn't very pleasant, because no matter how excellent the Black performers were, they wouldn't get recognition. When I began to gain acceptance from the other side, that caused a lot of problems within my community. Little did they know I was fighting for them to get here, too, but they thought I was abandoning ship. It became very difficult for me to work because I was too Black to be white and too white to be Black.

In the early nineties, Teryl Lynn was the first Black entertainer at the show bars on Bourbon Street, where she performed at Oz for fifteen years. *After that, I'd go back and see the show cast is now predominantly Black. I'm so grateful to live to witness the changes within the French Quarter. They didn't have any Black bartenders or doormen—it's a whole different world now.*

Teryl Lynn's ability to code-switch and pass within the straight and white worlds led to commercial modeling gigs for Saks Fifth Avenue and Canadian Mist whiskey. At every audition she ran the risk of being outed, but rather than go stealth she deftly balanced concurrent modeling and drag careers. She won the title of Miss Louisiana USofA 1991, and placed fourth runner-up at Miss USofA that year, her first time competing on the national stage.

> *"I had to prove something to myself."*

Her residency at Oz ended in 2005, the same year she lost everything during Hurricane Katrina. After a decade of rebuilding, she was crowned Miss Essence International Classic 2014, and Miss Continental Elite 2016. *I had to prove something to myself because my confidence was shot. That's a long time not being on stage. You think sometimes, "Do I still have it?"* She clinched the latter title with Diana Ross's cover of Billie Holliday's, "Persuasion/ T'Ain't Nobody's Bizness If I Do." *There ain't nothin' I can do / Or nothing I can say / That folks don't criticize me / But I'm gonna do what I want to anyway.* With a gardenia in her hair, Teryl Lynn transformed the blues standard into an empowerment anthem.

My mom always taught me to prepare for the future. Sometimes as we travel this life we get to a fork in the road, but I know whatever path I take, it will bring me to my destiny. I'm learning to embrace getting older, to embrace the grayness and the lines. People don't seem to notice but we tend to judge ourselves more harshly. I'm learning to accept it, and I know I should be grateful and thankful. But I'm going to be tight, do you hear me! I'm going to be yanked!

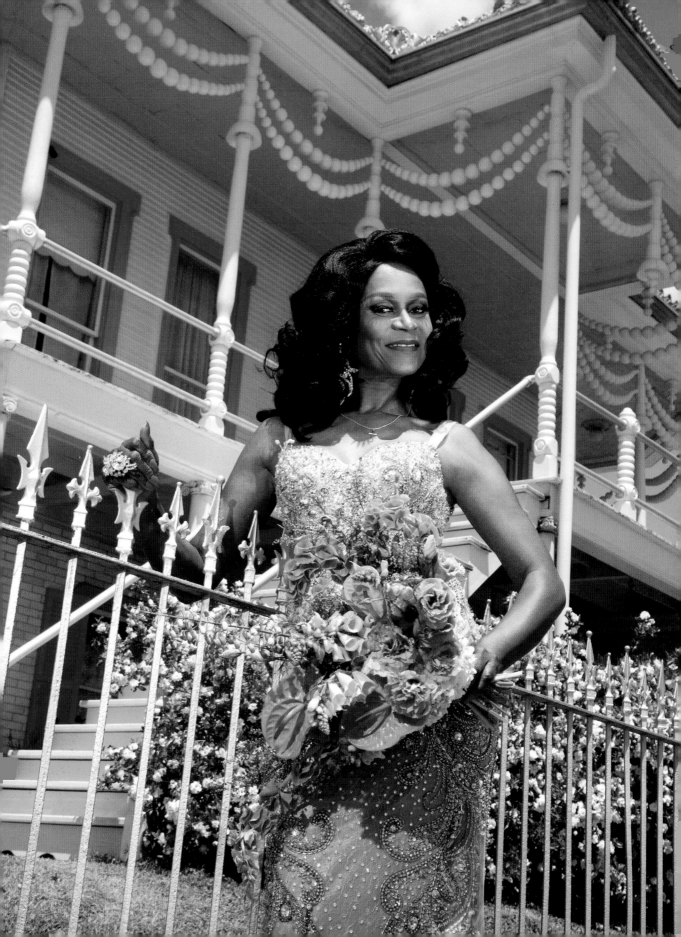

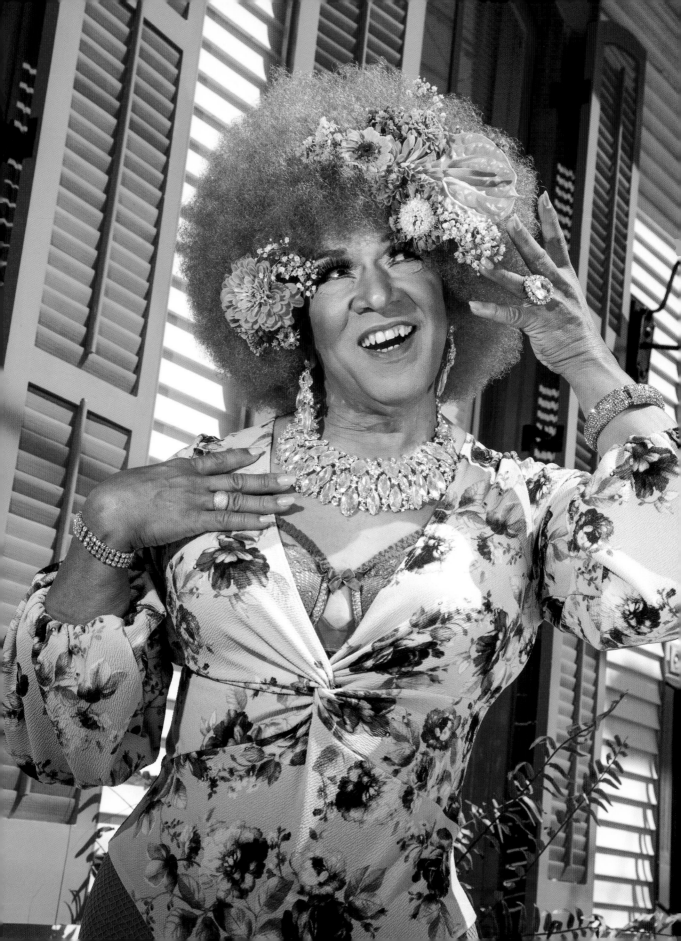

Vanessa Carr Kennedy

NEW ORLEANS × CAPRICORN

My story is a little different from a lot of the girls. As an armed, Creole, genderfluid, transgender, lesbian, grandmother who plays guitar and sings sixties and seventies protest songs, Vanessa Carr Kennedy is in a category all her own. Her look evokes resistance as well. *This is my Angela Davis/"Fight the Power!" wig.* She credits her wife, Desiree, with teaching her to accept and love herself in her totality. *Most of my life I was not happy with this impulse to express my femininity. My strong feminine side needs to be present, but also seen, heard, to be an advocate for myself, the community, and those like me: those who have this duality in their life and need to be able to express both sides.*

Growing up in a conservative Creole family with very specific ideas of what the girls should do and what the boys should do, I always wanted to be inside with the girls when they were getting their hair done and dresses made for them. By her late teens, Vanessa began experimenting with the transformative potential of makeup and hair. Throughout college she'd sneak out fully dressed to walk the French Quarter. Hiding from her family created a desire—*I wanted to go out and be seen. My first time out I felt aligned, inside and out.*

Vanessa reports that while the New Orleans drag scene persisted in the early eighties, spaces for cross-dressers remained a rarity. *I remember going into the Oz and being told I couldn't be in face—only performers could be dressed as girls.* She describes the drag scene then as very segregated as well: *Black girls did Black shows, white girls did white shows.*

Vanessa always did her own thing, but her highly unique show took decades to develop. Though kept separate from her cross-dressing, Vanessa's musical career ran parallel for many years. A self-described *marching band nerd*, she plays drums and guitar. She brought two of the latter to our photo shoot, including a customized pink and white Peavey Predator—*my baby.* After high school, she played in a funk band for two years before she and Desiree moved to California.

While on the West Coast, Vanessa played in jazz, blues, and rock bands. She also found her first drag family: the Mary

> *"My first time out I felt aligned, inside and out."*

Fucking Kays. Desiree and Vanessa also conceived their children. After fifteen years, the family returned to New Orleans.

I got involved in the scene here after four years being back. I went into Mag's—at the time, John Paul's—I didn't know anyone, so I sat and talked to the bartender. I told him my life story and that I was a musician. He insisted I play a show there, but I didn't want to blend those two worlds, music and drag. Her drag mother, Monica Synclaire-Kennedy, finally convinced her. Monica invited Vanessa to perform in her show. *I wanted to back out but ran into her at the wig store the week before.* Vanessa overcame her nerves and let the music flow through her. *After that, it took on a life of its own.*

I learned just by sitting and listening to Monica speak. The thing Monica taught me, which I was sorely lacking, was how to be a lady—how to carry myself and how to be respected and not care too much about what other people say about me. But when I step out, I look the best: pantyhose on, hair right, nails on, panties. She taught me how to honor her name.

Vanessa pays that lesson forward by ministering to the heterosexual cross-dresser community with which she still maintains connection. *They ask me to do makeovers for them. When they come to town, I arrange outings for them—a day being a girl.* When last we spoke, she'd just returned from a three-day cross-dresser conference in Oklahoma City. *More than just putting on a dress and a wig, I teach them how to do makeup or care about hair—to actually give in to celebrating the feminine side of oneself. The teaching aspect is the most rewarding part.*

Doing god's work earned this sixty-year-old the respect and recognition of her community. In 2016, she won Miss New Orleans Pride and Miss Louisiana Leatherette. When we shot together, she'd just been awarded a grant to produce her first album (as Vanessa Carr), which she intends to record locally.

She's not hiding from her family anymore either. When Vanessa spotted one of her cousins in the audience of her show, she walked up and introduced herself. He replied: "Aunt Judy's son? I've seen your show before and didn't know it was you!" She finally came out to the last of her family: a cop uncle in Atlanta. He didn't respond, but Vanessa isn't waiting around.

Moanalot Fontaine

NEW ORLEANS × **TAURUS**

A neighbor informed us that the owner of the house pictured behind Moanalot Fontaine mysteriously disappeared from the country, leaving the mail to pile up and vines to overtake the fence. Moanalot's booming voice, infectious laugh, and psychedelic palette brought the space back to life. In our afternoon together, she spoke variously about her Mayan heritage, her decorated history of drag shenanigans, and her intimidating reputation. She'd just celebrated a birthday and a twenty-third anniversary with her husband, who drove them both to the photo shoot and waited dutifully while we worked.

Through her career, Moanalot underwent multiple deaths and rebirths. Her husband catalyzed one such resurrection when, early in their relationship, he inquired about the contents of a large black chest in which Moanalot kept her drag locked away. Knowing healthy relationships require transparency, she opened the chest: *It felt like opening Pandora's box. Moana came out bigger, wilder, and crazier than ever, and hasn't stopped since.*

What escaped that day began in Los Angeles in the seventies with the elusive Cycle Sluts. The drag bike gang became notorious for their devil-may-care aesthetics—*combat boots, fishnets, corsets, mustaches, beards, glittered makeup*—and over-the-top antics and entrances to the various discos, like Probe in Hollywood. *People would go crazy when the Sluts arrived. One time we showed up in the back of a trash truck.* Moanalot got involved with the Long Beach chapter of the Sluts, known as the Dolls. *You'd take acid, put on your makeup, go to the club, and be wild. It was our version of club kids—the longer the eyelashes, the wilder the glitter makeup, almost bruised looking cheeks from all the rouge.*

Moanalot analogizes the Cycle Sluts as the Southern California version of the Cockettes—*that group Sylvester and Divine hung around with.* She befriended the latter and recounts Divine's kindness and shy disposition despite her larger-than-life stage persona. The onset of the AIDS crisis ultimately spelled the end for the group. *The majority of the Cycle Sluts are no longer with us.*

Moana developed her drag persona in 1987, based on a pair of cartoon characters doodled on napkins by her ex. *We were the Fabulous Fontaines: Moana and Melba.* They kept their mustaches and painted their faces white. *I called it flash drag, a concept from her Cycle Sluts era. We were campy and wild; we'd try to entertain the masses as much as we could.* The duo broke up in 1992, leading

> ## "It felt like opening Pandora's box."

to a brief hiatus and Moana's subsequent re-emergence in 1994. *I joked that Melba had died and now I'm grieving and moaning a lot.* So Moana became Moanalot and fell into the loving tutelage of her newfound drag mother, Psycadella Facade.

Psycadella was my initiator. I wasn't really a lip-syncing performer until she told me I had to learn. Moanalot entered a competition hosted by Psycadella in Long Beach. She performed "The Look of Love" from *Austin Powers*, wearing a big ruffle coat that she opened to reveal a G-string and panties. She won the contest as well as the admiration of Psycadella, who told her, "You are your own creator, you have a look of your own." Nonetheless, many point out an uncanny resemblance. *She has a huge lineage now, and I'm very proud to be her first daughter. I needed someone to push me in another direction, and I'm grateful she did. When I dove back into drag—my rebirth with Psycadella—I did it completely sober. I found a rush like no other high I've ever had.*

Though new to the stage, Moana barely stayed on it. She developed a reputation for sliding offstage and crawling on the floor, bouncing up and down on her hands and knees in panties and combat boots. She once broke the mirror of a DJ booth during a stunt. With her friends, Sheeya Mann and Jackie O'Nasty, she founded the Barbitchuates, who've become known for their theatrical parodies, elaborate set designs, and dramatic entrances and exits. When the group relocated to New Orleans in 2010 and rebranded as the Southern Barbitchuates, they *took the city by storm.*

Moanalot brought the Sisters of Perpetual Indulgence to New Orleans in 2012. Her involvement with the Sisterhood stretches back to California. An affinity with the order always existed by way of white face paint. She met founding sisters Reverend Mother and Sister Hysterectoria (Agnes de Garron). The latter moved to New Orleans herself after the chapter's epic and unrivaled Exequatur rite—a second line parade attended by sisters from around the world. The sisterhood formally exemplified Moanalot for life, in recognition of her decades of fundraising to combat HIV/AIDS. *Fundraising is really why I started performing. I reached a point in my twenties when I had to get all new friends because all of mine died.*

In the time since, *drag has been so many different things. It has evolved and evolved and evolved and then gone back. Other queens always tell me, "You seem to always bounce back to who Moana was." I tell them, "Yeah, but I just can't crawl anymore!"*

Agnes de Garron

NEW ORLEANS × **AQUARIUS**

gnes de Garron strikes the pose of the Fool: ready to leap through some doorway into some new adventure. Inspired by the theatrical tradition of *Commedia dell'arte*, she makes clear the reference. Rather than the dog often depicted biting at the Fool's ankle, our Harlequin steps off dogged instead by the Virgin and Leda—mirroring each other as iconic mothers of divine conception. When we moved Mary into frame, Agnes humbly asked, *Am I being upstaged?*

The Fool initiates a new endeavor. Agnes's path led her to become one of the founders of the Sisters of Perpetual Indulgence in 1979. *When I founded the Sisters there were four of us.* In Western esotericism the number four represents the elements, the cardinal directions, the corners of the home, and the crossroads. A number of structure and opportunity, four lends strength to any project. Sister Hysterectoria, as she's known in the order, founded the sisterhood alongside Sister Vicious Power Hungry Bitch, Sister Missionary Position, and Reverend Mother, the Abbess (Rise in Power!).

One of us died of AIDS: Reverend Mother. I never met a person so selfless. I thought he was my best friend. We lived together in two different apartments. I later realized that all these people thought the same thing. That's a lot of caregiving, to be so much to so many. To make them feel that important and to be that close. I never remember being jealous, though. I just wanted to be included. Everyone said he was the most spiritual person in their lives.

Of her own spirituality, Agnes ascribes a sacred glow to all acts of creating a character. Brought up Catholic, she found resonance with the early Radical Faeries. *I liked the whole pagan aspect. Not the ritual as much as the back-to-nature. Everything is all there, you're just living in a concrete jungle. The rituals that honor the Earth are good to me.*

Agnes journeyed alongside Reverend Mother as emissaries of the newfound sisterhood to the first Radical Faerie gathering in the fall of that year. In *The God of Ecstasy*, Arthur Evans recounts the experimental rites and orgies of the Faerie Circle in Haight-Ashbury in 1975, out of which the Faerie current emerged. Evans attributes the Faeries' animistic way of seeing to the presence of the god Dionysos—invoked as the horned god, before an orgiastic rite by a participant named Loki.

> *"I liked the whole pagan aspect."*

He writes: "The Dionysian tradition aims at ecstasy—stepping outside the limits of one's ego. By participating in the god's rituals, individuals enter an altered state of consciousness, break through ego boundaries, and let themselves dissolve into the world."

This return to the world, from above or below, holds transformative potential for the participants. "On returning to their ordinary mental states, they sometimes find that the old boundaries of ego-definition have been stretched and altered and that they are slightly different persons. They transcend objectivity not only by giving themselves to the world but by participating in the process of their own self recreation."

The sisterhood's method of street theater demonstrates this enmeshed cocreative process in action. *The reaction of the crowd was the tutorial. They were all saying Catholic things to us. It's all part of the game. People wanted to interact with us. "I hated all my nuns." I wanted someone I could hug. Others want that too. People would say to me: "You're a nice nun, not an evil one."*

The nuns each bring their own magic: Agnes brought dance as an originary contribution to the Sisters. She loved to dance as a child and yearned to take ballet, but as a boy was refused to entry to the classes. Agnes therefore took tap classes instead. She ranks dance as an extremely important aspect of her characters, and even today demonstrates a very graceful modern dance approach to movement and posing.

I started having a dance class for people in the order. Nobody had training except myself. I studied ballet as an adult with a company called Pacific Ballet. I saw Sisters doing dangerous things when we went out on the street. I want to teach them posture. People started inviting their friends. Out of this group came a dance company. That company, which Agnes calls a highlight of her career, became a chariot for the Sisters' entrance into the world. They put on a nun ballet. Their endeavors garnered increasing interest in this group of dancing cloistresses. *As the Sisters became famous we were asked to do these major appearances, including the old opera house in San Francisco.*

In 1981, the company opened for the Gay Men's Chorus. Sister Chanel 2001, who imbued the rainbow flag with its color-coded power, designed the set for that performance. *He said, "I have a rainbow flag that's actually bigger than the whole backdrop*

of this opera house. *I'm making a streamer for each color so that you can run across stage in all the rainbow colors."* It was so big you couldn't show both the red and the purple. Between red's sexuality and purple's spirit, Agnes wanted to portray a gay romance in a way as yet unseen on the stage.

Before the show, the Chorus wanted to trade the flag for some gigantic sheet of mylar they intended to use as a backdrop. It was like a mirror. Initially agreeing to the trade, they rehearsed with the mylar. The mirror, however, shattered the fantasy, and they ultimately insisted on keeping the flag. *Since it goes with the finale, and it is our flag, and Sister Chanel 2001 is in the order. The dancing was fantastic. The audience was really with us. This was a big enough stage that there was a wind effect. We ran right off the stage and in all different directions. It was spectacular. We upstaged the Gay Men's Chorus number.*

The image of the streamers against the encompassing flag points toward other key elements of the group's generative process: set design, props, costumery. In all these, Agnes is known for her use of unlikely materials. *I like to make outfits out of whatever I have laying around.* She arrived to our shoot with a bag full of scarves tied together. When asked beforehand what colors she'd wear, she replied, *Many.* She fashioned a jester's cap out of a straw hat, foam, a big spring, and pom-poms. Healing from a foot injury, she wore shoes acquired from the VA—she'd previously only encountered them in neutrals, so she snagged the blues as soon as she saw them. *I like to play eccentric people that don't look like anybody else. If you dress perfectly, you're just a mannequin. If you're not perfect, even if you tear something, you humanize. It's the little things.* Even with her humanizing detail, after checking her hand mirror, Agnes confirmed that she *looked like a creature, heavenly and rare.* This divine being completed her look with jewelry made from toys: four dice dangling from each ear and on each wrist, wristlets belonging to *a game that requires a very special kind of ball.*

Curiously these same toys—dice, ball, mirror—appear in Clement of Alexandria's *Exhortations to the Greeks*, a hostile Christian source on the ancient pagan traditions. These are

named in a passage wherein Clement explains an obscure story within the Orphic tradition, which conceived of Dionysos as thrice-born, having an incarnation before his more commonly known births out of his incinerated mother Semele and then again out of Zeus's thigh. The Orphics tell of a prior conception between Zeus and Persephone resulting in the birth of the child-god Zagreus. Of this child's untimely fate at the hands of Titans in Hera's employ, Clement writes:

> The mysteries of Dionysos are wholly inhuman; for they say that the Kouretes danced around his cradle clashing their weapons, and the Titans having come upon them by stealth, and having beguiled him with childish toys, these very Titans tore him limb from limb when but a child. As the bard of this mystery, the Thracian Orpheus, says: "*Konos* and *rhombos* and a doll with bending limbs and beautiful golden apples from the clear-voiced Hesperides." And so it is not useless to put forth for censure the useless *symbola* of your rite: knuckle-bone [dice], ball, top, apples, bull-roarer, mirror, wool.

Agnes knows those dolls with moving appendages, too. For nine years, between 1984 and 1993, she and Gabriel Quirk appeared as the Puppetears of Ecstasy. *I met this young guy who was a puppeteer, traveling to a Faerie gathering in New Orleans. He moved to San Francisco.* The pair brought their puppets to renaissance faires, performing up to six times a day. *The only way to keep from getting bored was to make new things.* They generated quite the collection, at times showing up to a performance with fifteen puppets. Four of them symbolized the four elements, and they even made one marionette the manager of the theater company. *When we were through with something we just put it on the stage.* Agnes often changes costumes through serpent-like shedding of layers to the floor. *The stage became this decorative thing of stuff we were finished with: fabrics, etc. If you're done with a marionette there's a way of laying them down like they've died so their strings don't get tangled. We brought out a coat hanger and hung them. They died but can come back to life if we need them.*

"They died but can come back to life if we need them."

These toys promise rebirth after death and dismemberment. Far from the impotent symbols Clement derides them as, the presence of these playthings in a creation story about the dismemberment of a child-god highlights the importance of play in the cocreation between self and world. They stand in for all the potential of world-making we experience in our acts of youthful imagination. Toys also gesture toward all the healing potential hidden in our childhood memories.

Agnes recounts her earliest memory of performance as a child in Springfield, Vermont. At the age of five, she dressed up to perform *The Nutcracker* for their family. The unexpected arrival of one sister's eighteen-year-old boyfriend caused a disruption and the recital ended in tears. Still, Agnes persisted in the theater.

The way I was able to perform as a child: when I first went on it was just me and that was frightening. It was just yourself and this routine they've given you. I remember wearing this suit, DayGlo green. The costume was enough to make me a character of this whole scene. We weren't ourselves. And then I was completely there. This stepping outside oneself—*ek-stasis*, ecstasy—requires a presence within a strong container.

When I perform drag, I don't get nervous. I'll give away anything of myself. I can be emotional, let it all hang out because I feel so safe. The audience goes for it when you do something like that. They're riding with you. If they identify that closely with what you're doing, they're doing their own dream of what you're doing. I have a plan because I'm a choreographer. I make something look like I've rehearsed it and done it a million times, but it just sets. I see drag as part of a broader theatrics.

Roman and later Catholic persecution caused the Dionysian tradition to retreat for a millennium or so into the god's historic enclave: the theater. Agnes too found refuge there. *As a gay boy that acted effeminate, the stage used to be my sanctuary. I would dance at the talent shows, in front of all the other students who are gonna tease you or make fun of you. But that's the safest place you can be. Even alone. Nobody can get at you.* Once during a high school variety show, some would-be bullies attempted to disrupt Agnes by throwing pennies at her. *Things sprinkling down from the balcony. Boys in the balcony thought they were gonna destroy my number. With the music playing, it was like a special effect. I never got hit. I guess I was supposed to break down and cry or leave the stage. Well, their plan backfired. It was a great idea . . . for me! Even if someone is gonna throw a pie or something, everybody gets to witness it. Somehow it gave me this freedom.*

That divine freedom of the stage demands cultivation and care. *Where we rehearse and study and work hard is also a sacred space. Many times, I am with a group of performers and I'm the one to get the broom, and I sweep. Things happen on stage. When we're on stage, we're in this together. It's spiritual. We can look at each other's faces. It gives us an enormous amount of power to have that type of confidence.*

After a decade in San Francisco, Agnes moved to New York City in 1986. She arrived as the AIDS crisis raged but before funding or organization existed to fight the epidemic. So many drag performers died. Agnes focused primarily on fundraising. Through appearances at benefits, *I got to meet all these new people and make these connections.*

Agnes started the NYC Sisters with people she mostly knew through the Radical Faeries, so they knew the drill. *I just told people to wear something black.* Her partner Gabriel helped make their headpieces. The Sisters made their first appearance at a big ACT UP demonstration in front of St. Patrick's Cathedral in December 1989. *The church was telling people not to use condoms and ignoring the fact that people were dying. There were thousands and thousands of people, all these individual actions. People went into mass, received communion, and then spit it in the aisle. People outside were marching in circles; the police made you keep moving. Instead, we decided to stand still and entertain people.* After the demonstration ended, the Sisters lined up in front of Rockefeller Center's decorated tree and sang "The Sound of Music" while dutifully distributing little packets of condoms. From the stage to the streets, the Sisters act directly to mourn the dead and fight for the living. They persist in the agenda, penned by the founders, "to promulgate universal joy and expiate stigmatic guilt."

> "The stage used to be my sanctuary."

MIAMI

Adora

MIAMI × SAGITTARIUS

Born on the winter solstice, the darkest day of the year, Adora always moves toward the light. Practically dancing her way out of the womb, she doesn't remember a time before the stage. She attended ballet school and was performing nightly Tuesday through Sunday by the age of seventeen.

Raised in Cuba, she spent half her life *living through communism* before inevitably leaving. *Gay life in Cuba was persecuted, to say the least. In 1979, all the gay parties were underground—we'd rent these vacation rentals confiscated from the wealthy. I went to a drag show on the second story of a beach house. The police came and everybody had to run for their life. I jumped out an upstairs door and had to scale a fence.* Adora evaded arrest but those caught up that night spent the next four years imprisoned.

That raid occurred in the context of a broader campaign of anti-queer repression by the regime. *Police would show up at any time to the gay area of the beach, pick everyone up, hold them for the night, interrogate them, inspect their underwear.* Countless friends came to Miami during the 1980 Mariel boatlift. *It's the only thing that saved them. Most still died when they got here, etc., etc.*

Her family left in waves beginning shortly after the revolution. Her grandfather and uncle worked as tailors for clients deemed undesirable by the Party. They stayed long enough to attend Adora's baptism in 1962. Her grandmother left in 1965. Her younger sisters (ages fifteen and nine at the time) were selected for the boatlift. *They got on a boat with people they didn't know to go live with relatives they'd never met.* Adora stayed until 1985, when her then beau, a French diplomat in Havana, brought her to Paris. She visited Miami a few times before permanently relocating there in 1989.

Adora dressed like a goth back then, all in black, hair hanging from the side of her face. She didn't take to the city at first. The queens all served a very eighties glam style of drag: not her thing. Fortuitously, Adora reconnected with Carlos, a friend from Cuba, and the pair went out together nightly. In South Beach, they discovered a very different scene, ready to embrace the new decade. *We were club kids. We were already doing hair when we went to a party in South Beach and saw drag queens. We had dresses back home down the street and said to ourselves, "Let's go put them on!" We returned in gowns and combat boots. The people at the club asked, "Well, who are you now?" and we answered, "The Adora sisters."*

We had a lot of fun getting dressed. We wouldn't ever go out without wearing something. You had to create a character. We wanted to do a cartoon kind of drag. The old queens called us clowns. When Carlos died in 1991, Adora thought she might give up drag. She ultimately decided to continue when she received a call for a solo photo shoot. *It was December 1991, the birth of Adora,* singular.

Adora assembled her character from a handful of powerful aesthetic references: Rosita Fornés for her humor and slender waist, the Italian singer Mina *with those arms for days,* Maria Callas the Greek soprano. Her grandmother played Yma Sumac while cleaning—*she learned to sing from the sound of the jungle.* And then of course there is La Lupe—*I didn't know her in Cuba but learned about her from Almodóvar's* Women on the Verge of a Nervous Breakdown (1988). *When I did drag for the first time it had to be La Lupe, obviously: the accent, the humor . . . perfect Adora!*

Incorporating dance into her routines came naturally—*when you're a dancer, it's in you. There's no way to move without using your arms*—but painting took more work. Adora saw her face in her mind's eye but struggled to apply. She learned some foundations from Electra but *nobody told me how to do my eyes; nobody could have taught me this. I learned and little by little became the Adora you see today.*

Her enduring club persona and devotion to curating strong vibes led Adora to DJ as well. *The drag made the doors open a little easier for me, having already a name and all that.* Whereas performance came as second nature, her work as a DJ remains a constant challenge. She calls it a big responsibility but finds the effort infinitely rewarding. She loves to see a room dancing around her—*it's an incomparable feeling.*

I'm proud that I'm doing what I'm doing for as long as I've been doing. I make a living out of it. Any prize, any title, anything can come and go, but people still wanting you—that's a huge deal. That's the biggest accomplishment of my career: still being here. I keep looking back and thinking how many aren't here or doing what they love anymore. It's a blessing.

> *"The police came and everybody had to run for their life."*

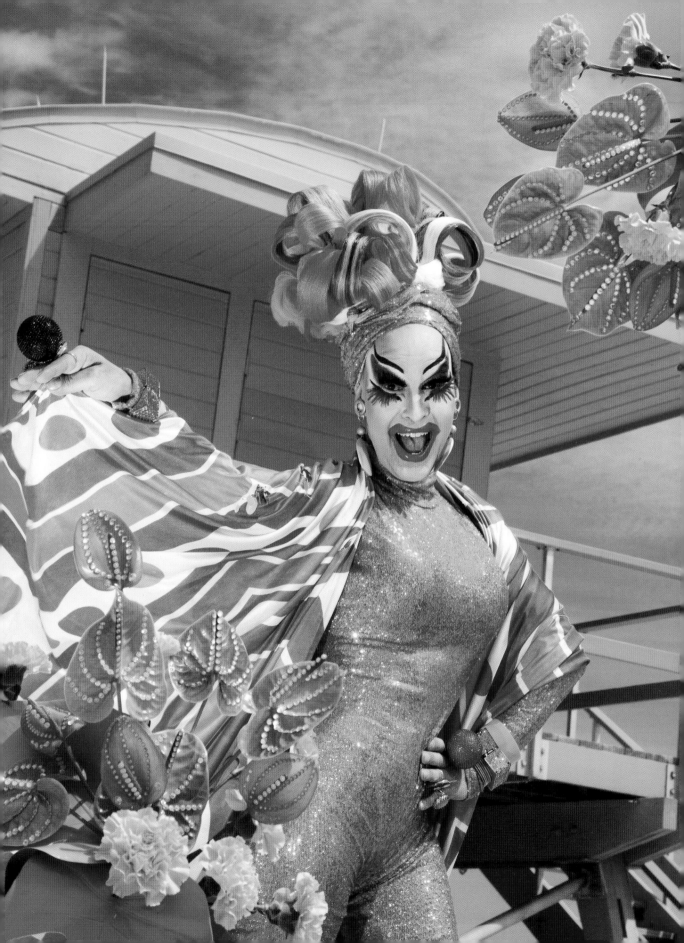

Kitty Meow

MIAMI × **VIRGO**

As the drag and club scenes converged in the early nineties to spawn the club kids, Miami's South Beach—a pastel paradise renowned for its Art Deco facades, palm trees, and neon lights—became their playground. *It was a period when Miami Beach was inundated with bohemian artists, muscle boys, supermodels, and designers. It was an incredible creative movement.* Kitty Meow found herself at the center of it all, hosting parties for Susanne Bartsch at the Warsaw Ballroom and as the resident door goddess at Paragon nightclub. According to the *Miami New Times* in 1994, "People drive past the Paragon just to see what Kitty is wearing." She's certainly hard to miss. Known for her chiaroscuro approach to eye makeup, glittering catsuits, towering headpieces, and her booming baritone voice, Kitty instantly commands any room.

During this era, a synergetic relationship existed between the club scenes of New York and Miami, enabling Kitty to learn from the best. *I met all of these really brilliant characters: James St. James—he was writing* Disco Bloodbath *at the time. I didn't even know what a hot-glue gun was, but he introduced me! People like James, Darrell Elmore, and Kenny Kenny defined what door people were about, so I strove to emulate them and inject my own personality.* Kitty scoured the society pages of *Ocean Drive* magazine to ensure she let the right people in, but also retained a sense of egalitarianism. *At Paragon, the line would be a three-hour wait, sometimes it shut down the street. I'd always go to the back of the line and pull people up to the front. I grew up in the Bahamas, where being flamboyantly gay was an impossibility, so if I saw anyone wearing combat boots and freedom rings, they were in.*

Kitty mostly worked circuit parties but crossed over into ballroom as well. *My friend Lisa Sawyer was doing these events called Girls of the Night. They were predominantly lesbian parties but included a lot of ballroom kids. They had a big house ball and she told me to bring my house. I would always hang out with an eclectic group of people, and I thought, "This isn't a house—this is a temple!" We started referring to it as the Temple of Kitty Meow. Each person brought their unique element to make it an institution. We had the muscle boy thing down! And a lot of drag queens!* One infamous showdown at the Warsaw Ballroom pitted the Temple against the House of Adora: *Me and my posse fully in leopard print and fur, and Adora in one of her classic*

> "This isn't a house—this is a temple!"

exaggerated Marilyn Monroe wigs, and all of her girls were dressed exactly like her but in different colors. It was outrageous! It went until 5:00 a.m. Their notoriety earned the crew an invitation to perform in Rimini, Italy, during the European Dance Music Conference in 1993. As the central deity of the Temple, Kitty adopted the mantra of *Pay it forward, open all doors!*

Kitty's playful evocation of divinity is grounded in a sincere spirituality. *I always ask the universe—well, I ask god—for the best outcome of painting my face. I always say the creative process, from beginning to end, is what I want covered by the grace.* She emphasizes the importance of trusting the process: *Sometimes when a look isn't turning out the way I envisioned, I remind myself to surrender my ego. Step back. Reapproach it; it may become something completely different. There's always multiple angles.* One of her favorite tracks to perform at circuit parties is "Not Enough" by Melanie Williams. *So many people lost and abandoned | Not enough love to go around | So many people at war with each other | Not enough peace to go around.*

Kitty venerates the influential queens who opened doors in Miami long before her arrival during the unprecedented club kid boom of the nineties. She recounted the legacy of the recently departed Henrietta Robinson, one of the first drag performers and out trans women in Miami Beach, pre-Stonewall. Henrietta also worked as a private chef for Al Capone, and she was so adored by her employers that they bestowed upon her gifts of Bulgari diamonds. Throughout the nineties, she would drop by the clubs with platters of gourmet desserts to nourish the hungry partygoers.

Since her club kid days, Kitty continues to emcee some of Miami's most high-profile events, including the White Party, the longest-running HIV/AIDS benefit in the world. Her infallible charisma led to roles as a reporter for iHeartRadio, culture correspondent for *Hotspots!* magazine, and entertainment director of Pride Fort Lauderdale, cementing her status as a bona fide media maven. From her temple atop the mountain, Kitty offers a hand to those coming up behind her. *I'd say to the new kids, look for the light and the positivity. Leave the shade and the darkness behind. Under no circumstances—don't let hate get in the way. And don't shoplift—let someone else do it!*

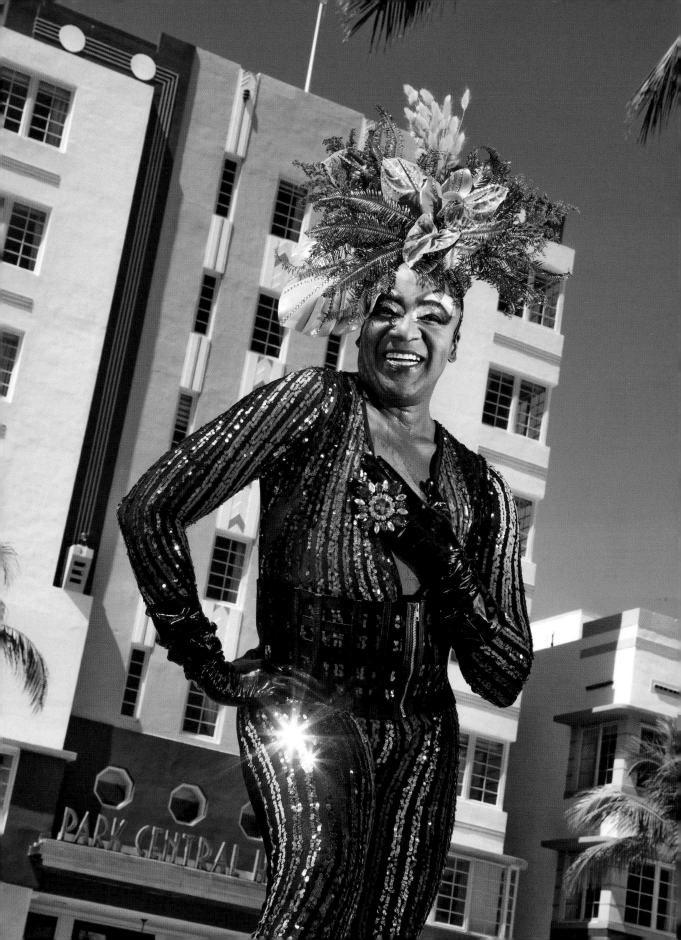

FORT LAUDERDALE

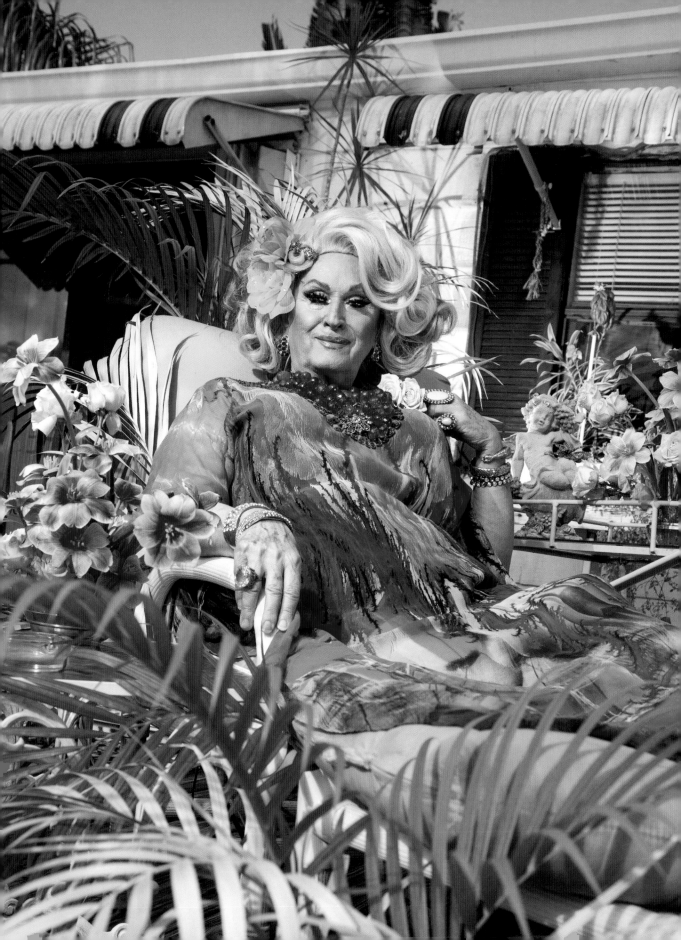

Charity Charles

FORT LAUDERDALE × SCORPIO

Throughout our afternoon with Charity in her dearest gal pal China's backyard, the pair gave us a glimpse into a half century of drag legacy. Both epic in their own right, Charity was sure to remind us that China outranks her in seniority. Though claiming retirement and permanent residence in Florida when last we spoke, Charity came to fame as a Fire Island girl. Born and raised in Boston, with the accent to boot, Charity remembers being *always girly, even as a boy; loved dressing up in my sister's clothes (never wanted to be a girl except for maybe a moment when I was eight)*. If that reads like a commonplace queer childhood, her drag origin story vastly diverges from the emergent formula.

My very first lover in Boston was a forty-two-year-old man when I was eighteen. He courted me when I was still a virgin. He took care of that. While we were together—after being with him a very short time—I discovered he'd had a drag queen before me, and they had scrapbooks of pictures of all these queens he knew. I met him in 1960. This was all underground drag going on in Boston.

When confronted with the scrapbook, he confessed: *He could see that I had the features and everything to be prime material for him to have another drag queen lover. He was a wealthy man and only knew other wealthy men and they all lived in town houses on Beacon Hill. They all had the same desires and had drag queen lovers too. He swept me up into this world. We'd go to dinner parties in drag with all the other couples. It was almost like straight people where the husbands all retire to the library after dinner to smoke cigars while the girls all gather around and gossip.*

He bought me beautiful clothes, not the cheap stuff—gorgeous shoes, wigs, you name it. I even had furs. He'd bring me to straight restaurants, and I could pass. I was twenty years old, very thin, long legs, didn't use a lot of makeup but had a pretty face. He was a gentleman, like the old-fashioned days. He ordered for me; I wouldn't speak. I just sat there looking beautiful.

When I moved to NYC in 1964, I left that whole life behind. Six decades later, she still serves a trophy wife fantasy. Regarding her portrait, she remarked: *I look like a rich housewife; I should have a cocktail in my hand.* On her first visit to New York with her elder suitor in 1962, she was blown away. *He showed me a wonderful time.* She remembers the exact day because the

> ## "I thought I died and went to heaven."

newsboy in front of their hotel kept screaming the headline: "MARILYN DEAD!" Besides *all the touristy stuff*, the trip included a detour to Fire Island.

I'd never heard of the island before. On the ferry over I see there's lots of gayness going on; I'm loving it. As we pull into the dock there are men waiting for us in Speedos and high heels. I thought I died and went to heaven. At her lover's instruction she brought period drag for a lavish Roaring Twenties party. They stayed in a home without electricity, lit only by kerosene lamps. The law at the time still forbade men from dancing together, so they played Motown music and line danced or swing danced so as not to hold each other. *I was good at that; it was fabulous. The Ice Palace was the place to be back then. Discovering Fire Island made me gayer than gay. My world completely opened up when I went to NYC. From that first time, I knew I wanted to move.*

During the weekdays she worked in fashion, designing the displays at Saks Fifth Avenue and later working for Lord & Taylor. *I was in the fashion world but doing drag on the side.* Her performing life centered around Cherry Grove. Charity came up with all the legends of the island: Panzi, Bella, Rose Levine, and of course China. *I started performing in shows at the community theater on the island. They gave me the little bits that the pretty girls get to do. I'd go on stage as a showgirl with big feather headpieces. Winning Miss Fire Island shot me up into fame, and people started to know who I was.* In 1968 she won the second Miss Fire Island after being expelled from the first for stripping out of her gold lamé gown on stage. *I didn't know what they were looking for. I came back with a vengeance the next year.* A friend, *who made the drapes for the Kennedy White House,* constructed her winning gown out of seventy-five yards of white silk organza. *I got a lot of evil eye from the bitchy queens backstage, but I won the contest hands down. The audience was screaming my name.*

Devotees of drag history will notice that a different Miss Fire Island appears in *The Queen* (1968). Flawless Sabrina asked Charity to participate in the film, but she declined. In her stead, they went ahead and cast *an imposter who was a friend of Crystal LaBeija. My friends were so angry when they saw the film, but I just laughed it off. I knew I was prettier anyway.*

China

FORT LAUDERDALE × TAURUS

A single moment in China's presence disproves the commonly held presumption of glamour's superficiality—as a facade or a masquerade. When she enters a room, every head turns. Her piercing green eyes, framed with dramatic fringe, gaze directly back into your soul. She possesses a vibrant magnetism comparable only to the greatest stars of the silver screen: Marilyn, Liza, Elizabeth. To know her is to love her. *I make friends easily*, she says with a gracious smile.

As we pulled into the Cypress Creek Mobile Home & Country Club on a hot and humid Florida afternoon, China greeted us from the end of her driveway: a vision in her peaches *à la mode* ostrich feather daydream. Her home is nestled in a corner of the park, a sleepy canal bordering it on two sides. Tall palm trees and lounging wild iguanas complete the atmosphere of a tropical oasis. Her south-facing deck receives direct sun all afternoon. A truck adorned in decals of the "don't tread on me" variety sat parked outside her double-wide. *Oh, that's my handyman, he'll be by later.* Wise queens always keep some rough trade around to tackle the dirty jobs unbecoming of their majesty. Her handyman looks after the place—her "villa" as he calls it—while China spends the warmer months in New York City and Cherry Grove. When he dropped by and encountered China in full drag, we detected a bashful reverence beneath his macho exterior. Even those good ol' Southern boys can't deny her charms.

China retired to Florida twenty years ago but spent most of her life in and around New York. Brought up on the Jersey Shore, she moved to the city as an adult and began summering on Fire Island in 1955. *When I first went out to the Grove there was no ferry. You took a water taxi from the mainland, which was almost like a rowboat. It was a lot of fun, but you didn't always arrive dry.* China felt an instant connection to the gay enclaves on the island. *From the day I went to Fire Island I had no desire to go anyplace else; it was a fairy land. I'm always waiting to go back.*

The openness she found there stood in stark contrast to queer life in the city, where the police frequently raided the mafia-run gay establishments. *You had to be on guard no matter where you were going, but I always felt safe on the island.* She recalls opulent balls at the Belvedere Hotel (then still a private residence), raucous dance parties in the heyday of the Ice

> "I always felt safe on the island."

Palace, and the evolution of the famed cruising zone known as the Meat Rack. *In the sixties, the Meat Rack was on the beach, then it moved to Maryland Walk, the last walk in the Grove. I clearly remember staying at this house on Maryland, we'd get up in the morning and there were all these people coming from underneath the deck.* Beyond the social opportunities, China also felt the pull of the ocean. *I used to live in the water. On the island you can go swimming any time of day or night.*

She spent nearly thirty summers there before joining the class of painted ladies. In 1984, China began cocktail waitressing at Cherry's, where they put on a different theme party each Saturday. China dressed in drag for the weekly function, at first sporting a heavily glittered mustache. Intuiting her star potential, China's partner Gary Collins refined her look in accordance with high-glamour standards. *Gary was so talented; he saw trends before they happened.* She went on to win nearly every title on the island, including Mrs. Fire Island, Miss Cherry's, Mrs. Cherry's, Miss Ice Palace, and Homecoming Queen. The couple became active in the Imperial Court as well, taking part in the legendary Night of a Thousand Gowns.

China's signature style—white hair and mini dresses trimmed in ostrich feathers—evolved over the years, cementing her icon status. Her look is nothing short of genius—instantly recognizable, utterly timeless, and the perfect complement to her rich golden tan. Her alluring power is much more than skin deep, however. *I wasn't considered a performer per se; I was a personality. I became very popular because I had a good time and everybody else had a good time—I don't know how else to say it!* China insists there are no secrets to her eternal glamour, but she did reveal the key to achieving the perfect tan: *Be Italian.*

Now in her ninth decade on Earth, China is part of a select few whose coming out predates Stonewall. She recalls being on the island when the riots occurred. *We heard about it; the news traveled so fast. We weren't sure if we should stay or go. Good friends of mine were there—Ivan the Terrible.* Faced with the choice to join her friends in the rebellion or remain within the safe haven of the Grove, China opted to wait it out. Each year she looks forward to the Pride parade in commemoration of that uprising, her fallen comrades, and the fights yet to be won.

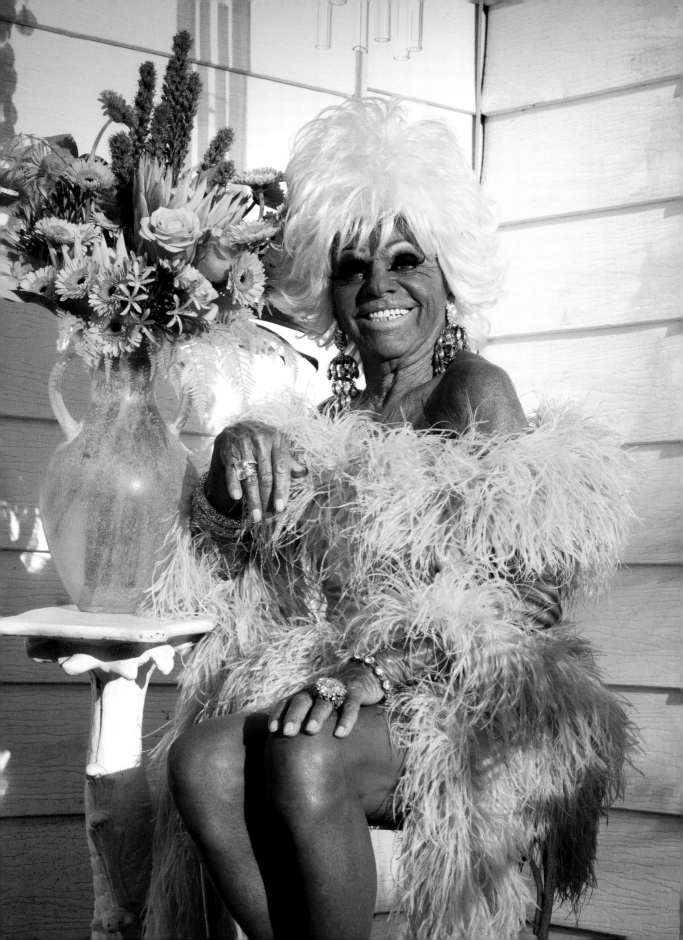

Sharde Ross

FORT LAUDERDALE × PISCES

The majestic mangrove wetlands and dunes surrounding Bonnet House Museum & Gardens display a stunning array of tropical blooms: flamboyant hibiscus, delicate water lilies, towering African tulip trees, and rare orchids of every coloration. Former proprietress Evelyn Bartlett collected such orchids, and in the 1930s she constructed an enchanted greenhouse to showcase her specimens. Nearly a century later the historic property played host to a rare flower of a decidedly more unnatural variety, though sublime in her beauty nonetheless: the seductive Miss Sharde Ross, clutching dyed-blue cymbidium orchids of her very own. In brilliant hues of yellow and cerulean beset with aurora borealis crystals, Sharde glistened under the Florida sun.

Though a fixture of the South Florida drag scene for over twenty years, Sharde's story began in the neighboring queendom of North Carolina. *In the late eighties, drag in North Carolina was HUGE. It was so big in our culture. Back in the day, you could count on good impersonators coming out of certain states. You automatically knew they were good, because of the level of competition. North Carolina was one of those; we were fortunate in that respect.* Thankfully, Sharde cultivated a close-knit sisterhood among her friends Tiffany Bonet and Lonni that ameliorated the fierce competition. They've all known one another since their teenage years, and Sharde and Tiffany share the same hometown. Sharde recalls clocking other effeminate boys in town, but *we were just the more bold and daring ones; we were a little out there.* Their local fame quickly grew after the trio won a Halloween contest with an acrobatic baton twirling act, frocked in majorette uniforms borrowed from their marching band cohorts.

The sisters assembled their own revue, incorporating impersonations of the Pointer Sisters, Tina Turner, Stephanie Mills, and the Supremes. Sharde portrayed her namesake, Diana Ross, of course. The troupe traversed the Tar Heel State for two years, performing at major clubs like Scorpio in Charlotte and Power Company in Durham, as well as smaller coastal and mountain towns. Throughout their life on the road, the sisters shared everything: wigs, tips, shenanigans, and occasionally men. *We call Asheville "Ashevegas," because it's a crazy little party town. Guys drive by with pickup trucks with a hay bale on the back and you think they're straight but they're gay as a dog. And you jump in the back and go for a hayride and next thing you know you're in the middle of nowhere with a pastor doing him out in the woods.* Sharde left no ambiguities about her skills in that arena: *I'm OK at drag, but I'm VERY good at fucking.*

As the nineties commenced the trio went their separate ways but remain close friends to this day. Sharde cultivated her own reputation as a strong competitor on the pageant circuit, with her first major win at Miss Gay North Carolina 1993. *Back then you had city and county preliminaries to the state pageant, so winning that title really felt like being Miss America of North Carolina. Everywhere I went I got in free, I was catered to, I was the belle of North Carolina.* Sharde packed up her bag of tricks and relocated to Fort Lauderdale in 1997, where she continues to compete in numerous pageant systems. She keeps a tiered curio cabinet surrounded by ostrich feathers, where she proudly displays her sashes, plaques, trophies, tiaras, and crowns: Miss Gay Florida USofA Classic 2009, Miss Gay Florida America 2013, and the latest, Atlantic Coast Showgirl Supreme 2019. No national wins yet, but at her current pace she'll soon need a larger cabinet.

"We were a little out there."

In alignment with both her impressive credentials and roots in Southeastern drag traditions, it follows that Sharde strongly prefers the title "female impersonator." *When I started doing drag in the eighties, "drag queen" was a derogatory term. As generations change, people look at things differently. My parents probably thought we were crazy too. I am rather old-school still, and I've learned to stay in my lane. Now you can do drag with a beard and the kids are loving it.* From the comfort of her own lane, she added dryly: *It's hot. It's in. Yay, go for it, child. I'm still doing Chaka Khan!*

Styles change but the function remains the same: *The attention you get when you're in drag—it's great. It makes me feel wonderful, like I'm my total self sometimes.* Sharde ruminates on what past life she's redeeming through her art. *Maybe it fulfills a thing I never got to do. Maybe I was a woman in my past life and I wanted to entertain but was too afraid, so I came back as a guy and put on a dress to finally get in front of an audience.*

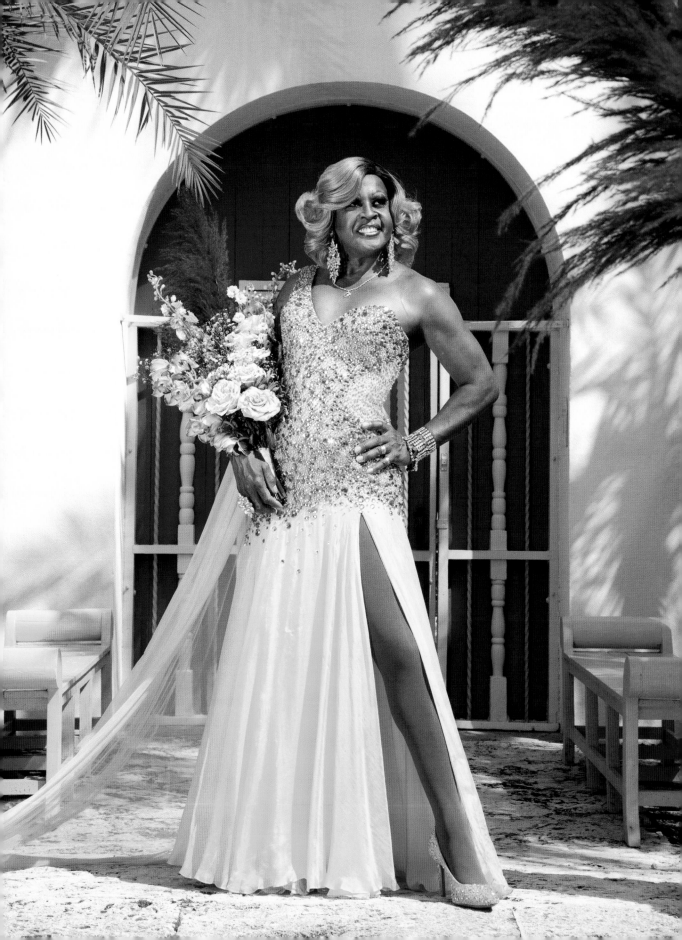

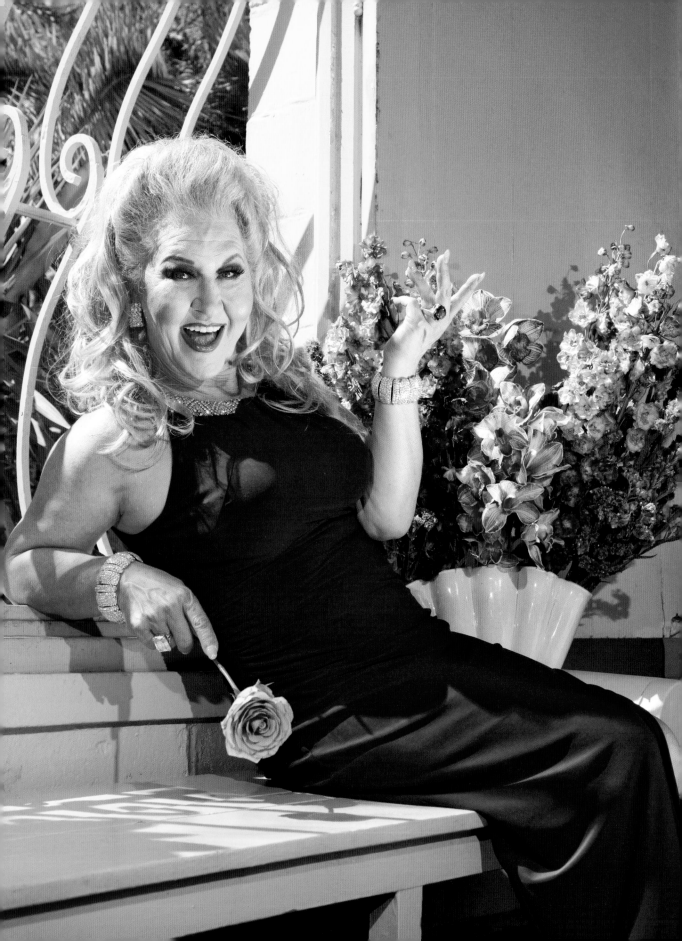

Nikki Adams

FORT LAUDERDALE × **GEMINI**

I wore my mother's wedding dress many more times than she did, Nikki Adams confessed. She describes her childhood in western Pennsylvania as *idyllic, like a Norman Rockwell painting.* Whenever her parents left home, young Nikki slipped into the illusive world of feminine adornment that beckoned from behind her mother's closet door. Her mother was complicit at first: for her third Halloween, Nikki wore a frilly peach dress with a matching white fur hat and muff, one of her earliest memories. *Mom knew,* she says with a smile (as mothers often do). By the time she hit puberty, her innate femininity was no longer a cute gimmick to be acted out at home, but the subject of ridicule from her classmates. Nikki resolved to get the hell out of that tiny town in Pennsylvania as quickly as she could. In 1977, at age eighteen, she hopped a ride with a friend down to Florida, her home ever since.

The journey south held the promise of independence, but the vibrant gay nightlife scene Nikki encountered in Fort Lauderdale was pure serendipity. *The first drag show I saw was Dana Manchester, an icon in Florida and beyond. She was a master of pantomime. It was like every song she did was coming out of her. Growing up, the only drag I knew of was Jim Bailey, from his appearances on variety shows. When I saw Dana, I thought to myself, "I've been rehearsing for this all my life."* Weeks later, Nikki stepped out in drag for the first time to see Dana win the title of Miss Florida Female Impersonator. Miss Florida represented the gold standard in female impersonation through the seventies and eighties. It carried the prestige of a national title, and during its peak drew thousands of spectators from across the globe.

Dana grew to be a close friend and mentor, and her successes inspired Nikki to try her hand at pageants as well. With some additional help from her drag mother Tiny Tina, Nikki won Miss Florida 1981. At only twenty-two, she was the youngest winner in the pageant's history. To this day, Nikki still uses the title "female impersonator" to describe her style of performance. *First and foremost, I see myself as an entertainer. When I started, I wasn't trans—I was a boy who put on makeup and did shows. I always felt more like myself when I presented as female, so I grew into that role. I don't love the term "drag queen." Back then, if you were a drag queen that meant someone who dressed up and*

went out to the clubs for fun. *"Female impersonator" has a more professional feel; it lends more credibility.*

The term first came into use during the vaudeville era, with the aim of marketing drag to straight audiences. Into the 1960s, female impersonators commonly retained male names: the famed Jewel Box Revue billed each of their performers as "Mr." alongside headshots of the cast in full glamour makeup and perfectly styled hairdos. "Female impersonator" achieves respectability by quashing any notions of gender play, implying that what you see before you is merely a site-specific illusion for entertainment only. Nikki lives as a glamorous woman on stage and off, effectively dissolving this misogynistic delineation and reclaiming the title as a testament to both her immaculate professionalism and womanhood. For female impersonators who are also trans, art imitates life and life imitates art.

Nikki's win at Miss Florida propelled her into the national drag circuit; during her reign she dazzled audiences across the country.

> *"I've been rehearsing for this all my life."*

At home, Nikki became a fixture at all the top clubs, in particular the Copa Lounge in Fort Lauderdale, where she and Dana performed together throughout the eighties. After a seven-year break from pageants, Nikki returned to the arena to fight for the title of Miss Continental. As she performed the high kicks in her talent routine, her·shoe flew off and sailed right over the judges' heads. She ended the number with her bare foot perfectly *en pointe*, and the judges gave her a higher score for maneuvering the mishap so flawlessly. *If I stumble, I always finish the number. The show must go on!* Nikki placed third alternate that year but returned in 2004, for the inaugural year of Miss Continental Elite, the division for entertainers over forty. With only two weeks to prepare, Nikki presented a Shirley MacLaine medley of "I'm Still Here" and "Hey Big Spender," complete with a tearaway gown and four hunky backup dancers. The juxtaposition of those two songs captures how the entertainment industry regards women of a certain age, and Nikki's insistence on defining her career on her own terms. Nikki's veracity resonated with the judges, and she won her second national title. After forty-five years of experience, the fantasy she creates on stage remains rooted in her quest for authentic expression. *Through drag, I'm not afraid to speak up and tell the world who I am.*

Electra

FORT LAUDERDALE × VIRGO

A spark, a kinetic phenomenon impossible to bottle or contain—her name scrawled in ancient myths, in many forms. Synonymous with revenge, daughter of Titans and mother of the rainbow, a nymph born of the ocean, a curious archetype of a woman consumed by supernatural forces—Electra, the conduit. Fort Lauderdale's own resident sea nymph took her name from a decidedly more modern doctrine: the yellow pages. *Finally, I got to the Es, and there's Electra, the name of one of the strippers from Gypsy, my favorite musical. It was just fabulous!*

Electra discovered her knack for creating characters back in her home state of North Carolina. Her theatrical background gave her a leg up while experimenting with early impersonations: *I didn't come from a beauty or cosmetology-type background, so I didn't have that vanity standpoint. That's a big hindrance for a lot of queens. Why paint your eye where your eye is? Paint your eye where it should be.* Electra's vast catalog of celebrity illusions includes iconic divas such as Lucille Ball, Cher, Barbra Streisand, Judy Garland, and Elton John. She offed her Marilyn Monroe impression once she felt realism could no longer be achieved. *At a certain point, thirty-six was pushing it.* Many of her characters came about through trial and error. One Halloween, her Wilma Flintstone costume bore an uncanny resemblance to Lucy, so Electra ran with it and learned the whole "Vitameatavegamin" skit. Seeing herself on the Mets' jumbotron wearing a top hat prompted the realization, *Holy shit I could do Elton and then I wouldn't have to wear as much makeup!*

I used to paint other queens to do Bette Midler back in the day, but I rarely did her. On Christmas Eve 1984, Electra brought her increasingly refined Bette look home for the holidays. She formed a Divine Miss M triad along with friends Natalie Napier and CB Laverne for a show at the Scorpio in Charlotte. *By the time I painted my face they were like, "Oh you bitch, look at you!"* Electra donned a previous incarnation of her mermaid outfit and borrowed her mother's motorized wheelchair to get around for the evening. The show was a resounding success, but late that night after the club closed, tragedy struck.

> *"It felt private and secret. Back then, you had to be."*

An arsonist stuffed gasoline-soaked rags down the exterior air vents and set the empty club ablaze. Rumors swirled regarding the culprit and their motive: insurance fraud, a mafia hit, a disgruntled lesbian? *They always blame lesbians for everything. And I don't think they do half of the mischief. They're too busy taking care of their cats.* In reality, it was a rival club owner who set the fire. The day after the inferno Electra returned to the club to help sift through the rubble. *Scorpio had a light-up dance floor with the biggest mirror ball this side of Backstreet in Atlanta. When we got there, that mirror ball had fallen into the middle of the floor, engulfed in melted plexiglass. They've had multiple fires. They picked up the pieces of whatever didn't burn and built onto that, so with each fire the club got a little bigger.*

Scorpio opened in 1968 and is now the oldest gay bar in Charlotte. During those early years it was still illegal to dress in drag or dance with same-sex partners. Individuals arrested on sodomy charges faced public shaming in the *Charlotte Observer*, which published their names, mugshots, and home addresses. The thrill outweighed the risk; small-town queers drove from hours away to party and cruise on Scorpio's frenetic dance floor. *The club was off a road at the bottom of a hill; it felt private and secret. Back then, you had to be. You weren't seen getting out of your car, you know what I'm saying?* Considering all the community endured, it's no surprise Scorpio rose from the ashes with a vengeance. We are the children of the sodomites you couldn't burn.

Electra recalls witnessing her very first drag show at Scorpio during her freshman year of college, a performance by Tiffany Arieagus in 1977. Many other inspirational legends passed through those same hallowed halls on their tours throughout the South. *Dana Manchester was a big influence. Tiffany Jones, the "Texas Tornado"—she did numbers on roller skates. Roxanne Russell was another one, absolutely gorgeous. Roxanne gave me my first wig; I still have it to this day! Now it's my Baby Jane Hudson wig.* On slower nights Scorpio hosted amateur drag contests. Precocious costume design student that she was, Electra rightly assumed she would win, and thereafter enjoyed a devoted local following throughout her undergrad years.

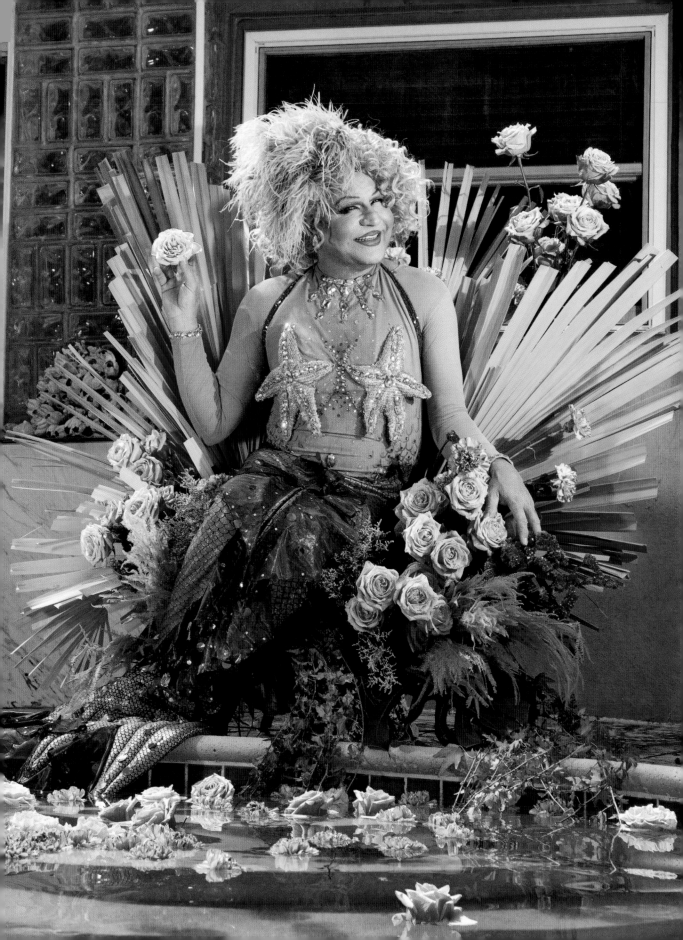

When Electra departed for Rutgers in 1980 to pursue graduate studies in set design, she naively left her drag behind in North Carolina. The call of the cloth soon gripped her once again as she explored the seedy gay enclave in Asbury Park, comprised of a bathhouse and three bars along Cookman Avenue. Among them was a bar called Atlantis, where the young mermaid discovered a *little show* run by a *crazy little queen* named Ivan the Terrible. Once Ivan learned of Electra's fair-weather fantasy, she immediately landed a booking. *Well, shit—I better get some drag.* Within the lost city she proved her ability to put looks together on the fly and attracted the attention of a legendary visitor.

Eartha Kitt had just done a disco album, and she was making her comeback traveling around to little gay bars. She saw my show at Atlantis, and I befriended her. Thanks to her I touched my first Bob Mackie gown. She had lost weight and I took it in by hand for her. I also started sleeping with her manager, and he got me my first professional New York gig at Sardi's restaurant.

I did dinner as Judy Garland, then changed to Bette Midler and they wheeled me out on the dessert tray. Well, Bette Midler is sitting there. I completely froze, the music kept going; she gave me this look like, "Go on." Somehow, Electra finished the number, a shaking mess, and retreated to the Sardi's kitchen, temporarily outfitted as her dressing room. *Bette came back to the kitchen and said, "God, you're a big one!" All I can say is, "Please don't sue me, I really like you!"* On the contrary, Midler expressed gratitude for Electra's role in perpetuating her pop cultural legacy. *She told me, "You all keep me popular while I'm sitting on my ass getting fat!"*

Electra felt uncertain how she'd fit into the New York scene, but after surviving her close encounter with Bette she shrugged off any doubts. After one year at Rutgers, she transferred to NYU and made her home in the East Village. *It's funny, as an entertainment capital you'd think the New York queens would be this really fabulous group, but when I moved, I found out they really weren't. It was an eye-opener. Back then, the big names always came from Atlanta, Florida, or Texas.* Indeed, most of the New York venues for drag deviated from the Southern tradition of glamorous showgirls in highly choreographed production numbers that Electra was

raised in. That upbringing, combined with her uncanny talent for impersonations and her proper theatrical background, quickly established her as a versatile virtuoso.

I worked at all the major clubs. I opened the Limelight and the Palladium. I worked at Copacabana and Studio 54—not the original but the second coming. I even worked at the Anvil believe it or not, with Ruby Rims. Then I started working cabarets like Don't Tell Mama and the Duplex. Along with International Chrysis, she performed at the short-lived TransRoMar, which offered an immersive drag experience. *They had a boutique downstairs where you could get all dressed up in drag; then you could walk around upstairs in drag till the end of the night. It was for truck drivers and people who got off on that stuff, ya know.*

By the time the East Village drag scene really took off, Electra was already in a different league. *I knew Bunny and Ru from Atlanta, but when they got to New York we didn't really cross paths. Connie Girl, Codie Ravioli—I knew all those Boy Bar girls too, but I was already headlining shows at bigger clubs. Bunny was a go-go dancer at the Pyramid, I was a bit above that and sort of snobbish about it. I wasn't snubbing them as friends or anything, but that was beneath my education—and pay grade.*

In 1984, she cautiously ventured to Fire Island for the first time. *A friend of mine told me I'd be a hit out there, but I didn't think it was so great to be trapped on a fuckin' island with a bunch of fags. I never like to be trapped anywhere I can't make an exit. And you really can't, after that last ferry! I won Miss Fire Island in 1985, and they gave me a job at the Ice Palace right then and there. I ran the place until '90.* Electra competed in other pageants throughout the latter half of the eighties, under the name Electra St. Gil. *I was dating a French guy who worked as a parfumeur, so I used his "St. Gil" because entering pageants like MGA you kinda needed three names. Ya know, like those Midwestern girls.* She won the very first Miss New York City in 1986, and Miss Gay New York America 1988.

Weary of the Northeastern weather and content with her accomplishments in New York, Electra accepted a role in the cast of *An Evening at La Cage* in Fort Lauderdale in 1991. The

> "I never like to be trapped anywhere I can't make an exit."

history and significance of La Cage spans both stage and screen, coast to coast: in 1980, Lou Paciocco opened a New York club called La Cage aux Folles, an homage to the 1973 French play of the same name. Inspired by success in NYC, Paciocco opened subsequent clubs in Hollywood and Atlantic City before *La Cage aux Folles* ever became a Broadway sensation. The Fort Lauderdale location, where Frank Marino and Crystal Woods made names for themselves before taking the show to Las Vegas, opened in 1984. Electra was hired to do eight characters, including Bette Midler. Bolstered by her reputation from New York she soon found employment at *every restaurant, every bar, every big disco, everywhere* in South Florida.

Her most memorable booking during this period was a New Year's Eve party for Gianni Versace at his Miami mansion, less than a year before his death. *Gianni saw me perform at the Warsaw Ballroom in South Beach, so he knew I did Elton John. Elton was one of Gianni's guests, so Gianni thought it would be very clever to book me. I started as Judy Garland doing "Somewhere Over the Rainbow," then transformed into Elton to do "Goodbye Yellow Brick Road." Elton loved it. That was really incredible—I'll never forget it.* Electra enjoys the challenge of morphing between several impersonations within the same set. *I do Lucille Ball into Cher. I do Barbra after I do Bette Midler, and from any character I can take it all off and become Elton John. I've perfected that over the years.* She continued to nurture her competitive spirit within the pageant scene as well, clinching the titles of National Entertainer of the Year 1994 and Miss Florida F.I. 1997.

In 2002, she received the opportunity to architect a birdcage of her very own. *This gorgeous Brooks Brothers model–type guy starts coming to all my shows, and he keeps hounding me: "I want you for my restaurant." I was like, "Honey I barely know you; I'd rather sleep with you first before we go into business together."* After their first meeting, Electra agreed to proceed once assured full creative control. Their joint venture took shape in the form of Madame's, conveniently situated halfway between Miami and Fort Lauderdale. They concocted a menu of elevated Southern fare and selected decor to evoke a bordello, complete with mismatched vintage furniture, fringed curtains of heavy brocade, and murals inspired by nineteenth-century French lithographs. The cast of performers featured drag queens alongside "straight" acts, singing bartenders, and tapdancing waiters— *We need everybody's money, not just gay money.*

Madame's harkened back to the variety shows and drag supper clubs popular in the mid twentieth century, long before drag queen brunch became a widespread phenomenon. *Lips in New York started around the same time, but Madame's was a totally different concept. Lips to me is like Denny's with a drag show. Plastic tablecloth time. We were all cloth and glass and aperitifs and after-dinner cordials. We didn't cater to loud bachelorettes vomiting on each other.* The restaurant closed after five years but remains immortalized in the 2009 film *Life's a Drag* (*When You're a Man in a Dress*). Electra plays herself in a fictionalized plot reminiscent of *The Birdcage* mixed with *The Adventures of Priscilla, Queen of the Desert*, plus a splash of courtroom drama and a sprinkle of Christmas magic.

Forever a queen of reinvention, Electra added another national crown to her collection in 2010: Miss Continental Elite. To win a pageant typically dominated by trans contestants is a testament to the power channeled through her immaculate transformations. *I always had to work my ass off.* It's fair to say she leaves her audiences electrified, as evidenced by her lasting impression upon Bette Midler. *When I met her again years later, she said, "You're the big one, aren't ya! Are you still doing me?" I replied, "Honey, I bought a house and a restaurant doing you!"—"Atta girl!"*

To any younger queens Electra offers a stern warning: *I can tell right away when a queen hasn't done her homework. DO YOUR FUCKIN' HOMEWORK. Put that on my tombstone. Do better— you're not good enough.* Tough love from a tough queen; heed her words and seize your destiny. *Drag has been a great outlet and often a savior for young queens. It's probably saved some lives. Probably destroyed a few too, but doesn't everything?*

> "Do better— you're not good enough."

NEW YORK CITY

Egyptt LaBeija

NEW YORK CITY × LIBRA

The leaves glimmered in golden hues in Central Park as we photographed Egyptt LaBeija. She radiated while the flashes fired, all ferocity and poise. A veteran of New York's ballroom scene and the overall godmother in the House of LaBeija, she knows all her angles. We shot together on Halloween, an auspicious time for Egyptt: her drag career began that night when the veil thins between the worlds.

At age sixteen, friends invited her out for some Halloween mischief. *That night they told me I was going to be a bride. "Won't I look weird?" I asked them. I used to play in makeup but not go outside.* To her delight, she found she attracted a lot of attention out in the world. *It excited me. I decided I wanted to do this often. It just felt right. Not the gown, but the whole package.*

Both of her parents worked at night, so she'd wait until her brothers fell asleep. She hid wigs around the house and would dress up and walk through her Long Island neighborhood just to see how it felt. By age eighteen, her method evolved, taking the train into the city and getting dressed in railway bathrooms. She met artists and performers and eventually found her way to the Grapevine, a club for trans women. *That's where a lot changed for me. There I felt I wasn't alone in the world. I learned there are other girls out here and I can do this and not feel like I'm an alien. Putting all that on for Halloween opened my eyes to a new life.*

Some of the Grapevine girls walked in balls too and introduced Egyptt to ballroom culture. *Back then it was underground. When I went it was too overwhelming. I saw the most beautiful women I've ever seen in my life and thought, "How is this possible?" It made me feel like I was doing something wrong. I didn't realize that a ball is a fantasy world for a night.*

Attending balls in the early nineties, Egyptt met some of the legendary mothers and innovators of the scene. *Dorian made a few outfits for me. I knew Avis, Paris Dupree, Pepper. I met people through the ballroom scene who invited me to be in their house. But I'd never show up. I didn't have the confidence then. If I did it back then, I would have become an icon. I'm a statement right now.*

> ## "When I go to a ball, the commentators know my name."

She clarifies, *There are different levels in ballroom: statements and stars, legends, icons, hall of famers—a system based on community recognition. There are people who push themselves to get the title. I'm at the point in my life where I don't need a title. When I go to a ball, the commentators know my name. They don't have to ask, "Who is that?" It means I've made a mark.*

Egyptt left the scene for a period of time. As she explains, *Balls can take a lot out of you.* She met many of the legends competing but didn't really get to know them until she walked away. Her hiatus allowed for meaningful conversation outside of the high-energy events. Eventually the mothers asked her back. They told her the time had come to start stomping the runway again. *I came back and I came back strong.* Freddie LaBeija brought her into the fold, and she's been with the LaBeijas for a decade since.

Ballroom is very hard and very disciplined. You have to always stay on point, whether in a ballroom or on the street. There are cameras everywhere. Even going to the supermarket, you have to look like something. You never know who you're going to run into.

To stay relevant and keep the girls guessing, Egyptt collaborates with designer Jose Xtravaganza for all her looks, including the shimmering aqua number worn for her portrait. They workshop ideas while Egyptt accompanies Jose fabric shopping. *It takes time to put the outfit together; everything has to fit perfectly. He knows my measurements though. He's making me do things I wasn't comfortable with before: more risque, more revealing. I appreciate it.*

Despite identifying as a trans performer, she referred to her look in Central Park as *full drag. Trans performers are performers like anyone else. Yes, when I put on all this extra stuff, it's called drag. All this makeup, corsets, hair, nails—I don't wear that every day. Drag is when you're doing the most. Making things bigger. I'm a trans drag performer.*

Egyptt's drag draws inspiration from others but maintains a marked uniqueness. *You learn from so many different people, and you compile these things you love about all of them, and you put it together into one, and that is who you are.* She attributes special influence to Marsha P. Johnson and Sylvia Rivera, those ancestresses *who started all of this by deciding to march.*

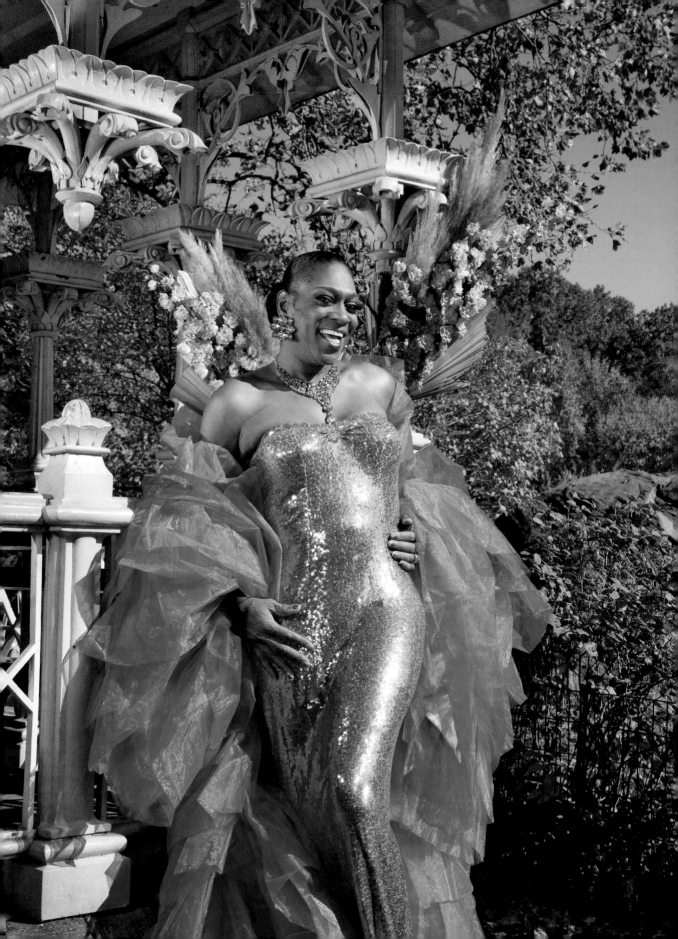

Linda Simpson

NEW YORK CITY × SCORPIO

Linda Simpson is the type of drag queen you can bring home to meet your mother. Her drag pedigree originates in the East Village, where she matriculated at the Pyramid Club. Uncommonly, Linda doesn't lip-sync. She's built her career on her gift of gab: always droll, never bitchy, always edgy, but never vulgar. Her distinctive vocal fry evokes a Midwestern Valley girl, but Linda is no ditz; she always knew her path would lead to New York City.

Like so many queer kids who grow up surrounded by philistines, she devoured all the New York media she could get her hands on. In particular, the glamorous editorials of *Interview* magazine, and alt mags like *Rock Scene* and *Creem* left an indelible mark. The performative displays of gender and sexuality in *The Rocky Horror Picture Show* (1975) resonated as well, but becoming a sweet transvestite herself wasn't part of the plan. When Linda first moved to NYC, she conceived of drag as tired female impersonators doing dusty acts from bygone eras. At Pyramid, however, she discovered a world where drag shed its anachronism to reveal a punk ethos that defined the countercultural sensibility of the downtown scene. Major players in the late-eighties Pyramid scheme included Tabboo!, Hattie Hathaway, Hapi Phace, Sister Dimension, and Lady Bunny. Amidst this clownish cadre of queens, Linda knew she had found her people.

Her first impulse was to document. Linda always carried a camera, at a time when few civilians did. She took snapshots of the late-night revelers just for fun, and most of the photos wound up in shoeboxes in her closet, but by 1987 that creative impulse took shape in the form of *My Comrade* magazine. *It took a lot of gumption. I wanted to plug into the wild and wacky drag scene of the East Village and also respond to the times we were in, which was the AIDS era. So the content was about gay love, gay unity, gay pride, tongue-in-cheek revolution, but it truly did have a sincere message.* The first cover featured a photo of Tabboo! in sequins, a beret, and an assault rifle with the headline "GAY LIB!" as an homage to Patty Hearst. The release parties for each Xeroxed issue became quite the social affair, and it was through her role as hostess that Linda's own drag persona began to take shape. With the mic in her hands and a wig on her head, the sissy affectation she'd been shamed for in adolescence became her biggest asset.

Hosting her own party was the next logical move, and fortuitously Wednesday nights at Pyramid were available. She conceived the weekly party Channel 69 in 1990, and it continued for two years. The party breathed new life into Pyramid, which by that point was frequently described as "a dump." A rotating cast of queens, including Mona Foot, Mistress Formika, and Page, appeared in talk-show segments, camp pageants, musical skits, and occasional castration scenes. A special presentation entitled *Lesbian Jungle Fever* starred Sherry Vine and Ebony Jett in an interracial dragsploitation plot with lots of queen-on-queen action. Mixed crowds often filled Pyramid, but Linda describes her audience as *hardcore gay*, and she found ample opportunities to trot mostly-naked men out on stage.

Over the subsequent thirty years, Linda established herself as New York City's most ubiquitous bingo emcee. *I love it because it's like being a game show hostess! I meet a huge variety of people, from youths to the young at heart. Really, it was unexpected. At Channel 69 the shows were at 1:00 a.m., and now I'm entertaining mostly straight audiences at seven o'clock at night. It's been really good for me as a performer, and it enables me to support myself just being a drag queen. That was always a goal I never attained during the Pyramid years.*

> *"It took a lot of gumption."*

In 2013, Linda revisited the shoeboxes of snapshots in her closet and realized she inadvertently created a time capsule of a transformative era in the city's drag history. She curated her photographs into a slideshow presentation titled *The Drag Explosion*, which she narrates with her signature incisive wit and insightful commentary. Her portraits capture candid moments with legends including RuPaul and Leigh Bowery, intimate scenes in the Pyramid dressing room, and flashbacks to the early years of the Wigstock festival. *The Drag Explosion* then morphed again into a sumptuous art book, released by Domain Books in 2021 to critical acclaim. Linda tends to downplay her successes; she calls herself a documentarian rather than photographer. The introduction to her monograph posits: *I was merely a vessel, destined by mystical powers to document a golden age,* but Linda is much more than that. Her decades-long body of work is a testament to her instincts as an anthropologist, vision as a creative director, and dedication as a steward of community history.

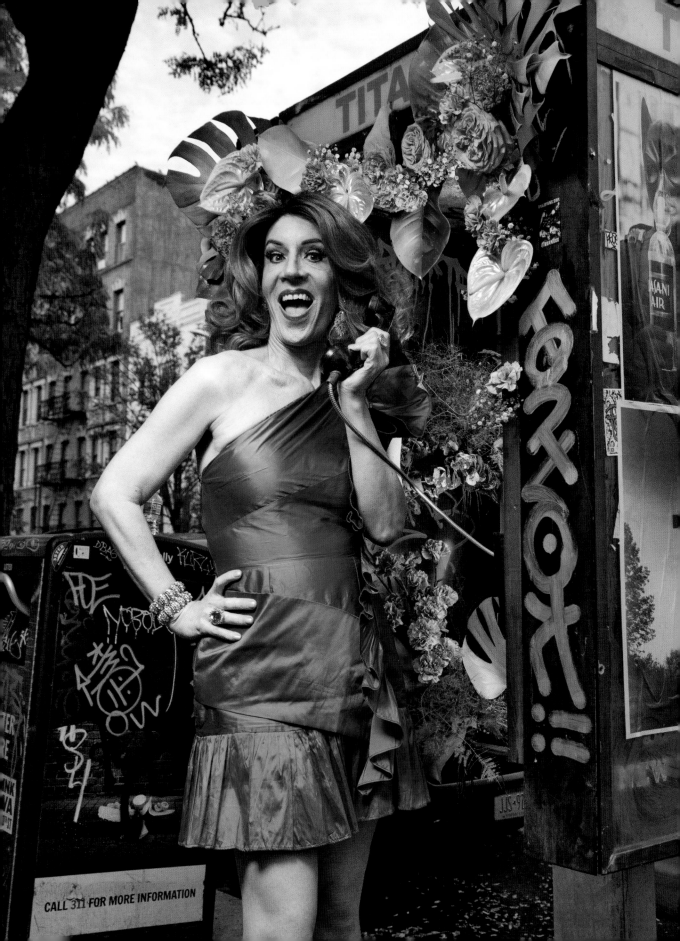

Harmonica Sunbeam

NEW YORK CITY × **CAPRICORN**

No stranger to the art of reading, Harmonica Sunbeam serves it to the children, literally, as a regular fixture of Drag Queen Story Hour events at schools and libraries throughout New York and New Jersey. *I love how excited and enthusiastic the kids are. They're not rolling their eyes and checking Grindr, you know what I mean?* It's easy to see why the children love her: Harmonica's signature style offers a sensory feast of neon colors, rainbows, and textures, matched only in vibrancy by her radiant personality. Through DQSH, she's proud to be a positive queer role model and exemplify the expansive potential of gender expression.

In 1986, still a child herself, Harmonica began hanging out in Greenwich Village. Pre-gentrification, gay life in the Village centered around Christopher Street and its adjacent pier. The pier offered a safe place the kids could go to kiki, cruise, and carry on in a way that's impossible these days, with the imposition of city park curfews enforced by NYPD. There, Harmonica met the up-and-coming legendary children who introduced her to the ballroom scene, and she walked several balls as an unaffiliated candidate. After demonstrating her potential on the floor, she was inducted into the House of Adonis.

The mother of the House, Allan Adonis, was a face child; he walked face categories. Richard was the father; he walked butch queen realness. I had walked other categories like punk rock, but nothing drag. Paris Dupree threw the Paris Is Burning balls; she was known for giving out the biggest trophies. She had a category called "Butch Queen First Time in Drags at a Ball," which is a gay guy getting in drag for the first time at a ball. I said I'd give it a try, and the house members totally put me together; I just had to go out there and sell it. I did, and to this day there are still bitches who are jealous. That means I won!

By 1990, Harmonica ascended to the role of mother of the Adonis clan. Her formative years in the ballroom scene coincided with the release of *Paris Is Burning*, the canonical documentary by Jennie Livingston. *Jennie would come to the balls; sometimes they'd let her in and sometimes they wouldn't. Sometimes they'd throw her out in the middle of the function, like, "OK, enough is enough." When people say the girls in it were exploited, well, it was a small project that became a big thing. As far as people that they interviewed, we all craved attention, that's part of what ballroom gave you. I was there—I was hiding from the cameras. When it came out, there was this mixed reaction; it was great to have this moment, but also—oooh, girl—people who were in the closet were now outed. The Madonna situation garnered a lot of side-eye, because the general public was under the impression that Madonna started this. I don't think she did enough to tell the truth of, "Oh, I stole this."*

Harmonica's early immersion in competitive ballroom culture made hosting drag shows in a bar seem like a piece of cake. She started performing in shows at First Choice in Newark, New Jersey, and picked up the mic after the hostess didn't show one night. *When I started doing drag, it was always the question of "Who do you do?" because we were "female impersonators." Everyone was fascinated with characters.* Harmonica preferred a less studied approach, instead relying on humor to define her character, which she parlayed into her own show at Two Potato in the West Village, and by 1993 she exited the ballroom scene. *Once I had success at Two Potato I did a lot of the big parties that were catered to African Americans. I was in a league of my own, in a sense. I worked at places that didn't have shows; I was the only entertainment.* One of the most memorable nights of her career occurred in 2004, when she opened for Beyoncé at the Roxy. The following month, Queen Bey left Harmonica a voicemail wishing her a happy birthday, which Harmonica burned to a CD and replays every year.

Harmonica's impact extends beyond the nightclub and even the library, as a volunteer for Gay Men's Health Crisis, Hyacinth AIDS Foundation, and the African American Office of Gay Concerns. Her connections to community organizations kept her especially active throughout the pandemic, when she worked up to five gigs a day hosting virtual bingo, fashion shows, and storytimes. *I've always been one to create work for myself. A lot of people sit and complain that the phone is not ringing, but what are you doing to help the phone ring?* Throughout all her work, the strength of Harmonica's roots shines through: *The thing I'm most proud of is that to this day I still bring ballroom with me, wherever I go and in whatever I do. It really teaches you to be the kind of person who can take criticism and still survive. Take it with a grain of salt and challenge yourself to come back stronger next time, rather than burn down the building.*

> "I just had to go out there and sell it."

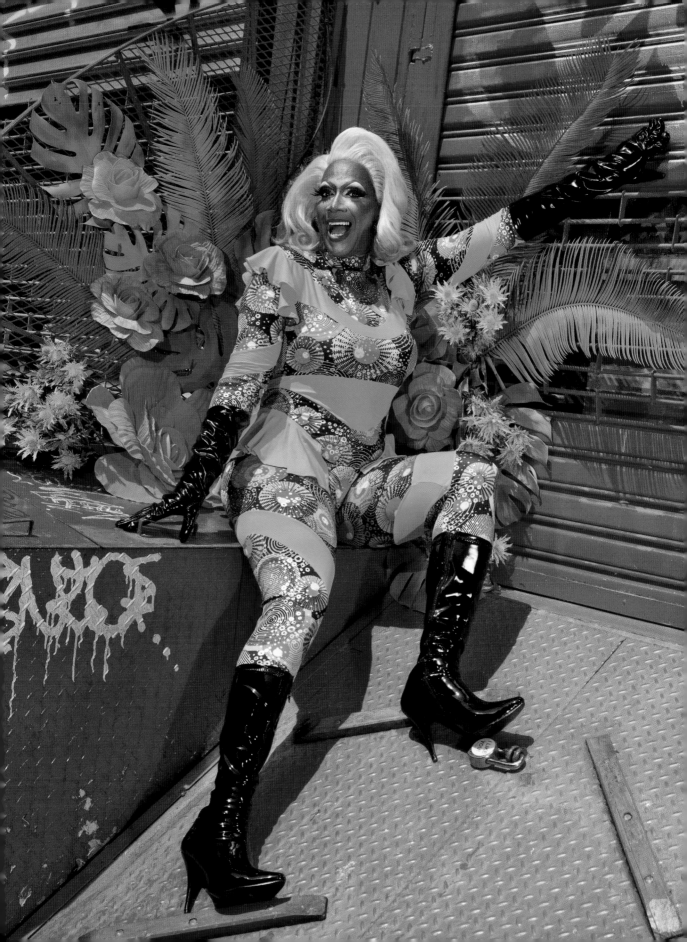

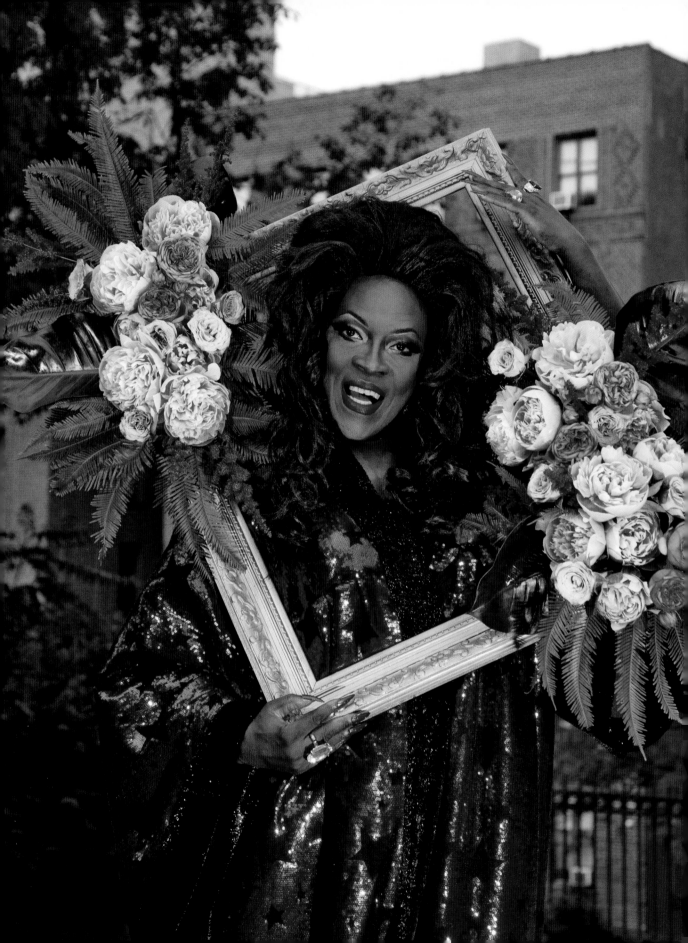

Princess Diandra

NEW YORK CITY × LIBRA

As the downtown New York drag scene exploded in the early nineties, two nuclei emerged: Boy Bar and the Pyramid Club, both in the East Village. The dueling venues propagated their own unique styles of drag, and Her Royal Highness Princess Diandra doesn't mince words in distinguishing where that line was drawn: *Boy Bar had the Beauties with the glamorous drag, and the Pyramid Club had the booger drag!* Naturally, Diandra belonged to the former school. *Someone told me once that going to see shows at Boy Bar was like seeing an MGM musical; at Pyramid you didn't know what you were gonna get. They went to thrift stores and got anything out of any bin and put it all on at once—we were more meticulous about our looks. A lot of good queens came out of Pyramid, but the Boy Bar Beauties were definitely the glamour girls.*

Boy Bar's resident Director/Producer Matthew Kasten had a knack for identifying budding queens and cultivating them into drag stars. One of the brightest was Diandra's gal pal Connie Girl, but Diandra never considered drag herself, even though she frequently turned crazy looks for nights out at Paradise Garage. That all changed on Halloween 1986, when she dressed as Diana Ross to see Connie perform, and Kasten took note. *When Matthew asked me to be in the show it was like a switch. Maybe I've got something here! "When's the show?" He says, "Tomorrow." I asked him, "What songs do I do?" He said, "Do the songs you were doing in the mirror your entire life." He was 100 percent right.*

For that first performance, Diandra selected tracks from *Dreamgirls* and the Supremes and channeled that little boy who used to dance around with a towel on his head. Her application of the Kasten method went off like gangbusters, and she was quickly adopted by the Boy Bar Beauties. *Glamamore, Shannon, and Connie were the trio really tearing it up: Shannon was the greatest beauty, Connie was an indescribable chameleon of looks and personalities, and Glamamore was the queen of a thousand faces.* By the early nineties, the downtown crew was the toast of the town. *We were feeling cute, doors were opening, all the best parties had drag queens, and we rode that wave!*

> ## "We rode that wave!"

Then RuPaul made that song, and I tell you from one week to the next it was like someone poured water on the gremlins—there were a gazillion drag queens! Where the fuck did they come from? In the 2000s it died down, thank god, but just as it was beginning to feel like old times, she came out with that damn show and here we go again! Diandra supports queens getting paid by any means necessary, but she finds the sanitized portrayal of drag on television to be distasteful. *I don't like that it's become the bible of drag, with all those stupid challenges. My vision of drag is not represented by that show at all. I couldn't navigate myself through that show. Being told how good or bad you are by D- or C-list celebrities? I don't think so! No ma'am.*

Many of Diandra's greatest triumphs were catalyzed by her original inspiration, Diana Ross. Her depiction of the Queen of Motown was immortalized in the 1989 film *Slaves of New York*. Clad in matching skintight red dresses, a trio of street urchin Supremes led by Diandra delivers a powerhouse performance of "Love Is Like an Itching in My Heart." Diandra shakes and shimmies with all the ferocity of Miss Ross herself. If there were any doubts about that fact, they were put to bed that very same year, when Diandra was hired by the promoters for Ross's Japanese tour. *She refused to do any press for this big tour, so unbeknownst to her, they hired me to do it. It was fabulous; they treated me like I was her; I had a driver and anything I wanted.* Despite her love for Ross, Diandra is no glassy-eyed fan. *She's not Jesus Christ to me, she's a woman with many flaws. She's very cold and bitchy—I call her Diana Frost. On the way back from Japan we were on the same flight and I saw her spaz out in the airport—that was worth the whole trip.*

Diandra returned to Japan fifteen times and has performed on five continents. She remembers a two-year stint in Israel as her favorite expedition. *You ever go somewhere and you're the only one? There was no competition, so I got laid every night I got dressed up and went out. I'd walk through the club and all the men would stop and stare; I had the pick of the litter. I tell anyone: If you're feeling down in the dumps, pick up all your best looks and go to a place where there's no one like you. Sit in the middle of the town on your suitcase and bat your eyelashes, and your life will be changed forever.*

Perfidia

NEW YORK CITY × **CAPRICORN**

Perfidia's drag is not confined to the realm of reality. *I use wigs as hair fantasies and for creating dreams. Wigs take you away from the mundane.* Her journey to becoming the dreamweaver of choice to New York City's most immaculately coiffed queens began over thirty years ago. Her first forays into nightlife took place in the 1980s punk, rockabilly, and New Romantic scenes that thrived in Southern California. By 1984, several of her friends had ditched the West Coast for the city that never sleeps, and they coaxed Perfidia to follow suit. *I remember when I got there, the YMCA was $7.99 a night,* she says with a laugh. *I was hanging out on Eighth Street and I'd just go into any place with a "help wanted" sign.* Perfidia's sunny California disposition made her stand out, and she scored a gig at a record store on Saint Mark's Place. Then in the autumn of '86, Perfidia suddenly found herself rocketed into the burgeoning downtown drag scene, as three planets aligned: *Within one month, I was working at Patricia Field, performing at Boy Bar, and roommates with International Chrysis.*

Patricia Field's eponymous Eighth Street boutique was the go-to destination for all the queens and club kids who wanted to stand out. Her racks mixed one-of-a-kind pieces with looks by emerging and international designers, merchandised by an equally colorful staff. Many of the Boy Bar queens both worked and shopped there, a reciprocal relationship often described as a "hormonal convergence." Perfidia's new roommate Chrysis was among them, and Chrysis became a motherly figure to the nascent queen. Chrysis's career began in pageants and supper clubs in the sixties when she was just a teenager, and by the eighties pivoted to a cabaret nightclub act. She had a small role in *The Queen* (1968), and considered Flawless Sabrina her own drag mother, situating Perfidia in a queenly lineage of the utmost prestige. Perfidia wouldn't meet Sabrina until years later, but they too had an instant connection: *When Chrysis introduced me as her daughter, Sabrina said, "That makes me your grandmother and aren't you just a little genius!" She was amazing, just so warm. I'm very, very thankful. It was like having a relative you didn't know who just loves you immediately.*

Perfidia quickly rose through the ranks in nightlife and daylife, winning the Miss Boy Bar pageant in 1986 and establishing her own wig bar within Patricia Field shortly after, which eventually became a full-fledged salon. *The sixties styles we were doing at Boy Bar crossed over into the store, and then you started seeing people like Deee-Lite and RuPaul wearing them too. That whole look became such a big thing. I sold so many red flips you can't even imagine.* Perfidia holds an encyclopedic knowledge of atomic-age hairstyles, acquired through a lifetime of collecting vintage beauty salon magazines from flea markets. *The golden years are 1965 to 1972, and '67 to '69 are my favorite, specifically. I became known for doing barrel curls, updos, and French twists.*

She credits Field with personally encouraging her artistry and instilling in her the importance of marketing. *Pat was another mentor, but also strict as fuck. There were no wire hangers in that store, believe me. She'd tell me, "Create your own style and then sell it to everybody else; that's how you do it."* Field brought Perfidia to Japan for the first time: *It was the trip of a lifetime, to be in a fashion show in drag in Harajuku, with Pat, who they all worshipped. I loved it so much I just kept going back, any excuse I could find.* Perfidia took to Japan just a little too well for her boss's liking, and after several subsequent trips, including a winning appearance on the game show *TV Champion*, her thirteen-year tenure at House of Field was terminated.

In the years since, she's mounted a spectacular second act, creating wigs for Broadway and television. Over two dozen theatrical credits include *La Cage aux Folles*, *Taboo*, *Three Penny Opera*, *Young Frankenstein*, and *Hedwig and the Angry Inch*.

Broadway taught me to shut up and listen. I don't have to be the star; when my wigs are on stage, there's a piece of me there too. In 2000, she created a new style for Amy Sedaris's character on *Strangers with Candy*. *When they brought me on in the second season the note was they wanted her to be crazy but also be kind of cute. I wanted to do something different, so I added that side hook and Amy immediately related it to Hermey the Elf from the Island of Misfit Toys. I went crazy with every type of version of that hook, even a double-hook version that kind of looked like an owl.*

Perfidia stepped out in drag the first time in over a year (since the pandemic), for our photo shoot in Central Park. She hardly stopped grinning for a single moment, beaming at the passersby and fully feeling her bubblegum showgirl fantasy. She emphasizes gratitude for all that drag has given her: *I'm lucky that I've just had one day in my life where I had the chance to wear such cool costumes. Some people never feel that transformative power.*

> *"When my wigs are on stage, there's a piece of me there, too."*

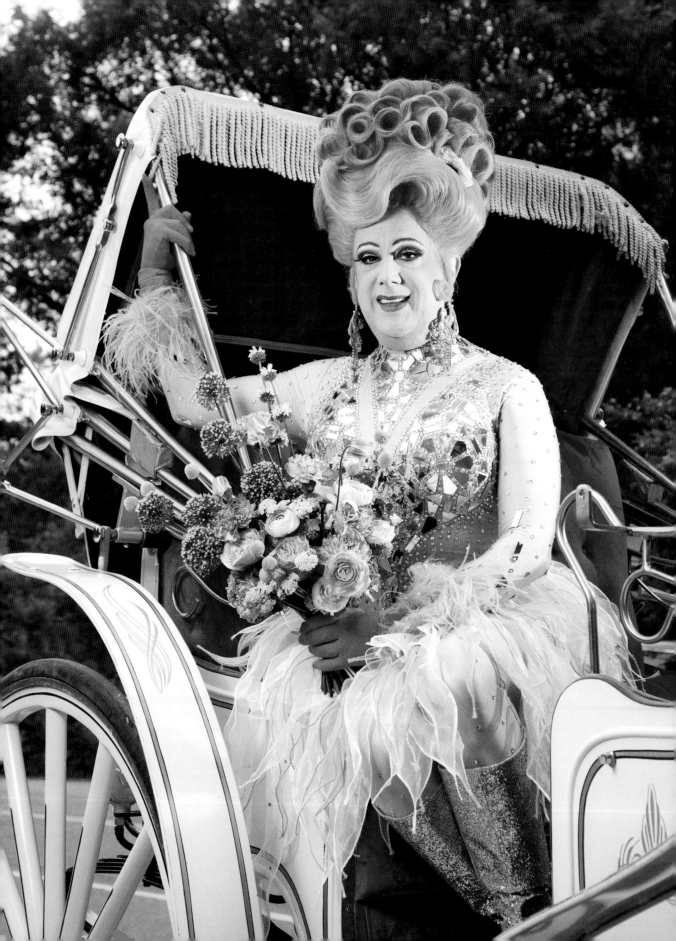

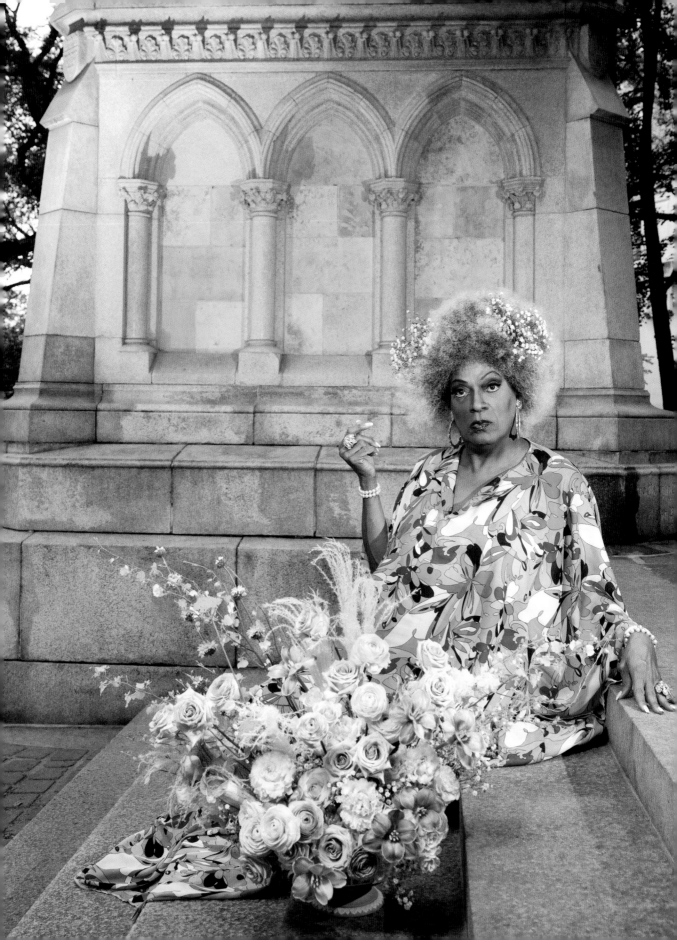

Flotilla DeBarge

NEW YORK CITY × VIRGO

Flotilla DeBarge burst into the room wielding a can of linen-scented Lysol disinfectant. She sprayed down the audience as she made her way to the stage, effectively setting the tone for an evening both confrontational and cathartic. It was the sold-out encore performance of her one-woman show, *Corona and Flo*, at Pangea, an intimate cabaret theater in the East Village. A veritable cabaret veteran, Flotilla in turn draws a veteran audience, who welcomed the ceremonial delousing with uproarious applause. To keep up with Flotilla, one must roll with the punches.

At six foot one in stocking feet, plus the size 12 patent pumps and colossal red bouffant (a custom Perfidia creation), Flotilla has an imposing presence. *Give me some reverb on the mic, I need reverb!* she demanded. The show opened with a *recitatif* of "Once in a Lifetime" by the Talking Heads. *And you may ask yourself, "Well, how did I get here?"* The pandemic, now well into its second year, infused this existential question with renewed poignancy. The lyrics became a hypnotic incantation. *Same as it ever was, same as it ever was . . . but it will never be the same as it ever was.* A sense of calm, or perhaps dissociation, washed over the room as the pianist faded out. Flotilla's reverberations mesmerized the audience, but the magic of live theater requires accommodating the unexpected. *Well, I busted another nail, y'all—it's going to be a good show!* The room erupted in laughter as she held up her uneven talons and blotted her face with an oversize powderpuff in exasperation. *I always start off the show looking like Halle Berry and by the end I wind up looking like Chuck Berry. Get into the delusion, darling!*

Flotilla masterfully traversed these tonal shifts throughout the evening. She dedicated the video for "Dry Ass Pussy," a parody of the Cardi B and Megan Thee Stallion song, in collaboration with Lady Bunny, to her recently departed sisters Lady Red Couture and Sugga Pie KoKo. *I've experienced a lot of loss, but losing your sense of humor is the last thing you want to do. Love your life, love your friends. There's beauty to be found in tragedy.*

She cautioned that if we were expecting to see the type of antics depicted on "Aunt Ru's Dog Race," we're at the wrong show. *I ain't one of those bitches who does reveal, reveal, death drop. The only thing I might reveal is the truth!* Trust and believe, Flotilla

> *"Get into the delusion, darling!"*

makes good on her threats. Before launching into a rendition of the Black national anthem "Lift Every Voice and Sing," she urged the crowd, *Get your history right. Today, August 20th, is the anniversary of the first enslaved people brought to Virginia in 1619. This country was built on war, genocide, and slavery, and the sooner we can acknowledge that and learn, the sooner we can move on. I chose this song for my ancestors.* As the audience joined in the song, Flotilla invited us to *stand under the umbrella of love and bask in the glory of hope. Only we can save us, giiiirl!* Her umbrella may be shady, but that too is a form of love, if you know how to accept it.

On the day of our shoot, Flotilla again invoked the ancestors. She requested baby's breath for her hair as a nod to iconic Black American songstress Minnie Riperton. Flo suggested our location: a monument to French heroine Joan of Arc on the Upper West Side. Famously tried for heresy due to her repeated and unrepentant cross-dressing, Joan stands as an original drag martyr. Although later declared a saint, her vested transgressions demonstrate a spirit of defiance and gender anarchy that lives on in the drag queens and kings of today.

Flotilla cites her role in *Angels in America* (2003) as one of her proudest achievements. She recalls that immediately after the audition with director Mike Nichols, she asked, *Did I get the part? Because I have tickets to Cher's farewell tour, so I won't be available that day.* Thankfully, Nichols showed both the good sense to cast her and avoid any scheduling conflicts. *I'm not difficult to work with, just misunderstood!* Flotilla insists, but she's earned the right to cop a divatude now and then. From Boy Bar and the Pyramid Club in the nineties, to world-class cabaret theaters Joe's Pub and 54 Below, to parts in *To Wong Foo, Thanks for Everything! Julie Newmar* (1995), and plays by Charles Busch, the sum of her experience is nothing short of legendary.

Toward the conclusion of her performance at Pangea, another of Flo's nails popped off. She graciously gifted it to a fan in the front row and encouraged them to sell it on eBay. Even when she's down a few nails, Flotilla's wit remains uncompromised. The ability to laugh at yourself is a hallmark of any great queen, and Flotilla admits she's still a work in progress. *I'm not perfect, but I'm not finished yet!*

Coco LaChine

NEW YORK CITY × VIRGO

Before meeting with Coco LaChine, her sister in the Imperial Court—Witti Repartee—warned us to treat her like a fine antique: "Be careful, she might break—she's ancient!" On the question of her antiquity, Coco offers no reply. *Never ask an Asian drag queen how old we are; we always lie about our age!* Her graceful strength during our photo shoot also trounces any allegations of fragility. She arrived fully dressed, carrying a wig head and luggage full of drag in tow. She brought help too in the form of Robert Sorrell, known as the Official Court Jeweler of the Imperial Court of New York—a title given to him by José Sarria herself. In addition to legions of Emperors and Empresses, his creations have adorned the likes of RuPaul and Thierry Mugler runways. Posing in front of the post office, Coco's diamante crown and collar sparkled in the sun and amidst the flashbulbs, turning heads and drawing a crowd.

Coco's cup overflows with bursting peonies, a flower she specially requested for her portrait. In the mythology of the Mediterranean, the peony is associated with the god Paeon, whose name also functions as an epithet of both Apollon and Asclepius—all three revered as gods of healing and medicine. The peony became the Queen of Flowers in Chinese lore, when Tang Dynasty Empress Wu Zetian tried forcing every flower to bloom in the middle of winter. Demonstrating a deep commitment to the Tao, only the peony refused the order. Traditional Chinese medicine recognizes the roots of the flower for its medicinal properties. Connected through varying traditions to Empresses and to the healing arts, the peony figures as the perfect bloom to celebrate another Empress who dedicated her reign to the health of her community. Coco holds the title Empress VII—the Celestial Dragon Empress—in the Imperial Court of New York. As a tradition bearer, she also transmits the history of the system itself:

José Sarria declared, "There are already enough queens here; I want to be an Empress," and named herself "Her Royal Majesty, Empress of San Francisco, José I, the Widow Norton." She got her drag queen friends together and formed herself a little court, complete with ladies in waiting. And that's how it all started. In the early days in San Francisco, they raised money for various things. They'd bail people out of jail for entrapment on gay charges. Most importantly, during the AIDS crisis, the Court System stood on the forefront of fundraising.

Here in New York City, the Court started in 1986. A group of friends heard about the Royal Balls in San Francisco, they brought the idea back and called it the Night of a Thousand Gowns. The first took place at the Waldorf Astoria. When I was invited to join, it was still not a formal organization, per se. By year four there was burnout among the people involved and some moved on to other things. So in 1990 four of us reorganized it into a membership organization. I became one of the original incorporators of the Court. This allowed us to put on more events and focus on raising money. Many other LGBTQ groups benefited from our fundraising. We support God's Love We Deliver and Trinity Shelter, which offers transitional housing for queer youth who've aged out of the foster system. I'd venture that we've raised over a million dollars—one dollar at a time, from tips at bar shows.

More than any other lesson learned from the International Court System, Coco wishes to uplift the ethic of self-organization she picked up from two decades of friendship with José. *José worked part time at a bohemian bar called the Black Cat, a very legendary place with a piano. One day during brunch José decided to sing arias because he enjoyed the opera. He sang parodies of different songs from* Carmen, La Bohème, Madame Butterfly. *Those recitals drew attention from a columnist who named her the "Nightingale of Montgomery Street," which only grew her popularity. José ended every show by singing a song called "God Save Us Nellie Queens"—set to the tune of "God Save the Queen"—reminding people that we don't have to love each other or sleep together, but we have to work with one another. If not united, they will get us one by one. At that point gay bars were still periodically raided and shut down. José organized her following to raise money for bail funds and to help people financially. We had to fight for ourselves. If we don't help our own communities, nobody is going to help us. We saw this especially during the AIDS crisis. So, we put some differences aside and worked together.* Coco celebrates this ethic—self-salvation—as one of the legacies of the Court System.

> *"They'd bail people out of jail for entrapment on gay charges."*

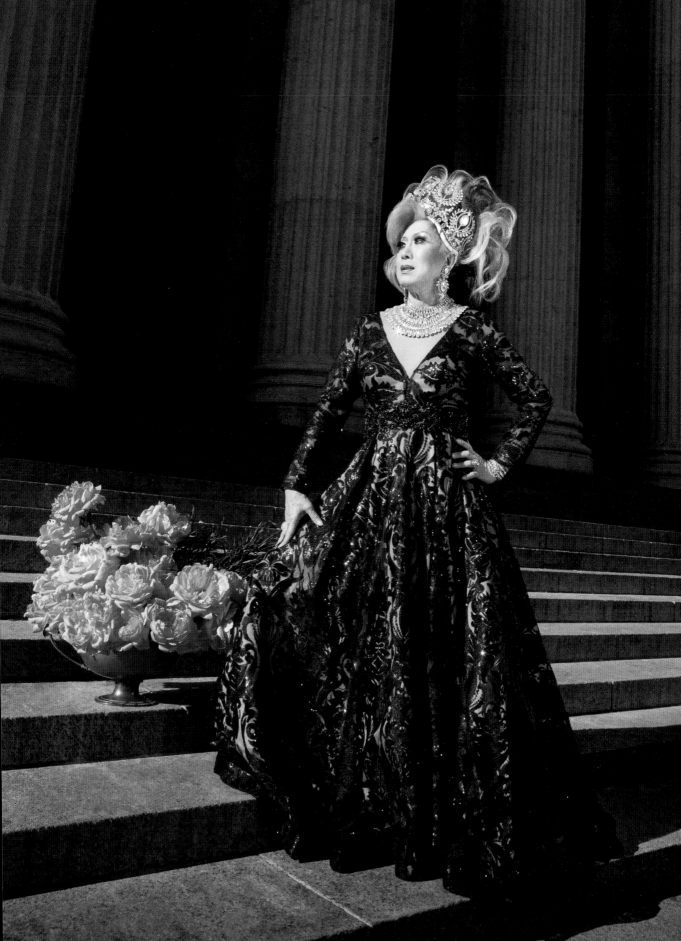

Coco also shares lessons from José's successor as Queen Mother of the Imperial Court system, Nicole Murray-Ramirez, known as Empress Nicole the Great. *Nicole came from a street background. I learned the importance of being out in the streets from her. I was out in the community a lot, not just in the Court system.* Coco found queer community by seeking it out. *When I came to the United States from the Philippines, I didn't know anybody or have family in NYC. I got involved with a community center. There I met some friends. Like many who found drag, it began on Halloween. Then it became Valentine's, then Pride. Before you know it, I was beginning to do it on a more regular basis. The dance committee at the community center held a prom-themed event. I was prom queen!*

With the emphasis placed on mutual aid, Coco clarifies that very few were doing this as a way to make a living. Prior to the careerist paths opened by television's drag frenzy, queens performed drag as part of a broader project of collective survival and enjoyment. Coco relays the aesthetics of the moment—fabulous hair, jewels, feather boa, beaded gowns—and challenges too: *In the old days, we'd impersonate personalities or entertainers: Judy Garland, Cher, Bette Davis. There are not many Asian celebrities I could impersonate. I've done Cher songs without trying to look like her. Back in the day, the point was to actually look like the person you're impersonating. The most I could do was Connie Chung and read the news. It was one of my dilemmas in my early days. I used to perform every week at a club called the Web or Club 58, on Fifty-Eighth next to TAO. It was a basement space, one of the few Asian bars. There used to be two others, but none remain now. Having an Asian bar was an important part of the club scene.*

In light of the ways *drag keeps evolving,* Coco welcomes change while insisting on the importance of memory. *In the beginning, drag was a very dangerous thing to do. You could be harassed, beaten up, arrested for it. When you are arrested by the police, they don't care whether you identify as gay or lesbian or transgender or a drag queen. They don't care about those issues. You're just a queer to them. Remember those who come before you. Remember the struggles they went through to do drag so you can*

> "Having an Asian bar was an important part of the club scene."

do it easier. Show some appreciation and some respect. An apparent historical amnesia among the younger generations concerns her, of course. She worries about *a certain identity we are losing. We've become so generic. So many young people only care about having a cocktail. How many young people don't know about Stonewall? A lot of the history is being lost, not because it's not there, but because people aren't interested in it. They didn't have to hide or live through the AIDS crisis or bury their friends every week.*

Since that first Halloween outing—that evening when otherworldly spirits come flooding in—the beauty of our ever-present seventh Empress blesses the boardroom and the underground alike. Coco holds records in her service to the Center as well. *I'm the first Asian drag queen—or person who identifies as part of the trans community—on the board of the LGBT Community Center. I'm also the longest tenured board member,* having already served for a year before the institution of six-year term limits. Coco's face graced the readers of HX magazine—*In the eighties and nineties we had gay zines.* Homo Xtra *was an old entertainment magazine: black and white with cute guys on the front, inside a bar guide. I was one of the first queens on the cover.* In 1994, *Out* magazine included Coco in their inaugural "Top 100." The following year, her portrait looked down over five thousand subway trains as part of an image campaign produced by GLAAD. *Those horizontal long posters on the train; I was one of the six people included in the campaign. I appeared there as Coco LaChine in a dress I bought at Macy's; looking back, a very secretarial dress! It ran on the trains for a month.*

Coco's platform reached new heights by way of her contributions to the film *To Wong Foo, Thanks for Everything! Julie Newmar* (1995). As she tells the events: when *Priscilla, Queen of the Desert* (1994) came out, the three main characters appeared on *Donahue.* Donahue called Coco looking for a drag queen. *"Can you come perform for us?" I'm not a big performer, but I agreed. I had to pick a song from the album so I picked "I Will Survive" and had my office fax me the lyrics in case I forgot. I opened the show to a very gay audience. I was introduced: "Please welcome*

Coco LaChine!" but couldn't hear the song over the applause. I caught up once the applause subsided.

I became Empress the year after. During the coronation, I received a call from Universal Pictures. They'd heard of Night of a Thousand Gowns and wanted to come. "We're trying to do a movie," they said. I responded, "Of course! You can buy a table for $3,000," and they did—the director, writer, producer, costume designer, casting director, and videographer, twelve of them total. They asked to interview me, so I told them to come an hour early to my suite at the hotel. As a result, I was cast in the film and became a script consultant. I gave lots of script comments. They took some and left others. They also asked me what to do in certain situations. The film shows a lot of things I told them to do.

With forehand knowledge of Webster Hall's hydraulic system, Coco proposed lowering RuPaul from the ceiling. She also suggested presenting the winner's envelope in a glass shoe, Cinderella-like. The onscreen pageant's conclusion required her input as well: *No pageant ever has a tie, so no pageant comes with two crowns ready to go. I told them to give one the crown and have a scepter for the other. Patrick Swayze got the crown and Wesley Snipes gets the scepter. I solved the problem of two winners.* Many smaller moments contain traces of Coco's finesse, too: *Patrick pops his finger on his lips, because he saw me doing it. And Wesley learned to put on his bustier from me: he puts the hook in backward and turns it around.* The three main characters were all assigned a queen to work with. *I was assigned to Patrick because I'm regal and classy and that was his role.* The producers rented drag paraphernalia from Coco's house—*trophies, plaques, crowns*—to style the film's dressing rooms. Because of her singular role, Coco received special thanks above Barbra Streisand and Gianni Versace in the final credits.

> "*Everyone was screaming my name, so the photographers thought I was important and took a bunch of pictures of me without knowing who this Coco LaChine really was.*"

Ever minding the elders and the wider community, Coco lined up work for the other girls too. She ensured the production crew met José at the Night of a Thousand Gowns. Her Imperial Majesty appears in the film, *sitting next to Quentin Crisp and Lady Bunny and Flotilla as judges in the opening scene. They treated us very well. The girls in the pageant scene were considered principal performers so we had the opportunity to join the Screen Actors Guild and got paid better than extras. They paid us well—for rehearsals too, and extra for doing our own makeup and wearing our own wigs. I got residuals too. They also turned to Coco to recruit a dozen NYC queens as ushers for the premiere and sent a limo to collect her for the event. Jean Paul Gaultier designed the gown for Julie Newmar, so everyone went crazy when he came out. Then of course they went crazier for Patrick. When I came out, the paparazzi didn't know me, but the crowd was full of friends and people from Court. Everyone was screaming my name, so the photographers thought I was important and took a bunch of pictures of me without knowing who this Coco LaChine really was.*

That film debut opened the door for other appearances on the big screen—*After Stonewall* (1999) and *Flawless* (1999)—but still only Coco can say *who this Coco LaChine really was.* In full regalia, surely she's someone else. She describes the ecstasy of that encounter: *When I put on the makeup and wig and dress, I'm a completely different person. I'm not Charles anymore, I'm Coco. It's a switch in my personality. My whole being changes when I dress up. I don't know how to describe it, but my whole feeling—my being, my spirit—everything else is just Coco. There is no trace of Charles. It's not just a facade for me. I transform into a different entity; not just a character but a complete being. I'm not trying to act like someone else. I'm just me.*

Panzi

FIRE ISLAND, NY × LIBRA

Every year on Independence Day, a barge of drag queens cruises into the Fire Island Pines harbor. The much-anticipated spectacle is welcomed by hordes of onlookers who cheer and applaud upon their arrival. What became a celebratory annual tradition grew from guerilla roots.

In 1976 a queen named Terry Warren, whom everybody in Cherry Grove idolized, was denied entry to the Blue Whale in the Pines, the neighboring hamlet. The owner, John Whyte, sent the maître d' to inform her she wasn't welcome in the "family establishment." There was already a marked tension between the Grove and the Pines, and the incident stoked the flames. Terry and Panzi attended a cocktail party where the celebratory centennial July Fourth flotilla in NYC sailed across the television. *As you get looser over the course of the day your emotions get bigger. Everybody got really angry about what happened. We decided to have our own flotilla to the Pines and tell them to go fuck themselves.*

All nine of us went home and got dressed, all in total drag. I of course was the Homecoming Queen of Cherry Grove that year and dressed up accordingly with my crown and my regal robes. We rented a water taxi from Randy and Sally's and went to the Pines to say, "Fuck you," in the middle of tea time.

We were giggling and laughing until we got to the entrance of the Pines harbor. We fell silent and thought, "What's gonna happen?" As we approached, Randy stepped on the gas and laid on the horn. Everybody came out and saw this boat full of drag queens and went wild. We all had a drink. We blessed the bay and we went home as quickly as we arrived.

Bestowing blessings was our big campy thing. I'd stand up on the third floor of the hotel and give the sign of the cross; when I was Homecoming Queen I'd also bless the bay there. I guess it was my Catholicism coming out. I'd go to the beach and say, "God bless the ocean." I'd go to the lesbian parties and say, "God bless the lesbians."

Inspired by the celebratory energy, Panzi proposed the invasion happen again the next year. Everyone told her such revelry only happens once and couldn't be repeated. Still, twenty people showed up and had just as celebratory a time. *We've done it every year since and it grows every year. We're aiming for the fiftieth anniversary at least!*

Panzi's entrée into the drag scene began long before the invasion, when she was just a teenager attending Jesuit high school in Jersey City. By fifteen she was taking the train into Manhattan to perform in clubs in the West Village. She joined a group called Mom's Greenery at the Gold Bug, where all the girls had flower names—Panzi was Daisy then—and a persona: Daisy always portrayed Marilyn Monroe or Liza Minnelli.

She first visited Fire Island in 1972 to see the Miss Fire Island competition. *The queens, like Charity Charles, really went all out to be beautiful and over the top.* Panzi relays a minority opinion on the contest. It excited her as a teenage attendee, but when she competed, she *realized that 90 percent of the audience were straights from Long Island who came to gawk at the faggots. It was a disgrace back then. Nobody else felt that way, but after I entered that year, I haven't been to one since.*

Since debuting on the island in 1975, Cherry Grove always felt like home. Panzi calls drag a *geographic ideology* and says that coming to Fire Island helped her escape the constraints of the performance art that dominated the NY scene. *Back then in Cherry Grove, everything was an antic. We used to call it Panzi-monium!*

I felt safe there compared to doing drag in the city. The city bars were all mafia run. We were always told to wear two to three items of men's clothing underneath our outfits in case of raids. Not to mention the fag bashers. The Village was a safe zone in the city, but in the Grove you can go anywhere.

The sense of the island as a refuge for homosexuals originates, according to legends, with the great hurricane of 1938. In the aftermath, a gay community congregated around Christopher Isherwood and W. H. Auden, who adorned themselves as Dionysos and Ganymede, carried aloft in processional rites. *This was a safe haven where gay people would come to get away from the world.*

Despite the sense of sanctuary on the island, the conflict that sparked the invasion is emblematic of hostility from within the community. *Fuck the world—but fuck the gay community too. Sometimes the gays are worse than the heterosexuals. We wanted to attack homophobia within the community.* It took a long time, but the politics in the Pines eventually changed. *John Whyte, who owned mostly everything, threatened me every year not to come. Every morning of the invasion he'd call me and give me a hard time or have his minions deliver nasty notes. He was gonna call the police and the Coast Guard. After fifteen years Whyte realized he couldn't beat us, and joined the celebration.* Like Dionysos, Panzi conquers through ecstasy rather than military might.

> "We decided to have our own flotilla to the Pines and tell them to go fuck themselves."

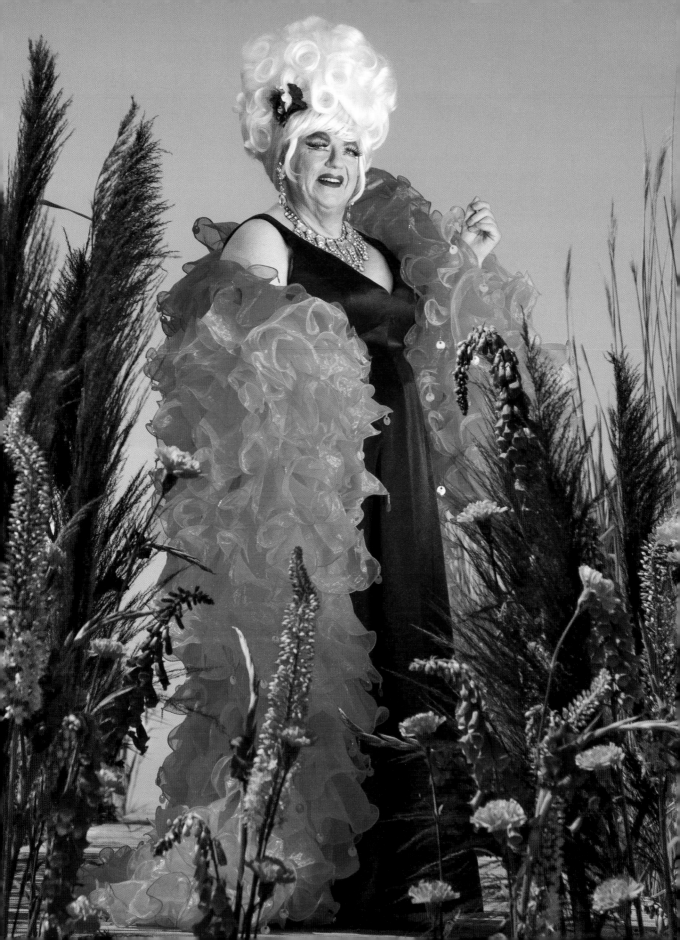

Barbra Herr

An actress by occupation, Barbra adamantly prefers to avoid identity labels. *I don't even like the terms "transgender" or "transsexual," I don't like any of that. In my opinion, we are all under the same LGBTQ+ umbrella—why can't we all just be queer and call it a day?* Growing up in the Bronx in the sixties, she wasn't always so self-assured. *I'm like Momma Rose: I was born too soon and started too late. It's very that.*

Barbra's family was part of the Puerto Rican diaspora that resettled in New York City post-WWII. Her mother Mona owned a social club in the Bronx, and young Barbra would tag along on the weekends. The club smelled like smoke and stale beer, but it was full of glamour, too. At six years old, Barbra recalls marveling at the immaculately dressed patrons: chiseled men in tight suits and women with beehive hairdos and stiletto heels who would dance and laugh until dawn. Her favorite part of the club was the jukebox, which played records by Latin legends Tito Puente, Johnny Pacheco, and La Lupe. Mona recognized Barbra's predilection for entertainment early on, and often dragged her child out in front of the crowd to sing Spanish boleros. Barbra imbued the songs with a passion and clarity far beyond her years. Within that smoky club, a star was born.

By 1970 the family relocated to Puerto Rico, where Barbra finished high school and college. She was determined to pursue acting, but playing stereotypically gay characters didn't interest her, and she was certainly no leading man. In 1973, while studying cosmetology, she discovered the underground world of drag and immediately put her new hair and makeup skills to use. Given the opportunity to embrace her femininity on stage, Barbra excelled. She landed a gig in Old San Juan at a straight venue called Cabaret, and through that scene she met Antonio Pantojas, one of the earliest pioneers of drag in Puerto Rico. *Antonio was not only my mentor, he was my dear friend. I never went to school for theater; my schooling in theater was him. He always told me it was very important to have discipline as an actor, because otherwise you wouldn't get anywhere. We always took care of each other, and I listened to everything he said.* Pantojas helped Barbra get booked at the bigger clubs in San Juan, and she developed a bilingual lip-sync act that set her apart from other performers. *I was very old-school, but I never did impersonations. I used voices. My big go-to voices were Streisand, of course, and Shirley Bassey. I did a lot of disco divas and Latin music too. Most other queens didn't know English, so being able to perform both brought me up quicker. Ironically, now living in New York and working in the Latin bars here, I started doing more Spanish songs. It kind of flipped.*

> ## "Why can't we all just be queer and call it a day?"

Barbra cultivated a following, performing at all the top discos in San Juan, for sold-out crowds in the Dominican Republic, and in the myriad small gay bars that dotted rural towns throughout the islands. Eventually, life on the road became a drudgery, and as the eighties drew to a close, Barbra witnessed her circle of friends and collaborators succumb to AIDS. *I was thirty-four and I was alone. I decided it was time for a change. I came back to New York to live here and to transition. At that point in time, in the late eighties/early nineties, trans women were still so taboo. You couldn't get cast in anything mainstream. We were limited to the drag bars. Basically, queen bars, because most gay bars didn't want us either.* In New York, Barbra started her career again from scratch. She forged a new sisterhood among the performers at Escuelita, the Latin club on Thirty-Ninth Street famous for larger-than-life showgirls and raucous dance parties. *Lady Catiria became my gay mother; she was a phenomenal talent. Jeannette Valentino was the first transsexual I ever saw; she embodied what drag is supposed to be. We used to call her "the body beautiful."*

Once she fully stepped into her womanhood, Barbra set her sights on the pageant scene. For seven years, she competed in Miss Continental, frequently placing in the top five. In 2005, she snatched the crown at Miss Continental Elite (the division for performers over forty) with a showstopping Sally Bowles routine. Continental afforded her the opportunity to travel and collaborate with entertainers across the country. Having seen it all, she still thinks some of the best drag in the world happens in Puerto Rico.

In 2014, Barbra decided it was time to leave lip sync behind and reclaim her own voice. *I stopped doing drag shows because they don't fill me up anymore. Drag is fun, but I don't take it seriously like I used to, because I know I can do other things. That changes the vibe.* She wrote and starred in a one-woman cabaret show at the Duplex titled *I'm Still Herr*, a dramatic retelling of her life set to music. Two years later, still frustrated by the lack of roles available for trans women, she wrote the play *Trans-Mission*. *It's about my journey to my sex reassignment. An off-Broadway theater presented it, and I won a Latin Theater Award. I was the first transsexual actress in Latin theater in New York, and it was a great honor.* Barbra's not done yet; these days she has a new agent, new headshots, and is focusing her energy on auditions. Barbra never saw herself as *just a drag queen*, but undeniably, it's a role that shaped her into the apex performer she is today.

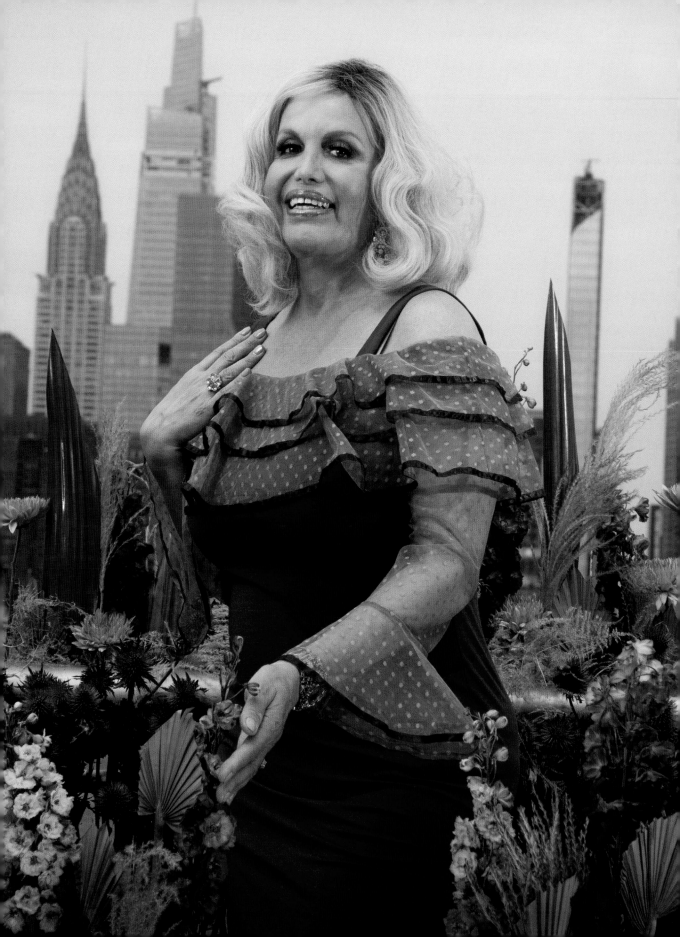

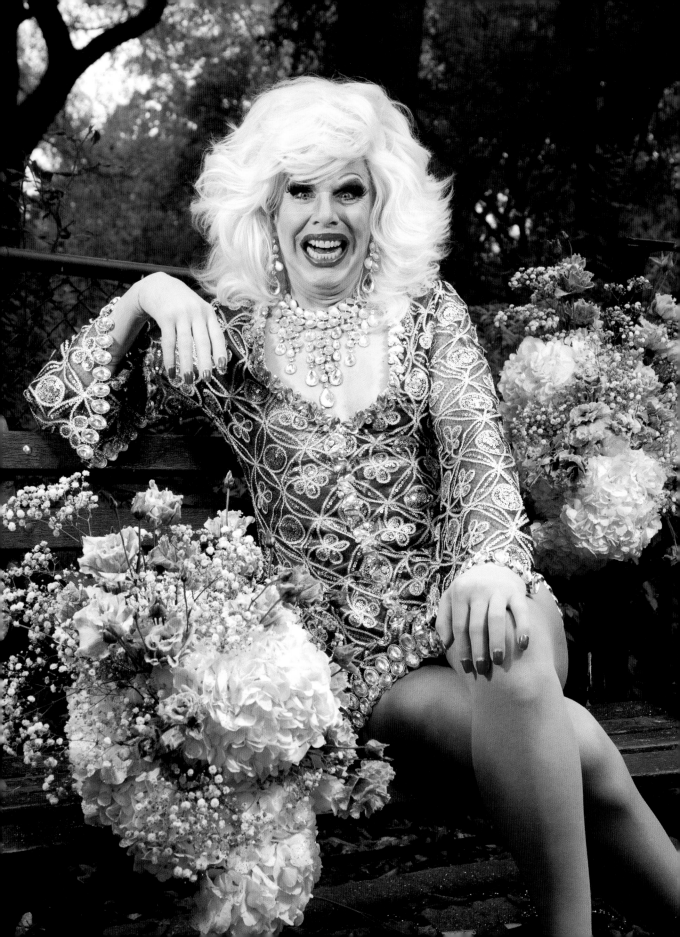

Pickles

NEW YORK CITY × SCORPIO

Most drag queens prefer to be seen and not touched, but Pickles relishes a more interactive experience. She loves attention from men—and knows just how to get it. *When I was first doing Pickles, she was modeled after a man's fantasy of what a woman looks like, with big boobs and big blond hair. Of course, I always wore a really short skirt, so I was a very easy-access girl.* Since 1998, she operates a basement sex club beneath a Brooklyn supermarket. Drag first entered the equation at her SPAM party, which she co-produced with a lesbian friend. *We had the entire spectrum of the queer community, which brought in drag. It was the first authentically inclusive sex party in NYC.* But it was the Eden Underground parties, hosted by drag legend Sweetie, where she more fully came into herself, and others into her. *I realized if I really dress up, the most attractive men I've ever met are totally into me, or even intimidated by me. That just blew me away. When you walk into a room and you know that everyone there wants to have sex with you, it's an incredible feeling.*

Her immersion in New York nightlife long predates Pickles's emergence. Under her given name, Michael Wakefield, she photographed RuPaul, Lahoma Van Zandt, and David Dalrymple on the Brooklyn Bridge for an issue of Linda Simpson's magazine, *My Comrade*. From 1993 to 2001 she hosted a late-night public access show called *It's a Wonderful Life*, which featured skits, local celebrity guests, and of course sex. It was ultimately canned by the network for an onscreen depiction of "sword fighting." A proto-Pickles even worked a few gigs at the Pyramid Club as a genderfuck drag go-go in a jockstrap.

Pickles gave her first full-fledged public presentation at "naked camp" in the Poconos, hosted by Gay Naturists International, where she won the 2010 Miss Lace pageant. Paradoxically, GNI only allows gay men, which is precisely the identity Pickles obscures with silicone tits while getting fucked by straight guys. A piece in *The Village Voice* investigating Eden Underground aptly deemed her a "tranny chaser chaser."

Once Pickles stepped out into the daytime, she found opportunities to integrate her persona with her other creative pursuits and inject more comedy into her drag. Music video parodies include "Wrecking Ball" by Miley Cyrus, where she rides a humongous scrotum suspended from the ceiling, and

"My Ass," a Mickey Avalon spoof in collaboration with Flotilla DeBarge wherein the duo rap increasingly creative metaphors to describe their anuses. Since 2014, she's produced and hosted the web series *Pickles' Playground*, which stays true to her public access format. She interviews kinksters at Folsom Street East, bakes tortes with Broadway veterans, and interviews *Drag Race* stars in her basement dungeon.

She threw her first sex party out of necessity: her work as a freelance photographer wasn't paying the bills, and as they say, *sex sells*. That party became "He's Gotta Have It," which ran from 1993 to 1997 out of various locations. The AIDS crisis was still in full swing, and the gay community had vastly disparate attitudes about safer sex party protocols. To keep her own guests safe, Pickles promoted HGHI as a mutual masturbation party, but with condoms always on hand. Pickles implemented a staunchly nondiscriminatory door policy, welcoming *men of all colors, sizes, and ages, because our community is already oppressed enough from the outside.*

Despite her own motives for indulgent self-fulfillment, she acknowledges her work in the sex club industry as a form of activism, rooted in her involvement with ACT UP in the eighties. During one protest with the group in Chicago, she was arrested for civil disobedience. Of that time, she says, *Everything had a political tinge to it because we were fighting that fight as a community.* The shared trauma of living through the devastation of AIDS informs her commitment to creating spaces where people can be themselves without shame. *A big part of the mission is being able to free people to express their sexual orientation and their gender expression, because it really is so fluid; people just need the space where they can do that. Sometimes it takes a place like a sex club for people to be open completely. The range of expression is unlimited.*

When Pickles first saw the portrait from our session in Tompkins Square Park, she was initially unnerved. *I don't usually look like that*, she assured us, though eventually conceded: *Pickles is very silly too; there's always a silliness that goes along with the sexuality. On the spectrum between showgirl and clown, I probably fall right in the middle.* Sexy clown is certainly a tough look to pull off, but Pickles's cartoonish charm is nothing short of orgasmic.

> *"The range of expression is unlimited."*

Ruby Rims

NEW YORK CITY × SCORPIO

Ruby Rims: a name, but also a statement of fact. Over the past fifty years Ruby refined her oral skills at many of New York's most fabled venues, and a few notorious bathhouses as well. *I always wanted to sing and perform. I'm a ham, ya know? I'm a fuckin' ham.* In that regard, she found doing drag a means to an end. After witnessing a drag performance at the Roundtable in 1973: *I thought to myself, "I can do that, and I can do it better!"*

Her raunchy shows at the Anvil are the stuff of legend. The Anvil was a sex club on Fourteenth Street and the West Side Highway, back when the Meatpacking District still lived up to its name. Official club policy did not allow women, and Ruby was the first queen they ever hired. *That first night I had to follow the fist-fucking show. Thankfully they wiped down the stage. They hired me as a goof, but it backfired. The crowd went nuts and two weeks later they offered me a job. I was doing two sets five nights a week, at 3:00 a.m. and 5:30 a.m.* Ruby began her career as a lip-sync artist, but on Christmas Eve 1977 she experienced a divine intervention. *I did my two songs. They were screaming for an encore, so I took the mic and said, "Boys I'm going to do something very special but I need everyone to calm down." The place got really quiet, which never happened at the Anvil. I sang "O Holy Night" a cappella, which brought a whole new interpretation to "fall on your knees." After I finished, someone grabbed my arm. It was a gentleman by the name of John Healy, who owned the Duplex. He said to me, "Why are you lip-syncing? You're going to do a live show at the Duplex."*

At the Duplex, Ruby cut her teeth as a cabaret artist, her shtick ever since. That gig led to shows at other cabaret houses like 88's and Don't Tell Mama, as well as summer residencies in gay resort destinations Provincetown and Fire Island. Through this work, Ruby cultivated her seemingly endless stockpile of one-liners and clapbacks. *There's only one type of man that interests me: breathing.* When we inquired about her astrological placements, she responded: *What's my sign? Slippery when wet! Actually, nowadays, it's more like "falling rocks." I'm a Scorpio—I*

> *"I'm a ham, ya know? I'm a fuckin' ham."*

was born on Halloween. That kind of explains everything, don't it? My parents had three children, one of each. Every mother's dream—nightmares are dreams too! Ruby readily laughs at her own jokes, even when she's the punch line.

Several appearances on *The Phil Donahue Show* throughout the eighties elevated her profile further. In one 1987 episode she sang "I'm Just a Drag Queen," with her trademark gravelly vibrato. As she strutted and kicked in her sequin tube top, feather boa, and strappy sandals, several Nancy Reagan look-alikes in the audience squirmed with visible discomfort. As a proud provocateur, Ruby always delights in challenging her audiences, but she's noticed a shift in attitudes over the years: *On Donahue, it was: "Let's watch the freaks." Now, it's: "Let's watch the drag queens!"* As far as we've come, she knows there's still a long way to go. In 2017, she told *Paper* magazine:

> *Transvestites and transgender people are still being treated like shit, even by their own brothers and sisters. Gay men can be some of the most prejudiced people in the world. It's a work in progress. Prejudice is a disease, just like HIV. You have to work on it every day. Because we've been discriminated against so much, we do it to ourselves. We forget.*

The Manhattan Association of Cabaret Artists honored Ruby with a Lifetime Achievement Award in 2018. In her acceptance speech she conveyed that her greatest achievement of all was *fuckin' staying alive. At the end of the world, it's gonna be me, Cher, and roaches!* During the early years of the AIDS crisis, this was no small feat. She credits her pugnacity as the key to her longevity: *I never stopped fighting. I had to fight because I was a little fat gay boy growing up in North New Jersey. Then I had to fight because I was a drag queen. Then I had to fight again because I had AIDS. This year is going to be twenty-nine years. I wasn't just HIV positive, I had full-blown AIDS. When I moved into my building twenty-five years ago, they didn't think I'd be here long. I was like, "Sorry I still have too many dresses to wear!" Don't give up. You know that saying, "It gets better." No, it doesn't. You do. You get better.*

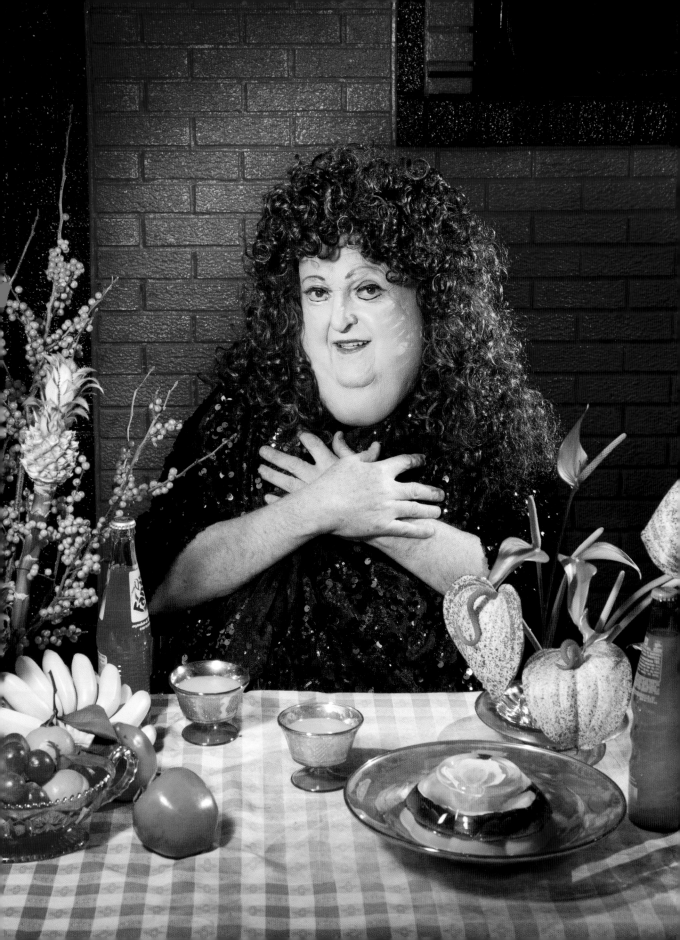

Witti Repartee

NEW YORK CITY × LEO

Whores don't like cut flowers—beauty cut down in its prime! We gave Witti Repartee a bouquet of candy instead, an appropriately indulgent arrangement to photograph at Coney Island's famous amusement park. The park's roller coasters attract thrill seekers from across the globe, and the nearby Circus Sideshow carries on the vaudevillian tradition of the freak show. The design of the orange and blue structure behind Witti is modeled after the entrance of the original Luna Park, which opened in 1903. Much like the iconic park, Witti too possesses a timeless charm. She admits that she has always been *a woman of a certain age*, and she celebrates the anniversary of her birth by turning thirty-nine every year.

I was born into the theater. Her parents met onstage and she joined them for her first appearance by the age of three. Her mother once asked, "Who do you think put the first wig on your head?" It all grew organically out of dress-up time. At age thirteen, the summer after the Church Lady debuted on *Saturday Night Live*, Witti attended a theater camp. She discovered a purple polyester suit in the costume shop and thought, *"Well isn't that special!"* Witti continued in the theater department in college. In spring 1995 she made an appearance at a party in full Norma Desmond drag. *I was very clear that it was Patti LuPone as Norma, not Glenn Close!*

After college she got involved with the Gay Activist Alliance of Morris County, New Jersey, which met every Monday at the Unitarian church. Every year the group produced a big drag show. Witti appeared there three times under the name Octavia Thunderpussy until *an ancient queen (younger then than I am now, mind you), said, "My darling no! Octavia Thunderpussy is not the energy you're presenting!"* She bestowed the name Witti Repartee.

Later that year, while working as the marketing director for a restored vaudeville house, she auditioned for the house's production of *La Cage aux Folles*. "I'm here to audition for Zaza!" *At twenty-three, it was inappropriate to do, but I had the balls to do it.* When they suggested Witti instead be one of *Les Cagelles*, she accepted under the condition that she be Mercedes, as that part had lines and dancing. *I was devastated that they didn't think a twenty-three-year-old could do Zaza!*

Victoria Weston played Zaza in that production and later invited Witti out to Fire Island to sing live at the Ice Palace in Cherry Grove. Witti precociously selected the Barbra Streisand arrangement from *Ladies Who Lunch*. *My first professional paid experience in front of an audience of drag aficionados, and I completely bombed! I hadn't yet figured out who I was and who the character was.* Victoria counseled her afterward. *Riding the ferry back the next morning, I thought a lot about character development. I'm an actor who plays a character, and you need a backstory. What matters is knowing who she is, where she's been, and what she'll do next.*

Victoria Weston pulled Witti into an Imperial Court meeting in 1997. *I took to it like a duck to water.* She joined as a Lady during the reign of Empress XI—Gianna, the Sapphire Heart Empress. The Emperor and Empress of reign XII asked her to become their press secretary. She quickly skipped from Baroness to Duchess, and her mother Victoria became Empress XIV. *I had hopes of becoming XVI, but it wasn't meant to be.* That year, 2002, she was elected Queen of the NYC Gay Men's Chorus. However, all the pomp and circumstance wore her out. *I was tired. I'd been going hardcore for six years. I'd just met the man who'd become my husband. I pulled back. I'd joke that Witti spent five years in Alaska.* Witti returned to the Court in 2009 and ultimately achieved the title of Empress XXVI in 2012.

As an eldest child, red-headed, Leo drag queen, did I need more confidence? Yes! All of that is smoke and mirrors to protect the fifth-grade fag. As Empress you learn how to walk into a room and hold space, how to speak on a microphone and to the press and to donors. It was a crash course in being a public speaker and community leader. From there you have two options: take that and build on it, or rest on it for the rest of your life. I always say, "Empress is not the pinnacle of your career, it's the beginning!"

Witti self-proclaims the distinction of being Queen of the New York Leathermen. She first came to fame in the leather community modeling a horse speculum at an auction. She ran the under-thirty-five group for GMSMA (Gay Male S&M Activists) and volunteered religiously at Folsom Street East. She hosts Halloween at the Eagle every year, which always includes a performance of "The Monster Mash." She crowned herself queen of the scene and looks forward to the day when another steps up to take the crown. *Don't come for me, just do the work! I'm happy to hand it off and keep it going. It's a camp title and has no meaning. There's no secret cabal in the back room of the Eagle that elected me.* As far as clandestine backroom dealings are concerned, Witti would appreciate an invitation.

> ## "Don't come for me, just do the work!"

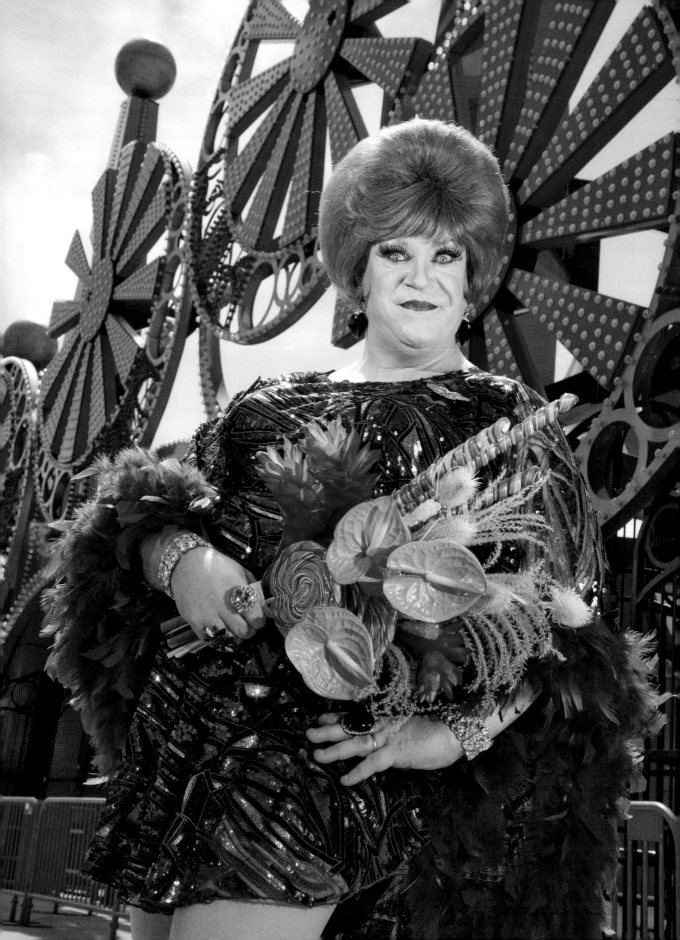

Simone

NEW YORK CITY × **GEMINI**

The first time we met Simone at the Stonewall monument, she was gingerly salting her cantaloupe and greeted us warmly: *Sit down baby, let's talk.* The monument memorializes the celebrated nights of rioting after a police raid on the Stonewall Inn, kicking off the Gay Liberation movement. The legacy of that place lives on for Simone and the community that gathers around her there: *When I'm here, I'm safe.* She hosts performances outdoors in the park throughout the summer, every weekend starting at four o'clock.

We returned in September to bring her a framed print of her portrait. During our visit, she waved at a girl having coffee across the park. When the girl didn't say hello back, Simone read her down: *You can't come into our space and make US feel uncomfortable! A lot of people want to come take pictures of Marsha—straight people think it's their world and we're just guests, but this is our space. Washington Square is over THERE! They might feel intimidated by a more beautiful woman . . . let me show you, honey.* The confrontation then turned into an impromptu photo shoot as Simone modeled her pink bra and matching pink glitter lipstick. She posed with her leg up on the bust of Marsha P. Johnson—newly erected guerrilla-style by community members who chose to pay no mind to the city's bureaucratic permitting process.

Simone got her start performing in the nineties working the Tunnel and the Limelight. *I performed at lots of bars, lots of clubs. I was the first queen to perform at Lips restaurant and anyone who says differently is a fucking liar! Every night was wild. A lot of people were trying to make a name for themselves, trying to put an image out. Everyone was trying to come through and excite the people, give them something they can't forget. Everything was glitter and spacey.* She always opens with "Last Dance" and closes with whatever hot thing she can think of. *Donna Summer was the girls' girl back then.*

She eschewed the label of "drag" when she started taking hormones. She quipped, *I can take it off, but I can't take it off,* then further clarified: *I'm a performer. I don't look at being beautiful as a drag queen. I fix myself up like any chick who wants to look nice. Performance is just a natural thing that comes out of me. I'm*

transgender. I'm a woman. I have to be an example to these young girls to show them the correct way to do something. I was the only role model that I had. I didn't look to anyone else.

In addition to performance, Simone offers spiritual counsel by way of palm readings and astrology. She snapped her fingers: *I can read people's energy just like that.* She attributes her gift of sight to her ancestors. *Astrology is in my family: my mother, my grandmother. We live our lives by it. We believe in god. I was born into an astrology world, to read people. I've had a gift since I was a kid. At first, I didn't know what it was; it scared the hell out of me. I thought I was crazy, but my mother explained to me that it came from within the family and it was a gift from god. I've held onto it.*

Simone maintains a personal practice as well. *I'm Catholic; I believe in my religion, and I believe in me. I talk to god a lot, even though I sometimes argue with him. You have to remember that god's in all of us. You have to encourage yourself, you understand? I have arguments within myself, when I'm frustrated, that only me and god can work out.*

> *"There are spirits everywhere."*

At Stonewall, she reports feeling the spirits of the queens who walked those streets before. *There are spirits everywhere. I feel these girls, Marsha and Sylvia, they want us to keep it alive, to keep it going on, for future generations. We need icons for young girls who are coming out to follow behind. We have to be examples for them.*

Simone worries about the impact the pandemic will have on that continuity. *After COVID, we're taking whatever we have and running with it. I do the shows in the park to keep some life in the area. We've lost so much. We're trying to stop New York from going out or dying away. People are leaving in droves. We're trying to save this city. This is to give people something to do when they're depressed.* Her efforts have finally received recognition from City Hall: In 2021, she received a grant from the City Artist Corps to continue doing public performances at Stonewall each weekend. The tips are okay, but she professes they could *always be better.*

As a friend was leaving the park, he turned to Simone and said, "Try to behave for once!" Another friend chimed in: "Don't listen to him! Be anything you want to be—this is your world!"

HELL HATH NO FURY: A CHRONOLOGY OF GENDERFUCK INSURRECTION

T his non-exhaustive chronology is reproduced with permission from the Gender Mutiny Collective, originally published in Queer Ultraviolence (*ed. Baroque and Eanelli, Ardent Press, 2011*).

Hell hath no fury like a drag queen scorned.

—SYLVIA RIVERA

The chronology below requires little introduction; the actions of all these rioters speak for themselves. Suffice to say that this chronology is a small attempt to address a fallacy in popular conceptions of insurrection—that insurrection is "macho," masculine, or that it reinforces gender norms. It should also address another fallacy in the commonly understood chronology of queer and trans resistance—the one that says, "Stonewall was first."

A note on language. Any terms we apply anachronistically will fail to reflect the ways these individuals and collectives identified. Moreover, we have first-hand accounts from none of these rioters, except some Stonewall and Compton's participants. Since any language we choose for such a broad span of time, place and culture will be historically inaccurate, we just say genderfuck insurrection. It has the nicest ring to our ears.

Genderfuck is an active term; it speaks of a force that acts upon gender normality. This is more interesting to us than other terms that are passive and speak of identity, which attempt to freeze and quarantine gender transgression into special individuals.

390

Thessalonica, Greece. Butheric, the commander of the militia, arrested a popular circus performer under a new law that punished "male effeminacy." The people of Thessalonica, who loved the performer, rose up in rebellion and killed Butheric. In response to the insurrection, authorities rounded up and massacred three thousand people.

1250

Southern France. A small crowd of cross-dressed males pranced into the home of a wealthy landowner. They sang, "We take one and give back a hundred," and ignored the protestations of the lady of the house as they looted the estate of every possession.

1450–51

Cade's Rebellion in Kent and Essex, England. Led by the "servants of the Queen of the Fairies," the peasants broke into the Duke of Buckingham's land and took his bucks and does.

1530

"New Spain." During his campaign of conquest against communities of resistance in western portions of "New Spain," Spanish conquistador Nuño de Guzmán wrote of a battle. The very last indigenous warrior taken prisoner after the battle was, in the conquistador's words, "a man in the habit of a woman" who had "fought most courageously."

16th century

Europe. Urban carnivals throughout Europe integrated cross-dressing and masks as key elements. The festivals were organized by societies of unmarried "men" with trans personalities. They were called the Abbeys of Misrule, Abbots of Unreason, "Mére Folle and her children," and others. During festivals, they would "hold court" with mock marriages and issue coins to the crowds. They made fun of the government, critiqued the clergy, and protested war and the high cost of bread.

1629

Essex, England. Grain riot led by "Captain" Alice, who was trans.

1630

Dijon, France. Mére Folle and her Infanterie went beyond throwing carnivals and mocking elites. They led an uprising against royal tax officers. As a result, a furious royal edict abolished the Abbey of Misrule.

1631

England. Riots against enclosure led by "Lady Skimmington" drag mob.

1645

Montpellier, France. Tax revolt led by La Branlaire, who was called by a term for masculine women.

1720

The Caribbean Sea. Untold numbers of trans pirates sailed across the open seas in the Golden Age of Piracy. It was not altogether uncommon at the time for "women" to "pass as men" while sailing in the navy, on mercantile ships, and as pirates. The two most well-known trans pirates of the era are Read and Bonn. They sailed together with Captain John Rackham, and their stories are known from when they were put on trial for piracy. They were said to be the most fierce and courageous fighters in their crew. Like most pirates, they were faggots.

1725

Covent Garden Molly House Rebellion, London, England. Since 1707, the Societies for the Reformation of Manners carried out systematic attacks on London's queer underground. More than twenty "molly houses" were raided by police in London and many "mollies" (MTFs) publicly dragged and hanged for cross-dressing. But on one day in 1725, the police attempted a raid of a Covent Garden molly house, and the crowd of mollies, many in drag, fiercely and violently fought back.

1728–1749

Toll Gate Riots in England. "To cite but four examples, toll gates were demolished by bands of armed men dressed in women's clothing and wigs in Somerset in 1731 and 1749, in Gloucester in 1728 and in Herefordshire in 1735."

1736

Edinburgh, Scotland. "The Porteous Riots, which were sparked by a hated English officer and oppressive custom laws and expressed resistance to the union of Scotland and England, were carried out by men disguised as women and with a leader known as Madge Wildfire."

1760s

White Boy commons restoration movement in Ireland. The "White Boys," a peasant guerrilla group who called themselves "fairies" and did mischief at night, were a central feature of the rural class war. They destroyed enclosures, sent threatening letters to elites, reclaimed properties seized by landlords, and freed bound apprentices. They were finally put down by armed force. Their spirit inspired the formation of the "Lady Rocks" and "Lady Clares" in the 1820s and 1830s, and the later Ribbon Societies and Molly Maguires—all were involved in Ireland's anti-enclosure and anti-colonial struggles and all cross-dressed.

1770s

Beaujolais, France. "Male" peasants dressed as women attacked surveyors assessing their lands for a new landlord.

1812

"General Ludd's wives" loom riot, Stockton, England. One of the early Luddite Rebellions against the Industrial Revolution was led by "General Ludd's wives," two cross-dressed workers. The mob of hundreds broke windows, stoned the house of Joseph Goodair, a factory owner, and later set fire to his house. They destroyed the products in the steam loom factory, smashed the looms and burned the factory to the ground. The rioting went on for four days until it was stopped by the military at Stockport, and then broke out again at Oldham.

1820s

Ireland. The "Lady Rocks" militant Irish resistance group active; inspired by the White Boys, they wore bonnets and veils.

1829

The War of the Demoiselles in the Pyrenees. A peasant uprising against restrictive forest code in which the peasants cross-dressed.

1830s

Ireland. The "Lady Clares" militant Irish resistance group active; inspired by the White Boys, their "official" costume was cross-dressing.

1839–1844

Welsh Toll-gate Riots, carried out by "Rebecca and her daughters." One well-documented instance was on May 13, 1839. At dusk, a call of horns, drums, and gunfire are heard across the western Welsh countryside. Armed male peasants, dressed as women, thunder up on horseback, waving pitchforks, axes, scythes, and guns. As they storm the toll-gate their leader roars: "Hurrah for free laws! Toll-gates free to coal pits and lime kilns!" These demands are punctuated by a cacophony of music, shouts, and shotgun blasts. The rebel troops smash the toll barriers and ride away victorious. They call themselves "Rebecca and her daughters." The Rebeccas are active for four years in Wales, leading thousands of cross-dressed "daughters" in the destruction of turnpike toll barriers. They receive widespread popular support.

1843

Militant resistance group the "Molly Maguires" active in Ireland. Inspired by the White Boys, the word "Molly" was the vernacular equivalent of what we might call "queen" today.

1959

Cooper's Do-nuts Riot, Los Angeles, May 1959. Police attempted a raid on Cooper's Do-nuts, a late-night hangout for drag queens, butch hustlers, street queens, and johns. The cops demanded IDs. The queers fought back. Doughnuts and coffee cups become projectiles. Fighting spilled out onto the street. The cops, taken by storm, called for backup. Rioters were arrested and the street was closed off for a day.

1966

Compton's Cafeteria Riot, San Francisco, August 1966. Compton's Cafeteria, an all-night hangout for drag queens and hustlers in the Tenderloin neighborhood. The restaurant management called the police on a group of young queens who were being rowdy. A police officer who was used to roughing up Compton's regulars grabbed a queen. She threw her coffee in his face. A fight broke out. Plates, trays, cups, and furniture were thrown. The plate-glass windows of the restaurant were smashed. Police called for backup as the riot took the street. The windows of a cop car were smashed, and a newspaper stand went up in flames.

1969

Stonewall Riot, New York City, June 28. The police conduct a "routine" raid of the Stonewall Inn in Greenwich Village. They began to round up trans people, drag queens, and kings to be arrested for cross-dressing, which was illegal. Hostility grew and grew until an officer shoved a queen, who responded by hitting him on the head with her purse. The crowd became fierce. Cops were pelted, first with coins and then with bottles and stones. When a bull-dyke resisting arrest called to the crowd for support, the situation exploded. The crowd tried to topple the paddy wagon while the police vehicles got their tires slashed. The crowd, already throwing beer bottles, discovered a cache of bricks at a construction site. Cops were forced to barricade themselves inside the Inn. Garbage cans, garbage, bottles, rocks, and bricks were hurled at the building, breaking the windows. Rioters ripped up a parking meter and used it as a battering ram. The mob lit garbage on fire and sent it through the broken windows; squirted lighter fluid inside and lit it. Riot police arrived on the scene but were unable to regain control of the situation. Drag queens danced a conga line and sang songs amidst the street fighting to mock the inability of the police to reestablish order. The rioting continued until dawn, and for the next four days. Crowds filled the streets and smashed more cop cars, set more fires, and looted stores.

1970

New York City. Marsha P. Johnson and Sylvia Rivera, veterans of the Stonewall riots, formed the Street Transvestite Action Revolutionaries (STAR). Marsha and Sylvia opened the STAR house for homeless drag queens and runaway queer youth to stay in. The house mothers hustled to pay rent so their kids wouldn't have to. The youth, in turn, stole food to bring home. STAR linked up with the Young Lords, a revolutionary Puerto Rican group, and with the Black Panther Party.

Special Thanks

Our parents, Katherine Latshaw, Rodolphe Lachat, Karen Valentine, Bridget Read, Ariana Marsh, Sebastian Andreassen, Zackary Drucker, for conducting the interview with Sir Lady Java, Trixie Mattel, Alan Cumming, Ari Seth Cohen, Juliana Spahr, Max Fox, Hari Nef, Fran Tirado, Virgil Texas, Joe Jeffreys, John Tarney, Janet Tarney, Tom Bamberger, Chris Tuttle, David Odyssey, Napaquetzalli Martinez, Drew Ritter and Erika Kettleson, The Field, Station 40, 223(A) Collective, Casa Bruja, Sycamore, Four Corners, Hotel Gaythering (Miami, FL), JC Raulston Arboretum (Raleigh, NC), A Little White Wedding Chapel (Las Vegas, NV), Bonnet House Museum & Gardens (Fort Lauderdale, FL), Gratitude Vintage (Dallas, TX), The Orange Show (Houston, TX), Cute Nail Studio (Austin, TX), La Belle Esplanade Bed & Breakfast (New Orleans, LA), Debra Falco, Tony Balistreri and David Jones, Jackie Seiden, Daniel Hymanson, Donny Hall and Michael Farnsworth, Nightshade Farm & Flowers (New Orleans, LA), Pine State Flowers (Durham, NC), Milwaukee Flower Company, Eleanor Gerber-Siff, Ashley Louie of Wild Club, Hilary Holmes at Emerald Petals, Yoni Levenbach, Jackie Krejnik-Ryan, Naomi Waxman and Dave Claussen, Michael Crisafulli and Morton Newburgh, Wendy Trevino, Saralee Stafford, Benny and Maryam, Manifestany Squirtz, Charlene Incarnate, Nicole Paige Brooks, James Michael Nichols, Chris Tyler, Cheno Pinter, Joshua Jenkins, Vivica C. Coxx, Erin Lux, Jacob Tobia, Gerald Knott, Dom Capobianco, Griffin Cloudwalker, Lori, Paula Woodley, Matthew Kasten, Manny Mireles, Cody Shulund, Antony James, David Buuck, Mitchell Jackson, Matthew Patrick, Owen Ever, Queef Latina, Rachel Wells, Heather Provoncha and Leo Hollen Jr., Spencer Martin, JD Doyle (*Queer Music Heritage*), Nick Anthony (*Our Community Roots*), Zagria (*A Gender Variance Who's Who*)

Credits

Executive Producers: The Windhover Foundation

Producers: Sasha Velour, Heil Family Foundation, Leslie Grinker, Joseph Pabst and John Schellinger, Andy Nunemaker Foundation, Amika (Heat Makes Sense, Inc.), The Valentine Fund, Michael Counter (Counter Culture LLC), The Sisters of Perpetual Indulgence of San Francisco, Beardwood&Co.

Photograph page 6: Yu Tsai; page 7: Tanner Abel and Nicholas Needham; page 8, 11, 12, 239: Deb Leal; page 15: Mercedez Gonzalez

Retouching: Christian DeFonte

Production Assistants: Deb Leal, Karina Solis, Miwa Sakulrat, Simone LaStrapes, Molly Rosenblum, Areïon, Slater Stanley, Conner Calhoun, September Krueger, Ehren Dei, Jacob Marrero, Ann Nguyen, Chantal Lesley, Jacob Foreman, Laura Kay Mercer, Susi Q Beck, Journey Streams, Mercedez Gonzalez, Nico Reano, Wil Zanni

LEGENDS
of DRAG

ISBN: 978-1-4197-5847-8
LCCN: 2021949389

© 2022 Harry James Hanson and Devin Antheus
Printed and bound in Italy
10 9 8 7 6 5 4 3 2 1

Texts: Harry James Hanson and Devin Antheus
Cernunnos logo design: Mark Ryden
Book design: Benjamin Brard
Design Manager: Shawn Dahl, dahlimama inc

Abrams books are available at special discounts when purchased
in quantity for premiums and promotions as well as fundraising or
educational use. Special editions can also be created to specification.
For details, contact specialsales@abramsbooks.com or the address below.

Abrams® is a registered trademark of Harry N. Abrams, Inc.

ABRAMS The Art of Books
195 Broadway, New York, NY 10007
abramsbooks.com

...HATIMA RUDE JOAN JETT...
...DEZ COLLETTE LEGRANDE ...
...VITA MORE MUTHA CHUCKA...
...SISTER ROMA MRS. VERA NEV...
...MISS ABU DARCELLE XV POI...
...TURE DOLLY LEVI MAXIMI...
...GODDESS BUNNY GLEN ALEN...
...DER TWINS VANCIE VEGA F...
...CONNIE PSYCADELLA FACA...
...LATE CRYSTAL WOODS DUW...
...SON KAREN VALENTINE BJ DA...
...SUGARBAKER TWINS RUTHI...
...CHILLI PEPPER MAYA DOUGI...
...ROUX HONEY WEST EBONY...
...LY RAY TINA DEVORE SHAWN...
...ACOBS KITTY LITTER REGI...
...VANESSA CARR KENNEDY MC...
...GARRON ADORA KITTY MEC...
...SHARDE ROSS NIKKI ADAMS A...
...DA SIMPSON HARMONICA S...
...PERFIDIA FLOTILLA DEBAR...
...RA HERR PICKLES RUBY R...